archiveology

33

A CAMERA OBSCURA BOOK

Catherine Russell

archiveology

WALTER BENJAMIN

AND

ARCHIVAL FILM

PRACTICES

Duke University Press Durham and London 2018

Text designed by Mindy Basinger Hill
Cover designed by Matthew Tauch
Typeset in Minion Pro and Trade Gothic
by Westchester Publishing Services

Library of Congress Cataloging-in-Publication Data
Names: Russell, Catherine, [date] author.
Title: Archiveology : Walter Benjamin and archival film practices /
Catherine Russell.
Description: Durham : Duke University Press, 2018. | Series: A camera
obscura book | Includes bibliographical references and index.
Identifiers: LCCN 2017039264 (print)
LCCN 2017056105 (ebook)
ISBN 9780822372004 (ebook)
ISBN 9780822370451 (hardcover : alk. paper)
ISBN 9780822370574 (pbk. : alk. paper)
Subjects: LCSH: Film archives. | Archives. | Motion picture film. |
Benjamin, Walter, 1892–1940.
Classification: LCC PN1993.4 (ebook) | LCC PN1993.4.R874 2018 (print) |
DDC 026.79143—dc23
LC record available at https://lccn.loc.gov/2017039264

Cover art: Still from *Film Ist.4—Material* (Gustav Deutsch, 1998).

FOR MARCO

CONTENTS

ACKNOWLEDGMENTS

In 2008 I began teaching the course Archiveology: Archival Film Practices in our newly founded PhD Program in Film and Moving Image Studies at Concordia University. Since then I have continued to teach such a course on a regular basis, and I am grateful to all the students who have contributed in many small ways to my understanding of the topic and its potential scope. Several students have been of particular help in the research that went into this book, especially Papagena Robbins, Tess McClernon, Dominic Leppla, and Kaia Scott. Thanks also to Joaquim Serpe for his invaluable assistance in producing the illustrations, Jennifer de Freitas for excellent design advice, and Melanie Honma for research assistance. Ken Wissoker, Elizabeth Ault, and all the staff at Duke University Press have been wonderfully helpful throughout the publication process, and I would also like to thank the anonymous readers and the Camera Obscura editorial board. I am fortunate to work with stellar colleagues, who have helped create a supportive and stimulating research environment in our department at Concordia. In particular, I would like to thank Martin Lefebvre and the Arthemis research group that he led for many years, not only for the funding support but for the collegial research environment. Many thanks go also to Kay Dickinson for her generous help with chapter 6.

Funding support from the Social Sciences and Humanities Research Council of Canada, the Fonds de Recherche Société et Culture Quebec, and Concordia University was instrumental to the completion of this research. The book includes excerpts from a number of articles that I have published over the last few years. I would like to thank all the editors for their support and for the opportunities they provided to develop my thinking about archiveology. I would especially like to thank Paul Flaig, Erica Balsom, Jodi Brooks, Therese Davis, André Habib, and Drake Stutesman.

In "remixing" a number of articles that have been previously published, I have borrowed extracts, rewritten and revised parts of them, and combined arguments and examples from different places. In their new context, these various articles are reorganized to suit the chapter breakdown of the book and have been integrated with new writing. Unlike the media practices that the book is

about, the original forms and contexts of the articles may no longer be legible in their remixing, but they can still be located in the following sources:

"*Paris 1900*: Archiveology and the Compilation Film." In *New Silent Cinema*, edited by Paul Flaig and Katherine Groo, 63–84. New York: Routledge, 2015.

"Cinema as Timepiece: Critical Perspectives on *The Clock*" and "Archival Cinephilia in *The Clock*." *Framework* 54, no. 2 (2013): 163–76 and 243–58.

"Benjamin, Prelinger and the Moving Image Archive." In *L'avenir de la mémoire: Patrimoine, restauration et réemploi cinématographiques*, edited by André Habib and Michel Marie, 101–13. Paris: Éditions du Septentrion, 2013.

"In the Mood for Cinema: Wong Kar-wai and the Diasporic Phantasmagoria." In *Cinephilia in the Age of Digital Reproduction: Film, Pleasure and Digital Culture*, vol. 2, edited by Scott Balcerzak and Jason Sperb, 111–31. New York: Wallflower Press, 2012.

"The Restoration of *The Exiles*: The Untimeliness of Archival Cinema." *Screening the Past* 34 (September 2012). http://www.screeningthepast.com /issue-34/.

"Dialectical Film Criticism: Walter Benjamin's Historiography, Cultural Critique and the Archive," *Transformations*, no. 15 (2007). http://www .transformationsjournal.org/journal/issue_15/article_08.shtml.

"New Media and Film History: Walter Benjamin and the Awakening of Cinema." *Cinema Journal* 43, no. 3 (2004): 81–85.

PROLOGUE

Archiveology refers to the reuse, recycling, appropriation, and borrowing of archival material that filmmakers have been doing for decades. It is not a genre of filmmaking as much as a practice that appears in many formats, styles, and modes. The goal of this book is to explore the practice of archiveology as it traverses experimental, documentary, and new media platforms. The film archive is no longer simply a place where films are preserved and stored but has been transformed, expanded, and rethought as an "image bank" from which collective memories can be retrieved. The archive as a mode of transmission offers a unique means of displaying and accessing historical memory, with significant implications for the ways that we imagine cultural history.

The films discussed in this book are examples of archiveology as a media art practice. In fact, the networking and remediation of audiovisual materials extends well beyond experimental works and includes the proliferation of pedagogical and poetic video essays. It also includes the hundreds and thousands of YouTube homages, supercuts, and remixes made by amateurs, alongside those made by film scholars, and mainstream film industry–sponsored trailers, tributes, and other montages made in recognition of film historical knowledge. The potential of film history in its cut-up form remains an open possibility, as well as a wounding and trauma to the integrity of narrative cinema. Walter Benjamin's cultural theory is significantly oriented toward the avant-garde as the corollary to the implicit dangers of the society of the spectacle, and the various compilation films, essay films, and experimental media that I discuss in this book are chosen precisely because they highlight the dualism and necessary ambiguity of archiveology as a language of media culture.

In "The Author as Producer," Benjamin demanded that writers take up photography, but not simply to document.[1] He calls on the activist intellectual to work on "the means of production," which is to say, the technologies of production, in order to turn spectators into collaborators. In the revolutionary language of a Marxist-inflected activism, Benjamin describes the writer as an "engineer" who adapts the apparatus, even if it is only a "mediating"

role in the revolutionary struggle against capitalism — which in 1934 he fully aligns with fascism and its "spiritual" qualities.[2] If Benjamin's rhetoric seems overblown, he nevertheless provides a more engaged model than that of Guy Debord, even if he shares with Debord an insistence on dismantling the society of the spectacle.

The emphasis on Walter Benjamin is admittedly a choice to sideline other media theorists who also have much to contribute to the significance and dynamics of archiveology. In this book I indeed draw on many key thinkers, including Michel Foucault and Jacques Derrida, Jacques Rancière, Giorgio Agamben, and Vilém Flusser, not to mention many cogent Benjamin scholars such as Miriam Hansen, Susan Buck-Morss, Margaret Cohen, and Christine Buci-Glucksmann, and many other film and media scholars as well. However, Walter Benjamin remains the central figure because a second aim of this project is to argue that archiveology as a cultural practice is a crucial point of convergence of many of Benjamin's central ideas, and that it makes his contribution to media theory "attain to legibility."

Benjamin is a challenging theorist, because he himself adopted the style of surrealist poetics at a certain point in his career. He felt that the surrealists had missed an opportunity for a revolutionary practice that he aimed to rectify with his own experimental study of Paris, *The Arcades Project*. *Archiveology* is not a term derived from Benjamin, whose wordplay did not include neologisms. He did, however, develop an archive-based critical method, and thought a great deal about archaeology as a metaphor for the transience and sedimentation of cultural memory. As Samuel Weber explains, Benjamin tended to form nouns from verbs so as to give them "abilities," and to make them potent, constructive, and dynamic: "Benjamin's writing practice advocates the reinscribing of established terms so that they part company with themselves — which is to say, with their previous identities. It is by virtue of such a movement of *parting-with* that words recover the ability to name, which is never reducible to any identifiable semantic content, least of all to that of a proper noun."[3] The term *legibility* is an example of this tendency in Benjamin; likewise, the pliable conception of language implicit in Weber's description underscores the mutability of archiveology as a language of the audiovisual archive.

Although his famous essay "The Work of Art in the Age of Its Technical Reproducibility" has been a cornerstone of film studies scholarship since the 1960s, it has only been since the 1990s that Benjamin's larger corpus of writing has been translated into English, providing more historical context for

that essay and more access to his diverse program of theory and criticism. Benjamin was deeply caught up in the political and aesthetic turbulence of Europe between the wars, and his concept of "experience" came from a life that was lived fully, and lived in a state of perpetual dislocation. His own death looms over his vast corpus of writing — much of it unpublished during his lifetime — as testimony to the catastrophe of history and the failed promise of modernity that motivated much of his work.

Critics, scholars, and filmmakers frequently cite Benjamin in the context of found-footage filmmaking because so many of his key concepts, such as allegory, quotation, "refuse," dialectical images, ruins, and the optical unconscious, seem particularly appropriate to the practice. In this book I hope to bring these ideas into something more than a collection of sound bites. Benjamin is eminently quotable, but film scholars have rarely stopped to try to bring it all together. By drawing on his early work on language and German tragic drama, as well as *One-Way Street*, *The Arcades Project*, and many of the essays on film and culture, my aim is to make Benjamin's diverse comments on images and history converge in light of archival film practices. As he himself argues about images, "they attain to legibility only at a particular moment in time."[4] This is the time when image culture is in transition, when analog image technologies are taking on the aura of something vanishing, and when we might be able to see "some beauty" in that vanishing.

Given the vast spectrum of activities and cultural practices that could potentially be subsumed under the rubric of archiveology, it may be necessary to justify the role of artists' moving image practices. The question of art is actually one of the key problematics at the heart of Benjamin's project. His implicit answer to the question of art in the age of its "technical reproducibility" (a.k.a. "mechanical reproduction") is that art needs to be engaged and, moreover, that criticism is obliged to "lift the mask of 'pure art' and show that there is no neutral ground for art."[5] Benjamin's own critical writing on Franz Kafka, Marcel Proust, Charles Baudelaire, and many other writers is consistently reflexive, engaged with the texts in such a way that their work is "illuminated" as a meeting of reader and author. Benjamin was less concerned with the judgment of works or the originality of authorship than with the ways that texts accumulated extra baggage in their afterlives: "the exegeses, the ideas, the admiration and enthusiasm of previous generations have become indissolubly part of the works themselves."[6] He described an obsessive focus on "the new and topical" as "lethal."[7]

In 1930 Benjamin advocated for a mode of criticism that would "consist entirely of quotations,"[8] which is where we are today with the burgeoning

form of the video essay, in which critics construct their analysis of films using extracts from the films themselves. Art and criticism are closely allied in Benjamin's thought as instruments of social and cultural critique. He cared not to evaluate work or to praise it but to situate work within the shifting tides of modernity. Artists are particularly well situated to negotiate the treacherous ambiguities of Benjamin's conception of culture in which the ideological and the utopian are intricately connected. His rhetoric of "blasting open," of "awakening," of the "monodological" and the dialectical is premised on a recognition that the only way to subvert or challenge the world of images that we inhabit is from within that world. Thus the tropes of porosity and the techniques of montage and collecting belong to an art of remix, recycling, and revisiting the past from the very particular vantage point of the present. For Benjamin, "now time" is a dynamic conception of the present moment as a break from the past, but a moment that might correspond to the image of a future as yet unrealized.

If the magical and utopian elements of Benjamin's messianic philosophy have proved troublesome to some, many artists and scholars have been drawn to his work precisely because of its imperative challenge to reason. Archiveology as a creative practice is a means of harnessing the energy of Benjamin's critical method in the context of an ever-expanding image bank. Moreover, the conception of a language at the heart of this practice is based in critical method rather than a "scientific method" such as semiotics. Benjamin's notion of allegory is argued by way of examples drawn from literary sources, and likewise the method of this book is to draw from examples of moving image culture.

By way of introduction, it may also be necessary to set aside several false expectations that readers may have of this book. It is not, for example, a book about the history of found-footage filmmaking, although archiveology is definitely an outgrowth of that practice. A more experimental practice of found-footage filmmaking continues to thrive in which media artists work with more "manipulative" strategies on more personal levels, and often draw on personal as well as public archives.[9] Archiveology has not entirely subsumed found footage or displaced it but offers another way of thinking about that practice as a critical cultural form. Nor is this a book about archival practices, or the ongoing challenges of preserving media history, or the missions and mandates of archivists. Archiveology is a creative engagement with the institutions, individuals, and materials of the media archive, but my focus is

on the images themselves, which are what are actually at stake in the growing discourse around media archives.

The convergence of research and representation, searching and exhibiting that are all part of archiveology tends to align it with both curating and criticism. Many of the works discussed in this book might be described as video essays, but that is not the focus either. Instead, this corpus is best considered within the context of the avant-garde — which is not exactly the same avant-garde as that which existed in Benjamin's day. In the era of the art star and the gallery film, media artists can no longer always remain outside the realm of capital, and the balance of ideology and utopianism is increasingly destabilized.

If the artwork is not autonomous but embedded in an image world of which it is a part, whose resources it destroys and constructs again, then it is not entirely surprising that some artists are making money from it. However, we need to keep in mind that the radical potential of film, for Benjamin, lay in its status as a collective practice. Thus, this book returns repeatedly to Hollywood, classical cinema, and the movie stars with their cultish auras. Video projections in destination museums often borrow the spectacular qualities of classical cinema not only to *détourne* mainstream cinema but to attract audiences.[10] That is just how powerful classical cinema, even in fragmentary form, can be. Nevertheless, it is also true that a committed avant-garde also exists, and archiveology continues to provide valuable tools for many forms of media practice, not all of which can be adequately accounted for in this book.

Film and media archives of many different varieties exist globally, many of them accessible in bootleg form and many still to be discovered. Many more remain hidden, and are always in danger of becoming permanently invisible due to overexuberant gatekeepers, lack of resources, neglect, or physical decay. Archiveology is above all a means of returning to the images of the past that were produced to entertain, or produced for more serious purposes of documentary recording, and reviewing them for new ways of making history come alive in new forms. Archiveology as defined here is not about personal memories but collective memories, the images produced to tell stories or to record public events. Another road not taken, but equally important, is that of the personal archive and the work made from home movies. Countless examples exist in which traces of identity are collected from image cultures both private and public and reconstructed into new work in which the maker finds herself within the fissures and contradictions between and among images.

Celebrity biographies of personalities such as Amy Winehouse, Marlon Brando, Ingrid Bergman, and Kurt Cobain can be constructed entirely from photographic materials. These are people who grew up in front of cameras and were often undone by them as well. But this is not a history of archiveology or the essay film. If it were, it would have to include key figures such as Chris Marker and Harun Farocki, who make only brief appearances. Marker and Farocki have their own strong methods of essayistic archiveology that certainly converge with Benjamin's cultural theory but, at the same time, seem to run parallel to it. Their relative absence from this project is due to a desire to resist auteurism and focus on somewhat lesser-known figures whose work collectively outlines the features of archiveology — a focus on works that tread a more precarious path through the dangers of image culture to reclaim its secrets.

As an art of editing, searching, compiling, and organizing, archiveology highlights the affinities of filmmaking with women's work. Esfir Shub is unquestionably the first archiveologist, and there are undoubtedly many more women whose work remains invisible.[11] Although Benjamin himself cannot be considered a feminist, his work has been instrumental to feminist film scholarship for a variety of reasons. His commitment to the politics of the everyday, to the flexibility of counterreadings and afterlives of texts and images, and to the ideals of social transformation and social justice have all been taken up by feminist filmmakers and film scholars. Barbara Hammer, Abigail Child, Leslie Thornton, Peggy Ahwesh, Sue Friedrich, and many others have developed impressive oeuvres of found-footage filmmaking. In the final chapter I will take up the topic of "awakening" from the gendered corpus of film history by means of archiveology. Although the book contains analyses of films of only two women, Nicole Védrès and Rania Stephan, the emphasis on gesture and on detail in archiveology necessarily shifts the focus of experimental media from masculinist oversight and vision to filmmaking as craft.

Although this book is concerned with many films made before 2000, the theorization of archiveology has only become possible after the millennium. Shortly after the completion of my book *Experimental Ethnography* in the late 1990s, I wrote a short half-page "definition" of archiveology for a "Lexicon 20th Century A.D." for the journal *Public*. I began by defining archiveology as "the technique of storing and accessing the vaults of cultural memory. Not to be confused with remembering."[12] Since then, many things have become more clear, including the fact that archiveology belongs to a lexicon of the twenty-first century, and that it is a mode of creative practice that draws on

the techniques of storing and accessing, but it is also much more. This book is an attempt to define the term again and give it more substance. Archiveology is a mode of moving image art, one that is particularly well suited to a reviewing and reimagining of the twentieth century. I also wrote in 2000 that "remembering" is "the recovery of fragments of the past that have become dismembered from the body of the present," which remains more pertinent than another somewhat naïve claim: my conception of history as being like a computer memory. Walter Benjamin's thought can be glimpsed even in my initial foray into archiveology, and I am even more convinced that his theorization of nonlinear historiography remains the most pertinent to this inquiry precisely because his passionate practice of thinking through images seems to be increasingly relevant to the appropriation arts of the twenty-first century.

In *Experimental Ethnography*, I wrote about found-footage filmmaking in terms of apocalypse culture. In 1999 it seemed as if this mode of film practice was preoccupied with "the end of history," and the promise that Benjamin held out for cinema had failed to be realized. Nearly two decades later, as archival film practices have become more prevalent in mainstream culture and in experimental media, I am more optimistic about the cultural role of audiovisual appropriation. One key change has been a shift in theory and practice to the recognition of the research function implicit in archival film practices. "Found footage" links the mode to surrealist practices of accident and recontextualization but negates the extensive searching that often sustains the practice. Recognition of the search function highlights the role of the moving image archive and its transformation in digital culture.

Given the dearth of non-Western media in this book, I would like to conclude this preface with a single film that draws on the archives of global media and serves as a good opening example of archiveology. Kamal Aljafari's *Recollection* (2015) is made from Israeli and American feature films shot in Jaffa from the 1960s to the 1990s. Using digital effects, Aljafari has removed the principal actors from the locations, leaving behind only the streets and buildings, many of them ruined by years of conflict. He lingers on the figures on the periphery, zooming into close-ups of Palestinian extras that he finally, at the end of the film, suggests may be relatives and acquaintances. The images are rendered inauthentic due to his magic tricks but are then given a new reality through his retrospective assignation of names and characters. *Recollection* is a film haunted by ghosts, memories, and a history of violence and occupation. The ruined city echoes with an emptiness that the viewer is compelled to fill with imagination and a recognition that the city is much older than the past

Recollection (Kamal Aljafari, 2015)

century. Aljafari projects himself onto the archival materials in a destructive, poetic, and very personal way. Digital tools have only amplified the means by which images can be "played" with and yet a film like *Recollection* points toward the potential even of destroyed and ruined archives to be remade as new ways of knowing the world.

If, for Benjamin, Eugène Atget photographed Paris as if it were the scene of a crime,[13] Aljafari's depiction of Jaffa renders the entire city a site of a political, historical, and humanitarian crime. His method is precisely a matter of "possessing the object in close-up" and "illuminating the detail," as Benjamin describes Atget's practice.[14] The "new way of seeing" that Benjamin identifies in Atget's photography of the early twentieth century has been renewed once again by Aljafari, whose process starts with refilming the Israeli films with a digital camera from the screen; his pans and zooms traverse and examine the cityscapes as media. His exploration of historical displacement is a literal recovery of the city as a space of domiciliation, memory, and imagination.

Archiveology is a practice of collecting images and compiling them in new and surprising ways, performed by artists and independent filmmakers, working in a variety of audiovisual media. It is an essayistic form, insofar as filmmakers are taking up previously used material as the basis of a film language. Appropriation filmmaking is an engaged practice, in which authorship is separated from vision, and yet a poetics of collage and a creative use of sound make this very much an art practice. The author is not only a producer; she is also a builder and a destroyer, constructing new work out of old and making new ways of knowing out of the traces of past experiences. Images and sounds are recordings that engage the senses, documents that are mysterious and secretive until their energies are released in flashes of recognition. Moving image artists are those who create these sparks, which only occur in the presence of the viewer.

1

INTRODUCTION TO ARCHIVEOLOGY

> Language has unmistakenly made plain that
> memory is not an instrument for exploring the past,
> but rather a medium.
>
> Walter Benjamin, "Excavation and Memory,"
> in *Selected Writings*, vol. 2

In contemporary media culture, fragments of filmed history are constantly being reassembled into new films and videos to create new audiovisual constructions of historical memory. Building on traditions of found footage and compilation films, digital media has made this practice proliferate. New technologies have also transformed the status of archives from closed institutions to open access, with significant implications for the aesthetics and politics of archival practices. Archiveology is a critical method derived from Walter Benjamin's cultural theory that provides valuable tools for grasping the implications of the practice of remixing, recycling, and reconfiguring the image bank. At the same time, contemporary archival film practices arguably make Benjamin's legacy more legible. Is this a new mode of film language? What is it saying, and how can we read it critically and productively? These are the questions posed by archiveology and with which this book is preoccupied.

The term *archiveology* was originally coined by Joel Katz in 1991, partly in response to the release of *From the Pole to the Equator* (1990) by Yervant Gianikian and Angela Ricci Lucchi, one of the first experimental films to explicitly work with material from a film archive.[1] Katz used the term to refer to the ways that filmmakers were making the archive useful and engaging with it on its own terms. By the early 1990s, Rick Prelinger's archive of ephemeral film was already pointing to the way that audiovisual kitsch provided a rich resource for rethinking and remaking American cultural history. Both the Italian team and Prelinger have continued to expand their archival film practices, along with a plenitude of other film and video artists, exploring the potential of audiovisual fragments to construct new ways of accessing and framing

histories that might otherwise have been forgotten and neglected—and to make these histories relevant to contemporary concerns.

Etymologically, *archiveology* might mean the study of archives, but the Greek suffix "-ology" actually refers to someone who speaks in a certain manner. When applied to film practice, it refers to the use of the image archive as a language. Moreover, the connotations of archaeology point to the cultural history that is inevitably inscribed in resurrected film fragments. The technologies of film stocks, video grain, and other signs of media history are often recorded within the imagery of archival film practices, inscribing a materiality into this practice; just as often, though, digital effects can alter the image and obfuscate both the original "support" material as well as its indexical link to an original reality. Nevertheless, film and media artists are transforming cinema into an archival language, helping us to rethink film history as a source of rich insight into historical experience. As Thomas Elsaesser notes, when postproduction becomes "the default value," it "changes cinema's inner logic and ontology." He compares the new mode of image-making to "the extraction of natural resources," among other things. His caveat that "the ethics of appropriation will take on a whole other dimension" is a theme for which Benjamin's cultural politics may provide valuable guidance.[2]

The term *archiveology* may also be used to refer to the study of archives, and the term has been used to refer to the work of Derrida and Foucault, who have of course contributed immensely to our understanding of the archive as a social practice.[3] Derrida's "archive fever" is manifest in the way that archival film practices work against the archive itself by fragmenting, destroying, and ruining the narrativity of the source material. The death drive is always at work in films that are built on the ruins of historical pleasures and experiences, subjecting them to the repetitions of remediation. The term *archiveology* surfaces occasionally in discussions of Foucault, for whom the archive functions as an archaeology of knowledge and is the basis of all discursive practice.[4] His sense of the archive as constituting a "border of time" is key to the effects of media archiveology and its discontinuous effects of historicity.

In the early twenty-first century, the architecture, social role, and politics of the archive have been radically changed from their origins in institutional "domiciliation." Film and media archivists are tasked with making film history accessible and transmissible; in "restoring" and preserving film, they are frequently transforming it into new media by using digital techniques, thereby challenging norms of authenticity, media specificity, and origins that have traditionally been attached to the archive.[5] The gatekeeping function

of the traditional "archon" no doubt persists and has taken on new personas such as that of the copyright holder and the paywall; but many gates are easily breached with the aid of digital tools. This book is not about the new challenges, platforms, and activities of film and media archives but will necessarily invoke some of the ways that archiving has changed and has in many ways blended into creative art practices. If we are all archiving all the time in an effort to manage our own computer files, then the public/private distinction between archive and collection is also arguably dissolving. The digital turn is, however, only one more phase of a process that Sven Spieker claims to be endemic to modernity. From the perspective of the avant-garde, the archive is a transformational process, with the power of turning garbage into culture. However, the flip side of this claim is also true — that "when an archive has to collect everything, because every object may become useful in the future, it will soon succumb to entropy and chaos."[6]

Spieker's analysis of the multiple art practices that have pitched themselves against the institutions and codes of bureaucracy is echoed in Paula Amad's account of the counterarchive, which makes similar arguments in connection to the film archive as it emerged in the early twentieth century.[7] The dream of complete knowledge in the totalizing capacity of the photographic record and the incorporation of "the everyday" into the historical record (the trash) constituted a real challenge to historiographic method. With the cinema, archives are no longer about origins. Documents are representations that have their own networks of secrets, which will always be in excess of their ostensible meaning as evidence. As Foucault has taught us, the archive should not be taken for knowledge itself, but should be recognized as a key site of the power and social relations that provide the conditions for knowledge.

The archive as a construction site was at the basis of Benjamin's understanding of it. In keeping with Henri Bergson and Siegfried Kracauer, the archive for Benjamin is always about memory and the condition of forgetting. The camera fundamentally altered the function of human memory, precisely by transforming it into a kind of archive. Benjamin himself never uses a neologism such as *archiveology* but he certainly evokes it in a fragment of writing from 1932 called "Excavation and Memory." In this fragment, Benjamin suggests that memory might itself be a medium. He compares memory to an archaeological process in which the "richest prize" is the correspondence between present and past. "A good archaeological report," he argues, "gives an account of the strata which first had to be broken through." He also says that the "matter itself," which "yields its long-lost secrets," produces images that,

"severed from all earlier associations, reside as treasures in the sober rooms of our later insights."[8] Memory, for Benjamin, is only a "medium" insofar as it is experienced; and it is precisely this reawakening of experience that the moving image is able to evoke.

In keeping with Benjamin's historiography, I am quite deliberately projecting contemporary cultural concerns onto the fragment "Excavation and Memory" to make it useful, and relevant, in the present. Many of his key concepts come into play in discussion of archival film practices, including the dialectical image and the optical unconscious; and many of the figures of *The Arcades Project* return as well, including the collector and the ragpicker. In the following pages, many dimensions of Benjamin's cultural theory will be "illuminated," including his theory of language and allegory, in terms of contemporary themes of audiovisual recombination and media archaeology.

THE LIVING ARCHIVE

Benjamin's theory of the allegorical image has been widely understood in terms of a modern Baroque, but it is evident from contemporary archival film practices that the language of appropriated images is not a dead language. While the archive certainly lends itself frequently to a melancholic sensibility, works such as *The Maelstrom: A Family Chronicle* (Péter Forgács, 1997) awaken us to new meanings and new histories that can be produced from the ruins of the past. Forgács is a moving image artist who is also a collector and archivist of home movies made in Europe during the middle decades of the twentieth century; his work provides astonishing insights into the "everyday" of families living in totalitarian regimes.[9] This is precisely how Jan Verwoert has described the new arts of appropriation. He suggests that the post–Cold War period has entailed an emergence of multiple histories that had been previously made invisible by dominant historical narratives. In the late 1970s, he notes, "the frozen lumps of dead historical time . . . became the objects of artistic appropriation."[10] Modern history appeared to be at a standstill, and indeed this was the overwhelming implication of the apocalyptic sense conveyed by found-footage filmmakers such as Bruce Conner in the 1960s.

Verwoert argues that since the 1990s the appropriated image can no longer be considered dead but speaks to the living. He argues that there has been a momentum in critical discourse "away from the arbitrary and constructed

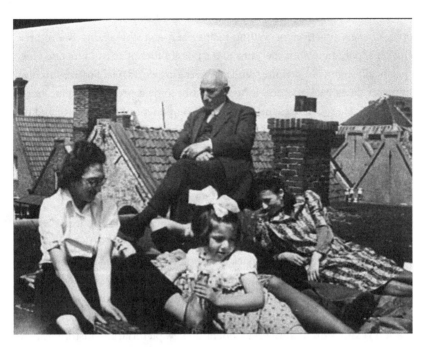

The Maelstrom: A Family Chronicle (Péter Forgács, 1997)

character of the linguistic sign towards a desire to understand the performativity of language."[11] Citing Derrida, Verwoert argues that the appropriated object or language can and will speak back, resisting the desire of the collector seeking to repossess it. The unresolved histories and modernities lingering in the image bank are, in this sense, awaiting practitioners to bring them to life and allow them to speak. Although Verwoert is discussing archival art practices in general, this seems especially true of moving images. The causes of this shift may have less to do with the end of the Cold War (which may not be over, in any case) than with the rise of new media and digital culture, which has exponentially increased the global traffic in images.

Underlying much of the rethinking of archive-based arts after postmodernism is a recognition that images are constitutive of historical experience and not merely a representation of it. For example, Emma Cocker argues that archival film practices can produce "empathetic — even resistant or dissenting — forms of memory, a progressive politics."[12] She describes "ethical possession" as a mode of borrowing from archives for discourses of recuperation and resistance. Unless one ascribes to the prescription of copyright

law, appropriation needs to be understood as a form of borrowing that can open up new practices of writing history and conceptualizing the future.[13] Cocker's "paradigm shift" pertains to the possibilities of artists' film and video specifically, but it is a definite trend across the art world. Hal Foster's "archival impulse" dates back to 2004, when it had become a prevalent theme in the visual arts. He recognizes the "paranoid" component of the practice and describes it as the "other side" of the utopian ambition of the archival impulse as a theme of modern administrative and bureaucratic museology. Foster argues that the move from "excavation sites" to "construction sites" is also a move away from a melancholic culture that "views the historical as little more than the traumatic."[14]

For Benjamin also, the link between excavation and construction is crucial, if the traumas of the past (the history of barbarism) can be the foundation of historical thought. He describes his method in *The Arcades Project* as one of "carrying the principle of montage into history . . . to grasp the construction of history as such."[15] Precisely because images are mediated, or "second nature," they offer unique insights into the past. Okwui Enwezor explains that the 2009 exhibition *Archive Fever* "opens up new pictorial and historiographic experiences against the exactitude of the photographic trace."[16] In other words, the historical value and implications of appropriation art are grounded not in the indexical authority of the document but in the life of the document-as-image, and the image-as-document.

Marc Glöde has also observed that something substantial changed in found-footage filmmaking after 1990. This was the year of Matthias Müller's *Home Stories*, a compilation of scenes from Hollywood melodramas that Müller captured on German TV. Glöde describes the experience of watching this film as "somewhere between hysterical laughter, the most intense empathy and a surgical way of watching a film at the same time."[17] Along with artists such as Stan Douglas, Christian Marclay, Monica Bonvincini, and Douglas Gordon (among many others), Müller uses found footage to help us better understand the cinema as a language of gesture, sensation, emotion, and experience. Much of the contemporary work has the effect of rendering the cinema itself archival, revealing the secrets that were hidden in plain sight.

Death, ruin, and loss remain prominent tropes in archiveology, especially with respect to the recovery of celluloid and other time-ravaged media. And yet the experiential, sensual dimensions of reanimated footage, sounds, and images can be visual, dynamic, and very much present. It is not coincidental that the emergence and prevalence of archiveology has occurred in tandem

with the "death" of cinema, its centenary, and the digital turn. While this seems eminently obvious, we have yet to fully grasp the potential of archiveology as a media art. At the same time as questions of film preservation and film archives have come to the forefront of film studies discourse, a parallel discussion of media archaeology, attending to the technologies of media production and exhibition, has emerged.

The filmmakers discussed in this book frequently highlight and work with the traces of celluloid degradation, pixilation, and other signs of the media from which imagery is borrowed, speaking back to the technologies of production at the same time as they speak back to the image archive. Many filmmakers refer to their work as archaeological, and their films are evidence that media archaeology cannot simply be about technologies and hardware but needs to account for images and sounds, viewers and makers. Walter Benjamin's contribution to media archaeology will be developed further in chapter 3 in conjunction with collecting practices. Benjamin's theory of history is inspired by the reconceptualization of time and memory that was introduced with photography, and he understood how changes in technologies of representation have had ripple effects with significant political and social ramifications.

At the same time as filmmakers are recycling sounds and images in new ways, museums and film archives are also undergoing significant changes in the digital era. In 2012 the EYE Museum in Amsterdam launched a series of innovative strategies for integrating film practice and production with film restoration and heritage.[18] Filmmakers such as Gustav Deutsch and Peter Delpeut have been invited to use film fragments from the Netherlands Film Archive for new work; and through online digital platforms, the general public has also been encouraged and enabled to rework material from the film archive. Archivists are reaching out to filmmakers to make the film archive accessible and to bring it to life. Meanwhile, media artists such as Christian Marclay in *The Clock* (2010) and *Video Quartet* (2006) and Rania Stephan in *The Three Disappearances of Soad Hosni* (2011) are sampling the archives of popular culture, challenging the conventions of curation and provenance that have historically governed museum practices. These new relationships between filmmakers and museums and galleries point to a new role of the moving image in the refiguration of filmed history and the history of film.

In the last twenty years, the postmodern critique of appropriation has lost its traction in the digital era, and pastiche has taken on new sensory and affective valence.[19] The lack of distance that is produced through the borrowing

of previously used material can have important effects of seduction that can bring us closer to experiences of the past, mobilizing sensory perceptions of cultural histories. This is where the audiovisual archive is fundamentally different from any other archival practice. It produces an excess of temporalities and an excess of meaning and affect that the filmmaker as archiveologist can harness and explore for new effects of history. Thinking these issues through Walter Benjamin's critical historiography reveals how image culture tends to shut down historical thought but also contains the tools for its own undoing. Film and media artists are uniquely positioned to find and use these tools to produce critical histories and trigger historical awakenings.

FOUND FOOTAGE, COMPILATION, COLLECTION

Found-footage filmmaking originated as a genre of experimental film, but in the last twenty years it has evolved into an important type of documentary film and a key component of gallery practice. Compilation filmmaking originated as a form of newsreel,[20] combining pictures from various sources, but neither of these terms, *compilation* or *found-footage*, seem particularly appropriate to work that engages critically with the archive. First, few filmmakers are finding their source material in accidental or random ways, but they are actively searching for it in material and digital archives, which is to say that their films are researched. The film fragments that are recycled are not found in the garbage or the flea market (or not only found there) but also come from eBay and from official state-funded archives.

Second, filmmakers are dealing less with footage than with digital files, which may have originated as film but are now measured in bytes and pixels that are eminently searchable by digital means. Sounds and images are collected and recombined in ways that produce new insights into the past. All of this work is always, already, about film history, the history of filmmakers filming people, places, and things. Moreover, that history is revealed to be a rich vein of collective memory, experience, and imagination. For example, Bill Morrison's film *The Great Flood* (2012), consisting of footage of the Mississippi disaster of 1927, is edited without narration, allowing the archival images to come alive with their own effects, augmented by a subtle jazz guitar soundtrack by Bill Frissell. Compared to the documentary collages of American baseball, jazz, and American national parks authored by Ken Burns, Morrison's

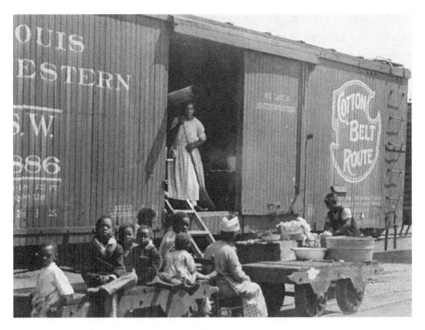

The Great Flood (Bill Morrison, 2012)

collage is essayistic in its openness and its refusal to pin down meaning. He offers new images, rarely before seen, to create a history of national disaster that is deeply implicated in the racial fabric of the American South. This kind of work may even be described as a form of sensory ethnography, given its lyrical evocation of human behavior tied to specific places and times.[21]

In William Wees's 1993 book *Recycled Images*, he makes a very neat distinction between compilation, collage, and appropriation. In his analysis, the compilation film is grounded in a realist conception of the image as historical document, whereas the appropriation film is completely cut off from history and treats the image as a superficial simulacrum. For Wees, the collage mode exemplified by Bruce Conner is the only genre of found footage that interrogates the media sources of the images. Collage techniques of montage, he argues, are reflexive and invest found footage with new meanings and can thus challenge the power of the media. He aligns the appropriation mode with postmodernism, using Michael Jackson's music video "Man in the Mirror" as his chief example. Wees makes a convincing argument for the appropriation of the avant-garde by mainstream media, but twenty years later, the "simulacrum" is not necessarily an empty signifier. It can be recognized as a

performative image loaded with potentiality. Wees's critique does not hold as a blanket critique of appropriation, which can also function as homage, borrowing, recycling, and archival retrieval, even preservation. For example, in *Tribulation 99* (1992) Craig Baldwin arguably uses appropriation for his pastiche of American movies that supposedly "illustrate" U.S. involvement in Central America from the 1950s to the 1990s. Jaimie Baron, in fact, adopts the term *appropriation films* to refer to a large spectrum of films formerly known as "found footage."[22]

Wees's critique of the compilation mode uses *Atomic Café* (Jayne Loader, Kevin Rafferty, and Pierce Rafferty, 1982) as his main example. He claims that the filmmakers do not challenge "the representational nature of the images themselves."[23] In fact, I would argue that many of the clips in *Atomic Café*, such as the educational films that the filmmakers include, are highly performative. Rather than a realist mandate, *Atomic Café* is about how nuclear anxiety was represented in popular culture and educational media. Moreover, many archive-based compilation films, such as *The Clock*, have explicitly drawn their source material from fiction films and make no claims whatsoever to realism. Wees's distinction between the compilation mode and the appropriation mode has more to do with the exhibition contexts of the films than the formal components of the films themselves. The work of a filmmaker such as Adam Curtis in *Century of the Self* (2002), which is constructed out of scenes culled from feature films and TV broadcasts, may be described as appropriation, but are his excerpts really stolen, or merely borrowed? The term *compilation* refers to a collection and has been applied, for example, to albums of music, and thus the compilation film is best described as a collection of borrowed sounds and images.

In the digital era, archives have been reconfigured, redesigned, and significantly remade. At the same time, the status of "the media" as a powerful ideological force needs to be revised. In the democratization of media, corporate and state power still exists, to be sure, but as more media makers proliferate, not only is more media available for recycling and remixing, but it has become more and more part of everyday life. The distinction between historical reality and its mediation is less of a critical issue than the recognition that media history is a reality. The "society of the spectacle" is no longer as homogeneous as it once was,[24] and the multiple forms of interactivity around us mean that it can be broken into pieces and remade; moreover, media practices themselves are historically diverse, and in being recovered can be potentially reused and reanimated with contemporary concerns.

Patrik Sjöberg has pointed out that compilation films resist any generic or categorical distinctions, as they tend to straddle the lines between documentary and experimental film. He also points out that the compilation mode originated as a form of newsreel and was used extensively for propaganda purposes throughout World War II.[25] In twenty-first-century media culture, the compilation mode has flourished in advertising and television news propaganda, and archival analysis has formed the backbone of TV news and satire programs such as *The Daily Show*. Films as diverse as *The Autobiography of Nicolae Ceaușescu* (Andrei Ujica, 2010) and *Le Grand Détournement: La Classe américaine* (Michel Hazanavicius and Dominique Mézerette, 1993) can be described as compilation films, as well as being examples of archiveology.

The terms *compilation, appropriation,* and *collage* are inadequate to account for the variety of films being made today from archival sources, as we are clearly dealing with a convergence of all three methods. The practices of remix and recycling begin with a process of collecting sounds and images, and using various search tools, which may be manual, automated, or algorithmic. The films discussed in this book clearly lean toward compilation but they do so by appropriating previously filmed materials, and their assembly exploits the potential of collage as a method of juxtaposition. Fan-based work posted on social media featuring movie stars is exemplary of the way that compilation film practices have proliferated in the digital age, but it is also true that the lines between amateurs, artists, and scholars are increasingly blurred in the age of the cinephiliac video essay. When clips are borrowed from fiction film and recontextualized within a star study or a mashup, the effect is a puncturing of the fiction and a spread of fiction into all recorded events. Film images become documents of their former fictional context and also documents of the profilmic reality that was in front of the camera. In all cases, they become units of a new language that can be constructed critically, or creatively, or not; but this "language" is not the privilege of the avant-garde alone.

The term *database films* is sometimes used to describe work based on digital search techniques. Examples of database films include the many YouTube mashups and supercuts in which a specific phrase or actor is repeated in multiple variations, such as "I'm too old for this shit."[26] Lev Manovich defines "database logic" as being antinarrative, replacing the cause and effect structure of storytelling with a system of lists derived from algorithmic searches. In semiotic terms, he claims that syntagmatic relations are "given material existence" in the form of the database.[27] Manovich's theory may well apply to computer games, web-based documentaries, mashups, and supercuts; and the materiality of

the archive indicates precisely the historical effects of archiveology. However, because we are dealing with a montage-based form in which new relations are being created between images, and between sound and image, archiveology is not necessarily nonnarrative. It may be nonlinear, but unlike database film-making, these works have shapes and stories to tell. In fact, archiveology often adopts the narrative form of the essay. The distinction between database film-making and archiveology is important because although *archiveology* refers to films made without cameras, they do not lack authorial "vision," as creativity and imagination are essential for effective montage practice. Moreover, while the works are authored, they are nevertheless engaged with cultural and collective memory. They may not tell conventionally shaped stories, but, like Benjamin's storyteller, they deal with "short-lived reminiscences," glimpses and fragments of the past, and they deal with "many diffuse occurrences."[28] The archiveologist is in this sense a craftsperson, whose work takes place primarily at the editing table or computer, fashioning the "raw material of experience" into a "ruin that stands on the site of an old story."[29]

ARCHIVEOLOGY AND THE ESSAY FILM

Archiveology is a mode of film practice that draws on archival material to produce knowledge about how history has been represented and how representations are not false images but are actually historical in themselves and have anthropological value. Often, this process of layering and remediation falls into the category of the essay film. Although there is little consensus on what it is exactly, most critics would agree that the essay film involves a conjunction of experimental and documentary practice, and also that it is a mode of address that is often subjective.[30] The essayistic value of archiveology lies in the way that the filmmakers allow the images to speak in their own language. One of the key features of archiveology is that it produces a critical form of recognition. The viewer is able to read the images, even if their origin is not always exactly clear.

Timothy Corrigan cites Benjamin in terms of what he calls "essayistic agency." Benjamin predicted the interactivity of archiveology when he observed that with mechanical reproduction, "at any moment, the reader is ready to become a writer."[31] Moreover, as Corrigan points out, "within Benjamin's larger philosophical scheme, thinking in history becomes a tempo-

rally fragile and thus risky recognition that recovers or rescues the meaning of events from a 'homogeneous empty time.'"[32] While Benjamin's theory of the dialectical image is notoriously ambiguous, for Corrigan, the "now of recognisability," the flash of awakening in which time is crystalized, is precisely the kind of stance that the film essayist takes toward history. I would refine Corrigan's argument even further to argue that it is specifically the reuse of archival material that can produce this mode of recognition. Moreover, in its increasing prevalence within the contemporary mediascape, it needs to be recognized as a new and urgent form of knowledge.

Jaimie Baron describes the archive effect as a perceptual experience on the part of the viewer. Rather than parsing definitions between that which is "found" and that which is "archival," she argues that through juxtaposition and recontextualization, found footage takes on the historical import of the archival document.[33] She goes on to argue for the role of irony in the production of the archive effect, "which is based on the viewer's awareness of multiple meanings and contexts surfacing within a given appropriation film."[34] Michael Zryd has similarly argued that *Tribulation 99* constitutes a "discursive metahistory" of Cold War–era U.S. intervention in Central America. While I have criticized *Tribulation 99* as being "outside history" and having no contact with the real, Zryd correctly points out that the film references "the discursive forces behind historical events; the rhetoric of history rather than the representation of history."[35] Both Baron and Zryd use linguistic terminology to describe the many ways that archival, found, and fragmented imagery takes on new meanings in archive-based film practices.

According to Baron, "Like irony, the archive effect is defined by the recognition or influence of an 'other' meaning — stemming from an 'other' context, temporal and intentional, in which a given document meant (or was intended to mean) something else."[36] For Benjamin, allegory was a mode of writing in which image and signification are split apart and meaning is built on the ruins of historical detail providing an elegant conceptual framework for recycled film images in which the profilmic event stands alone. Traces of the original context take the form of historical styles of filmmaking alongside historical styles of performance, costume, and other markers of the past. That many of the images in archiveology are commodities in their first lives as feature film images makes Benjamin's theory of allegory all the more relevant to archiveology.[37] Criticism, for Benjamin, entails the "mortification of the works," and in this sense archiveology has a critical function, and even an urgent one if the "allegorical is to unfold in new and surprising ways."[38]

In keeping with these reconsiderations of found footage as historical discourse, I am proposing that archiveology is in fact a language of the audiovisual archive. William Wees cites Benjamin frequently in his taxonomy of found-footage films, but he misses an important dimension of Benjamin's writing, which is that Benjamin saw film as exemplary of a second order of technology in which an "interplay between human and nature" is prioritized. As Miriam Hansen has elaborated, one of the key terms in this formulation is "play."[39] Here again, it seems as if the proliferation of archival film practices finally makes Benjamin's theory more clearly useful as critical practice. For Benjamin, "room-for-play" indicates the extent to which a mediated world contains its own fissures and points of resistance. Far from a power structure, the apparatus conceals "productive forces" that can be redirected and restaged. This, I would argue, is the space that archival film practices now occupy and will continue to expand. In other words, insofar as we live in the society of the spectacle with no way out, we need to reuse the remnants of past image cultures in order to better conceptualize the future.

Compilation, appropriation, and collage are collapsed together in the essay film, which is first and foremost a documentary mode that demands the viewer to pass judgment. Collage is a key component of this bleeding together, as productive tensions and nonlinear narrativity as well as surprising correspondences and repetitions are part of the process, if it is to have any critical effect. Voice-over narration is not, in my view, a necessary component of the essay film, as "meaning" can often be created through musical cues as well as the dynamics of the images themselves. For Nora Alter, the essay film is also distinguished by its ability to disturb the empiricism attached to visibility, to stir up the "political in/visible and in/audible that moves stealthily beneath, within, and around vision, visuality, and visibility."[40] In her discussion of Harun Farocki's *Images of the World and the Inscription of War* (1988), she argues that the essay film "questions the subject positions of the filmmaker and audience as well as the audiovisual medium itself."[41] Archiveology likewise challenges the viewer to imagine the limits of visibility insofar as all images are incomplete, mere pieces of larger views that are missing. As Emma Cocker argues, borrowing images from the archive is a "practice of re-writing history . . . a process of inventory and selection of what has gone before in order to provoke new critical forms of subjectivity through which to apprehend an uncertain future."[42]

Wees's observations about the critical function of montage in collage forms are still highly relevant, but montage effects are not incompatible with the doc-

umentary impetus of compilation practices. Once compilation is aligned with collecting, sorting, and re-representing, archiveology can be seen as a mode of curating and exhibition. In archiveology, images from diverse sources are juxtaposed, and they are also organized and structured so as to produce new knowledge about cultural history, including how that history was filmed and what films it produced. In this sense, archiveology converges with the essayistic. The objective is to produce new modes of thinking about the past, which, in keeping with Benjamin, is also about futures that did not happen, or previous futures we may still encounter.

CINEPHILIA

The preoccupation with film history in archiveology is also, in many cases, such as Jean-Luc Godard's *Histoire(s) du cinéma* (1998), a form of cinephilia. The rich vaults of commercial and art cinema are split open and recombined into new forms, including experiments with star images such as *Meeting Two Queens* (Cecilia Barriga, 1991) and the various works of Candice Breitz. The archives of Hollywood and other classical cinemas constitute a heterogeneous archive that mixes low and high film cultures, media arts, and platforms. The emergence of the video essay is symptomatic of what Girish Shambu describes as the "new cinephilia" that has moved well beyond the cultish iconoclasm of art cinema to a mode of knowledge about a collective, mediated memory.[43] In chapter 5 I will explore the relation of cinephilia and archiveology further to argue that some forms of cinephilia construct new ways of knowing cultural history and can have an anthropological function quite separate from the subjective forms of cinephilia described by Shambu and Christian Keathley.[44] Beyond video essays, archiveology plays a role in films that might be more typically thought of as documentaries that provide new insights into film history. Sophie Fiennes's *A Pervert's Guide to Cinema* (2009), featuring Slavoj Žižek's psychoanalysis of American cinema, and Maximilian Schell's film about Marlene Dietrich, *Marlene* (1984), in which Dietrich dismisses all her great prewar films as pure kitsch, are great examples of how archive-based filmmaking can produce important and insightful knowledge about film history itself.

Once classical cinema is itself recognized as an archival cinema, in the sense that it is searchable and that there is much in it to be found and reconsidered,

rethought and redeemed, it becomes much more than a catalog of stars and directors; it can be explored on multiple levels. Details of gesture, sets and costumes, locations and color palettes take on greater significance, and thematic patterns can be pulled out of a diversity of materials. Tracey Moffatt, in collaboration with Gary Hillberg, has made a series of films on themes pulled from the Hollywood archive: *Lip* (1999) about black maids, *Artist* (2000) about artists, and *Love* (2003) about the climactic Hollywood kiss. Although most of the work under consideration in this book is grounded in American film history, in chapter 6 I will discuss *The Three Disappearances of Soad Hosni,* in which Stephan has recycled clips from classical Egyptian cinema. Indeed, the theme of classical cinema, particularly in the form of melodrama, is a major component of my sense of archiveology and its affinities with Walter Benjamin's conception of allegory and the theater of culture. The proximity of the avant-garde to the mainstream and its détournement of popular cinema bring us close to the deep ambiguity and ambivalence at the heart of Benjamin's cultural theory.

In keeping with a general trend of experimental media, the makers of archiveology have tended to shift their sites of exhibition from the theater to the gallery. As cinema is rendered obsolete, it seems to have moved into the gallery as a form of "old media" from which artists are constructing new works. Erika Balsom suggests that cinema in recycled form evokes the collectivist impulse of its origins as a "mass art." In contrast to contemporary spectatorship, which is increasingly atomized and individualized, "old cinema" was consumed collectively.[45] In this context, Balsom evokes Walter Benjamin, for whom a large part of the promise of cinema was its collective consumption. She argues that "the return to classical Hollywood in art since 1990 provides a way of excavating an experience of collectivity stemming from a shared reception of media."[46]

The appropriation of classical film brings with it an appropriation of the sensual effects of popular genre cinema, including the emotional charge of melodrama and the aesthetic spectacle created by industrial techniques. For Benjamin, this was very much part of the potential of film as an instrument of social change: its ability to move people. In "One-Way Street," for example, he endorses commercial advertising because it provides the "most real, mercantile gaze into the heart of things." Advertising is "superior to criticism" because it is "not what the moving red neon sign says — but the fiery pool reflecting it in the asphalt."[47]

In archiveology, film clips are compiled and ordered according to a system and arrangement other than that for which they were originally made. In this sense, the collection serves as a new archive; many films are composed according to the model of "files" or "tapes." As Foster has pointed out, archival art often assumes a "quasi-archival logic," in a "quasi-archival architecture," with an intrinsic sense of incompletion.[48] *Film Ist* (Gustav Deutsch, 1998–2009),[49] which consists of thirteen episodes to date and remains unfinished, and Rick Prelinger's "Lost Landscape" films of Detroit and San Francisco are not only interminably incomplete projects that could continue indefinitely; they also blur the lines between the personal collection and the public archive as they assemble materials into epic serial forms.

Filmmakers such as Bill Morrison, Gustav Deutsch, and Yervant Gianikian and Angela Ricci Lucchi are making archival material accessible, bringing it out of the darkness of the vault and into the light of public memory. Other filmmakers, such as Matthias Müller, Rania Stephan, Tracey Moffatt, and Christian Marclay, proceed by rendering the familiar landscape of popular culture and fiction film archival, precisely by breaking it up into pieces that then take on new meanings in new contexts. The two tendencies have in common a recognition of their archival sources. They frequently cite either the film titles or the archives from which the material was found. Filmmakers are reflexively engaging with historical documents, which are neither anonymous nor random but carefully chosen for more than their formal and aesthetic properties. Shifts in experimental and documentary film practice are of course consistent with, and run parallel to, dramatic shifts in the form and function of the archive itself, which has moved from a closely guarded site of curated documents to the various open access sites of digital archives both "official" and "unofficial." Archival film practices need to be recognized as creative engagements with this new social role of media storage.

By rethinking found footage as archiveology, I hope to emphasize the documentary value of collecting and compiling fragments of previously filmed material. How and when does an image become a document? I would argue that it does so as soon as it is excised from its narrative origins, or from its original "documentary" form, if that is where it comes from. In "One-Way Street," Benjamin distinguished between the artwork and the document in a

section called "13 Theses against Snobs." Among his pithy pronouncements on the document, he says,

- The more one loses oneself in a document, the denser the subject matter grows.
- A document overpowers only through surprise.
- The document's innocence gives it cover.[50]

Digital tools have made archiveology accessible and available as a critical practice to amateurs and artists alike. We need to distinguish between those practices that push back against historical transparency and those that access the archive to construct seamless histories of linear causality. Benjamin's historiography is based on a nonlinear conception of correspondences between past and future and on the shock or crystallization of the moment produced through juxtaposition and montage. His aesthetics of awakening and recognition are techniques of interruption of the "flow" of images on which conventional historicism relies. The death of "film" and the rise of digital media has effectively enabled and produced a new critical language that we are only really learning to speak. As video essays begin to proliferate as a mode of critical discourse, we need to retain the techniques of collage within compilation modes, and this depends in part on a recognition of detail and density; it also depends on surprise and on the kind of inversion of background and foreground that archiveology can produce. If fragments of fiction film become documents of fashion and architecture, fragments of documentary become recognizable as performances.

Remarks on film are scattered through *The Arcades Project*, as if Benjamin's method was itself informed by cinema: "Only film can detonate the explosive stuff which the nineteenth century has accumulated in that strange and perhaps formerly unknown material which is kitsch."[51] Benjamin was writing at a crucial moment in European history, and he was undoubtedly inspired by the specific conjunction of technology, propaganda, capitalism, and fascism. As we swerve around the digital turn, with a hard left to the archival turn, in the early twenty-first century, Benjamin's thought illuminates the politics of the image archive that has become the lingua franca of digital culture.

Once we recognize that images, media, and moving pictures are part of history and the "real world," there can be no discontinuity between images and reality. Archiveology takes us into the interior of a dreamworld that has put itself on display for viewers in the future. The archival excess enables us to look beyond the "evidence" of the past to the failed promise of technological modernity.

Regardless of how we might want to categorize films as documentaries, experimental films, or essay films, when they are based on collections — which are in turn drawn from archives of various kinds — and compiled into new texts, they have a great potential for gaining historical insight into a history made up of many recorded memories.

The interactivity of digital media has made it possible for anyone and everyone to rewrite history, and this, of course, has its dangers as well as its potential. Archiveology teaches us that history does not need to be written or to tell stories. It can also be constructed, cut and pasted together, which is to say that the archive lends itself to practices of searching and collecting, and the materialist historian is one who respects that piecemeal construction of historical experience. If history breaks down into images,[52] archiveology is a means of engaging and indulging those images to construct collective memories from which new futures can be known.

A good example of archiveology is Gustav Deutsch's experimental compilation *Film Ist*, made up of thirteen sections of borrowed imagery, most of it from the Netherlands Film Museum. For Deutsch, "film is" everything that has ever been filmed, and the project is interminably incomplete. He has created files or "convolutes" — not unlike Benjamin's in *The Arcades Project* — of fragments of film that he makes speak to each other. In a section called "Memory and Document," he uses the motif of the returned gaze to link a series of disparate images from early cinema. The conjunction of powerful-looking people with a cameraman and African children playing with tripods relies on surrealist techniques of juxtaposition. Deutsch shows us how cameras affect performance, evoke responses, and create networks of gazes. Filmed history is a history of engagement between people. Deutsch's collage approach reveals how the document is produced and also points to the limits and unreliability of memory. Walter Benjamin thought that the cinema could reveal the "optical unconscious" of industrial society, and this kind of film practice is ideally positioned to realize this potential.

Another section of *Film Ist* is called "Material." Here Deutsch has collected discarded footage, purchased at a flea market, from a Brazilian soap opera. The damage on the filmstrip was caused by its being used as a floor mop, literally drenched in soap.[53] In this sense he is recycling the recycled film, and still we see the men and women acting serious in 1970s domestic interiors. The "material" is thus doubled as the celluloid and the image, both of which have historical registers. As Tom Gunning has said of *Film Ist*, Deutsch's collage techniques "awaken energies slumbering in old material."[54] Indeed, the sense of energy

Film Ist (Gustav Deutsch, 2004)

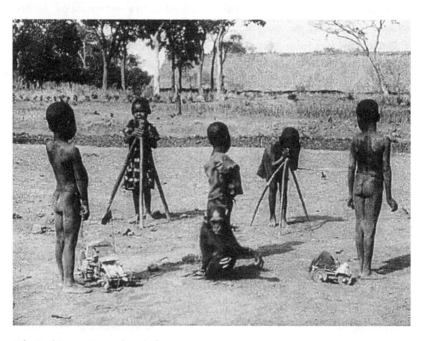

Film Ist (Gustav Deutsch, 2004)

Film Ist (Gustav Deutsch, 2004)

created by moving images enables a sensuous contact with the past. By incorporating layers of material decay and destruction, the archival fragment is perceived as archaeological: it is a fossil with its own temporal inscription.

Deutsch's archival research does not discriminate between documentary and fiction. As experimental film practice, it is indicative of the direction that a great deal of new media is taking, returning to film history as an archive of imagery rich in style and form, provocative and sensual. All is fiction; all is fact. History is all about forgetting what was true, because all memories are valid memories whether they are torn from "the movies" or torn from the world in front of the camera. In the archaeological record, the fragmented history is the only one we can see and hear, the evidence of a past that can be reassembled in the present so that we can try to reorder the future differently. Digital tools certainly facilitate the researching, the reordering, and the reconstructing of the past; and in this sense the past is opened to reconstruction by bringing into the foreground details that were previously obscured by dominant narratives of history. Archiveology thus offers endless opportunities to rethink the diversity of histories and stories that can come under the rubric "memory and document."

CONVOLUTES

The translators of *The Arcades Project* chose to use the term *convolute* for Benjamin's use of the term *Konvolut* in German to designate the sections of the project, which at the time of his death were contained in files and which may never have been intended to become a book per se. They considered the terms *file folder* and *sheaf* but found them to be inappropriate for Benjamin's collections of notes and materials, including the many quotations that he meticulously copied out.[55] He assembled them under the various headings of "Fashion," "Mirrors," "The Flâneur," and so on. Like the examples of media archiveology that I am concerned with here, for Benjamin, the research itself became a "transmissible" form of communication. This book is structured more conventionally in the form of chapters, and yet each chapter is in a sense a collection of film analyses and critical concepts borrowed from Benjamin and other scholars. While I hope to avoid "convolution," I aim to respect Benjamin's essayistic approach to the compilation of notes and materials.

The following chapters demonstrate how archiveology plays out on different fronts, using selected films to show the creative engagement with moving image archives of many varieties. Before getting to these examples of films and videos, in chapter 2 I focus specifically on Walter Benjamin. Because his cultural theory has been subject to so many interpretations and is incredibly vast and interdisciplinary, I tease out the specific strands that can be woven into a theory of archiveology as a critical method. Benjamin has been a constant figure in film theory, but his relevance and contribution continues to change with new translations, new media, and new interdisciplinary perspectives. Chapter 2 concludes with a discussion of *Histoire(s) du cinéma* (1998), Godard's epic example of archiveology that was arguably inspired by Benjamin's *Arcades Project*.

In chapter 3 I take up the theme of the city, and the long-standing affiliation between city films and montage. Benjamin's cultural theory is in itself deeply invested in the kaleidoscopic form of the cityscape and its layers of ever-renewing history. Working through analyses of *Paris 1900* (Nicole Védrès, 1947) and *Los Angeles Plays Itself* (Thom Andersen, 2003), I explore a number of Benjamin's concepts from *The Arcades Project*, including fashion, magic, the dream city, and architecture. The chapter concludes with a discussion of *The Exiles* (Kent MacKenzie, 1961), a "lost film" that was "found" through the production of *Los Angeles Plays Itself*. Archiveology is a kind of untimely cinema in its ability to engage with the afterlives of texts in critical and productive ways.

Chapter 4, on collecting, is also about the anthropological and ethnographic dimensions of archiveology. The three films that are discussed in this chapter, *()* a.k.a. *Parentheses* (Morgan Fisher, 2003), *Hoax Canular* (Dominic Gagnon, 2013), and *World Mirror Cinema* (Gustav Deutsch, 2005), could not be more dissimilar in terms of content, cultural context, and exhibition history. Nevertheless, in each case, the filmmakers create unique cultural panoramas of specific ethnographic "chronotopes" based in media forms. Among the themes covered in this chapter are media archaeology, physiognomy, and Aby Warburg, all of which have important links to Benjamin and his constellation of ideas about language, memory, and technologies of representation.

The comparison between phantasmagoria and classical cinema in chapter 5 is more of a superimposition of one concept onto the other, a superimposition that is also a destruction and fragmentation of the two kinds of dreamworlds. Through my analyses of *The Clock* (Christian Marclay, 2010), *Kristall* (Christoph Girardet and Matthias Müller, 2006), and *Phoenix Tapes*

(Christoph Girardet and Matthias Müller, 1999), the parallels between these two image spheres should emerge in critical form. In this chapter I also argue for a critical mode of cinephilia by means of thinking through a further analogy between melodrama and baroque drama, as Benjamin theorized the latter in *The Origin of German Tragic Drama*. Melodrama emerges as an important category of film criticism for archiveology in its reliance on gesture, emotion, and "double articulation." The melodramatic image corresponds closely with Benjamin's understanding of film as "kitsch" and as "warming." At the same time, melodramatic images are highly performative, staging their gestures of melancholy and desire on the stage of media history.

Chapter 6 returns to a canonical example of found-footage filmmaking, Joseph Cornell's *Rose Hobart* (1936), to reconsider it in terms of archiveology and the aura of a star of the archive. The question of gender emerges directly from the previous chapter on the phantasmagoria, and the question of awakening from the archive and détourning its gender politics is especially pressing in the context of classical cinema. Following Laura Mulvey, Domietta Torlasco, and Agnès Varda, this chapter argues for a heretical archival practice in which the female spectator and the women who populate film history, even in the form of ghosts, can be given the critical tools of awakening. Benjamin's concept of anthropological materialism will be developed here as a concept he borrowed in order to talk about women in a revolutionary history of Paris. Finally, *The Three Disappearances of Soad Hosni* will be discussed as an instance of archiveology in which another archival star, the actress Soad Hosni, is awakened into a new mode of interactive spectatorship.

2

WALTER BENJAMIN AND THE LANGUAGE
OF THE MOVING IMAGE ARCHIVE

The realization of dream elements in the course of waking up is *the* canon of dialectics. It is paradigmatic for the thinker and binding for the historian.

In order for part of the past to be touched by the present instant, there must be no continuity between them.

Walter Benjamin, *The Arcades Project*

Walter Benjamin's name is frequently cited in English-language film studies scholarship, and he has been a mainstay of the theoretical corpus since "The Work of Art in the Age of Mechanical Reproduction" was included in Mast and Cohen's canonical *Film Theory and Criticism*, first published in 1974.[1] Benjamin's cryptic essay appeared there without its copious footnotes, and with little contextualization. Until 1996, only a handful of his essays and books had been translated into English, and even now that most of his writing is widely translated and accessible, it has become clear that he did not write very much specifically about film. The "artwork essay," as it has come to be known, remains his single essay devoted exclusively to the cinema, although film remained central to his thinking on many levels and is frequently referred to in letters, reviews, and essays on a wide variety of topics. In some ways, the artwork essay may have been something of a red herring for film studies. With the publication of *The Arcades Project* in English in 1999, it is clear that the artwork essay offered only a small and somewhat confusing part of the story. Although *The Arcades Project* is ostensibly about nineteenth-century Paris, its historical methodology is deeply indebted to cinema, and it is clearly written from the perspective of the 1930s.

A small cottage industry has developed around Benjamin's corpus, producing an ongoing stream of interpretations, applications, and contextualizations. A host of different "Benjamins" have arisen, depending on the great

variety of analytical frameworks and disciplinary concerns. Benjamin's difficult life in interwar Europe as a nomadic character on the fringes of so many cultural circles is very much part of his philosophy and cannot be entirely separated from his critical theory. Benjamin worked on the edge of a political precipice and adapted methodologies from a wide range of cultural currents, expressing himself eloquently in French and German, providing a significant challenge to his English translators. His work will never stand up to the rigors of a "scientific" challenge, but in my view, it needs to be evaluated on the basis of its value as a methodological tool. What he called "profane illumination" is the degree to which the ordinary, the everyday, and the banal can be understood as dynamically historical, pointing the way out of the reification of commodity capitalism. He challenges the film critic and media analyst to craft new avenues of interpretation in order to recognize the utopian within the ideological, and to illuminate the lost promises of technological modernity.

Film studies gambles with Benjamin every time he is cited because, like Benjamin's gambler, every time we seem to start afresh.[2] The same cryptic phrases are quoted repeatedly, in the hopes that he will lend scholarly work a critical edge, a kind of spirit of resistance within a mediasphere that repeatedly seems to eat its own young, co-opting one exit after another. As "film" comes to encompass precisely the social, technological, and architectural sphere of moving image practices that Benjamin always considered to be part of "film," I believe that his theory is actually becoming more relevant than ever. In working through his relation to archival film practices, I hope to channel the energy that is contained in his surprising interruptions. He understood the urgency of his own critical practice as a response to a history in which image culture was closely tied to political currents and was undergoing rapid change with new technologies.

Benjamin's dialectical and nonlinear concept of history is particularly appropriate to archiveology as a critical mode of image recycling because his theory of the image links technologies of reproduction to a concept of historical imagination. It lies at the heart of a philosophical program that situated aesthetics and criticism within a dynamic theory of historical materialism. Unpacking Benjamin's writing is always a challenge because he expressed himself in the language of criticism. Especially in translation, his ideas can often be opaque, and they are frequently submerged or entangled with his critical objects — writers such as Baudelaire, Proust, Johann Wolfgang von Goethe, and Kafka. Living in Europe through the first half of the twentieth century, Benjamin was furthermore influenced by the shifts of intellectual

and political history, as well as his own challenges as a German Jew in exile, without university accreditation. Within the rising and falling tides of political promise of the 1920s and the disillusionment that forced him finally to take his own life in 1940, Benjamin's views on art, modernity, and the image underwent significant change. As a freelance writer, he lacked security and was frequently answerable to his editors and colleagues, with whom he maintained a fierce correspondence. On the other hand, lacking academic restrictions, he was able to situate himself as an activist and as an engaged critic and historian.

In light of the biographical implications of Benjamin's scholarship, and the many internal contradictions and switchbacks that characterize his work, the secondary literature on him becomes particularly important as a means of assessing his ideas and their relevance to media history. Throughout this book I will draw on many of the commentators on Benjamin whose interpretations have necessarily influenced my own reading of him. It is true that his ideas frequently converge with many of his contemporaries — such as Bertolt Brecht, Kracauer, Theodor Adorno, György Lukács, and others — and have been influential in sometimes subtle ways for theorists such as Roland Barthes, Gilles Deleuze, Derrida, and Agamben. However, for the most part these convergences will be left aside for the purposes of this particular project, with the hopes that they will be picked up later by myself or others.

Perhaps the deepest contradiction in Benjamin's larger oeuvre is his conflicting views on "aura" and its relationship to modernity and technology. In the version of the artwork essay that was originally published in English in *Illuminations* and in the Mast and Cohen reader, aura is surpassed and overcome by technological reproduction.[3] Film is opposed to aura and aligned with the progressive values of Dadaism and distracted spectatorship. Benjamin's role in 1970s "screen theory" was to bring Brechtian strategies to the movies.[4] And yet, around the same time as he was working on the artwork essay, Benjamin wrote "The Storyteller," an essay in which "a new beauty" could be glimpsed in that which was vanishing, specifically the experiential mode of oral storytelling with all the ritual and cult values that Benjamin seemed to be casting aside in the artwork essay in favor of a politicized aesthetic.[5]

With the English publication of Benjamin's *Selected Writings* by Harvard University Press, including all three versions of the artwork essay, and with Miriam Hansen's comprehensive analysis of Benjamin's thoughts about film,[6] it is evident that his theory of aura is in fact far more complex than was first thought by film scholars. In the second version of the artwork essay, which

Hansen calls the "ur-text," he argues that "the first technology really sought to master nature, whereas the second aims rather at an interplay between nature and humanity."[7] This concept of second technology did not make it into the third version of the essay (the one that appeared in *Illuminations*), but as Hansen points out, it is key to Benjamin's hope for auratic experience to survive in technological modernity. The second technology manifests itself in play, and its "results" are always provisional, subject to experimentation and testing. Hansen also elaborates on the concept of play in Benjamin's writing, which is closely linked to gambling, and to surrealist methodologies of the dreamwork. Repetition, for Benjamin, is emblematic of his ambivalent historiography in which catastrophe is always accompanied by possibility; the ever-same by the flash of memory. Hansen argues: "In Benjaminian terms, repetition in the mode of the 'yet-once-again' (it might work this time) is linked to the messianic idea of repairing a history gone to pieces. . . . [Benjamin] invested the cinema with the hope that it could yet heal the wounds inflicted on human bodies and senses predicated on the mastery of nature; the hope that film, as a sensory-reflexive medium of second technology, offers a second — though perhaps last — chance for reversing sensory alienation, the numbing of the human sensorium in defense against shock."[8]

In other words, Benjamin still held out the hope for aura to be perceptible within the "fallen world" of second technology, and film was a privileged medium for this to happen. However, it would not happen within film itself, and he offers no easy recipes for critical analysis. Key to Benjamin's legacy is the nonautonomy of the artwork, as Hansen indicates. He is concerned, above all, with the effects of film on audiences; and his allegorical theory of the image opens up a space for reflexive, critical spectating. Artists, spectators, and critics are thoroughly historical, so any redemptive practice is the responsibility of the critic as historian. The inversion of values that is found in the different versions of the artwork essay, in which aura seems to be at once found and then lost again, is symptomatic of Benjamin's reflexive critical practice.

As an essayist, Benjamin composed the third version of the artwork essay at a critical moment in European history, and his ambivalence regarding the aura of cinema can be directly attributed to that context. The appropriation of Disney by fascist aesthetics dealt a serious blow to Benjamin and led to his revision of the artwork essay in which fascism and revolution are polarized, with the ambivalent promise of aura excised completely. Benjamin was persuaded to drop the "Mickey Mouse" section of the artwork essay by Adorno and Max Horkheimer, who rejected outright Benjamin's interpretation of the therapeutic

effects of collective laughter.[9] Benjamin himself realized by 1936 that a "full analysis" of Mickey Mouse's kinetic imbrication of technology and nature "must not repress their counter meaning."[10] The convergence of horror and comedy in Mickey Mouse cartoons became deeply linked to the terror and violence of everyday life in the Nazification of German culture.[11]

In her monumental study, *Cinema and Experience*, Hansen traces the Mickey Mouse references through Benjamin's diverse writings, pointing out how he himself wrestled with the monstrous violence of the cartoon character. Through the figure of Mickey Mouse, Hansen argues, Benjamin makes a case that film, "in the form of play, could reanimate, prematurely detonate, and neutralize — on a mass basis — the psychopathological effects of the failed adaptation of technology."[12] Hansen concludes that by the late 1930s, "Benjamin had maneuvered himself into an aporia," in which Mickey Mouse disappeared from the third version of the artwork essay.[13] Nevertheless, both Esther Leslie and Hansen point to the ways that Benjamin anticipated the digital aesthetics of posthumanist representation that evolved from prewar animation.[14] Hansen concludes the section of her book on Benjamin by saying that she hopes "to have complicated" Benjamin's posthumous relevance in relation to fascist aesthetics and digital culture, "along with the assumption that his positions on these matters can be easily pinpointed."[15] In other words, although Hansen's book is the most comprehensive account of Benjamin's film theory to date, even she reneges from drawing any final conclusions about what he really means for film studies.

Benjamin's thinking underwent significant change during his lifetime, as he shifted from a theological understanding of art practices to a materialist one. The concept of aura is associated in his earliest writings with the truth values of a particular theory of language. The transposition of this theory of language to a materialist philosophy of modernity was accomplished through the model of photographic reproduction, which Benjamin was interested in not only as a symptom of modernity but as a form of knowledge in itself. He may never have developed a systematic philosophical system, but as Rainer Rochlitz argues, Benjamin did maintain a consistent set of principles throughout his diverse and disparate texts.[16] Working backward from the archiveology of twenty-first-century media practices, we can track this theme of language back to Benjamin's earliest writings on language, allegory, and mimesis.

In his essays on language, Benjamin sought a mode of revelation that corresponded to lost practices, before the "fall" of language to instrumental "bourgeois" systems of thought. In 1916 he imagined a "pure language" in which

things have their own way of communicating. A crucial division that would continue to inform his view of language and, later, history exists between "language as such" and "the language of man." Before man there was the more immediate relation between things and God. However, he also imagined a "language of sculpture, of painting, of poetry . . . languages issuing from matter."[17] Mankind is merely an intermediary between nature and God, providing names for things, but a more pure language can be detected on occasion in the practice of translation. In the movement from one language to another, the truth of language can be perceived, almost as a kind of leakage or excess. "Translatability" is an essential quality of certain works, which for Benjamin is evidence of a "specific significance inherent in the original,"[18] a quality of direct communication without need of codes or systems.

Benjamin's preoccupation with origins can be disorienting for film theory and criticism unless we are willing to grant the film image itself the status of a thing in the world. This is key to the thinking of archiveology as a language, especially as a language that is a language of things that have become writing. Benjamin's theory of allegory, developed in *The Origin of German Tragic Drama* (a.k.a. the *Trauerspiel*), takes up this idiosyncratic theory of language into the realm of representation. The image is conceived in the *Trauerspiel* specifically as a ruin, a fallen form of language but a language nevertheless. "Every image is only a form of writing . . . only a signature, only the monogram of essence, not the essence itself in a mask."[19]

In the *Trauerspiel*, Benjamin remarks further that "that which lies here in ruins, the highly significant fragment, the remnant, is, in fact, the finest material in baroque creation."[20] When he adds that in Baroque literature, fragments pile up "ceaselessly, without any strict idea of a goal," the relation to the montage and collage practices of his own time (circa 1924) becomes evident. Although he was writing about a seventeenth-century dramatic form, Benjamin was clearly aware of the dynamics of modernity in composing this text, which challenged many of the norms of romantic aesthetics — particularly the autonomy of the artwork. For Benjamin, it was always implicitly historical. For Christine Buci-Glucksmann, Benjamin's allegorical mode is a "game of the illusion of reality as illusion, where the world is at once valued and devalued." The world expresses itself as theater, or more specifically "theatre that knows itself to be theatre."[21] Even within the dynamics of mortification that dominate the *Trauerspiel*, Benjamin nevertheless recognizes in language a means of thinking through the logic of transience and decay. Language is reinvented in

Baroque tragic drama as a means of looking backward, of producing meaning from within the detritus of decadent culture.

In the late 1920s, Benjamin then rethinks his theory of language under the sign of commodity capitalism and advertising. As Rochlitz points out, in the *Trauerspiel* Benjamin has no theory of reception beyond the theological.[22] Baroque allegory was redemptive in its appeal to pagan gods that oversaw the originary space of naming and pure language. Turning his attention to modernity, under the sign of historical materialism, the commodity becomes the symptomatic allegory. In *One-Way Street*, influenced by surrealism and by the symbolist Stéphane Mallarmé, Benjamin developed his own method of "picture writing" or aphoristic writing. Juxtaposing anecdotal images drawn from the urban blizzard of "changing, colourful, conflicting letters," Benjamin also began to incorporate the apparatuses of writing and research, including archival technique, into his own reflexive method: "The card index marks the conquest of three-dimensional writing, and so presents an astonishing counterpoint to the three-dimensionality of script in its original form as rune or knot notation."[23]

As Benjamin's view shifted more toward the urban landscape so thoroughly infiltrated by technology and language, the utopian theme of the aura took on new forms and became the underlying theme of *The Arcades Project*, the work that most comprehensively foreshadows the archival film practices that proliferate in the early twenty-first century. The figures of the child, the flaneur, and the collector, Benjamin's own avatars in the Paris arcades, are also figures of urban enchantment with lingering magical properties. Rochlitz points out that in *One-Way Street*, "a new form of myth begins to forge a path." These figures, who emerge in Benjamin's work, are "exposed to the terrors of myth" but are "the only ones who still recognize the miraculous."[24]

Through his writings on Baudelaire, Benjamin struggled to articulate his politics of the image, which remained consistently torn between a critique of ideology and a celebration of the phantasmagoria. The aura in decay is better than no aura at all, and Baudelaire seems to embody this duality that for Benjamin is always a dialectic of the promise of modernity and the many losses that it harbors. Rochlitz argues that for Benjamin, Baudelaire was both a symptom of the arcades and a heroic artist who captured precisely the decay of aura that Benjamin himself observed in modernity. He goes so far as to point out that Benjamin's inability to reconcile the aesthetic values of Baudelaire's poetry with his symptomatic status within the arcades accounts not

only for the way that the two projects became so deeply intertwined but also for Benjamin's inability to completely overturn the concept of art in the age of mechanical reproduction.[25] The shift from a theological theory of language to a critical historiography that takes place in Benjamin's last decade is also a shift in his own self-identity as a critic to being a historian. In fact, it is the crystallization of the critic in the historian that lies at the heart of the "awakening" that he consistently calls for.

The historian, who takes over the role previously filled by the critic, proceeds by a process of recognition. The historian is always responsible toward the past; in not being indifferent, she is invested. Insofar as the past is conceived as a fluid, incomplete project, with no teleological, necessary outcomes, the historian's discontinuity is modeled on photography and film. For Benjamin, these "new media" had the capacity to evoke auratic experience in the form of a correspondence between past and present. His own method in *The Arcades Project* is specifically "a dissolution of 'mythology' into the space of history." That can only happen, he says, "through the awakening of a not-yet-conscious knowledge of what has been."[26] He quotes André Monglod's photographic metaphor: "The past left images of itself . . . comparable to those left on a photosensitive plate. The future alone possesses developers active enough to scan such surfaces perfectly."[27]

As Miriam Hansen has summarized, for Benjamin, photographic media do not reproduce reality, but they "store and reveal similarities that are 'nonsensuous,' not otherwise visible to the human eye."[28] Benjamin uses the term *nonsensuous* to refer to language of the "second technology," which he describes as "an archive of nonsensuous similarities, of nonsensuous correspondences."[29] Michael Taussig explains the mimetic faculty as "the nature that culture uses to create second nature,"[30] and it is very specifically a human capacity that, for Benjamin, is in constant flux, in tandem with the shifting sands of modernity and technology. In other words, nonsensuous correspondences are produced by humans, not by gods or nature, so etymologically the "non-" refers to the fallen state of human perception and communication. However, technologies of visual culture have embraced the capacity for mimicry to the point where experiential modes of knowledge can kick in, involving the entire bodily sensorium. For Hansen, "innervation" is key to Benjamin's program and is essentially "a structural equivalent to auratic experience that can open up to a mimetic connection with the afterlife of things."[31]

Yet another version of the auratic within the technological is Benjamin's concept of the optical unconscious, for which he overtly borrows a Freudian

paradigm of layering that also informs his understanding of memory. In his imprecise but provocative distinction between voluntary and involuntary memory, the auratic is that which somehow escapes the technological determinism of the camera but nevertheless is produced in its shadow, not unlike Barthes's punctum. Hansen warns the reader that Benjamin's theory of the optical unconscious is "not a philosophical concept but rather an experimental metaphor, and like all complex tropes, has multiple and shifting meanings."[32] In the digital era in which the indexical truth of the image can no longer be counted on, the canon of nonsensuous correspondences has surely only multiplied exponentially. Thus, Benjamin's gamble remains alive, and even more pressing in an age in which the state of emergency has been equally amplified beyond geopolitical crises to encompass environmental catastrophe as well. Rochlitz poses the question of Benjamin's politics in terms of the collective unconscious. In the face of the radical forgetting of technological modernity, "is it possible to speak of 'involuntary memory' at the social level?"[33]

In keeping with Benjamin's own historiography, I am quite deliberately projecting contemporary cultural concerns onto him to make his theory useful, and legible, in the present. Critics of found-footage filmmaking like to cite enigmatic phrases from Benjamin's work, such as "nothing that has ever happened should be regarded as lost to history"; "history decays into images, not into stories"; and Benjamin's stated method of *The Arcades Project*, "Literary montage: I needn't say anything. Merely show."[34] Indeed, the prevalence of archival film practice makes Benjamin's own thinking about image culture legible and many of his most significant insights into historiography and media less cryptic than they were during his own lifetime.

For Hansen, if Benjamin seems to have been wrong about the great promise he saw in film as critically positioned to activate the social dynamics of technological modernity, new technologies and new media may yet prove him to be exceptionally farsighted. She points specifically to the way that digital media enables spectators to be more active as users and agents in "simulated situations." Her own analysis of the artwork essay explains in detail how notions of play and semblance are deeply entwined as a productive tension and polarity,[35] and it is only one more step from there to inquire into experimental media practices that play with the language of the film archive. Archiveology as an experimental practice embraces film images shorn of their original instrumental use in whatever documentary, narrative, or institutional mode they were originally put. They may be put to new purposes, but at its best, archiveology allows the nonsensuous correspondence to come forward as a

residue of a means of knowing the world that we will never actually know. If, for Benjamin, this fallen state referred to a "primeval, primitive" mode of language, in archiveology it refers back to the sensational experiences attached to media such as classical cinema, colonial cinema, home movies, TV history, and the authoritarianism of instructional film, all of which are riddled with tropes of violence and pleasure.

COLPORTAGE AND COLLECTING

In *The Arcades Project*, Benjamin investigates the architecture, the literature, the philosophy, and the politics of display culture as it peaked in the World's Fairs of the nineteenth century. His own system of collecting fragments of discourse is highly reflexive, inspired by surrealist practice, in the hope of realizing what they failed to do: wake up the collective from their dreamworld of commodity fetishism. The "hyperlinks" in *The Arcades Project* — tag-like code words that frequently appear at the end of a citation or following Benjamin's own phrases — anticipate cross-references that he was never able to actually use in a digital age he never saw. Within this sprawling, incomplete work, we find many cues that anticipate the archiveology of later decades, foreshadowing the technologies that would render the archive transmissible, accessible, and pliable.

One of the tags that runs through *The Arcades Project* is "colportage," which means something akin to mobile book peddlers but by which Benjamin refers to the circulation of texts, and of cultural styles, and the historical remaking and transit of historical materials and styles over time. The ragpicker collected the city's discarded materials in order to trade, recycle, and reuse them, and Benjamin likewise focuses on what he calls the "The Refuse of History" — including the ragpicker himself, alongside the trivia of fashion, interior design, and numerous writers and thinkers whose words had fallen by the wayside.[36] Archival film practices are likewise composed of film footage that can be bought cheaply or that has been orphaned, neglected, and forgotten. Bruce Conner and Joseph Cornell both bought footage in bulk, remaindered by Hollywood film studios; contemporary practitioners use digital marketplaces such as eBay and YouTube to collect moving image materials.

Another key figure in *The Arcades Project* is the collector, who not only lets old works speak but enables them to speak a new kind of language. Collect-

ing, for Benjamin, is a practice inundated with dreams and magic, through which the collector detaches the object from its use value and places it within a new order. In the struggle against dispersion, though, the collection is never complete: "For the collector, the world is present, and indeed ordered, in each of his objects."[37] Collecting, for Benjamin, "is a form of practical memory" in that "the smallest act of political reflection makes for an epoch in the antiques business," which leads to one of the more potent aphorisms in the book: "We construct here an alarm clock that rouses the kitsch of the previous century to 'assembly.' "[38]

Benjamin also identifies a kind of magical property in the collection and suggests that the collector might even live a piece of dream life. Benjamin examines the Paris arcades "as though they were properties in the hand of a collector." The collector is like the dreamer in that the "rhythm of perception and experience is altered in such a way that everything . . . concerns us."[39] In the archival film, perception and experience are likewise reconfigured so as to address the spectator in the present historical moment. Influenced by the random juxtapositions of surrealist method, Benjamin provides an exemplary model for the potential of archival cinema to disrupt the expanding landscape of archival imagery.

The collector strips things from their use value, and their exchange value, to allow them to enter new relations that remain unfixed, ungoverned, and incomplete.[40] In his critical essay on Eduard Fuchs, a contemporary of Benjamin's in the 1930s, Benjamin makes a crucial link between collecting and historical materialism. Fuchs collected items of mass culture and popular arts, provoking Benjamin to recognize the particular configuration of historical thought entailed in the collection: the "constructive element" replaces the "epic element." Detached from its original context, the collected item harbors its own relations of production.[41] The past is incomplete and can take on new meanings in the context of its afterlife. Objects and artworks do not need "appreciation" but can be valued for their material character, and for their dialectics of history, insofar as they carry the traces of entire cultural networks into the present.

Likewise, in *The Arcades Project*, Benjamin says that through the method of montage, rags and refuse "come into their own" by being shown, not inventoried. He need not "say anything."[42] This is very much true of many of the media works discussed in this book that proceed without narration. Many neglect to credit their sources in any detail, citing archives rather than producers or actors. They have no need for inventories as all is shown and revealed, and their access to the archive is according to patterns of movement, location,

gesture, sounds, and other nondiscursive elements of the moving image archive. These films, I believe, exemplify Benjamin's quest to "carry the montage principle into history," which for him entailed linking "a heightened graphicness to the realization of the Marxist method."[43]

Benjamin saw Fuchs's practice as a fundamental challenge to the disciplinarity of the humanities, pointing out that "cultural history presents its contents by throwing them into relief, setting them off. Yet, for the historical materialist, this relief is illusory and is conjured up by false consciousness."[44] This leads Benjamin to his famous pronouncement that "there is no document of culture which is not at the same time a document of barbarism."[45] The collected fragments of material history will always have a lineage within a history of production relations, just as film clips necessarily speak about conditions of media production. Fuchs's collection offers a dialectical passage out of this conundrum insofar as his objects, excerpted from the continuum of history, lack any signs of genius, appreciation, or "aura." Cultural history is, for Fuchs, "the inventory which humanity has preserved in the present day."[46]

MORTIFICATION AND THE DREAMWORK

As Susan Buck-Morss argues, the notion of temporal transience in Baroque allegory becomes central to Benjamin's critique of commodity culture: "The other side of mass culture's hellish repetition of 'the new' is the mortification of matter which is fashionable no longer."[47] Benjamin's view of history as contingent, messianic, and materialist is eminently embodied in the signs of decay and transience that are inscribed in the ruin. The impermanence of history ensures the utopian possibility of social transformation promised but not delivered by modernity. In archiveology, the fictional fragment is "mortified" as documentary and the newsreel fragment is "mortified" as spectacle; they thus become allegories of their former mystique.

Moreover, the absences, gaps, and incompletion that become evident in this process of mortification lend themselves to irony. If in Baroque allegory, "death digs most deeply the jagged line of demarcation between physical nature and significance,"[48] in archiveology, this "death" is precisely the unfixing of meaning, the loss of certainty and truth. But, at the same time, the image contains a trace of "physical nature" in its profilmic materiality, a trace of time inscribed in the language of cultural styles, and in some instances, the visage

of a celebrity, a cityscape, or a historical scene. If the "significance" is up for grabs, archiveology is a film practice that enables the image to retain its allegorical doubleness as at once meaningless and meaningful. As pastiche, it may elicit "a specific emotional or affective response,"[49] including laughter, or even doubt as to the evidentiary basis of the image. In digital culture, all images can be falsified, so their "meaningfulness" tends to be more and more detached from indexical claims. Images are performative, enacting meaning from their location in discourse.

Even more importantly, Benjamin refined his critical notion of the phantasmagoria, or the image sphere of nineteenth-century modernity, through surrealist tropes of the unconscious dreamworld. "Profane illumination" is his term for the surrealist experience — a materialistic, anthropological inspiration — although he also found that the surrealists were not quite equal to the job they set out to do. *The Arcades Project* is intended, through a more rigorous form of inquiry, to open "the long-sought image space." If surrealism is the "death of the nineteenth century in comedy,"[50] *The Arcades Project* proposes an awakening through dialectical recycling.

Benjamin's historiography is oriented toward a "not-yet-conscious knowledge of what has been," which is in turn an excellent premise for the reuse of archival footage that enables us to see the past on its own terms, torn from the mystifying contexts in which it lies dormant. Ernie Gehr's wonderful film *Eureka* (1974) transforms a "phantom" streetcar ride in San Francisco circa 1906 into a trip through another world where traffic, pedestrians, and horses take us deeply into the urban experience of the era.[51] We are immersed not in information but in sensation, movement, and space. Jeffrey Skoller says the film "affirms Benjamin's supposition that 'evidently a different nature opens itself to the camera than opens to the naked eye — if only because an unconsciously penetrated space is substituted for a space consciously explored by man.'"[52] In archiveology, images may attain a legibility tied to a historical index that constitutes a "critical point in the movement at their interior"[53] precisely by marking a moment in time and rendering it meaningful within a new audiovisual context. Benjamin's notion of an afterlife of cultural artifacts ruptures the linearity of teleological history and nostalgia. The dialectics of now and then are integral to archiveology, giving rise to works that are frequently infinitely incomplete, and always in flux, according to the historical conditions of reception.

Film studies in the early twenty-first century has seen the "death of cinema" segue into the rise of digital media, which is not necessarily a rupture but a shift in perspective. While digital media lacks the imprimatur of authenticity,

indexicality in analog photographic methods never guaranteed access to truth in any case;[54] the film document and the digital document are equally untrustworthy on their own terms. New technologies offer new forms of historical imagination, and indeed, coincident with the transformation of moving image media, new modes of salvage and access have transformed the archival landscape. Techniques of copying, downloading, fragmenting, collecting, and recombining have democratized the archival function, in which the arts of appropriation are responding not only to materials borrowed from the past but to the history of the future, or what Domietta Torlasco refers to as the "future anterior" — the future that was, and that may be revisited.[55]

As celluloid dissolves into dust, images of the past have an increasing value, not only as visual evidence of history but as documents of the recording of history itself. This is perhaps why *From the Pole to the Equator* (1987) has had such an important role to play in the history of archival film practices. Yervant Gianikian and Angela Ricci Lucchi reassembled the footage from a specific archive, shot by a specific filmmaker, Luca Comerio. The process of salvage is becoming a challenge for the film archive, as digitization is arguably a conversion of film to a new medium, and restoration often entails a loss of medium specificity.[56] Archival film practices are feeding off this transition and often speak back to it in works like *Decasia* (Bill Morrison, 2002), blurring the lines between preservation and ruination.

Walter Benjamin's own archive has been collected, displayed, exhibited, and published, indicating how he meticulously inventoried his own work in all its various stages and fragments. His fear of losing bits and pieces of his labor was real, arising directly from his itinerant homelessness as an exile in interwar Europe. But as the editors of the English translation of his archive point out, his collecting and archiving was always intended to be "used productively and grounded in the present."[57] Thus, a contemporary reading of Benjamin is necessarily guided by the transformation of archival image culture in the digital age.

Miriam Hansen points out that Benjamin's conception of nonsensuous similarity encompassed two different forms of "sameness" — both the standardization of consumer culture and the distorted perception of hashish. She suggests that "if the world itself is distorted . . . the only adequate mode of representation is one that displaces and destroys the obvious: a 'distortion of a distortion.'"[58] Moreover, she argues that photographic representation becomes, for Benjamin, the ultimate form of nonsensuous similarity. She says that in an increasingly instrumentalized culture of statistics, Benjamin abandoned his project "to reconceptualize the conditions of possibility for experi-

From the Pole to the Equator (Yervant Gianikian and Angela Ricci Lucchi, 1990)

ence in modernity" and turned his attention away from the question of individual experience toward the question of collective experience, coming back to the cinema as a mass art.[59] In *The Arcades Project*, these conditions of possibility for experience are examined in retrospect, among the ruins of modernity, precisely in the context of the archive, revisited and scrambled, and broken into imagistic, fragmentary pieces. Against "eternal truths," Benjamin advocates for a constant remaking of history as it comes in and out of legibility.[60]

A key argument of this book is that the dreamworld of the arcades, the phantasmagoria that Benjamin analyzes with such fascination, is a forerunner of the classical film archive. As Rainer Rochlitz has argued, in *The Arcades Project*, Benjamin undertakes to decipher the dream images of the collective unconscious "according to their dual status, ideological and utopian."[61] The image bank of commodity culture, when ruined, takes on new and potentially critical and counterarchival meanings. Films such as *The Clock* and *Los Angeles Plays Itself* dismantle the commercial cinema only to exploit its tropes of comedy, celebrity, and spectacle. These cinephiliac films bring us close to an understanding of Benjamin's phantasmagoria as a dream sleep from which we

need to awaken. They might even be exemplary of Benjamin's dialectical images: they are renewed in their new contexts so that they become newly recognizable. Images in these films "become legible" in Benjamin's sense because they can be read as the language of history and memory but also because they can still excite us with some kind of intangible magic that was — and is still in important ways — Hollywood's bread and butter.

Benjamin's key insight, that "it is another nature which speaks to the camera as compared to the eye,"[62] is exemplified in archiveology. The compilation of clips from fiction films can often resemble the false consciousness of historicism, and yet the phantasmagoria is only the surface of a roiling sea, an excess of images, and is always constructed from the flotsam and jetsam of a haphazard archive. Benjamin describes his own method in *The Arcades Project* as one of carrying over "the project of montage into history."[63] He also develops a nascent theory of the dialectical image as a point where the past and the "now" form a constellation in the form of an image that flashes up quite suddenly. Archiveology is precisely a means of shocking the past into attention, awakening its latent technologies from their preoccupation with the allegorical novelty of commodity fetishism.

In archival film practices, the image bank in its fundamental contingency and instability becomes a means by which history can speak back to the present. The dialectics of the film image, and the optical unconscious, are mobilized for the ongoing rewriting and reconstruction of history as a materialist practice. Once we recognize that images, media, and moving pictures are part of history and the "real world," there can be no discontinuity between images and reality. Archiveology takes us into the interior of a dreamworld that has put itself on display for viewers in the future, which is precisely the effect of contemporary compilation media. In films such as *Kristall* and *Film Ist*, everyone seems to live within the dream life of cinema. The archival excess enables us to look beyond the "evidence" of the failure of the past to a future in which "memory" is thoroughly saturated with technologies of reproduction and is thus perceptible as public construction materials.

GODARD, BENJAMIN, AND THE DIALECTICAL IMAGE

Jean-Luc Godard's *Histoire(s) du cinéma* (1998) is not only one of the most well-known examples of archival filmmaking, and certainly the most monumental and epic; it is also arguably inspired by Walter Benjamin.

Both Kaja Silverman and Monica Dall'Asta have made this argument and have quite convincingly outlined the key points of convergence between the two projects, which are well worth examining here. Silverman describes Benjamin as the "resident spirit" of *Histoire(s) du cinéma*, while Dall'Asta claims that a direct reference to the *Angel of History*—the Paul Klee painting that Benjamin adopts as an emblem for his philosophy of history—was included in an earlier version of part 1B of Godard's opus.[64] In the final version, only a few letters of the word *"l'ange"* remain, although "the reference to the Angela Novus continues to haunt the whole extension of 1B through the traces of its own effacement."[65]

No doubt Godard was familiar with Benjamin's writing, as many other filmmakers are as well.[66] Godard's project arguably has a scope and epic perspective comparable to Benjamin's in *The Arcades Project*. Dall'Asta even suggests that Godard wanted to do for the twentieth century what Benjamin did for the nineteenth.[67] For Benjamin, "the century was incapable of responding to the new technological possibilities with a new social order."[68] For Godard, the twentieth century did no better, prolonging and exaggerating the themes of sovereignty and brutality; he even suggests that it is only a recapitulation of the nineteenth century, bringing us no closer to the promise of technological modernity that Benjamin glimpsed in the decadence of the Paris arcades.

Godard's cinephilia enables us to better understand the parallels between Benjamin's phantasmagoria and the archiveology of classical cinema. *Histoire(s) du cinéma* is composed of a diversity of material, including many excerpts from Godard's own films, American and European film, documentary and newsreel footage, paintings, photographs, and excerpts from musical compositions. But his project is nevertheless dominated by an image of Hollywood cinema as masterminded by the early moguls Irving Thalberg and Howard Hughes, who emerge as the veritable Joseph Stalin and Adolf Hitler of the cinema. Thus "the cinema" is the narrative fiction commodity form of the spectacle, which Godard proceeds to dismantle and reconstruct in his elegiac compilation released at the cusp of the new century.

Godard's love of the cinema leads him into techniques not of salvage or critique but of reawakening. Compared, for example, to Guy Debord's seminal collage films of the 1960s and '70s,[69] in which all commercially produced images are cast as ideologically corrupt, Godard deploys a series of strategies in an overt attempt to "wake up" from the dream of the twentieth century. Silverman and Dall'Asta have both shown how these strategies very closely

echo Benjamin's own historiographic methodology. For example, while Benjamin's theory of the dialectical image is notoriously vague and imprecise (because he cites no examples from any kind of cultural practice), Silverman argues without hesitation that it is exemplified in Godard's multiple forms of collage, including his mix of video and film, or re-mediation of cinema. She notes the range of juxtaposition and palimpsest in Godard's project, including film and photography; music, text, voice-over, and original soundtracks; and historical and geographical diversity.

Silverman argues that the dialectics involved in Godard's collage evoke and exemplify Benjamin's theory because they operate as a language. For Benjamin, "only dialectical images are genuine images . . . and the place where one encounters them is language."[70] Benjamin gives no concrete examples of dialectical images, but he certainly privileges them as critical tools essential for the principle of awakening from the phantasmagorical dream sleep of image culture. In *The Arcades Project,* dialectical images are linked to the "monad" and the constellation, and are "filled to the bursting point with time." Or, in yet another variation on this theme, "images are dialectics at a standstill."[71] Most provocatively, for a theory of the moving image, Benjamin writes: "For while the relation of the present to the past is purely temporal, the relation of what-has-been to the now is dialectical; not temporal in nature but figural <*bildich*>. Only dialectical images are genuinely historical — that is, not archaic — images. The image that is read — which is to say, the image in the now of its recognizability — bears to the highest degree the imprint of the perilous critical moment on which all reading is founded."[72] And in yet another formulation, dialectical images have a historical index that attains legibility "only at a particular time . . . according to a specific critical point at their interior."[73]

The theory of the dialectical image is open to a variety of interpretations, especially when conjoined with other remarks Benjamin makes in other places about shock, montage, and quotation. Dall'Asta argues that the images in *Histoire(s) du cinéma* are like "vertiginous monads" akin to Benjamin's constellations. She points specifically to Godard's use of freeze-frames and black leader that create the very literal "flashing up" effect mentioned by Benjamin. She describes the mode of collision in Godard's montage as "inorganic," with no control over the spectator. While I would agree that all these techniques are consistent with the dialectical image, Silverman's analysis comes just a bit closer to how one might "apply" the theory of the dialectical image to archiveology.

Histoire(s) du cinéma (Jean-Luc Godard, 1998)

Silverman's account of the proximity of Benjamin and Godard hinges on the interpenetration of "reality" and "fiction," and thus the responsibility of cinema toward history and vice versa. She explains that "the relation between a film and what it depicts should be fraternal — a kind of brotherly 'give and take.' The filmmaker makes this relation possible when he puts reality into his work and then uses the work itself to realize the real. . . . It implies that actuality can only become 'itself' by means of a representational intervention."[74] In other words, the techniques of quotation and montage employed in the construction of films from other films enables the dialectics of documentary and fiction to be recognized. The flashing, the constellations, the legibility, and the standstill — the effects of Benjamin's dialectical image — might be brought about when the "actuality," the profilmic, or the documentary origins (which in my view all refer more or less to the same thing) are allowed to emerge in equal force as their fictive forms. And of course, the reverse must also be possible: the performative, fictive, and "staged" qualities of documentary material must also be visible.

Without making *Histoire(s) du cinéma* the exemplary model of archiveology, I would like nevertheless to retain this reading of the dialectical image for archiveology. Not only does it correspond to a view of image recycling as a kind of language; it is specifically a "materialist" theory of language, proceeding

Histoire(s) du cinéma (Jean-Luc Godard, 1998)

from "an operation of *découpage* in time."[75] If Godard is concerned above all
with the cinema that might have been, and the cinema that may still be pos-
sible, archiveology is likewise a mode of media practice with identical effects
and objectives.

Recycling, remixing, and remaking is not only a strategy of salvage and
review; it is historical in Benjamin's sense, with a strong sense of the present
and the future embedded in the crystallization of temporality. Silverman ulti-
mately challenges Godard's discussion and representation of gender, suggest-
ing that the only way we can awake from the dream of the nineteenth century
is to properly recognize the "other" as "you." He may finally succeed in this
respect, and yet it is also true that Godard places himself very centrally in his
dream sleep of cinema. His images of the happy heterosexual couple may fi-
nally bring his dialectics to a standstill through his recognition of his partner,
Anne-Marie Miéville,[76] which for Silverman constitutes a self-critique of "the
many images of Godard at work alone," but Godard's opus remains a personal
"visionary" project. In archiveology, this stance is more typically sublimated
to the materiality of the images and the bodies and voices of those who in-
habit the images.

3

THE CITYSCAPE IN PIECES

> Our bars and city streets, our offices and furnished rooms,
> our railroad stations and our factories seemed to close
> relentlessly around us. Then came film and exploded this
> prison-world with the dynamite of the split second, so that
> now we can set off calmly on journeys of adventure among
> its far-flung debris.
>
> Walter Benjamin, "The Work of Art in the Age
> of Its Technological Reproducibility"

Benjamin's explosive description of film and the city is one of the most frequently cited passages from the artwork essay because it underlines the utopian thrust of his thinking precisely at the conjunction of cinema and the built environment. Miriam Hansen has suggested that there is an "imaginary city film" evoked in the artwork essay,[1] and I would add that there is a kind of imaginary city film pulsing through *The Arcades Project* as well. Benjamin links film to technologies, to kitsch, and to surrealism, and at one point he cites Georges Méliès and Walt Disney as possible exemplars of surrealist film, while he also claims that J. J. Grandville, a prolific illustrator in nineteenth-century Paris, is a forerunner of surrealist film.[2] Benjamin's refusal of a historicism that presents history "as it was," and his insistence on reconstructing history from its ruins and traces, is a conception of fragmentation and decay that is in turn modeled on film and photography.

It is no coincidence that Benjamin wrote some of his first studies of urban life in the late 1920s and early '30s, at the peak of the montage-based city-film cycle that included *L'Entracte* (René Clair, 1924), *Man with a Movie Camera* (Dziga Vertov, 1929), and *À propos de Nice* (Jean Vigo, 1930). Film played an indirect role in his portraits of Naples and Moscow, which are constructed as series of images, with a journalistic attention to detail and movement as he puts the immediacy of his own experience into words. His memoir *A Berlin Childhood* was in many ways an experimental model for *The Arcades Project*. In all these essayistic studies, Benjamin chose the fragmented, epigrammatic

style of collage construction for his writing, as if inspired by the photo essay and the collage film. By carrying the "montage principle into history,"[3] Benjamin constructs texts from the fragments of cities in pieces.

The references to film throughout Benjamin's study of nineteenth-century Paris are prominent clues to his historical method. As an inscription of a technology newer than his object of study, Benjamin underscores his own historical moment in the form of imaging. For example, in Convolute C, ostensibly about "Ancient Paris, Catacombs, Demolition, Decline of Paris," he writes: "Couldn't an exciting film be made from the map of Paris? From the unfolding of its various aspects in temporal succession? From the compression of a centuries-long movement of streets, boulevards, arcades, and squares into the space of half an hour? And does the flâneur do anything different?"[4]

The flaneur is certainly Benjamin's most well-known legacy regarding cinema and the city, especially in the feminist reconsideration of the flaneuse as a model of female spectatorship in early cinema.[5] The flaneur in many ways evokes the vérité filmmakers who took journalism to the streets of many cities after the war, although in Benjamin's own time the cameraman was more of a spectacle than the flaneur who is virtually incognito as he blends into the crowd. In *Man with a Movie Camera*, the cameraman is a hero; in *Berlin: Symphony of a Great City* (Walter Ruttman, 1927) he is hidden. Thus, the idea of flânerie has had the most traction as a theory of spectatorship, rather than film practice. In fact, through his cross-referencing of convolutes in *The Arcades Project*, Benjamin suggests that the flaneur is doing much more than wandering the streets of Paris observing the phantasmagoria. The "exciting film" he associates with the flaneur collapses time and space, juxtaposing "various aspects" with "centuries-long movement" of urban geography. In Convolute C, he is concerned with the archaeology of the city and associates film with the layering of temporalities.

Benjamin's essays on Naples and Moscow are highly imagistic. In *A Berlin Childhood*, the images are moreover refracted through a discourse on memory and childhood as he recollects site-specific moments and scenes. Graeme Gilloch describes Benjamin's city writing as having six interlocking rubrics: physiology, phenomenology, mythology, history, politics, and text.[6] Even that series of themes misses the autobiographical element that lies within so many of his essays. Gilloch stresses throughout his own study that Benjamin's love of cities was always countered by critique. He saw the struggle of modernity being waged across the urban landscape, and for every hidden secret passageway to the past there was also a beggar and a swindler, not to mention

the architectural display of commodity capitalism that dominates the arcades. In his idiosyncratic dialectical program, Benjamin does not dismiss the myth of progress that is displayed in the city but critically redeems it through his writing. As Gilloch says, myth is not delusion for Benjamin but a form of hope and possibility that can still be glimpsed within the metropolitan scene.[7] Benjamin's historiography is grounded in an archaeological model in which traces of the past harbor unfulfilled aspirations. Regarding Benjamin's textual affinity with the city, Gilloch writes: "Benjamin seeks to produce texts which not only give an account of the city, but have metropolitan experiences fundamentally embedded within them: form and content coalesce. The dominance of the visual, the predilection for the fragmented and the concern with the immediate and with 'shock' are both definitive characteristics of modern life and central formal properties of Benjamin's texts. As a modernist, Benjamin regards the city as a space of intoxication, of excitement and distraction. As a historical materialist, he rejects it as the site of bourgeois domination."[8]

Benjamin's first surrealist-inspired work, *One-Way Street* (1928), is not about any particular city but evokes the decentered, labyrinthine form of the metropolitan landscape as its model and as its fragmented object of analysis. The snapshots are also his first real foray into the conjunction of Marxism and surrealism that underpins his later work. The theme of the underground appears here also: "Underground Works: In a dream I saw barren terrain. It was the marketplace at Weimar. Excavations were in progress. I, too, scraped about in the sand. Then the tip of a church steeple came to light. Delighted, I thought to myself: a Mexican shrine from the time of pre-animism, from the Anaquivitzli. I awoke laughing (*Ana* = *ává*; *vi=vie*; *witz* [joke] = Mexican church [!])."[9] As Peter Osborne has noted of this fragment, Benjamin is awakening from the joke, in contradistinction to the surrealists whom he laments in other places not to have awakened at all. The colonial inversion implicit in his dream is also a joke on the church, and is thus in keeping with surrealist tropes. As Osborne notes, the text needs to be recognized as an avant-garde literary work.[10] Given this context, one can also clearly see the cinematic potential of this little fragment: the emergence of a steeple from an empty lot in the city. The terrain is a marketplace that might have once been a church but emerges as a Mexican shrine. The city seems to have an unconscious, and while Benjamin situates himself here as the dreamer, in *The Arcades Project* he takes on the role of dream interpretation.

The city films that are embedded in Benjamin's writing are becoming increasingly legible as the collage-based city film experiences a renaissance

in the early twenty-first century. Films such as *My Winnipeg* (Guy Maddin, 2007) and *Time and the City* (Terrence Davies, 2008) conjoin autobiographical reminiscence with creative assemblies of archival sounds and images. Where Guy Maddin indulges in fakery, testing our belief in the archive and our memories, Terrence Davies cannot refrain from a lingering love of the pomp and circumstance of empire. Beyond the dozens of city films that continue to be produced as essayistic, poetic, experimental documentaries, using archival and original footage, the subject also lends itself to interactive web-based documentaries such as *Highrise, PinePoint*, and *Fort McMoney*.[11] These projects embrace the film archive as precisely the in-process, forever incomplete tendency of archiveology, transforming all images into archival images. They also embrace the labyrinthine structure of Benjamin's city essays that wander through the streets of discarded things, shards of memory, and barely glimpsed shocks of recognition.

Time and the City and *My Winnipeg* are both constructed as homages to the filmmakers' hometowns, the cities where they were born. They share an autobiographical narration and are grounded in extensive footage shot in their respective cities over many decades, evoking both the fragmentation and the layering of Benjamin's cityscapes. Maddin even delves into an archaeological fantasy of the deep structure of the city, in which the union of three rivers is merged with the lowest level of a three-story underground public pool where various childhood desires and terrors are remembered. In *Time and the City*, Davies is less duplicitous than Maddin, and sticks more closely to historical truths, but he too has a complicated relationship to his city of Liverpool. Both directors use the archive to build up a richly diverse weave of temporalities in which their own childhoods intersect with the histories and myths of their respective cities. Like Benjamin, they indulge in the myths of the city; and yet there is also a strong critique of the ways that urban planning and development have negatively affected the citizenry.

In this chapter I will discuss two city-based examples of archiveology that are more sociological than autobiographical: *Paris 1900* (1947) by Nicole Védrès and *Los Angeles Plays Itself* (2003) by Thom Andersen. Over half a century separates these two films, and yet they both convey Benjamin's conflicted sense of urban life in the form of the essay film. Like Maddin and Davies, Védrès and Andersen tend to incorporate a commentary on the image into their compilations. Indeed, these films bring Benjamin's hidden city into a kind of focus as they drive home the point that cities are places where films are often made. Not to dismiss rural filmmaking, or suburban studio backlots,

but ever since the Lumière brothers' first exhibits in Paris, and the relocation of the American industry from New Jersey to Los Angeles in the second decade of the twentieth century, filmmakers on all points of the commercial spectrum have been drawn to the city as location and as subject.

In Rick Prelinger's 2008 manifesto on open access, he says that "the public domain is the coolest neighbourhood in town."[12] Indeed, the city is traditionally the site of flea markets, garage sales, and remainder stores. It is the place where things and people are in constant circulation, and in many ways the city is a model for the Internet itself, as Friedrich Kittler has indicated, through the terminology of ports, gates, traffic, sites, and homes that are used to navigate the web.[13] As Will Straw says, "the sedimented thickness of urban life is not just a function of the city's density and multi-levelled accumulation; it is a result as well of the city's circuitousness, of the innumerable destinations and itineraries it offers to the object as it ages."[14] Among the "objects" in circulation are images of the city itself. Prelinger has tapped into such rich resources of city films made by the industry, amateurs, and nontheatrical producers that he has been able to make continual remakes and installments of his film presentations *Landscapes of Detroit* and *Landscapes of San Francisco*. Rather than finish these films, Prelinger prefers to screen them theatrically, inviting the audience to collectively add the narration live.

Like the city, the archive is a living, breathing entity as "documents" are continually added and, more importantly, continually "rediscovered." The surface of the archive is now; its depths are passages to the past. Thus it is always instructive to return to archive-based films, such as *Paris 1900*, to be able to discover again what was rediscovered in the past. *Los Angeles Plays Itself* abruptly ends around 2000, and will thus gain historical significance as we come to know the Los Angeles of its future, and the archival entropy of the film becomes associated with its director's heroic accomplishment. Thom Andersen contributes a first-person narration to his film, which is like Maddin's and Davies's in that it conveys a conflicted relationship to the city. Each of these directors gains a persona who is evocative of Benjamin's appreciation of Baudelaire as an urban poet whose "heroism" is deeply ironic, gained only through the ongoing battle with the crowd — or what Kracauer called the "blizzard" of images. All these films exemplify the practice of archiveology as a process of excavation and remembering precisely by an embrace of the urban kaleidoscope that has also created the destabilizing amnesia of technological modernity.

> If this book really expounds something scientifically, then
> it's the death of the Paris arcades, the decay of a type of
> architecture. The book's atmosphere is saturated with the
> poisons of this process: its people drop like flies.
>
> Walter Benjamin, *The Arcades Project*

Paris 1900 has been largely overlooked by film historians, perhaps because its director, Nicole Védrès, made too few films and was the wrong gender to become recognized as an important French auteur. It may also have been overlooked because in 1947 it challenged the usual paradigms of film classification. Jay Leyda recognized it in his book *Films Beget Films* as the first important compilation film made after the war, and he situated it within a history of such filmmaking that drew primarily on newsreels.[15] However, Védrès takes the compilation format a substantial step forward by combining clips of fiction film footage with photographs, newsreel, and *actualité* footage, and by the scope of her archival research. She repurposed imagery from not only film libraries but also personal collections, flea markets, and other sources, including garrets, blockhouses, cellars, garbage bins, and even a rabbit hutch.[16] In other words, *Paris 1900* expands the concept of the archive and "official" history to include many other histories that were recorded on film and subsequently abandoned as inconsequential.

Paris 1900 consists of excerpts from over seven hundred films, with original music by Guy Bernard, to represent the period often known as the Belle Epoque, from 1900 to 1914, as a mythical period of peace in which social optimism and the arts flourished in France. The film could be described as "superficial" in that it depicts Paris as a kind of image culture (and this is precisely how Bosley Crowther described it in 1950),[17] and yet there is a lingering undercurrent of impending disaster that is finally realized with the commencement of the Great War in 1914. The omnipresent camera underscores the role of technology in this excitable culture, and the archival excess seems indirectly responsible for the impending collapse. As Védrès herself puts it, she felt she had completed a "novel that ended tragically — although no one can tell, even now, whether it was by crime, accident or suicide — in August 1914."[18] Despite the light-hearted commentary and the playfulness of Parisian fashions, entertainments, and diversions, this postwar city film is

significantly less celebratory than the famous prewar antecedents of Dziga Vertov and Walter Ruttman, which celebrated their own modernity, rather than a former one. *Paris 1900* is less a "symphony" than a kind of sugar-coated eulogy. Instead of nostalgia, it exhibits an undercurrent of failure and false promise.

Indebted to the newsreel tradition, the voice-over commentary of *Paris 1900* may strike contemporary audiences as somewhat heavy-handed, although it is far less authoritarian than the norm of the time. The voice-over in both French and English (the French version is read by Claude Dauphin) is witty and sardonic, but like the newsreel format, it is somewhat relentless, pausing only occasionally in its commentary, spoken in the voice of the "present tense" of the late 1940s. This is one of only two films Védrès made before her death in 1965. A public intellectual, novelist, and journalist, she was very much part of the Left Bank scene, with a background as a researcher at the Sorbonne.[19] Despite the key role of narration in the film, Védrès understood her project as one in which silent pictures were an invitation and opportunity to talk, "to give voice to things, facts and faces."[20] Védrès is one of the first filmmakers to double as an archivist, and like the generations of found-footage and compilation filmmakers who followed, she turns the archive into an expressive, experiential language of history.

The Belle Epoque is depicted in *Paris 1900* as a vibrant period of amusements and artistic expression; the city of Paris is a living, breathing entity in which floods, slums, and criminals may be briefly glimpsed but are quickly swept up in a self-congratulatory pride. At the same time, the narration is coy and ever-so-slightly ironic, as if the sudden and surprising outbreak of war in 1914 should not have been so sudden and surprising. The mystique of the period is undercut precisely by the cinema that seems to intervene everywhere between history and its representation. Védrès has also included fashion designers, along with notorious dancers and models, representing the period as one in which women were very much present in public life, even if it was principally "to be seen." The film's reflexivity emerges from the display culture of the period, which Védrès's collage structure highlights and then undercuts with the final buildup to the outbreak of war.

Dozens of artists, writers, musicians, painters, poets, and socialites appear in the film, including Claude Monet, Enrico Caruso, Pierre-Auguste Renoir, André Gide, Paul Valéry, Cecile Sorel, Mistinguett, Gabrielle Réjane, Sarah Bernhardt, Maurice Chevalier, Colette, André Bleriot, Mary Gardens, and

Buffalo Bill.[21] Many French politicians are also featured, along with ironic commentary on their contribution to the social fabric. The president, M. Fallieres, is repeatedly said to be "content," until finally, he is no longer content, and is succeeded by M. Poincaré, who is seen traveling on a series of diplomatic missions that unspool into a series of events across Europe leading up to the assassination of the Austrian archduke of Sarajevo.

Most strikingly, the film is punctuated at the three-quarter mark by the so-called birdman, Franz Reichelt, leaping to his death from the Eiffel Tower in 1912, witnessed by Pathé newsreel cameras. The sequence begins with the birdman preparing himself at the top of the tower, balancing on the rail, while the musical score trembles softly. The narrator is momentarily silent before the leap into the air. The suspenseful pause before the birdman's jump is perhaps the film's longest, making us very briefly aware of the passing of time. Says the narrator, "He hesitates. Finally he jumps." Cut to a second camera on ground level to capture the fall. The narrator describes the six-inch hole at the bottom of the tower and explains, "They carry away the remains of this premature birdman. But others have been luckier in conquering the skies." Without missing a beat, the compilation moves on to Louis Bleriot's successful 1909 flight across the English Channel. The sequence is typical of the film's style in the way the narrator and the music are intermingled on the soundtrack, and in the way that the narration facilitates a flow from one incident to another. The images of Bleriot's successful flight across the English Channel begin before the narrator has completely finished the story of the premature birdman, obscuring the fact that Reichelt's fall actually took place three years after Bleriot's flight.

Both André Bazin and Siegfried Kracauer commented on the film when it was first released, noting its implicit discourse on historical time. The film indicated for Bazin that "cinema is a machine to recover time, only better to lose it. *Paris 1900* marks a tragedy that is peculiar to cinema: that of time twice lost," while Kracauer describes it as marking "a border region between the present and the past. Beyond it the realm of history begins."[22] Bazin also comments on *Paris 1900* in his essay on *The Bullfight* (*La course de taureaux*, 1951), directed by Pierre Braunberger and "Myriam" (a.k.a. Myriam Boroutsky) — the producer and editor, respectively, of *Paris 1900*. In "Death Every Afternoon," Bazin claims that the filming of death is cinema's great obscenity, and emblematic of its specificity because it marks the finitude of the singular moment in time.[23] This observation is also a place where Bazin's views on cinema link up well with Benjamin's, insofar as Bazin's notion of the cinema as a technique that "embalms time" implies that the cinema is "a new social practice that

Paris 1900 (Nicole Védrès, 1947)

completely transforms the phenomenology of memory," in Monica Dall'Asta's words.[24] Benjamin recognized the privileged relationship of cinema to modern time in its ability to extract and freeze a moment from the continuum: "The camera gave the moment a posthumous shock."[25] Like Baudelaire's conception of spleen, cinema has the potential to "expose the passing moment in all its nakedness."[26]

Kracauer's comments on *Paris 1900* stress the doubleness of images drawn from the past that are at once familiar and unfamiliar.[27] Archiveology is indeed an uncanny discourse, as old images are given new meanings in new contexts. For Benjamin, the act of collecting, which lies at the heart of archiveology, is a practice of allegorization in which objects are detached from their use value and exchange value and given new meaning within the terms of a private archive. This effectively means that they are "dead" but have a future nevertheless. For Benjamin, the rags and refuse of the Paris arcades are richly allegorical as ruins of the past. For the collector, "the world is present, and indeed ordered, in each of his objects."[28] Védrès's act of collecting fragments from the "dust-bin" of history in the 1940s was an innovative and radical act that challenged more conventional views of history, exposing its gaps and its

forgetting alongside what Paula Amad describes as the "historicist illusion of total recall" created by newsreels.[29]

In *Paris 1990* the optical unconscious of the cinema is on display in the form of fiction films, trick films, and other "attractions" of the era. These clips effectively render the newsreel imagery as playful, dialectical documents that are fictive in their own right. The compilation style — rushed, flowing, light, and breezy, interrupted only by the catastrophic death of the birdman — is in keeping with a false consciousness of historicism, and yet the phantasmagoria is only the surface of a roiling sea, an excess of images, and is clearly constructed from the flotsam and jetsam of a haphazard archive. In Benjamin's enthusiastic endorsement of the satirist Karl Kraus, he points to the way Kraus makes even newspapers quotable. He writes that "the empty phrase is suddenly forced to recognize that . . . it is not safe from the voice that swoops on the wings of the word to drag it from its darkness."[30] Védrès likewise renders the most banal newsreel images into a lament. By juxtaposing trick films with newsreel films, Védrès may even be loosening the knot with which Kraus, according to Benjamin, bound technology to the empty phrase.[31] Like Kraus's, her method is an anarchic play with language, although for Védrès, it is a language of images.

Several reviewers at the time described *Paris 1900* as a "re-creation" of Paris between 1900 and 1914,[32] but Bosley Crowther complained that "the pictures by themselves do not say anything except that people looked funny, by our standards, in those days."[33] Decades later, the images can be readily perceived as allegories and ruins of their original moments of production, containing traces of the technologies of reproduction along with their dynamic traces of human behavior. For viewers in the early twenty-first century, the film points to the potential of film fragments to create alternative cultural histories based in moving images.[34] Védrès's particular use of special effects from the cinema of attractions and her preoccupation with fashion and women make the film especially provocative as the construction of a memory of a forgotten future. It is more than evident from the perspective of archiveology in the digital era that the film is less a "re-creation" of Paris than a remaking of its self-image and an appropriation of its energies and hope for a future that ultimately failed it.

In "On the Concept of History," Benjamin describes the materialist historian as "brushing history against the grain."[35] History is a question of recognizing the past not "the way it really was" but as it flashes up in a moment of danger.[36] He also notes that "the only historian capable of fanning the spark of hope in the past is the one who is firmly convinced that *even the dead* will not

be safe from the enemy if he is victorious."[37] The enemy in this passage is the danger of conformism and capitalist exploitation.

To return to the birdman, who is made to look somewhat ridiculous in his failed and deadly experiment, his role in *Paris 1900* is precisely to underline the vulnerability of the past to teleological narratives of success in which an aviator such as Bleriot is a hero and poor old Reichelt is forgotten. If Védrès manages to redeem him as a hero of an earlier age of the spectacle, her film is arguably consistent with Benjamin's utopian hope for a flash of something transformative to emerge from the ruins of the past. Benjamin specifically insists that this spark can only be detected within a "constructed" history that articulates not empty time but time filled by *Jetzeit* or "now time."[38]

The omnipresent film camera contributes to the tone of "newness" that pervades *Paris 1900*, as newsreel footage itself is attracted to the latest, greatest, newsworthy events. The Belle Epoque is depicted as many Parisians apparently saw themselves, at the cutting edge of modernity. New technologies, new fashions, and great shifts in the arts, music, literature, and the sciences seemed to be on the horizon. Védrès's compilation enables us to see the promise of modernity in the forms of the past. The film recycles images of history in such a way as to produce new knowledge about history that evokes a deeper, more sensual, and experiential understanding of the past. The blend of fact and fiction is at times overt, in the inclusion of "trick films" of the period, but also duplicitous, insofar as footage from an Éclair fictionalized reenactment is used to stand in for a police showdown with the Bonnot criminal gang, while the narrator says, tongue-in-cheek, "a cameraman just happened to be present."[39] The film says little directly about the role of cinema in the Belle Epoque, and yet implicit in the compilation is the fact that cameras were everywhere, capturing every major public figure, along with many minor, marginal events and characters. The camera is the democratic everyman; the archiveologist therefore digs through the strata of amnesia to better learn about the possibility and potential of everyday life in modernity.

History Breaks Down into Images:
The Origins of the Essay Film

Paris 1900 is arguably an early incarnation of the essay film, indicating how the status of the archival image subtly shifts in the immediate postwar period from being unquestionably authoritative to being rhetorical.

Paula Amad points out that *Paris 1900* registers the status of the midcentury film archive as being heterogeneous, uncatalogued, and haphazard.[40] Even the Cinémathèque Française, under the jurisdiction of long-time impresario Henri Langlois, had no systematized classification system at the time. It was more of a collection than an archive. The juxtaposition of diverse modes of film practice in *Paris 1900* speaks back to the materiality of film collecting, and its intuitive and creative montage strategies become an essayistic reflection on the "counterarchival" cinematic representation of the past.[41]

Timothy Corrigan claims that the essay film emerged as a form in postwar France, and he highlights the films of Alain Resnais, Chris Marker, and Agnès Varda in the 1950s, but the first film he mentions is Resnais's *Van Gogh* (1948),[42] which was produced by Pierre Braunberger and narrated by Claude Dauphin, all three of whom had also worked on *Paris 1900* two years earlier. The density and complexity of the found footage in Védrès's compilation, furthermore, anticipates Guy Debord's subsequent work in France in the 1950s; but where Debord enacted a systematic critique of image culture, Védrès indulges in the phantasmagoria — the world of images — and in many ways anticipates the more archival modes of found-footage and essayistic film practices of the early twenty-first century.

In a 1950 review, Arthur Knight gives some indication of how the essayistic address was perceived by the film's first English-language audiences. He is impressed by the casting of Monty Woolley, noting that "his reading during the closing sequences is eloquent, spoken not by an actor but by a human being who seems himself to have known and felt the impact of the events he is describing."[43] Knight indicates how the narration implies a first-person subjective viewpoint, like that of the travelogue, in contrast to the objective tone typical of newsreel narration of the period. This impression of subjectivity is conveyed in part by the gendered point of view; Védrès defers to the dominant male patterns of visual culture of the time but also to the stream-of-consciousness ramble of associative logic by which the various elements of the compilation are sewn together.

The tone of the narration, in both French and English, remains slightly distanced from the images, as if the narrator were watching them unspool along with the viewer. The French narrator, Claude Dauphin, is especially dramatic and expressive, and both narrators note at a certain point "follies, more follies." Given the kind of research that went into the film and its incomplete, slightly off-kilter approach to truth, *Paris 1900* unquestionably embraces the essayistic mode. As archiveology, it indicates how the historical evidence available to

the filmmaker is unique in its capacity to produce historical knowledge that includes the trivia of everyday life alongside global politics. One reviewer was particularly critical of the film's crude use of humor, and points out that while the narration "mentions the socialist politician Jean Juarès, it completely fails to mention his final words: 'I blame Germany. I blame France. I blame Russia. I blame England. I blame Austria. All are to blame and all will suffer.'"[44] In fact, Védrès simply lacked the footage of the Juarès assassination, which, for many, marked a traumatic turn of events, and she turned to the birdman footage for something that might stand in for it, marking the gradual descent into war.[45]

The film seemed to some critics to lack depth, as its historical analysis was replaced with what another critic in 1987 described as an excess of vitality "that simply leaps from the screen."[46] It now seems to be a haunted film, as its excess masks a failure of modernity to make good on the promise of its technological novelties. For Bazin, the film marks a second level of tragedy, which is "the impersonal gaze man now directs towards his history."[47] The death of the birdman points to the role of public memory embedded in the compilation film, as if the camera had no soul. Kracauer notes how the film separates the self from history, marking a discontinuity of the past thrown up in objective, detached form. The habitual fashions of the past suddenly seem ridiculous, and it is laughter that summons a more acute sense of the present as historical time.[48] Indeed, the shock of the birdman's death, caught by an anticipating camera, is black comedy, pointing up the way that *Paris 1900* is self-conscious about its own superficial ironies.

Paris 1900 uncannily invokes Benjamin's view of history as nonlinear, imagistic, dialectical, and always undergoing construction, reconstruction, and retrieval in the interests of an ever-changing future. The film begins a few decades after *The Arcades Project* ends, and it ends a decade or so before Benjamin began living in Paris and writing about the city, filling in the gap between the two eras. The nineteenth-century phantasmagoria that he was so fascinated by has, by the early twentieth century, become a full-fledged dreamworld. After World War II, the nightmare concealed within this dream becomes recognizable as a function of the dream itself. The architectural marvel of the Eiffel Tower, a landmark to which Védrès repeatedly returns, is the climactic monument to the iron construction that housed the shopping concourses of the arcades. Some of Benjamin's twentieth-century heroes appear in person, such as Paul Valéry and Guillaume Apollinaire, exemplary poets of the so-called Belle Epoque. Moreover, the film arguably dramatizes

Paris 1900 (Nicole Védrès, 1947)

the dialectics of the phantasmagoria that Benjamin addresses in his sprawling opus.

Benjamin's fascination with the nineteenth-century phantasmagoria recognized the way in which it presented an illusion predicated on its own ruination, and he found keys for its undoing — the potential of awakening — within its very fabric. The essayistic flow of *Paris 1900* creates a seamless sense of historical time, as if it were a kind of monument to the period, and in this sense, it exhibits all the traits of historicism that Benjamin denounced. At the same time, its archival composition, its fragmentariness and contingency, its montage of disparate sources and styles, along with its implicit sense of mortality, show the cracks in the edifice of history. The tone of the narration and its slightly impersonal flavor render history as a dream time. But most importantly, everyone and everything subsists in the "second nature" of cinema. There is no everyday life, and there is no "realism." The men outside a urinal on a busy street, for example, are no longer men but are produced by the cinema, which has essentially rendered them as elements of the city. The celebrity artists are highly self-conscious about performing themselves for the camera. A few of them, including Sarah Bernhardt, are accompanied by

voice recordings from the period, awkwardly synched to their images. In this form, subsumed entirely by mechanical reproduction, they seem even further removed from experience, from humanity, and from life.

Everyone in this film is definitely dead, especially the birdman. Bazin suggests that if the cameras had not been there, "a sensible cowardice might have prevailed."[49] The stakes were raised by the camera's presence, and the astonishing footage constitutes one of the earliest snuff films. By including this "modern Icarus" within her compilation, Védrès allows its critical effects to undermine the film's otherwise whimsical celebration of the era. In keeping with Benjamin's theory of allegory as a process of mortification and loss, the birdman's death proclaims the failure of the Belle Epoque to save itself, and the world, from devastation. Made just after the liberation of Paris from Nazi occupation, *Paris 1900* speaks of the decadence underlying the flourishing of the arts. The phantasmagoria Védrès depicts is not one of consumer culture but of a national, urban culture that integrated cinema into itself so thoroughly that the image came to stand in for reality. This is particularly evident in the section on women's fashion.

Fashion: The Tiger's Leap into the Past

For Benjamin, fashion was a key feature of nineteenth-century Paris, a fundamental sign of the historicity of modernity. As the perpetuation of novelty, fashion constitutes the inscription of the future; and yet fashion is always already in a state of decay. In fashion, the human body has most evidently submitted to the reign of the commodity, but Benjamin understands its proximity to the revolutionary energies lying dormant in the city. As the parody of the motley cadaver, Benjamin links fashion to revolution, and to love, in his epigrammatic *Arcades* fragments. Ulrich Lehmann argues that fashion constitutes Benjamin's primary example of the dialectical image, threaded as it is, throughout *The Arcades Project*.[50]

In his 1935 exposé, or introduction, for *The Arcades Project*, Benjamin writes that "fashion prescribes the ritual activity to which the commodity fetish demands to be worshipped."[51] In the fashion convolute of this project, he describes fashion as the "predecessor — no, the eternal deputy of surrealism"; and in "On the Concept of History," fashion is "the tiger's leap into the past."[52] Benjamin noted in particular how fashion continually recycles bygone styles to make them fresh again, even if it remains within the logic of commodity fetishism. "The open air of history" can thus be cleared by the ever-renewing

cycles of fashion; but it does so only through its invocation of the corpse, given the way it commodifies the body itself: "To the living, fashion defends the rights of the corpse. The fetishism that succumbs to the sex appeal of the inorganic is its vital nerve."[53]

The privileged role of fashion in *Paris 1900* makes it seem almost as if Védrès had read Benjamin and borrowed some of his surrealist logic, as it is an important means by which the display culture is linked to progressive values and to the gendered fabric of the city. Early in the film, the new style of Art Nouveau is illustrated with a bronze female nude. The narrator says, "She symbolizes modernism. The salon leads us to manners, indeed to ethics." The film thus makes a transition from the new architectural style of the metro to a parlor scene in which ladies greet each other in the latest fashion. The sequence then rambles on through a patronizing litany of fashion details, including hats, hairdos, handbags, and jewels; and on to haute couture designers and the new fabrics imposed on the "slaves of fashion"; but then we move on to sportswomen, trousers, the liberation from the corset, and suffragettes.

Fashion is unequivocally linked to the woman's suffrage movement, although even that political reference is undermined by the narrator, who singles out the leader as not wearing a pretty hat. From women's liberation, the narrator and the visuals move on to images of some of the period's more libertine dancers and actresses, including several dance sequences. And then the narrator abruptly switches to the plays of Monsieur Willy, husband of Collette (who is pictured with her cats), and the topic of adultery is illustrated by a melodrama of the period. Various scenes from this film are then roughly edited together with the narrator commenting on their significance vis-à-vis typical behaviors of the era. A man and a woman ride bicycles into a park and sneak into the bushes together; then the woman in her bed pretends her lover is her doctor when her husband returns, which leads to a discussion of hypnosis, a fad of the period. The woman dreams of revenge, as a man puts a gun to his head; then we cut to an excerpt from Méliès's film *The Brahmin and the Butterfly*, in which a woman turns a magician into a caterpillar. From here, the film moves on to a scene in which a man has his wife photographed while sleeping, followed by a shot of a painting, over which the narrator says, "Another fact: women have themselves vaccinated in public." And from here it moves on to Turkish baths and a list of famous authors who presumably might be found there — "safe from intruding females." The ladies, we are told, no longer only want to see; "they want to be seen."

Paris 1900 (Nicole Védrès, 1947)

In its associative logic, the film very clearly articulates the gendered fabric of the Belle Epoque. The woman's body is the support for a plethora of discourses on the arts, literature, film, fashion, liberation, hypnosis, and the phantasmagoria of everyday life — but it is also linked explicitly to social revolution. What strikes me about Védrès's Benjaminian consideration of women in the city is the way that gender also implicitly underscores the blending of popular culture and social fact in *Paris 1900*. Women's genres, along with women working and rabble-rousing, are part of the social fabric; fashion seals their participation in commodity culture, and yet they clearly resist its deathly grasp with dynamic movement, sexuality, and the threat of their looks.

Benjamin intimates that fashion may be a predictor of revolution, but he himself seemed unable to read its "secret signals of things to come." Only the "feminine collective" was in the know.[54] And yet, as Peter Wollen points out, Benjamin "understood that the sensuous and poetic aspects, the aesthetic and psychological aspects of costume, should not and cannot be discounted."[55] If revolutionary energies are perceptible in commodity culture, Benjamin is most explicit about the role of fashion in undoing the grasp of the past on the present, and in shifting perspectives for an awakening from the dreamworld

of image culture. The role of ladies' fashion in *Paris 1900* links fashion and film as techniques for revisiting the past dialectically.

Sequences from the explicitly gendered terrain of fiction films, including hysterical melodramas and comic chase films, are used to illustrate historical facts. For example, when a few moments of a Méliès film are inserted as the dream of a woman in another film, which is used in turn to illustrate the new science of hypnotism, Védrès very literally explores the dream life of the epoch. Because all varieties of film are presented in the form of documents, rather than entertainment, popular culture is deeply incorporated into the narrative of the times. Although masculine genres such as chase films are also included, fashion provides a key pivot from newsreel to fiction, blurring the distinction between documentary and staged performance. The extensive imagery of fashion and celebrity is reminiscent of Victorian-era scrapbooks, suggesting that Védrès's practice may have been inspired by a variety of practices of collecting and montage, including those performed by women.

The important role of fashion in *Paris 1900* underscores the historical convergence of early cinema and fashion modeling in Paris during the early years of the century. As Caroline Evans has pointed out, the two industries shared a common discourse of display in which the woman's body became a site of transformation. Fashion shows were among the many attractions of the era, featuring in newsreels primarily, through the teens and twenties. Evans points out that, like Méliès's trick films, fashion shows deployed various techniques of staging to show women "appearing, disappearing, and reappearing in different costumes, sometimes replicated confusingly in the mirrored interiors of salons."[56] The convergence of fashion and film, implicit in Védrès's compilation, is arguably symptomatic of the intermedial display culture of the city. This is precisely why Benjamin features it so prominently in *The Arcades Project*. Fashion as a "tiger's leap" into the past is a key to the temporal passage that he identifies in nineteenth-century Paris.

As Giuliana Bruno has interpreted Benjamin's provocative argument, "a sartorial, material philosophy is born that can ultimately convey in the folds of its fabric the capacity to fabricate the texture of cultural memory."[57] Védrès's leap, in turn, into the Paris of fifty years before indicates how cinema itself in postwar Europe had assumed the dialectical properties of fashion. Her recycling of historical film fragments is so very different from a nostalgic mode of remembering and instead harnesses the cinema's properties of mortification alongside its complicity with the eternal recurrence of novelty implicit in the cycles of fashion.

Magic: The Special Effect of the Archive

In *Paris 1900*, presidential appearances, society ladies, parades, and circuses are interspersed with trick films from the period in which special effects are smoothly integrated into the flow of everyday life. This casual undermining of the realism of the cinematic document aligns the film closely with the surrealists' distortions of reality. Benjamin's interest in Paris was explicitly inspired by the surrealists, and Margaret Cohen has argued that his unorthodox Marxism was informed by André Breton's surrealist analysis of Paris. She describes Benjamin's "gothic Marxism" as an analysis of how the "expressive character" of the Parisian environment shapes Karl Marx's thought, alongside Baudelaire's: "Benjamin constructs the expressive character of the Parisian environment with appeal to aesthetic products, certainly, but also with appeal to representations across the ideological spectrum cutting through the boundaries of institutionally separated genres."[58] The parallels between *Paris 1900* and *The Arcades Project* include practices of collage and juxtaposition in which strange bedfellows are brought into conversation with one another, and in the process, materialist history is threaded with poetic "magical" eruptions made possible by technologies of representation.

In his 1929 essay on surrealism, Benjamin notes that Breton "was the first person to perceive revolutionary energies of the outmoded."[59] The "marvelous disorientation" provoked by random cinema going described by Breton, dropping in and out of movie theaters,[60] is an important precursor to the shifting perspectives provoked by archival film practices such as *Paris 1900*. For Benjamin, the surrealists' Paris was "'a little universe.' That is to say, in the larger one, the cosmos, things look no different. There, too, are crossroads where ghostly signals flash from the traffic, and inconceivable analogies and connections between events are the order of the day."[61]

If, for Benjamin, "image" was a metaphor for the visuality and display culture of nineteenth-century Paris, for Védrès it is very literally the ruins of that culture. As Cohen describes it, Benjamin was interested in "how social facts manifest themselves primarily in the world of forms, in a world of forms that is not aesthetic but rather the realm of social fact."[62] Recorded on film, these "social facts" become expressive fragments of memory, ripe for discursive play in their recycled form. Védrès accesses film not only for its images and representations but also for its status as a social practice and process that is never fixed or static but always incomplete, transformative, and transitory. Through techniques of collection and collage, moreover, she has arguably "blasted the

epoch out of the reified continuity of history," as Benjamin puts it, precisely by "interspersing it with ruins — that is, with the present."[63] Most significantly, by borrowing the magical properties of the cinema of attractions, the documentary status of *Paris 1900* is rendered radically unstable and unfixed.

In the opening sequence of *Paris 1900*, documentary and fiction are thoroughly blended in a segue from a series of generic shots of the city, including Montmartre and the Place de la République, into a chase film set on the streets of Paris. The narrator says, "Out of the morning mists, some questionable characters emerge. If they are thieves, the gendarmes will be in hot pursuit," and the soundtrack music abruptly shifts from an orchestral celebration to the familiar piano music accompaniment of silent film, preceded by a police whistle. A scene from a Keystone Cops–style chase film unfolds, complete with stop-motion comic special effects. A rogue criminal leaps up out of frame and, after a second, falls on the cops, scattering them so he can make his escape — a classic stop-motion effect of early chase and comedy films.

By including sequences from trick films such as this in the compilation, Védrès borrows a specific style of editing from the period. As Tom Gunning has argued, the stop-motion effects used by Méliès and other cineastes of the era were adapted from nineteenth-century popular entertainments staged in magic theaters, often using screens, such as magic lantern shows and phantasmagorias.[64] The special effects of the cinema of attractions privilege a continuity of framing over spatiotemporal unity, producing discontinuities that are superhuman and a "thrill of display." The attraction is always, in part, the technology itself, which produces such magical results as the metamorphosis that takes place in the clip from *The Brahmin and the Butterfly*. The magical effect of early film tricks is produced by various forms of collage, either in the frame or between frames. For example, ladies' smiling faces appear in miniature matte shots of a display of singing jewelry in yet another example of a cinema-of-attractions special effect appropriated by Védrès. The banal excess of a lady's jewelry box is suddenly energized by the comic style of popular culture. These juxtapositions of kitsch and technological wonder are precisely the material with which Védrès herself is working, effectively situating cinema and its disruptive role within the phantasmagoria.

The most sustained example of a trick film in *Paris 1900* is Védrès's inclusion of the entirety of Ferdinand Zecca's short film *The Moon Lover* (1905). It is the only fragment to be introduced specifically as a film, complete with accreditation and attribution; "its admirers call it innovative," we are told, and indeed the film features a drunkard flying through the stars to land back in his

Paris 1900 (Nicole Védrès, 1947)

room with dancing bottles. This trick film, which follows a sequence of music hall entertainers and *café-concerts*, takes us deep into the dreamworld of the Belle Epoque and its chaotic diversions. The camera enters the frame of the film by zooming in over the audience and the orchestra. The falling man is the third such descent in the film, including the birdman and the falling criminal.

Benjamin's complex notion of the phantasmagoria was based on the shadow plays of nineteenth-century Paris invented by Étienne-Gaspard Robert (stage name Robertson), which Benjamin recognized as being both manipulative and sensual.[65] In his 1939 revision of the 1935 exposé for *The Arcades Project*, Benjamin replaced the terminology of the dream that he borrowed from the surrealists with that of the phantasmagoria, to better implicate the Marxist notion of the ideological veil in the project.[66] His notion of the phantasmagoria is also developed from Baudelaire's poetic interpretation of Marx, using the vocabulary of magic and the supernatural. As Cohen explains, "The magic is that of commodity fetishism, a situation in which social relations between men take on the phantasmagorical form of relations between things."[67] The two notions of dream and phantasmagoria nevertheless remain deeply entwined throughout *The Arcades Project*, as the recurring refrain of "awakening" through dialectical

method echoes throughout the project. The phantasmagoria thus refers to the magical entertainments of the nineteenth century, to the Marxist theory of ideology, and to the surrealist dreamscape of the unconscious.

We can understand more clearly from *Paris 1900* how surrealism emerged from the Belle Epoque. We can also understand perhaps how Benjamin's surrealist view of nineteenth-century Paris was so closely informed by cinema, a medium that emerged only in its aftermath, the period depicted in *Paris 1900*. Cinema may be deeply ambiguous with respect to temporal and documentary accuracy, and yet that very instability gives it a transformative power over everyday life. Cinema takes its place in *Paris 1900* alongside Claude Debussy, Édouard Manet, and Apollinaire. As the Académie Française gives way to the impressionists and women start wearing trousers, cinema is incorporated into culture not as an art form but as a causal element of the dynamic phantasmagoria.

Dream City/Documented City

The integration of fiction and documentary, newsreels, and the various styles that we associate with the cinema of attractions do not compromise the documentary value of *Paris 1900* but instead establish a level playing field for the status of film as document. The narration plays freely with these documents, making them work with whatever story the narrator chooses to tell. The slippages of meaning are especially playful in the charting of time. Although the film covers a period of fourteen years, it is also structured somewhat like a prewar city film, such as *Man with a Movie Camera* or *Berlin: Symphony of a Great City*, with the city rising as a living, breathing organism. At the end, just before the War Notice is posted, the narrator says, "The sun sets for the last time on a peaceful Paris" over a shot of the Seine at dusk.

Despite the structure of a day in the life of the city, *Paris 1900* is explicitly compiled from footage covering fourteen years. The flooding of the Seine is clearly historical in the sense of marking a fairly specific moment in history, linking the epoch to a date, and the birdman's demise underscores this specificity; but shots of the Eiffel Tower, like shots of the Seine at dusk and many of the activities and shots of celebrities, are impossible to periodize with any accuracy. The challenge of film to the archive is precisely this instability and incoherence. Once it is removed from its can — its archival prop — the film clip can mean anything one wants it to mean. As Védrès herself explains, "One must go . . . through the first appearance of the selected shot to feel and, without insistence, *make felt* that strange and unexpected 'second meaning'

that always hides behind the plain and superficial subject."[68] In the context of historical compilation, these second meanings go well beyond denotative and connotative significations to register the typical, the habitual, the everyday, and also the once-only event, which anchors the image in history. The bird-man's death shudders through the film to remind us of this duplicity, and thus the whole evidentiary system is ever so subtly compromised.

In *Paris 1900* the sensual, affective aspects of the culture of the period are incorporated into the city film in such a way as to bring us closer to its trans-formative potential and its failures. The discourse on fashion and display culture draws us into the dream life of the period, but there are also moments, such as the Méliès and Zecca films, the talking jewelry and the stop-motion effects in the chase film, that suggest how the cinema participated in the transformative effects of modernity. It may even have led the charge. Hardly anything has not been staged in some way for the camera. If the cut in the birdman's fall signals the failures of the era and the lost promise of modernity that Benjamin wrote about so eloquently in *The Arcades Project*, its failure is all the more melancholy because of its alliance with the magical properties of cinema demonstrated elsewhere in the compilation.

In the last twenty minutes of the eighty-one-minute film, the collection of im-agery begins to spiral out to include aerial shots of mass protests as labor unions are formed. A group of city councilors visits "a part of Paris that tourists never see" — the slums — to which their response is to build a new morgue and to have garden parties for starving children. The deeper we go into the political history of the era, the more cynical the narration becomes, as the details of weaponry are assembled and troops are paraded on city streets across Europe. Finally, "the happy times are over," and the socialist Juarès, who defended Alfred Dreyfus, is assassinated. By creating a series of events from such a wide assortment of fig-ures, places, imagery, angles, and information, discrete historical facts are made to speak to each other and against each other, on the multiple levels that Benja-min describes as the "fore-history" and "after-history" of collected works.[69]

No amount of self-serving cultural celebration can offset the subsequent history of two devastating world wars, the second of which handed Paris over to the worst "barbarism" imaginable. And yet the unconscious elements of the dream city, as they are glimpsed in fragmentary form, are documents of pos-sibility and potential. As Hansen has noted, Benjamin's sense of the inherent affinity between film and the city is based in the photographic process that breaks up empirical reality into pieces. The city film then plays with those pieces of the urban scene to "destroy it in effigy, and to make its scattered

fragments available for transformative play."[70] Maybe *Paris 1900 is* the imaginary city film of the artwork essay.

Benjamin's research was challenged — and formed — by the "innumerable sources" generated by the mass-circulation press,[71] and Védrès likewise worked from the vast archives and private collections of postwar France. The excess of information, of images and sounds, available to the collector-filmmaker is growing ever more excessive in the digital era. It may be this excess of information that provokes a correspondence between contemporary archiveology and *Paris 1900*, rendering it visible as a key moment in the emergence of the essay film, precisely when "compilation" had lost its credibility as a mode of documentary film. The excess of the Belle Epoque may also be recognizable in new ways, in light of the contemporary Gilded Age of vast global inequality.[72]

Paris 1900 provides an instructive point of reference between Benjamin's moment and our own, because Védrès was working with an image bank that was remarkably close to Benjamin's own historical study of nineteenth-century Paris. The viewer becomes a historian such as Benjamin describes, a historian who "takes up, with regard to [the image], the task of dream interpretation."[73] The history in this film, like the history in *The Arcades Project*, challenges all disciplinary bounds and respects no scientific laws. Moreover, the techniques of cutting, extracting, and fragmenting evoke the destructive edge of technology that finally brought the city to its knees, just as the absence of an auteur behind the camera evokes the terrifying role of the war machines on the horizon. The film exemplifies Benjamin's observation that "overcoming the concept of 'progress' and overcoming the concept of 'period of decline' are two sides of one and the same thing."[74]

LOS ANGELES PLAYS ITSELF: TRANSCENDENT KITSCH

> In reality, we live in the past. That is, the world that
> surrounds us is not new. The things in it — our houses,
> the places we work, even our clothes and our cars — aren't
> created anew every day. . . . Any particular period is an
> amalgam of many earlier times.
>
> Thom Andersen, *Los Angeles Plays Itself*

Thom Andersen's 2003 film *Los Angeles Plays Itself* is an attempt to separate the virtual city of images from the "real" city of history, an attempt

that is ultimately doomed to failure. Andersen's essayistic narration is a critique of Hollywood and the ways that the film industry has appropriated Los Angeles for its various nefarious, fantastic, and duplicitous ends; but it is also a melancholy ode to a city that has had to continually remake its own history in the face of its simulacral servitude to the dream factory.[75] Los Angeles is a comparatively young city, burdened with its own lack of historicity. The deep irony of *Los Angeles Plays Itself* is that Andersen betrays his own obsessive cinephilia with his vast knowledge of film history, displayed in a brilliant montage of excerpts from genre cinema, auteur cinema, art cinema, and independent cinema.

Amid the dozens of clips of Hollywood movies, Andersen lingers occasionally during the 169 minutes to offer more extended interpretations of a number of key titles, including *Double Indemnity* (1943), *Chinatown* (1974), *L.A. Confidential* (1997), and *Dragnet* (1951 and 1967). These sections function as video essays embedded in a compilation film. Andersen's commentary is full of insight and analysis. His montage is expertly paced, and the film offers a unique perspective on the relation of film to urban space in general, as well as the specific aspects of the L.A. setting. *Los Angeles Plays Itself* is far from comprehensive — especially since the focus is almost exclusively on the postwar city — and yet it is an excellent example of film criticism in the form of archiveology. Moreover, it has had a direct impact on film history, in its recovery and redemption of *The Exiles* (1961), which had been more or less "lost" until Andersen "found" it and included it in his film.

Thom Andersen's narration in *Los Angeles Plays Itself* borrows some of the postmodern critique of image culture but complicates it with a recognition of the untimeliness of historical disjunction and displacement. He points out that because Los Angeles is a city where there are few historical landmarks outside those that designate former movie locations, the reality of lived history in the city is overlaid with fictional representations of life in the city, including the full repertoire of car chases, explosions, thrillers, romances, teen pics, and horror films. By organizing his cinematic collection around the use and reuse of specific L.A. locations, Andersen evokes a key principle of archival film practices. He explains, "If we can appreciate documentaries for their dramatic qualities, perhaps we can appreciate fiction films for their documentary revelations." Extracting a sense of place from the multitude of films set in Los Angeles, Andersen reveals cultural significance precisely by transforming Hollywood films into archival fragments.

Some of the highlights of *Los Angeles Plays Itself* are the sequences about specific buildings such as the Bradbury Building in downtown Los Angeles, Frank Lloyd Wright's Ennis House, Union Station, Richard Neutra's Lovell House, and other architectural sites in the city. Against the recognition of familiar fiction films, Andersen reveals the built environment that underlies their fiction and that has in turn become transformed, in many instances, by its cinematic double. In fact, the city is inseparable from the city on many levels. Despite Andersen's melancholic critique of the way the film industry has hijacked the city from its inhabitants, the film is lovingly constructed from the trivia and detritus of a cinephiliac collection. *Los Angeles Plays Itself* uses archival fragments of fiction films to reveal the documentary of Los Angeles that is concealed within Hollywood film history.

The indexicality of the imagery renders the films as traces of what Emma Cocker calls a "charged space of contestation and reinvention." Cocker's position is that archival film practices develop what she calls "empathetic forms" of making meaning and cultural memory.[76] Andersen's film is a good example of this, and it furthermore exploits the doubleness of the archival film fragment once it is detached from the phantasmagoria. It becomes allegorical in Benjamin's sense of the term, but it is far from dead. Each fragment retains some of the sensory aesthetics, formal properties, and dynamic movement of Hollywood cinema, while situating these forms at the cusp of a lost city, a city that has always been disappearing behind its own preoccupation with representation.

In his 1939 exposé for *The Arcades Project*, Benjamin quotes the dissident Louis-Auguste Blanqui as saying, "Humanity will be prey to a mythic anguish so long as phantasmagoria occupies a place in it,"[77] and yet he also finds that a practice of appropriation is already part of the same social formation that produces the modern phantasmagoria. The collector is nominated as one of the unique figures in urban modernity who can divest things of their commodity character, by creating his own "phantasmagoria of the interior."[78] In his conception of the collector, Benjamin struggles to recognize and reconfigure the utopian impulse within the modern phantasmagoria, and to rescue it from its deadening service to commodity capitalism.

Thom Andersen is not only a Benjaminian collector; the vocabulary of his narration frequently echoes that of Benjamin. His analysis of Los Angeles and its cinema might be considered as a version of *The Arcades Project* for the early twenty-first century, especially since he situates himself within the urban landscape as both inhabitant and critic. He espouses his affection for Los

Los Angeles Plays Itself (Thom Andersen, 2003)

Angeles and even for many of the movies made there. Only a cinephile could have found the clips that Andersen found, such as Gene Kelly roller-skating in *Xanadu* (1980), shot in the abandoned Pan American auditorium, "our Streamline Moderne palace, once the city's most famous landmark," which burned down nine years later. Like Benjamin, he is drawn to the commercial display culture, but he also brings into play the avant-garde and independent cinema. Andersen closes the film with references to a few key titles, including *The Exiles* (Kent MacKenzie, 1961), *Bless Their Little Hearts* (Billy Woodbury, 1984), *Killer of Sheep* (Charles Burnett, 1978), and *Bush Mama* (Haile Gerima, 1979). He also makes note of *Meshes of the Afternoon* (Maya Deren and Alexander Hammid, 1943) and titles by Edward James Olmos and John Cassavetes, but at the same time he confesses his attraction to kitsch, even the "transcendent kitsch" of local architecture in *The Loved One* by Tony Richardson (1965).

Remarks such as "the back lot is an enchanted village of surrealism" underscore Anderson's affinities with Benjamin. In the middle of a lengthy analysis of *Dragnet*'s authoritarian rigor, heavy-handed irony, and depiction of Los Angelinos as chronically weird, Andersen says, "Actually, I love *Dragnet*." He is the postmodern ironist version of the Benjaminian/Baudelairean hero of the city. His love/hate relationship takes the form of a critique that refuses to take refuge in nostalgia but insists on grasping the dialectics of the urban landscape. Benjamin says of Baudelaire, for example: "Shock is a poetic principle

Los Angeles Plays Itself (Thom Andersen, 2003)

in Baudelaire: the urban scene traced out by the *fantasy escrime* [fantastical swordplay] of 'Tableaux parisiens' is no longer a homeland. It is a spectacle, a foreign place. . . . How well can the image of the big city turn out when the inventory of its physical dangers is as incomplete as it is in Baudelaire?"[79]

Andersen is drawn to the spectacle of Los Angeles, including its disaster movies; his essay film also tries to get at the real corruption in the city's history (as compared to the movie versions of that corruption in films such as *Chinatown* and *L.A. Confidential*). And yet he is also able to indulge himself in the glorious destruction of the city. For him, the "best car chase movie" made in Los Angeles, *Gone in 60 Seconds* (1974), is a realization of "Dziga Vertov's dream: an anti-humanist cinema of bodies and machines in motion." Andersen's montage of disaster movies is a wonderful sequence of fiery, explosive images of demolition and destruction; but even here, he points to his own investment in the imagery by saying, "and whenever there's a disaster movie, there's George Kennedy." Clearly this is a collection of images drawn from an infinitely extensive archive. B movies tend to predominate over more well-known titles. His sequence of rogue, dirty, neurotic, and unstable cops ends with a wonderful scene from *Short Cuts* (1993) of Tim Robbins dognapping in a tight-fitting police uniform, and Arnold Schwarzenegger's violent destruction of a police station in *The Terminator* (1984). In all these sequences, Andersen is borrowing the emotional charge of comedy, cinematography, performance, and energy that is constitutive of the movie indus-

try that he supposedly loathes. His inventory is also an exploitation, rendering his essay film a highly enjoyable viewing experience.

Andersen also shares with Benjamin a critique of "history written by the victors," which he intends to challenge by way of his collage-based film. Over a series of images of the Hollywood stars implanted in the sidewalk, Andersen says, "There are stars for the enforcers and the informers, but none for those they informed on," and pauses on the name Edward Dmytryk, one of the Hollywood Ten of the House Un-American Activities Committee (HUAC) years. Andersen's liberal stance is in many ways a familiar left-wing position and could be described as a version of what Benjamin described as "left-wing melancholy," an "attitude to which there is no longer, in general, any corresponding political action." For Benjamin, "the metamorphosis of political struggle from a compulsory decision into an object of pleasure, from a means of production into an article of consumption — that is literature's latest hit."[80] Although Andersen is not immune to this critique, much has changed since 1931 when Benjamin identified this form of political melancholy. The relations between activism, intellectuals, and creative intervention have arguably shifted along with the rise of an image culture that has become a tool of both politics and art.

In contrast to Benjamin's "heavy-hearted" poet Erich Kästner, Andersen has arguably taken up the tools of production in the creation of new knowledge and political critique, along the lines of what Benjamin advocates in "the author as producer," precisely by making a new movie out of the commodity culture he is concerned to critique. The "city of walkers" in *Los Angeles Plays Itself* refers not to flaneurs but to those who cannot afford cars, by which Andersen makes a clear distinction between his project and Benjamin's somewhat romantic notion of the bourgeois flaneur, while maintaining his dialectical engagement with the phantasmagoria. And yet his attempts to access the real history behind the images are inevitably less persuasive than the movies he attempts to debunk.

Andersen's assessment of *Chinatown* and *L.A. Confidential* includes a critique of their ineffectual politics: "*Chinatown* teaches that good intentions are futile." Despite the fact that the film twists the history rather badly, it has become an originary myth of the city. Andersen's "correction" of *Chinatown* is made by the inclusion of documentary footage of Hollis Mulwray in undated newsreel clips, probably from 1928, and pages from the Hearst Press from 1905. But if Noah Cross (John Huston's character in *Chinatown*) is "too powerful," so is the movie version of California's history of corrupt water

projects. Andersen's corrections lack the vitality and evidentiary force of the Hollywood version featuring Jack Nicholson in his finest form. Likewise, *L.A. Confidential* suggests another "secret history of the city," but Andersen argues that the filmmakers got this story wrong as well, missing out on the "real scandal" of the early 1950s over public housing. In fact, he says, "the L.A.P.D. didn't control the rackets in the fifties; it controlled the city." Even so, "cynicism has become the dominant myth of our times, and *L.A. Confidential* proves it."

We need to ask if Andersen's project is any less cynical, and any less futile, than the star-studded histories of the city that he dismantles, given that his dismantling is also a recycling and reprise of key scenes from the films. Like Benjamin, his critique remains couched in the language of the dreamworld, and he is too much of a cinephile to dismiss the movies altogether. Andersen's film ends with a shot from *Bless Their Little Hearts* of an African American man driving past the ruins of the Goodyear Factory on South Central Avenue. The ruins, photographed in black and white, are the only ruins featured in the film, graphically illustrating the failed project of American modernity. Without the cinema, though, would we still be able to see them? Andersen's narration notes that the factory once provided jobs for the black working class; visitors could once take tours "just as today they can take a studio tour and see how movies are made." In fact, *Los Angeles Plays Itself* cannot penetrate the veil of image culture, but Andersen's "dream interpretation" arguably enacts the mode of allegory that Benjamin describes as "a form of expression" and a form of writing.[81] Andersen conforms to the melancholic, for whom the only pleasure is that of allegory.[82] The ruined factory, shot from a moving car, completes the film on a note of movement, pointing to the interminable incompletion of the archival project and the open-ended future of the city.

Andersen's melancholic historiography also evokes Benjamin's claim that allegory is said to reveal a "crossing of the borders of a different mode."[83] He describes his project as a "city symphony in reverse," in order to underline his critical perspective, but in the process of inversion, he has transformed the Hollywood archives into something much more than the leftovers of the entertainment industry. He has in fact used them to document a history of the city. The "other mode" that is produced through his melancholic, allegorical language is not only an essay; it is transformative, creating a kind of memory that is always on the verge of being forgotten as the industry continues to churn out new variations on the dream of a better urban future.

Los Angeles Plays Itself (Thom Andersen, 2003)

Architecture and Urban Space

The car, in *Los Angeles Plays Itself*, is first introduced as the new form of private space in the postmodern city. It is the new space of dwelling, the shell that insulates the individual from the collective. Andersen notes the paucity of public space in Los Angeles and returns to this theme from a number of different angles, many of which echo Benjamin's commentary on architecture in significant ways. For example, in one of the longer video-essay-like passages on *Double Indemnity* (1944), Andersen lingers on the interior of the domestic Spanish-revival architecture of the Dietrichson home. He compares footage from the film with the still-standing house, noting the minor changes that Billy Wilder made to shoot the interiors in the studio: "For Wilder, a consistent modernist, the phony historicism of the architecture and interior reflects the honesty of the lives contained within." The "banal evil" of the petty-bourgeois taste in *Double Indemnity* is reminiscent of Benjamin's damning critique of the nineteenth-century bourgeois interior. This is a theme that runs through his *Berlin Diary*, *One-Way Street*, and *The Arcades Project*. The

domestic interior, with its inward-looking collections of knick-knacks, up-holstery, and drapery, was "an addiction" of the nineteenth century, a kind of shell that protected the individual from any sense of collectivity.[84] The arcades represented an imposition of the space of dwelling onto the street but at the same time offered a potential porosity, a blurring of inside and outside.[85]

Architecture is a key component of Benjamin's theory, and *The Arcades Project* is often said to be more of an "architecture" itself than a book: a fore-shadowing of the interactive, archival structure of web-based media. He was especially attracted to the use of glass in architecture, not only in the arcades but in the modern architecture of his own times. He saw it as an overthrowing of the dwelling and the house: "Dwelling has diminished."[86] But with Benja-min, there is always another side to the equation. He remarked that "streets are the dwelling place of the collective . . . [among which] the arcade was the drawing room. More than anywhere, the street reveals itself in the arcade as the furnished and familiar interior of the masses."[87] As Tyrus Miller has noted, for Benjamin, "architectural modernism is . . . to be celebrated precisely for its negative, nihilistic, aspect. . . . It is a means to abolish the already residual existence of dwelling in the twentieth century."[88]

In *Los Angeles Plays Itself*, Andersen draws particular attention to the way that the movies have tended to demonize modern architecture, frequently as-sociating it with villains and corruption. Scenes from *The Big Lebowski* (1998), *L.A. Confidential*, and *The Limey* (1999) seem to illustrate this point well, and Andersen selects clips in which the characters comment on the architecture, usually in a way that underscores their lack of appreciation of it. Like Benja-min, Andersen recognizes the utopian socialist aspirations of the designers and blames "the movies" for imposing their own ideology of commodification onto the lavish homes, which may be somewhat disingenuous, although the proximity to nature that L.A. designers imagined does tend to be consistently neglected by Hollywood scriptwriters.

Recognizing specific buildings and locations in movies is described by Andersen as a matter of using one's "involuntary attention" rather than one's voluntary attention, because "movies bury their traces." While this conceptual apparatus may not match up exactly with Benjamin's, the vocabulary certainly does. Involuntary memory, for Benjamin, is a technique of recalling experi-ence lost in modernity. It is spontaneous, elusive, and linked to the shock experiences of modernity that can open up surprising access to the past. It is a crucial element of his historiography and the dialectical image: "Is not the involuntary recollection, Proust's *mémoire involontaire*, much closer to

forgetting than what is usually called memory? And is not this work of spontaneous recollection, in which remembrance is the woof and forgetting the warf, a counterpart to Penelope's work, rather than its likeness?"[89] Benjamin describes "Penelope's work" as one of weaving, and its counterpart is work that indulges exclusively in remembering, in the way that Proust sought ways to exclude the stuff of present experience, by shutting himself off from the world.

The *mémoire involuntaire* is also closely linked to the dialectical image and the monodological theory of historical time, in which present and past collide in the flash of a constellation. Here, Gilloch's interpretation of these notoriously vexed concepts is useful: "The dialectical image, as a moment of remembrance, is the redemption of lost time to accompany that of despised things. Benjamin states: 'the dialectical image is to be defined as the *mémoire involontaire* of a redeemed humanity.' . . . Benjamin's archaeological monadology and his attempt to make historical materialism imagistic are fundamentally concerned with the redemption of forgotten past moments, of the utopian impulses and stunted aspirations of dead generations, of the traces of those whom 'historicism' has consigned to silence."[90]

For Benjamin, the mémoire involuntaire is linked to the unconscious and its irruption within the shock-like rhythms of everyday life in the city. Andersen's use of the terms *voluntary/involuntary* is arguably an inversion of Benjamin's insofar as he invites us to use our "voluntary attention" in order to evade the kind of attention that movies demand. Instead of following the stories (involuntarily), he asks us to appreciate the documentary revelations through an exercise of our voluntary attention. However, these revelations are in turn linked to involuntary memory in the sense of a recognition of architectural and geographic locations, especially for those viewers who share Andersen's intimate knowledge of the city of Los Angeles. Moreover, in his analyses of the mythology of water corruption inspired by *Chinatown*, Andersen notes that "although Los Angeles is a city with no history, nostalgia has always been the dominant note in the city's image of itself." In contrast, Andersen's own strategy is more akin to melancholy than to nostalgia. Given the distinction that Celeste Olalquiaga makes between Benjamin's theory of memory, split between conscious "reminiscence" that leads to nostalgia and unconscious "remembrance" that leads to melancholy, the kind of "attention" that Andersen demands is closer to Benjamin's understanding of remembrance.[91] His melancholia is a dense weave of forgetting and remembering, given that his inventory of Hollywood films is interminably incomplete. By mourning a lost city, by way of a forgotten cinema, he struggles to redeem them both.

Los Angeles Plays Itself (Thom Andersen, 2003)

Andersen's strategy is, moreover, grounded in the language of representation, appropriating the monadology or dialectical images embedded in the cinema. He transforms this lost cinema into a new language of history for a city that lacks a history. Several sequences in *Los Angeles Plays Itself* show how Los Angeles locations have "played" other cities, and other countries, including Switzerland, China, Chicago, and "anytown USA." The ability to imitate other places through the "magic" of the Hollywood illusion is precisely, and ironically, exemplary of Benjamin's mimetic faculty. This is one of the things that he loved about the movies: their transformative ability to perfectly pretend to be somewhere else. It is "the blue flower" in the land of technology, the aura that is made possible through second technology, that provides access to the experience liquidated in the fall of modernity. Despite Andersen's cynicism and critical demeanor, his "heavy-heartedness," I would argue that he is able to point to the lost potential of this "magic" at several points of *Los Angeles Plays Itself*. This would include the car chases and explosions, star turns by well-known actors speaking well-written lines, and other engaging moments that evoke the "innervation" made possible by the movies.

In addition, certain images inscribe a mortification into this magic. During a sequence of clips of *Union Station* (1950) shot in the eponymous train station in Los Angeles, the action shifts inexplicably to Westchester, New York, and Chicago as a man flees his killer. Finally, he is stampeded by cattle in the

stockyards, and the camera lingers on the flattened corpse before the compilation moves on and the narrator wonders why there are palm trees in the background of the Chicago stockyards. "Silly geography makes silly movies," says Andersen's narration, but there is nevertheless something not so silly about the scene of brutal violence. At another point, after a couple of clips from Cassavetes films that Andersen endorses for the director's "eye and ear for ordinary madness," we see a blurry shot of Cassavetes behind glass. Andersen says, "For Cassavetes, happiness is the only truth. So he drank himself to death." These moments of stillness are brief interruptions in the flow of the film, pointing obliquely to the flaws in the surface, moving past the "on-going catastrophe" of violence, explosions, and car chases by which everyone else dies in the movie.

The Bradbury Building is one of the most versatile and enduring film locations that Andersen illustrates with examples from seven different movies shot there between 1943 and 1995. The building features a glass roof like an arcade, and wrought-iron balustrades. It was built in 1893, making it an important architectural link between Benjamin's project and Andersen's. *Blade Runner* (1982), which was shot in this former "dream house," is described by Andersen as expressing "a nostalgia for a dystopian vision of the future that has become outdated," a lost sense of the future, which is precisely one of the dangers that Benjamin observed in modernity in the repetitions of the ever-new. While the Bradbury Building still stands, many buildings featured in Los Angeles movies no longer exist. The theme of obsolescence is remarked on by Andersen, regarding everyday places like drive-in restaurants and drive-in movies, which are repeatedly torn down and replaced. Only the movies have documented their evolution when they were of no more importance than a movie location.

Andersen quotes extensively in *Los Angeles Plays Itself*, and not only from movies. He cites a slew of writers and historians, including Mike Davis, whose *City of Quartz* was an important inspiration for the project. The title itself is borrowed from a canonical porn movie, which also features in the film among a series of titles that Andersen claims are responsible for shortening the name of the city to the breezy L.A. And yet, despite Andersen's argument that Hollywood has appropriated the city from its inhabitants, he nevertheless indulges in the mythology endemic to Hollywood, in which magic is possible, kitsch can be transcendent, and architecture is porous and transparent. The most multilayered argument about obsolescence in the film is made concerning Bunker Hill, a neighborhood in the heart of the city. Andersen "rediscovered"

The Exiles, a "lost film" shot in Bunker Hill, while making his compilation, leading to its restoration by the UCLA Film Archive and rerelease on DVD by Milestone. It is a rare but telling example of how an archival film can have a real effect on the archive itself.

Andersen and Benjamin clearly share a view of the city that is deeply contradictory. They each in their own way seek the mythic strata of lost possibility that can still be gleaned from the commodification of space, in cities that have given themselves over to the rule of the image. For both, it is from within image culture, or the phantasmagoria, that dialectical inversions may become visible. For Benjamin, that visibility may be merely a glance or a flash of recognition. Andersen is able to linger and to excavate the hidden layers of image culture that have accrued over the last century. And yet he, too, approaches the problem of mythology and utopian aspiration through an analysis of the image. Despite his claim that *The Exiles* "proves that there once was a city here, before they tore it down and built a simulacrum," the beauty of *The Exiles* is precisely the phantasmagoria of the night-time urban spectacle associated with film noir.

The Exiles: *Untimely Cinema*

One of the key concepts of *The Arcades Project* is that the "afterlife" of cultural phenomena can be understood by challenging conventions of historical progress and decline, or the grand narratives of history.[92] Benjamin's historiography can thus be considered as a theory of untimeliness, and the exemplary archival phantasmagoria of *The Exiles* demonstrates how archiveology can be a constructive method of film historiography. From its curious history of apparent failure, followed by a virtual disappearance and subsequent rediscovery, it would seem that it is only as an archival film that *The Exiles* becomes legible.

The accomplishment of *The Exiles*, a film about American Indians living in the Bunker Hill neighborhood of Los Angeles in the late 1950s, is precisely its depiction of the expressive phantasmagoria of "everyday" in the city at night. Director Kent MacKenzie and his cinematographers, Erik Daarstad, Robert Kaufman, and John Morrill, were all trained at USC to shoot and edit according to the Hollywood model. Against all odds, they managed to light the scenes and shoot them with truckloads of equipment and elaborate set-ups. Even if they were aiming to re-create a "natural" feel, the result is extremely underlit, and because it was mainly shot at night, the source lights of neon signs, shop win-

dows, and car lights give the film its distinctive noir feel. Many of the daylight shots have a softness to them, perhaps because they were shot in the early morning hours. The whole film is bathed in a kind of glow of the city, which gives the film its transcendent quality.

The "revolutionary" character of *The Exiles* is not due to its originary status, because it did not start a movement or even belong to one. Its revolutionary character is due to its status as a historical marker of unrealized possibility, the way that it records the untimely dynamism of the might-have-been. It is not only a portrait of a particular group of people at a particular moment in time; its sheer novelty as a "document" made it virtually invisible and yet also potentially explosive. The film is exemplary of Benjamin's dictum that "historical 'understanding' is to be grasped, in principle, as the afterlife of that which is understood."[93]

When Andersen includes an excerpt of the gas station scene of *The Exiles* in *Los Angeles Plays Itself*, alongside gas stations in *Kiss Me Deadly* (1955) and *Messiah of Evil* (1973), he says in his voice-over narration: "Of course, there are certain types of buildings that aren't designed to last. They must be rebuilt every five or ten years so they can adapt to changing patterns of consumption. So the image of an obsolete gas station or grocery store can evoke the same kind of nostalgia we feel for any commodity whose day has passed. Old movies allow us to rediscover these icons, even to construct a documentary history of their evolution."

Concerning Mike Hammer's reel-to-reel answering machine in *Kiss Me Deadly*, Andersen notes, "What was new then is still with us." This sequence of *Los Angeles Plays Itself* culminates in a scene from *The Disorderly Orderly* (1964) featuring the spectacular implosion of stacks of cans in a supermarket. In other words, the "antiquity" of the 1950s is an antiquity of novelty. Commodity capitalism has to continually reinvent itself, a process that, in retrospect, can constitute a kind of awakening or demystification of "progress."

The Exiles incorporates Indians into the language of modernity, into the glow of the city and the energy of its novelties, challenging the conventions of both narrative and documentary cinema, as well as the not-yet-constituted principles of observational cinema. Despite Andersen's attempt to frame it as neorealist, the film radically eschews any kind of Bazinian aesthetics of long-take, deep-focus realism, indulging instead in dramatic editing and pacing, with close-ups of the principle actors guiding the narrative. While her husband parties all night, Yvonne goes to the movies and wanders home past well-lit stores. Fast cars and lonely nights, memories and desires, as well as a

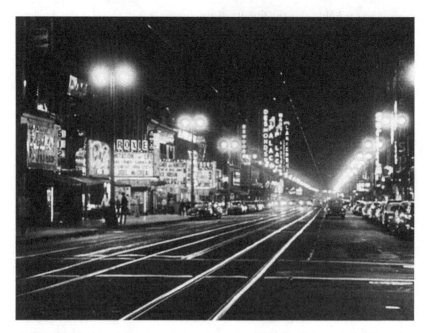

The Exiles (Kent MacKenzie, 1961)

desperate embrace of the moment charged with the "now-time" of the present: these coextensive experiences of time are also evidence of the failures of modernity to accommodate the Indians and their aspirations.

Critics of the time did not take kindly to the depiction of Indians drinking and misbehaving, and the film was deemed "too negative" at the prestigious Flaherty Seminar in Puerto Rico in 1961.[94] MacKenzie's elaborate attempt to portray Indians as urban citizens with urban experiences and challenges was appreciated only at European film festivals — Venice and Mannheim — where the film was very well received. The rereleased version, which is "presented" by Sherman Alexie and Charles Burnett, has been endorsed by contemporary critics of independent, alternative cinema. It was included in lists of the best films of the year in both *Film Quarterly* and *Film Comment* in 2008 when it was theatrically released.[95] The restoration itself accounts for some of the praise, as the new print has the rare glitter and glow of a freshly minted black-and-white gem from the period.

Once we consider *Los Angeles Plays Itself* as an archival film, it is apparent that it creates the conditions for understanding *The Exiles*, precisely by creating the categories and classifications necessary for knowledge. For Fou-

cault, the archive "is that which, at the very root of the statement-event, and in that which embodies it, defines at the very outset the system of its enunciability." The archive does not collect "the dust of statements that have become inert once more. . . . It is that which defines the mode of occurrence of the statement-thing: it is *the system of its functioning*."[96] Andersen effectively places MacKenzie's film within a language of the city, architecture, film history, and cultural history; by placing it side-by-side with *Kiss Me Deadly*, he is grasping the image from within, from its discursive formation and not from its humanitarian objectives or anthropological fumblings. In keeping with Foucault's notion of the archive, *Los Angeles Plays Itself* "deprives us of our continuities" and "breaks the thread of transcendental teleologies."[97] And it does so precisely by grasping the image from a movement in its interior, which is how Benjamin describes the "historical index" of the image — what distinguishes it from the essences of phenomenology.[98]

Although Andersen also links *The Exiles* to *Killer of Sheep* (1978) by Charles Burnett, Burnett did not know about *The Exiles* when he made his film about an African American working-class neighborhood in Los Angeles.[99] The "problem" of *The Exiles* is that it exists outside any spheres of influence. MacKenzie was not aware of Lionel Rogosin or Jean Rouch; likewise, neither John Cassavetes nor Burnett, not to mention David and Albert Maysles or Fredrick Wiseman, knew about him. Cinema was being "reinvented" all over the world during the 1950s in disparate ways, and *The Exiles* is anomalous in its glamorous reenactment of classical film techniques in the service of ethnography; its "dirty realism," as Sherman Alexie calls it,[100] is not really as dirty as *On the Bowery* (Lionel Rogosin, 1956) or *Moi, un noir* (Jean Rouch, 1959), or even *Salesman* (Albert and David Maysles, 1968), for that matter. It therefore arguably remained invisible until it was placed side-by-side with *Kiss Me Deadly* as a film about a city.

The emergence of the new generation of Indians, challenging the norms and protocols of their parents' generation, is set against the radical transformation of urban renewal in *The Exiles*. The redevelopment of Bunker Hill in the 1960s is described by Greg Kimball as "the largest urban renewal project in history,"[101] and indeed the political background to the project is an ugly story of capital investment displacing public housing on an exaggerated scale. Residents were relocated with a pittance of support, and the century-old homes were razed to a naked hump of a hill. The reconstructed Bunker Hill now hosts such cultural monuments as the Museum of Contemporary Art, Frank Gehry's Walt Disney Concert Hall, and the Bonaventure Hotel, and

Anderson cites it as the location of a series of postapocalyptic fantasy movies such as *Omega Man* (1971), *Night of the Comet* (1984), and *Virtuosity* (1995). Other nearby neighborhoods and landscapes, including Hill X, were similarly razed during the 1960s and '70s as Los Angeles sold itself to international capital to claim a place in the global marketplace. Most of the displaced people were Mexican and Asian immigrants, seniors, and Indians — people already displaced from their original homelands.[102]

John C. Portman's Bonaventure Hotel, constructed in 1975, was famously described by Fredric Jameson as the emblematic "postmodern hyperspace,"[103] and the Bunker Hill redevelopment can be compared on some levels with Baron Haussmann's reconfiguration of Paris in the nineteenth century. For Walter Benjamin, Haussmann's urban renewal project created the conditions for flânerie and the display culture of the arcades. But the Bonaventure Hotel clearly shuts down these possibilities, radically cutting off the "private space" of the hotel from the public space of the now-deserted streets. The faux-public spaces of the hotel's interiors, including a nostalgic re-creation of Los Angeles as a garden, is radically separated from the city, as Mike Davis has pointed out.[104]

Davis has challenged Jameson's embrace of the Bonaventure Hotel as a postmodern utopia. The parallels between the Bunker Hill gentrification project and Benjamin's analysis of the Paris arcades have to include the displacement of urban populations that made way for two different kinds of display cultures. For Davis, the Bonaventure Hotel symbolizes a profoundly anti-urban impulse, "hardly a possible entryway to the new forms of collective social practice towards which Jameson's essay ultimately beckons us."[105] Jameson concludes his essay with a question about "whether postmodernism can resist the logic of consumer capitalism." A film like *The Exiles* points in this direction, and perhaps it is best read as an untimely postmodern film (*avant la lettre*). The "truth" of the Indian experience is apprehended through the transformation of their everyday life into the phantasmagoria of image culture; but this is the truth of their hopes and dreams, their sorrows and their disappointments. It is a language of affect and melodrama, even if the drama is downplayed and distended. Thom Andersen may position the film as an antidote to the simulacrum of the city; and yet the techniques of reenactment in which every shot is staged are precisely those of the postmodern simulacra. In their profound inauthenticity, the "exiled" Indians perform their own impending displacement by corporate capitalism.

And yet there is a larger drama being played out in the untimeliness of this idiosyncratic film. The obliteration of the Bunker Hill neighborhood, like the

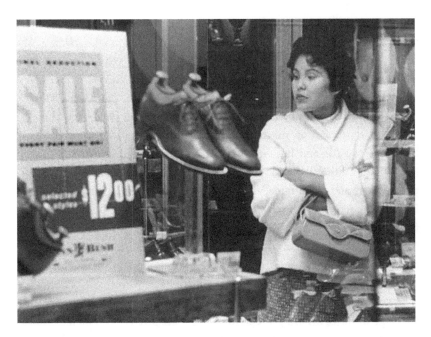

The Exiles (Kent MacKenzie, 1961)

obliteration of the Indians' ancestral cultural practices, finds archival form in the early twenty-first century in a new form of memory. Films such as *Los Angeles Plays Itself* point to the ways that the cinema has spawned a new medium of archival cinema. Traces of the past, culled from the vast repertoire of twentieth-century culture, can be recombined to write a new history of the twentieth century. *The Exiles* in this sense depicts a culture of alcoholism, poverty, and sexual politics; but it also inscribes its characters into a larger firmament of popular culture. They are no longer outside looking in but comprise a full part of the generational energy that surged through American culture in the 1950s.

The archive in the early twenty-first century has become a dynamic site of reconstruction, reordering, and reanimation of the past. The walls are crumbling and the memories of unheard voices are rushing in. When Benjamin says that "the concept of progress must be grounded in the idea of catastrophe," he points to the radical potential of a film such as *The Exiles* to interrupt the story of cinema, Bunker Hill, ethnographic film, and the noir mystique. "Phenomena," he says, are rescued from "their 'enshrinement

as heritage.'—They are saved through the exhibition of the fissure within them.—There is a tradition that is catastrophe."[106]

The archive is always predicated on loss and on the division between that which is inside and that which is outside. If there is an archival drive, as Derrida describes it, in the archival cinema discussed here, that drive is clearly linked to the desires embedded in narrative cinema. Both *Paris 1900* and *Los Angeles Plays Itself* draw on the rich resources of films shot in their respective cities of Paris and Los Angeles to construct their essay films. Védrès's use of fiction films alongside newsreels gives her compilation the sensuous feel of magic and melodrama, and all the sensation of the cinema of the Belle Epoque. Andersen's use of fiction gives his film the dynamic vocabulary of Hollywood spectacle, including some of its secrets alongside its comedy and its celebrities. These archival city films take us deep inside the dramas and desires that fuel their respective cities, even while launching a critique of the urban inequities and mythologies upon which the cities are built.

In archiveology, the fashions and styles of the city are transformed into a language of history. Past, present, and future are layered in a palimpsest of glimpses and images that are at once photographic documents and playful dream images. They are collective memories belonging to a collective imagination. Once the urban scene is broken down into the ruins of the collective dream, the archival city film reassembles those ruins into the "second nature" of a built environment that is indeed an image sphere inhabited by experience, memory, and desires. If the original city was the construction of commodity capitalism, in its ruined state, the traces of the built environment caught on film are fully loaded with the potential of exploding into the future.

In the twenty-first century, the city has become the site of explosive catastrophe for all the wrong reasons. City after city has become the scene of violent chaos and destruction in an era of terrorism and unrestrained anger. Cities everywhere are in ruins due to economic disaster (Detroit) or interminable civil war (Baghdad). The image archive may become in turn increasingly valuable as a means of remembering the promise that infused each city with its own heterotopian promise. As Rick Prelinger has shown with his *Landscapes* series, in which he has compiled home movies into interactive screenings for Detroit, San Francisco, Oakland, and Los Angeles, archiveology may provide the tools for engaging the collective imagination with urban history as a key to future public spaces.

4

COLLECTING IMAGES

> One may start from the fact that the true collector
> detaches the object from its functional relations. But that
> is hardly an exhaustive description of this remarkable
> mode of behavior.
>
> Walter Benjamin, *The Arcades Project*

Benjamin's remarks on collecting in *The Arcades Project* and in his essay on Eduard Fuchs are notably inconclusive. He champions Fuchs as a collector of mass arts and of images but also decries his failure to appreciate the Baroque, or to completely shed the cloak of the bourgeois antiquarian.[1] Fuchs's principle accomplishment may have been to foreshadow Benjamin's own practical solution to the aporias of theory: collecting is a practice that has the potential to challenge the "history of culture" and its attachment to causality, masterworks, and genius. A nonlinear historical materialism is constructed in the collection as a "new and critical" mode of historical understanding. For Benjamin, the method of montage in *The Arcades Project* is a means of showing, or "actualizing" images and documents, and thus a solution to the challenge of reconciling contradictory discursive formations.

The collector is one of the key figures or avatars in *The Arcades Project* who exemplifies this method insofar as his rags and refuse are not inventoried but are "allowed to come into their own."[2] As discussed in chapter 2, Benjamin's endorsement of Eduard Fuchs is grounded in a critique of the disciplinarity of the humanities, and a recognition of the social setting and anonymous labor that accompanies and offsets the masterpieces of a "history of culture." Benjamin's image of the collector is inspired by surrealism and embraces the principle of chance that can inhabit a group of objects brought together by a spirit of innovation and even subjectivity, which is why the collector remains, even for Fuchs, a slightly romantic figure on the verge of modernity. The collected fragments of material history are, for Benjamin, passages to the past that can be experienced in the present. Their cultural value is predicated on their role

in a collection, while their exchange and use values are undercut in favor of new "functions" that are practical, constructive, and historical.

This chapter is about the filmmaker as archiveologist, who is in turn an example of the collector, putting together diverse fragments of past experience that bear with them the traces of their original conditions of production. Benjamin's collector cuts through the auratic qualities of images and safeguards them as souvenirs not only of their referents but of the constellations of social relations from which they were produced. As "documents," the images collected in archiveological films acquire meaning through their usefulness and their ability to awaken, stimulate, or attune the viewer's belief in their indexicality. They are not to be taken for granted but to be recognized as passages into the past.

The three films discussed in this chapter present extremely different views of cultural history and radically different modes of presenting and exhibiting that history. As instances of archiveology, they each test the limits of the image as something that is collectible. The "archive" that Morgan Fisher works with in () a.k.a. *Parentheses* (2003) consists of 16mm versions of unknown 35mm fiction movies that he bought on eBay. The "archive" that Dominic Gagnon works with in *Hoax Canular* (2013) is YouTube — although many of the videos he sampled are no longer available on that platform. The archives that Gustav Deutsch uses in *World Mirror Cinema* (2005) are actual institutions: European film archives that are named and credited at the end of the film. All three filmmakers have collected images that might otherwise have disappeared and remained unknown. Their different techniques of collage are strategies of transformation, rendering the various historical documents "legible" and not simply salvaged. The moving image extracts take on an ethnographic character and supply clues to the future anterior, which is to say, the imaginary futures of the past.

This chapter includes a discussion of media archaeology and develops further Benjamin's contribution to this dimension of media studies. Archiveology could in itself be considered a practice of media archaeology, in its curatorial exhibitionist mode. When the collection of images consists of images of people, in the mode of talking heads, for example, archiveology also impinges on physiognomy, a somewhat outdated but nevertheless constitutive element of Benjamin's phenomenological method, in which people consist principally of their appearances. Moreover, the display of the collection, which aligns archiveology with the museum, also opens a passage into the mysterious confluence between Benjamin and Aby Warburg, who

were most definitely familiar with each other's work on collecting and the production of cultural knowledge.

The practice of collecting is a cornerstone of both archaeology and anthropology. Thus the recognition of collecting as central to archival film practices is a means of articulating the relationship of media to human sciences premised on the collection of things. Hans Belting has argued that an anthropological perspective is necessary if images are not reduced to "artifacts of technology." Belting insists that images are mediated by bodies as well as their representational supports, so while images are "nomadic," moving between different media, they are always dependent on a viewer. He says that "images behave according to the rule of appearances, but inasmuch as they are embodied in media they exist also in the world of being, of bodies, and therefore occupy a place in social space."[3] The intersections between anthropology, media archaeology, and archiveology are further complicated by the role of the avant-garde, critical practice, and aesthetics. Benjamin's understanding of collecting as a potentially redemptive force is intimately tied to the play with images that is the regime of the avant-garde. Benjamin recognized that collecting and looking were deeply conjoined in modern technologies of reproduction and that collecting was becoming part of everyday life. Once the image is accessible and collectible, it is a thing in the world and something to be experienced.

Stanley Cavell notes that Benjamin harbors "a fantasy of a future which promises a path — through collecting — to new life, a new practicality with, or use for, objects."[4] Archiveology, the ability to collect images and reassemble them in essayistic form, is Benjamin's future world. In Cavell's reading of Benjamin, collecting is a means of closing the distance between people and objects within the impoverishment of experience that characterizes modernity. The "nearness" to objects that the collector displays is, however, a somewhat impersonal form of experience. For Cavell, collecting is an important mode of thinking in which juxtapositions, gaps, and correspondences are produced in order to be filled by thought.

For Benjamin, the collector is closely related to the allegorist, although while the collector "takes up the struggle against dispersion," the allegorist is resigned to it. For him, "objects represent only keywords in a secret dictionary," and may accumulate without cease, in a "patchwork" of productive disorder. At the end of his convolute on the collector, Benjamin invokes a principle of archival classification, the "registry," to account for the disappearance of experience behind the "classificatory" system of mémoire volontaire.

This is opposed to the canon of the collector—aligned with the mémoire involontaire—which resists such archival systematization. In fact, an allegorist resides within every collector and vice versa, and Benjamin ultimately leaves the section resolutely unfinished, acknowledging that it needs "further study."[5]

In the context of archiveology, this imbrication of allegory and collecting can take several forms. On one level, recycled images are allegories of their original media and often bear traces of pixilation, celluloid damage, or other traces of their "ruined" materials. Insofar as these inscriptions are a function of representation and can be easily faked using digital technologies, they are not reliable signifiers. In the context of a collection, however, they may be restored to their allegorical status and retain a historical index, in Benjamin's words "at their interior." Second, Michael Steinberg has described Benjamin's collector as a "cipher of an economy of memory."[6] Images find new uses in a collection, precisely because they inscribe a discontinuous break with the past and are thus open to new readings in the present. Finally, collected images are also allegories of their human sources, including camera-people and other means of production.

The doubleness of Benjamin's notion of memory clearly aligns it with modernism and with psychoanalysis. Benjamin's approach is echoed elsewhere, most notably by Derrida and Sven Spieker, who both argue, in somewhat different terms, that Sigmund Freud at once undermined the archival principle and transformed it into a modernist medium. Benjamin's larger body of work on the topic helps to further underscore how it was the cultural diffusion of film and photography, in conjunction with psychoanalytic discourse, that reformed, revised, and reinvented the archive in the first decades of the twentieth century.

In Derrida's reading of Yosef Hayim Yerushalmi's reading of Freud's reading of the Old Testament, Derrida argues that the archive after Freud is located at the breakdown of memory. As the threshold between inside and outside, the private and the public, the archival economy is predicated on a principle of loss. *Archive fever* is Derrida's term for an archival desire that is closely bound to the infinite possibility of forgetting. If the archaic definition of the archival is one of consignation, of entrusting to a kind of house arrest, in its modern form, the practice of archiving has become unhoused and destabilized, precisely because memory, recollection, and recall have themselves become challenges to the law of the institution. Derrida's remarks on Freud's attempt to write history have ramifications for the modern form of the archive more generally. He says, "The limits, the borders, and the distinctions have

been shaken by an earthquake from which no classificational concept and no implementation of the archive can be sheltered. Order is no longer assured."[7]

Spieker has fleshed out some of these theoretical ideas formulated by Benjamin, Derrida, and Freud in terms of the avant-garde's preoccupation with the archive manifest since the 1920s. He points out that the doubleness of the archive invokes a coextensive principle of order and chaos, and that on the other side of the bureaucratic systems of classification that enable the instrumentality of the archive lies a productive disorder.[8] In fact, this is also what makes an archive so useful. Objects and documents are collected under one principle of classification, but they become legible according to other principles once they are removed from their original contexts and displaced into the archival setting.

The surrealist inquiry into the archive, which was also the impetus behind Benjamin's archival method, involved an inversion of this principle. By collecting and inventorying that which was previously unarchiveable — cultural trash aligned with the unconscious and preconscious — the archive becomes a medium of revelation. Spieker's account foregrounds the spatial geography and temporal structure of the archive, noting how "in the modernist archive we encounter things we never expected to find; yet the archive is also the condition under which the unexpected, the sudden, the contingent can be sudden, unexpected and contingent."[9] He also shows how the archival principle became linked to montage. The fragmentary and serial forms that objects and documents tend to take up once collected are coextensive with the decentered gaze of modernist art practices.[10] Although he does not address archival film practices per se, Spieker provides a valuable framework for considering those practices within a larger cultural reconfiguration of the archive that took place over the course of the last century. Spieker underscores the role of chance in the surrealist embrace of the archive, noting that "the artist in Benjamin's account occupies a place simultaneously inside and outside of contingency, finding a rhythm in or through the waywardness of chance."[11]

As a technique of collecting, fragmenting, and reassembling, archiveology involves a recognition of the thingness of images, and for Benjamin this gives them a secret dialectical power of revelation. Jacques Rancière has also pointed to the way that when images take on the autonomy of objects, they achieve a doubleness that reveals the "purity" and "power" inherent in the cinematic image — which is to say, its "connecting and disconnecting" power.[12] Rancière has declared that in the "new aesthetic regime" of fragmented, recycled filmmaking, images are no longer signs but need to be recognized as

"things." Responding to the section of *Histoire(s) du cinéma* dedicated to Alfred Hitchcock's method, Rancière dissects Godard's method and the effects of his extraction of objects from Hitchcock's narratives. Hitchcock's filmmaking certainly lends itself well to such dissection, as proven most exceptionally by Christoph Girardet and Matthias Müller in *Phoenix Tapes* (1999), which I discuss in chapter 5. Regarding Godard's treatment of the objects that litter Hitchcock's films — such as the glass of milk in *Suspicion* (1941) — Rancière claims that the objects already have the status of "pure, autonomous" images before Godard extracts them. Objects in Hitchcock's films tend to move the story along and also to pause it. Rancière is not the first to recognize the way that Hitchcock bridges modern and classical cinemas by hybridizing the representational function of the image in narrative and the aestheticizing function of the image within an "avant-gardist" tradition. However, he notes that this doubleness is especially highlighted in Godard's fragmentation of Hitchcock.

For Rancière, the new relation between images and things entails a whole new role of collage. Echoing Benjamin's remark that "history decays into images, not into stories," Rancière notes that "disconnecting images from stories, Godard assumes, is connecting them so as to make History."[13] Indeed, new forms of connection emerge as associative, and symbolic links take precedence over dialectics because it is not only the "clash" of images but also the overlap and coincidence of images that are produced through collage. According to Rancière, "This means that the practice of collage since the 1960s and 1970s has been thoroughly overturned. Collage is no longer a means of unveiling secrets: it has become a way of establishing a mystery."[14] Although in some ways, Rancière is inverting Benjamin's emphasis on discontinuity and dialectics, he indicates how collage practices have become a kind of language. He stresses "the continuum of co-presence" that is produced in the re-presentation of images from the past, in a magical collapse of the space-time continuum whereby "all experiences are held in store and can function as the metaphor for one another."[15] Like Belting, he includes the presence of a viewer, or a body, in the production of images, radically curtailing the "control of the Universe" that Godard ascribes to Hitchcock's method.[16]

Images in archiveology themselves are processes and practices that are beautiful, shocking, surprising, and affective on multiple levels, evoking a proximity to history on the level of experience. Benjamin's textual quoting in *The Arcades Project* is itself a mode of collecting, and the unfinished state of that project suggests that it was always more of a collection than anything else. He shares his aphoristic method with other philosophers, such as

Ludwig Wittgenstein and Adorno, but Benjamin takes it one step further by integrating his theory of quotation and dialectical imaging into the process of writing. This theory implicitly links the context of his thought — the Paris arcades — and its culture of display with his method. In my view, the dialectical image can be a means of thinking through the documentary status of the film image in its fundamental contingency and commodity status, as an object or a thing in the world and not merely a representation. Digital media has only amplified the nomadic character of images across media and between bodies that has been there since people began collecting images in the nineteenth century.

The transition of digital culture has many implications, one of which is the transformation of the archive into an accessible database, searchable by algorithms, textual tags, and even, to a limited extent, nonlinguistic indexes. As Jussi Parikka points out, "The archive is no longer simply a passive storage space but becomes generative itself in algorithmically ruled processuality."[17] His notion of "archivology" [sic], drawn from Wolfgang Ernst, is less about culture and more about "the technoarchive itself."[18] And yet, if we are concerned about culture and historiography, including the histories and cultures of technologies — such as those of early cinema — Benjamin's method is particularly useful. In fact, the digital archive is in many ways a remediation of the film archive, for which it has provided valuable new platforms for expansion, so that "the cinema" is not only growing more accessible; it is also growing deeper and wider.[19] In digital culture, the compilation model has taken on new dimensions and has increasingly enabled the construction of histories from fragments of other histories. As a form of archiveology, the research function of compilation media is paramount, even if this research is increasingly performed by search tools that find images in the form of data that can be compiled systematically. Images are found and compiled specifically as images, with specific dimensions and "sizes" and not as people or places. The correspondence with the "real world" is to a real world of documents and files from which images are assembled from a limitless image bank. Archiveology names the process by which the image bank in its fundamental contingency and instability becomes a means by which history can speak back to the present. The dialectics of the film image, the optical unconscious, is mobilized for the ongoing rewriting and reconstruction of history as a materialist practice. Once we recognize that images, media, and moving pictures are part of history and the "real world," there can be no discontinuity between images and reality.

> Film: unfolding of all the forms of perception, the tempos
> and rhythms, which lie performed in today's machines,
> such that all problems of contemporary art find their
> definitive formulation only in the context of film.
>
> Development of the "Interior Chapter":
> entry of the prop into film.
>
> Walter Benjamin, *The Arcades Project*

Morgan Fisher is an experimental filmmaker who has been mak-
ing films since the 1970s and is counted among the canonical American
avant-garde filmmakers who were active in the seminal years of the movement.
Many of his early films feature components of film production and exhibition
processes — pieces of the apparatus — including photography, sound record-
ing, cameras, and projectors. Fisher's reflexive method throughout the 1960s
and '70s was turned inward, to the film's own mechanics of construction and
exhibition. In keeping with the minimalist aesthetics of the period, these films
are somewhat austere, although nevertheless witty in their self-conscious
playfulness.[20] Paul Arthur has described Fisher's film *Standard Gauge* (1984)
as an avant-garde essay film. This work is made from archival footage pulled
from the filmmaker's own collection with a voice-over narration in which the
filmmaker talks about his experiences as a marginal worker — editor, extra,
lab technician — in the film industry.[21]

In *Standard Gauge*, Fisher drags the 35mm filmstrips, many of which are
outtakes and reel-ends from the shoots he participated in over the years,
over a lightbox. In one long take, the filmstrips are presented to the 16mm
camera as Fisher narrates. Like his early films, the title refers to the media
technology, although which "gauge" — 16 or 35 — is the "standard" remains
an open question, as in the 1980s, 16mm was still the standard for experi-
mental practitioners (although now it is virtually obsolete). *Standard Gauge*
includes examples of stock footage, as one of Fisher's many jobs was work-
ing for a stock footage company, and he confesses in his commentary to an
obsession with collecting film shards. In comparison with his early films,
the filmic material competes with the apparatuses for attention, staging a
multilayered conversation between images and their means of production
and display.

() a.k.a. *Parentheses* (Morgan Fisher, 2003)

Fisher's next film, *()* a.k.a. *Parentheses* (2003), was made nineteen years later, and for the first time, it is not ostensibly about the technology at all. It is constructed entirely from archival material, and yet it indicates how this material — images from narrative films, none of which are clearly recognizable or familiar — is in fact part of the "machine" of classical cinema. The film is composed entirely of what Fisher calls "inserts": close-ups of things that are typically linked to a character's point of view in narrative film. Each shot is held for one to five seconds before cutting to another object from another film, occasionally returning unpredictably to a similar shot but not always. The images tend to be loaded with drama, insofar as they include guns, clocks, notes and messages, keys, knives, maps, body parts, and a surprising number of machines. Knobs, levers, dials, and switches occur repeatedly in the montage. Fisher also includes many shots of dice and other games, record players, money, animals, cigarettes and food, door knobs, and musical instruments in the mix. These clips constitute a series of objects isolated from their narrative contexts, establishing a consistent relationship between image and "thing." Often a hand is included in the shot, but these hands are never connected to bodies. The omnipresence of hands invokes Robert Bresson and Fritz Lang,

but there is a banality generated by repetition that associates the images more with a kind of "generic" form of classical cinema — unremarkable in itself but familiar in its iconography.

() is a silent film, about twenty minutes long, made up of clips of films that Fisher found on eBay, which might be described as a digital flea market. The films from which the excerpts have been taken are 16mm versions of narrative feature films, mostly in colors that have faded over time. The originals are "reduction prints" of 35mm features that were made to be screened in institutions such as prisons, schools, and film societies.[22] The stock of details derives from a generic mode of filmmaking that belongs to an indeterminate past. Fisher describes these insert shots as "instrumental," as the most lowly in the hierarchy of narrative information because they need only convey information. He describes his project as one of "liberating inserts from their stories [to] raise them from the realm of Necessity to that of Freedom."[23] To do so, he insisted on a refusal to edit according to any kind of compositional principle. Instead, he devised a "rule," which he refuses to divulge, according to which the shots would be cut together. As he puts it, "The rule can be stated, and its being stateable locates the origin of the work outside the artist. The artist didn't make the work, the rule did."[24] Thom Andersen has described the work as revealing the "unexpected beauty of the strictly instrumental." Andersen adds that both *Standard Gauge* and *()* "produce knowledge about cinema," implicitly recognizing their essay-film qualities.[25]

One of the influences on Fisher's rule-based aesthetics is Raymond Roussel, a Paris-based writer in the early twentieth century who was much admired by the surrealists. By establishing formal constraints on the work, the rule enables chance operations to occur. In *()*, one shot follows another, and while the sequence may appear "intentional," the connections between shots are generated only in the viewer's mind.[26] The film thus provides a sophisticated commentary on the language of images that have acquired the status of objects in a collection. In a perceptive analysis of the film, Joana Pimenta says, "The objects found in *()* do not originally have the status of cinematographic memorabilia; they are normally seen in passing, used as information that aides the construction of narrative and then is discarded. Transferred to the space of these brackets they are devoid of their nature as props, and their operation becomes an assertion of their materiality, their activation as things."[27]

Film language in *()* is broken down into archival fragments and then recombined in such a way that the cinematic image attains the status of a collectible artifact, but these are images in motion, and the excerpts often include

small camera movements to reframe the "action" so there is no mistaking this for a photomontage. The rhythm of montage in () is regular enough to mimic the flow of narrative but irregular enough to produce surprising collisions and clashes. Moreover, the presence of hands — grasping weapons, holding photos and notes, pouring poison into a teacup — incorporates a rhythm of gesture and human presence that renders the object images transitive and performative.

Fisher's method is a strategy by which the artist can pose as a machine, designating an algorithmic process by which the film appears to have made itself. And yet this conceit is rather thin, given that Fisher collected the material himself by searching specific archives, looking for specific kinds of images. The proliferation of machines and gambling dice are reflexive signals of the film's own method, and the film makes no pretentions to be an accurate accounting of all kinds of inserts in all narrative films. Nevertheless, the way that the film plays with the mechanics of narrative form provides some unusual and unexpected insights into film history. Moreover, () provides an analysis of the mechanics of classical narrative within the specific vocabulary of the image, and in this sense, it offers a unique access to the optical unconscious of genre cinema.

The *optical unconscious* is a term that Benjamin uses in a variety of ways in different essays. Miriam Hansen describes it as an "experimental metaphor" rather than a concept and points out that, like so many of Benjamin's concepts, it links human activity and the body to the image world: "The optical unconscious refers as much to the psychic projection and involuntary memory triggered in the beholder as it assumes something encrypted in the image that nobody was aware of at the time of exposure."[28] In the artwork essay, it refers to things that appear only to the camera, "another nature,"[29] but the metaphor of the unconscious also allows Benjamin to link the documentary quality of the image to the viewer's memory. In Hansen's reading, the "elusive 'flashing up' of a contingent moment long past" could be read "in terms of photographic indexicality narrowly understood," but she says that Benjamin wanted to understand the photographic image as "bridging the gap between inscription and reception," or between then and now.[30] The optical unconscious is not unlike Barthes's punctum, but it embraces a historical dialectic within its structure of recognition.

The optical unconscious is thus a link between technology and "magic," but it also operates as a function of the collective unconscious, an inverted form of the phantasmagoria insofar as the past that is recalled is not a private past but a collective, archival past. In "Excavation and Memory," Benjamin employs a

Freudian model of the strata that the archaeologist breaks through. Moreover, he advises that the search for a buried past be one of repetition, returning again and again to the "same matter," which eventually will yield "long-lost secrets" to the man digging.[31] Benjamin's models of memory as medium and archaeology as a repository of historical correspondences are paradigms that are roughly based on a Freudian model of repression. Indeed, *The Arcades Project* is explicitly modeled on the method of dream analysis.

If () evokes the optical unconscious of genre cinema, it is because the image things that are activated in it have a kind of fetish quality that is nonetheless undermined by their own performativity. As Thom Andersen has noted about the film, it "fetishizes" its archival material.[32] The fragments of fiction films are dream images that are somehow active and dialectical, anchored in the historicity of the celluloid material and also in the historicity of the obsolete props. Among the images are many notes, cards, signs, and plaques inscribed with provocative messages such as "Women's Prison" and "So long, I couldn't have spoken without playing the crybaby." These shots clearly inscribe a linguistic quality to the images and enhance the sense of storytelling that is otherwise missing, making the film into a "second revision" in Freudian terms, or a "second nature" in Marx's. The film encroaches on a dream logic while foregrounding the artifactual material qualities of the ruined, obsolete celluloid. Benjamin's idiosyncratic blend of Freudian and Marxist concepts, which did not always endear him to his colleagues but which come together in such "experimental metaphors" as the optical unconscious, might be in fact the best conceptual apparatus for the idiosyncrasy of Fisher's surrealism for the twenty-first century.

The fragments are also "dated" by their styles of dress, decor, and media (typewriter, record player, and handwriting). While the classical mode of filmmaking may still be very much with us, the fragments in () nevertheless refer to a style of filmmaking that was associated with prestige directors such as Lang and Hitchcock, in which the insert was indeed instrumental. In other words, the insert shot has not disappeared, and Fisher's "lesson" is still valid, but the dynamic power of this "evidence" is based in its obsolescence. As a key component of classical narrative form, the insert shot is deeply implicated in the gender politics of that modality.

Fisher's selection of inserts includes several shots of car interiors, with hands on the wheel or the stick shift, but in several instances a man places his hand on a woman's knee. The threat of violence that haunts the film is not without its predictable sexual component, as this is indeed part of the engine of dramatic narrative as it was developed in the twentieth century. A photo-

() a.k.a. *Parentheses* (Morgan Fisher, 2003)

() a.k.a. *Parentheses* (Morgan Fisher, 2003)

graph of a woman is the only real facial close-up in the film, presented as if she were an object — a missing person, for example. If the theme of the insert refers, above all, to the objects that are scattered through narrative film, these few signs of gender tend to confirm the conclusions of feminist apparatus theory. Removed from their narrative home, these signs of gender are revealed and recognized as key components of the mechanics of narrative film.

Benjamin's theory of the image is not only based in a Freudian understanding of memory; it is also born of a critique of commodity culture. Here, too, the genre cinema that Fisher has excavated in () may be understood as a version of the phantasmagoria of twentieth-century media culture. By breaking it down into the mechanistic elements of guns and keys, newspaper headlines and explosions, Fisher has assembled a unique collection of image fragments. While Benjamin's theory of the dialectical image is notoriously opaque, Max Pensky has provided a particularly insightful analysis that underlines its emphasis on the image as commodity. He argues that Benjamin's dialectical images "were intended to save the concrete particular historical object from the abstractive tendencies of both idealist and positivist historiography."[33] The dialectical image necessarily entails a "distinctive loss or occlusion of the

commodity itself as fetish," and the materialist critic "masters the temporality of the image-fragment at the expense of the commodity itself, which remains unfathomed and unrepresentable."[34]

The 16mm films that Fisher found his inserts in were already poor imitations of their 35mm originals. Their coloring is a distinctive sepia tone that is a sign of degraded celluloid. In their faded state, they have lost their luster. Provocative as these glimpses are, the fragments fail to entice us to desire the original films. Unlike the film clips that comprise other archival films such as *Kristall* or *The Clock* (both of which I discuss in chapter 5), the clips in *()* are curiously abject, stripped of their commodity appeal — although I would agree with Paul Arthur that "the narrative or genre affect originally pumped into the inserts . . . retains a spectral presence. That is . . . we can sense an immanent anger or elation, heated onslaughts of betrayal, murder, insanity, lurking just outside the frame."[35] The film significantly lacks any discourse of looking, such as we find in both *Kristall* and *The Clock*; with no reverse shots and no master shots, only an arbitrary unknown rule, the insert shots gain the autonomy of the objects they feature, becoming surprisingly close to them as objects in the world.

The machine aesthetic of *()* is certainly not typical of archival film practices, but neither is Fisher's medium-specific choice of images. *()* was very specifically designed as a 16mm film made from 16mm film fragments, and yet Fisher used digital tools to collect his material through the Internet, and I have been able to excerpt it as frame grabs using other digital tools. The 16mm celluloid becomes precisely the ironic museum that Wolfgang Ernst identifies as the "master trope of cultural historiography," corresponding to "an awareness of the medium at work with the message."[36] However, if we consider this medium of obsolete genre cinema in Benjamin's terms rather than Marshall McLuhan's, we can better grasp the human component within it not as voice or vision but as what Benjamin calls "innervation."[37]

As Miriam Hansen has explicated it, "innervation" for Benjamin was a "porous interface between the organism and the world that would allow for a greater mobility and circulation of psychic energies."[38] The sensorial investment that *()* solicits constitutes an experience of media history in which the mechanics of the apparatus are nakedly exposed. As dialectical images, they trigger both the commodity form of genre cinema and the collective, shared experience of that cinema inscribed in the precise form of genre cinema. The film, therefore, functions as a great example of media archaeology, with the emphasis on the inventory of images produced by an obsolete media practice.

Media Archaeology

> The refuse- and decay-phenomena [are] precursors, in
> some degree mirages, of the great syntheses that follow.
> These worlds . . . of static realities are to be looked for
> everywhere. Film, their center. □ Historical Materialism □
>
> Walter Benjamin, *The Arcades Project*

Thomas Elsaesser has proposed that Freudian theory may be a valuable precedent for media archaeology, citing Benjamin's theory of the optical unconscious as a key link between media and the psyche. Freud's contribution, in Elsaesser's view, is to differentiate the transmission function from the storage function of the archival apparatus of cinema. By "transmission," he means the mirror function of classical narrative and its production of subjectivity, while "storage" refers to the memory traces that remain open for "new impressions."[39] The temporal discontinuity between the two functions is precisely the historical break that Benjamin describes as archaeological strata, and that a film such as *()* embraces in the recycling of film fragments from the "classical" era, transmitted without any mirror function. The viewer is put in the role of archaeologist, anthropologist, and materialist historian. The return to the vast paraphernalia of overlooked detail in Fisher's insert shots provokes jolts of recognition and memory that might be said to flash, not as recollections of specific films but of the experience of watching such films.

Walter Benjamin's name is frequently cited by theorists of media archaeology wishing to construct a retroactive lineage for a field that has only recently emerged. Jussi Parikka and Erkki Huhtamo position him as a key forerunner, alongside Foucault, describing *The Arcades Project* as an exemplary form of media archaeology, insofar as it is composed of discursive layers of culture, reconstructing Paris from its traces in a wide variety of media.[40] Benjamin certainly has much to offer this new field, given his recognition of the sensorial effects of new media technologies and the allegorical status of the ruins of material culture.

Although Wolfgang Ernst cites Benjamin in numerous places in his book *Digital Memory and the Archive*, he also curiously cites "Excavation and Memory" in a curt dismissal of him as misunderstanding Foucault's archaeology of knowledge.[41] Benjamin, writing thirty-seven years before Foucault, deployed a model of archaeology to theorize memory as a medium that could reproduce images linking the experience of the past to that of the present.[42] If, for Foucault, the archive is the condition of knowledge, for Benjamin, it functions

as a mode of transmission, activating history in the form of traces that may need to be repeatedly returned to until they "yield their secrets." Benjamin's contribution to media archaeology is precisely in his recognition of the role of images in the layered construction of media history. I would argue that his particular contribution to media archaeology constitutes an incorporation of the image archive into the discussion of media histories.

For Ernst, cultural history and media archaeology run in parallel lines. If Benjamin is to be mobilized for a theory of media archaeology, these lines will necessarily converge and intersect. The question of "the politics" of media archaeology is inseparable in my view from the question of cultural history and the role of the archive as a mode of transmission. In keeping with Benjamin's allegiance with the avant-garde, it is also clear from films such as () that archive-based film and media works can be important forms of media archaeology, insofar as they constitute collections of the traces of media left behind in representation. Ernst claims that media archaeology is a parallel discourse to cultural history because he takes the work of Stephen Bann, a historian committed to great works, great men, and a discursive narrative mode of historiography, as his model of cultural history. According to Ernst, despite Bann's reflexivity and his recognition of the role of media in the archival prerequisite for knowledge, he ultimately asserts the primacy of aesthetics over technological form.[43] For Ernst, the "cold gaze" of media archaeology is, in contrast, "on the side of the indexical and the archival." While Bann's historiography, he says, is symbolic, photography belongs to the (physically) real. Above all, Ernst wants to position media archaeology in opposition to the humanism of a historian like Bann. He says, "Media archaeology concentrates on the nondiscursive elements in dealing with the past: not on speakers but rather on the agency of the machine."[44]

Nevertheless, the dichotomy that Ernst develops betrays a narrow and arguably dated conception of cultural history. If we were to recognize archival art practices such as found-footage filmmaking as exemplary instances of cultural history, then Ernst's parallel lines might be seen to converge. For decades now, filmmakers such as Chris Marker, Jean-Luc Godard, Harun Farocki, Leslie Thornton, Péter Forgács, Gustav Deutsch, and Rania Stephan (to mention only a few names out of hundreds if not thousands) have assembled fragments of film found in various collections, archives, and other sources to rethink and reframe history as cultural construction. In keeping with Ernst's definition of media archaeology as being "on the side of the indexical and the archival,"[45] these filmmakers work with documents that contain traces of what Ernst calls

the (physically) real. They eschew symbolism for the register of the document, and in this sense, while made by artists, this work nevertheless embraces the "agency of the machine" precisely because the image of history is limited to that which was filmed and that which survived, even if that survival is often a matter of remediation.

Archive-based filmmakers extract images from their narrative homes and displace them (or détourne them) to create new meanings. At the same time, the images are also metonymically linked to their origins in other media, and are thus arguably always allegorical — or in Benjamin's terms, ruins of their former media sources. Footage is still "found" but it now speaks back more often to its origins in media history. The 16mm "reduction print" footage that Fisher collected for () includes several "squashed" images made for an anamorphic lens and a wide variety of black-and-white and color tonalities with different degrees of fading and emulsions. The great variety of temporal and material "traces" within the montage, including the predictable scratches and flaws of old celluloid, were important qualities for Fisher, for whom they point to "different places in time."[46]

In archival film practices, images of the past come into legibility, as Benjamin says of the photosensitive plate, which he takes as his model of historiography. The images of props or the collection of "image-things" in () are good examples of images that not only "belong to a particular time," as Benjamin would say, but whose legibility at a later time is intimately connected to a "movement at their interior." Their "historical index" lies precisely in the dialectics of temporal correspondence.[47] Granted, the archive may be mobilized in many ways, but Benjamin's argument insists on montage as a technique that renders the image critical, which is to say, détourned, allegorized, and rendered dialectical. () seems to produce precisely the kind of power that Rancière identifies in *Histoire(s) du cinéma*. The image is an agent of condensation, almost abstract in its formal composition; and at the same time it is an agent of dispersion, able to connect to any other image whatsoever. In this binding/unbinding dual function, the images are able to reveal their "pure sensory power" or "presence" but only in the form of "the testimony of children about their parents,"[48] which in Benjaminian terms might mean images as allegories of their original stories. The difference is that where Rancière has to dismiss Godard's larger critique of Hollywood, no such overwhelming narrative is evident in (). The various props and detritus cast off from narrative films have been carefully

collected and allowed to speak for themselves. Fisher's cinephilia is coy but not denied.

Jussi Parikka notes that "an archivology [sic] of media does not simply analyze the cultural archive but actively opens new kinds of archival action."[49] For Parikka, following Ernst, this action seems to be specifically tied to data banks, algorithms, and other technical processes. The archive is no longer passive but is made to generate "new insights" and "unexpected statements and perspectives."[50] Benjamin's conception of the image, in conjunction with his insights into media, historiography, and the avant-garde, provides a means of thinking of archiveology as a creative practice produced by humans, not machines. Archiveology, in this sense, involves the interface of human and machine, or as Hansen has argued in her parsing of Benjamin, a gamble with technology. The stakes of such a gamble are precisely that of the survival of the human senses within the domain of technology.[51]

The images of women, guns, cars, and keys are among many of the most predictable things one might expect to find in an inventory of "inserts" extracted from narrative film. Not so predictable are the images of dice, cards, and roulette wheels, most of which appear to have come from one or more Western movies. The theme of gambling is important to Benjamin, as the gambler is another one of his own avatars in modernity. The gambler embodies the "shock" of modernity in his experience of time, which is at once lost and continuously disrupted as each game begins anew. The gambler's waiting game is "outside of time" and is frequently enhanced by intoxication (another theme in Benjamin's repertoire of themes), but he is also always alert to that "flash" of contingent awakening by which his fate will suddenly be changed.

For Benjamin, the gambler preserves some kind of residue of fate and obsolete belief systems within the experience of modernity. The equations of money with time and time with work are momentarily denied by the gambler, who casually evades the capitalist regulation of time, as does the flaneur, the collector, and the ragpicker. The gambler is engaged with technology but makes it work for him, in tandem with the rules of chance. For Benjamin, the gambler is a kind of hero of modernity, as is the poet Baudelaire. However, the poet "does not participate in the game. . . . He rejects the narcotics with which the gamblers seek to submerge consciousness."[52] With this commentary on gambling, it may be evident how a filmmaker like Fisher can engage with the phantasmagoria on such an intimate level. The reflexive trope of gambling in () underlines his own gamble with the archive and with the instrumentality of the apparatus.

As media archaeology, *()* is perhaps more playful than some texts, but it is also more stimulating, alerting the viewer to the power inherent in cinematic images. In Fisher's extracts, the cinematic image is synonymous with things — things that appear more often in movies than in everyday life. The film underscores the reason why archival film practices should not be excluded from the study of media archaeology. The forms of knowledge that emerge from experiments such as Fisher's and those of many other filmmakers incorporate a discourse of the image into obsolete media practice. As Benjamin has claimed and proven in his own extensive work on media histories, "To write history means to *cite* history. It belongs to the concept of citation, however, that the historical object in each case is torn from its context."[53] If we are going to take Benjamin seriously as a founder of media archaeology, the dynamics of Marxian and Freudian theory in his work remain valuable methods for analysis of the role of the image in the archaeology of twentieth-century media. The imagistic "matter" that is excavated by Benjamin's archaeologist, under scrutiny, may yield "those images that, severed from all earlier associations, reside as treasures in the sober rooms of our later insights — like torsos in a collector's gallery."[54] Archiveology is a practice that embraces the ruins of images to produce allegories of former, collective experiences of media.

HOAX CANULAR: INTERNET 2.0 AS ETHNOGRAPHIC CHRONOTOPE

> What are phenomena rescued from? Not only, and not
> in the main, from the discredit and neglect into which
> they have fallen, but from the catastrophe represented
> very often by a certain strain in their dissemination, their
> "enshrinement as heritage." — They are saved through the
> exhibition of a fissure within them. — There is a tradition
> that is catastrophe.
>
> Walter Benjamin, *The Arcades Project*

A boy wearing aviator shades leans into his webcam with a Confederate flag pinned to the wall behind him. "This is Jeff the Confederate, up here on the Internet, perhaps for the very last time." His profanity-laden rant continues for about sixty seconds as he describes his preparedness for the end

Hoax Canular (Dominic Gagnon, 2013)

of the world with "so many guns I sometimes scare myself," concluding that he will "emerge into the new world and unite the righteous survivors in the new utopia. Fuck the apocalypse and God bless America." Cut to a missile firing into a city street, probably lifted from a video game. Cut to a girl in a headscarf tightly framed with abstract wallpaper behind her. She offers a two-minute commentary on the rumors circulating about the end of the world. The misconception, she believes, is due to the seduction of images in movies and TV shows. According to the Koran, she says, when the world ends there will be nowhere to hide. "There's a reason it's called the end of the world," she continues, and we should prepare by doing the things that need to be done now, and live like we're dying tomorrow. The girl's testimony is interrupted twice by apocalyptic imagery of cities being destroyed and followed by American TV weather reports of impending hurricanes.

These are two of the monologues collected by Dominic Gagnon in *Hoax Canular* (2013). Borrowing imagery from social media and weaving in bits and pieces of music, TV footage, film clips, and video game extracts, Gagnon has compiled a fascinating documentary of teenagers' angst as framed by their own media production. Not all speakers are as articulate as the Confederate and the Muslim. Some prepare for the zombie attack; others enact the apocalypse in their school; others cry and make playlists. The film is a great example of the performative capacity of archiveology, especially in its use of the digital archive as a new mode of what Benjamin called "physiognomy." The theme of

apocalypse is a long-standing trope of found-footage filmmaking, and here it is treated as a media event that actually enables new networked modes of communication. Beyond the ironies of impending doom, Gagnon has created a unique portraiture montage that arguably has ethnographic significance.

The digital archive has been hailed as a democratization of so-called heritage; freed from institutional regimes, interactive platforms have opened up the accessibility of archived materials. Moreover, given that millions of videos are uploaded every day, and billions are in turn streamed, as Rick Prelinger points out, "much of what we might construe as archival access occurs completely outside the realm of 'established' physical archives and their embryonic online projects."[55] Digital media and the interactivity of Internet 2.0 have not only altered the accessibility and selection of archived materials; they have altered the very conception of the archive. As Trond Lundemo has argued, "Digital technologies shift the emphasis from storage to transmission, which in turn sets the entire concept of the archive in motion."[56]

Lundemo also notes that the distinction between archive and collection "has only become more problematic in the digital age," because so many platforms, such as YouTube, are based on somewhat random, personalized features of inclusion and exclusion. And yet it is a mistake to assume a completely egalitarian, free flow of archival materials on the Internet. Against the "democratization" argument, data mining and other techniques associated with corporate-owned platforms compromise privacy and effectively constitute forms of surveillance. Censorship and copyright laws are rigorously at play, even in the so-called free world, compromising the ostensible freedoms of the Internet. Lundemo further points to the proprietary algorithms used by search engines that further confine and regulate the everyday use of the Internet as an archival platform.[57]

Within this vexed terrain of Internet culture, any progressive theorization needs to be balanced by a recognition of the limitations of technologies that are for the most part deeply implicated in commodity capitalism, so Benjamin's dialectical methods may be particularly applicable and useful. For Lundemo, the "paradigm shift" of digital culture is in many ways only a second phase of the shift that took place at the turn of the twentieth century with the "intermedial archive" that began to incorporate photography and film alongside textual documents. Paula Amad has described this shift as the emergence of a counterarchive that introduced gaps and fissures in the production of knowledge due to the failures of photographic media to conform to the nineteenth-century principles of historiographic knowledge.[58] Even now, the

image archive remains searchable mainly by text-based metadata — although facial-recognition software is beginning to be implemented by law enforcement practices. The lack of referential security of the digital image — its susceptibility to fakery — is itself nothing new. Special effects and trickery, including the effects of montage and collage, predate even the cinema.[59] The phantasmagoria, as Benjamin understands it, depends precisely on the illusory capacity of media technologies for mimetic effects that can and should then be inverted into ruins of the utopian imagination, which is always historically circumscribed by its own media. The strategies of awakening from the dream state will in turn change with those technologies.

While the politics of the Internet are debatable, its ethnographic value is indubitable. The acts of "self-fashioning" and auto-ethnography have become part of everyday life for millions of people in possession of cell phones and computers; and the maintenance of public diaries is widely practiced by young people as well as scholars and journalists. The collector of ephemera need only design a search algorithm to make order out of disorder, which is precisely the technique used by Dominic Gagnon to make *Hoax Canular*. The title suggests that it is a hoax of a hoax, and the viewer is thus warned to "believe" very little of what is collected. And yet Gagnon's collection of teens performing for their webcams is terribly believable, not to mention funny, moving, and alarming. The excerpts are documents of teens interacting with digital imaging technologies at the "end of the world." The common denominator in this collection is the impending apocalypse of December 21, 2012, predicted in the Mayan calendar and popularized in the Hollywood film *2012* (Roland Emmerich, 2009), from which Gagnon extracted several clips.

Gagnon describes his process as a combination of capture software and search engines to find material tagged as "apocalypse," "end of times," "doomsday," and "rapture."[60] He then edited two hundred hours down to a ninety-minute montage of material that includes creative animations and collages by the kids themselves, along with a wide range of performative acts and monologues. Many of the young people speak to a coterie of fans and followers, and after pronouncing the end of the world, they remind viewers to "like," "share," and "leave your comments." Gagnon thanks "the project's objective collaborators" at the end of the film but does not name them. Most clips run for under a minute, and the longer ones have been interspersed and overdubbed with other clips. Sound overlays help create a flow between extracts, which are also linked somewhat by thematic continuity or by juxtaposition.

Gagnon has pointed out that, as an archival practice, he has in many cases salvaged material that has subsequently been taken down from YouTube. Two of his earlier films constructed around similar principles featured aggressive rednecks and survivalists, and the original clips were frequently censored for language and violence and removed from the Internet.[61] The compilations were hard to watch because of the unrelenting kookiness, whereas the young people are far more empathetic. Many of the kids' videos were also censored for language and violence but were also removed because "so many videos had the same titles in such a short time that even the video sharing platform had a hard time differentiating them."[62] *Hoax Canular* functions as an archive in itself then, preserving and making available documents of a very specific moment in time, many of which can be found nowhere else. Gagnon himself has made his work widely available for streaming on YouTube and is a firm believer in open access.[63] The film confirms Lundemo's observations concerning the digital archive and also indicates how "the media" can no longer be confused with Debord's "Society of the Spectacle." Gagnon has collected self-portraits of young people who may all have been seduced by the same ideology of apocalypse but are nevertheless able to engage with media and make it their own, even (or especially) in the context of an impending apocalypse. Their seduction by the media takes the form of a game in which they are all players.

Because *Hoax Canular* includes no credits, the "contributors" or "subjects" — or "objective collaborators" — are identified only by signs, such as the Confederate flag and the headscarf. A few speak in different languages, including Japanese and Russian; a few are Asian; one of them is from Canada, where "people are pretty sane . . . nothing terrible is going to happen here"; and some have British, Australian, and New Zealand accents. Gagnon's methodology captured mainly American teens, but even among them, a great variety of faces, attitudes, performance styles, and voices can be found. The Carpenters song "The End of the World" is performed three times, including once by an Asian boy, and Gagnon layers it over other clips, providing the film with a kind of theme song. Against this melancholia are a variety of survivalists, as well as dramatic gunplay punctuated with animated special effects, and a fair amount of clowning around.

The YouTube videos function somewhat like home videos, except that in most of them the camera is fixed on a talking head in a teenager's bedroom, decorated with posters, stuffed animals, and other domestic kitsch. Except when performances with friends are being staged, the speakers are very alone.

Hoax Canular (Dominic Gagnon, 2013)

Hoax Canular (Dominic Gagnon, 2013)

Like the arcades, the Internet turns the inside out, providing a new "transparency" of the interior. Unlike home movies, which traditionally document family life, there are no families here; instead, these video clips document a certain loneliness, an urge to connect, to be part of something larger than the closed space of the teenage bedroom. The fear of apocalypse tends to stand in for the real fear of growing up; thus the desire for a life-changing event seems to have taken the allegorical form of a terrifying prediction of the end of the

world. This is precisely the kind of mythic belief that Benjamin sought in the urban landscape. It is thus not surprising to find it in social media, but it required a collector-ethnographer-filmmaker to render it legible.

In *The Predicament of Culture*, James Clifford described an ethnographic chronotope of Claude Lévi-Strauss in New York in the early 1940s. This is the time that Benjamin should have, would have, been in the city himself, and Lévi-Strauss was equally influenced by surrealist techniques and methods. Clifford describes Lévi-Strauss there as an anthropological flaneur, collecting artifacts and sights of ethnographic diversity, "primitivism," and modernism all bumping up against each other. Clifford notes that in this chronotope, "the world's cultures appear as shreds of humanity, degraded commodities, . . . or vanishing 'loopholes' or 'escapes' from a one-dimensional fate. . . . In New York a jumble of humanity has washed up in one vertiginous place and time, to be grasped simultaneously in all its precious diversity and emerging uniformity."[64]

Could this not serve as a description of social media? Certainly the slice served up by Gagnon functions as a chronotope of a "global allegory of fragmentation and ruin."[65] For Lévi-Strauss, modernity entailed a kind of collision of temporalities and is consistently haunted by the loss of purities within the commodification of archival relics in modern and tourist art, museums, and monuments. Clifford's "art-culture system" is likewise built around criteria of authenticity: a Greimasian square with "masterpiece" and "science" as one axis and "authentic" and "inauthentic" as the crossing axis.[66] He is interested in how objects move through this system when they are collected and displaced. Most artworks would fall in Zone 1 between "masterpiece" and "authenticity," but documentaries might fall into any of the other zones, depending on their "scientific" character. Archiveology would fall into Zone 3, where Clifford places "ready-mades," between inauthenticity and masterpiece.

Clifford notes that his system is by no means fixed, and it will continue to change as collectible artifacts take on new values;[67] clearly the notion of what is in fact collectible also changes in archiveology. If we can consider *Hoax Canular* as experimental ethnography, something clearly has changed in the nature of the collectible artifact and its authenticity. Insofar as Clifford's schema applies to Benjamin's own negotiation of cultural modernism, the auratic cannot be aligned with the authentic, which is the common mistake that was often made in interpreting the artwork essay. Instead, it must be sought out precisely at the apex of the inauthentic, where "not-art" and "not-culture" converge. *Hoax Canular* may be precisely such a chronotope, and it is here where the mythic belief in fate appears to subsist.

The teenagers in Gagnon's excerpts are clearly performing for the camera, but their performances are nevertheless their own. As ethnography, the piece might also be compared to the mondo films of the 1960s, as "collaboration" can also be a twenty-first-century version of exploitation.[68] Gagnon's ethnographic hand is played with an extract of a young man who begins his monologue by asking, "Are you making fun of these subjects, or are you using humor to bring attention to these subjects?" The speaker is "disguised" as a forty-five-year-old man and might be a stand-in for the director, except that after saying yes, he is using comedy to draw attention, he asks viewers to "subscribe to survive," and we never really know what he is talking about. This reflexive ethical gesture is incidentally backed up by Gagnon, who has said that he tried to follow up with his "objective collaborators" for permission to use their material, and while some obliged, many did not respond or had vanished from the Internet by the time Gagnon had edited his film.[69]

Physiognomy and Talking Heads

> The great physiognomists — and collectors are the physiognomists of the world of things — turn into interpreters of fate.
>
> Walter Benjamin, "Unpacking My Library,"
> in *Selected Writings*, vol. 2

Hoax Canular is an example of portraiture in the digital era, and as such, might be compared to the discourse of physiognomy, which was one of Benjamin's preoccupations. The physiognomist is another kind of collector. Physiognomy, or the reading of character in a person's face, is among the more challenging of Benjamin's conceptual methodologies and is especially difficult to follow into the sphere of digital and social media, where the role of sound and voice play such key roles. The notion of a physiognomy of things applies more clearly to a film such as *()* a.k.a. *Parentheses*, where objects reveal themselves directly to the viewer, framed by neither sound nor narrative. Physiognomy was an epistemological method that was popular among many left-leaning intellectuals in Weimar Germany. The idea that you could "read" a person's character from a photograph, and that appearances could be considered testimony of individuality, took hold during a period in which the question of the individual within class society was deeply politicized.

In "Little History of Photography," Benjamin praises the "anonymous physiognomy" of August Sander's portraits, which he compares to the people in Russian films. For "people who had no use for their photographs . . . the human face appeared on film with new and immeasurable significance. But it was no longer a portrait." Of Sander, he says, "Sudden shifts of power such as are now overdue in our society can make the ability to read facial types a matter of vital importance. Whether one is of the Left or the Right, one will have to get used to being looked at in terms of one's provenance. And one will have to look at others the same way. Sander's work is more than a picture book. It is a training manual."[70] Sander himself positioned his work as a progressive attempt to record social and cultural conditions of the time as they are evident in people's faces. Benjamin likewise enthusiastically endorsed the "typage" of Sergei Eisenstein's *Battleship Potemkin* (1925), which he saw as a physiognomic practice. He defended the film against Oscar Schmitz's critique of stereotyping by pointing to the "individualism" of photography that had an evidentiary power equivalent to statistics.[71] The positivist thrust of physiognomy, which tended toward a transparency of the image, also lent itself well, of course, to fascist practices of eugenics and other authoritarian practices of social control and surveillance.

For Sander, photography was a "picture language," but physiognomy went "beyond language" to a modernist epistemology. Alan Sekula notes that despite the "deafening" ring of nineteenth-century scientism, Sander stood to the liberal side of positivism because he organized his pictures according to social rather than racial typologies. For Benjamin, Sander, Alfred Döblin (Döblin wrote the preface to Sander's *Face of Our Time*), and others, photography provided an empirical means of representing the differentiations of individuals within a class, countering the homogenizing effects of mass media and social-democratic political ideologies. As Sekula notes in his article "The Traffic in Photographs," the debate and contradictions surrounding physiognomy in Weimar Germany are inseparable from larger questions concerning the "continuities between fascist liberal capitalist, social democratic and bureaucratic socialist governments as modes of administration that subject social life to the authority of an institutionalized scientific expertise."[72]

For Benjamin, physiognomy functioned as a dynamic strategy of critical reading, a technique of interaction between the critic and the work. If he treads closely to the uglier side of the technique, he does so in order to harness the power of the image. Graeme Gilloch describes Benjamin's physiognomy as "an act of critical unmasking." Applied not only to portraits but to architecture

and cityscapes, the physiognomist can pierce surface appearances to reveal hidden horrors and beauties within: "What is required is not distance but proximity, a closeness to things, and enlargement. . . . The physiognomical gaze is not merely microscopic or micrological, it is also destructive. . . . There must be a stripping away or crumbling of the exterior, an act of demolition. . . . It is a way of seeing which involves the ruination of a thing so as to look deeply within it. The act of reading is possible only at the point of the death of the object. The physiognomist's gaze is a look of 'love at last sight.'"[73]

The faces of young people in *Hoax Canular*, pressed up close to their webcams, can be perceived as physiognomical once they are extracted from their social media context and recombined as archiveology. In that space, they lend themselves to the physiognomical gaze, for which the images are "ruins" of individuals who have now become different people. The video clips are produced as ephemeral, fleeting contributions to a media-induced illusion of the end of the world; they are also cries in the media wilderness. The voices, however scripted and performative, are nevertheless grounded in bodies that are virtually tethered to machines (many wear headphones). These bodies are "vanishing" into adulthood and into a time beyond the apocalypse, which evidently has not happened. For the physiognomist, their various hairstyles, makeup, physique, language, dress, and other markers of difference render them individuals, each with their own idiosyncratic interest, or professed disinterest, in the end of the world. In their attempt to draw attention to themselves, they might attract the data-mining practices of corporate media but also the gaze of the physiognomist.

As archiveology, *Hoax Canular* deals with a very recent past, but even moments after the predicted apocalypse failed to appear, the portraits were already "historical," belonging to a certain moment in time. In this sense, the film confirms another one of Benjamin's cryptic dictums: "That things are status quo is the catastrophe." If "the concept of progress must be grounded in catastrophe," Benjamin insists that we recognize the catastrophe that exists in the everyday: "Hell is not something that awaits us, but this life here and now."[74] For Benjamin, the techniques of modern life, especially film, provide the means of temporal fragmentation necessary to challenge the continuum of a modernity predicated on technological progress. The cutting-up of montage creates "objects of history," transforming images into things in the world to which we can be brought close. These objects are "blasted" out of the continuum of historical succession, because their monodological structure demands it, and "this structure first comes to light in the extracted object itself."[75]

Hoax Canular (Dominic Gagnon, 2013)

The theme of apocalypse tends to recur in archiveology precisely because of the way it marks a definitive moment in time, a moment that defies the durée, the continuum, the repetitions of the status quo. Indeed, several kids in Gagnon's montage comment on their boredom. They count down to the end of the world to cut the tedium. One of the most notorious "fake documentaries" that is also a great example of archiveology is Peter Greenaway's *The Falls* (1980), which at 195 minutes tests the viewer's capacity for repetition. *The Falls* details the various trivial events that follow a VUE (violent unexplained event). Greenaway's parodies of British bureaucracy and administrative structures are deeply enmeshed with his documentary pastiche of precisely the kind of positivist science implied in Weimar-era physiognomy. His postmodernist critique marked the "fall" of documentary authority. A film such as *Hoax Canular* points to a new mode of apocalyptic mythology that actually yields genuine insights into the role of social media. As an archival practice, it is clearly positioned on the cusp of a surveillance culture, while providing valuable passages, networks, and links between individuals within its web.

In *Experimental Ethnography*, I describe the apocalyptic tendency in found footage as an eclipse of history. My analysis of *A Movie* (Bruce Conner, 1958), *Atomic Café* (Jayne Loader, Kevin Rafferty, and Pierce Rafferty, 1982), and *Tribulation 99* (Craig Baldwin, 1992) concludes that although found footage has the potential to break through the myth of the end of history, these films

fail to penetrate the surface of representation. I suggest that *Handsworth Songs* (John Akomfrah, 1986) provides a more radical and progressive use of found footage in its activist use of newsreel imagery, but in 1999 there were few such examples at hand. I wrote at that time that in found-footage filmmaking, "the body of the 'social actor' takes on what Roland Barthes calls an obtuse meaning, a supplementality that exceeds its role in the production of meaning. This is the potential of the form, but it is only realized on the cusp of an eclipse of 'the real' in representation."[76] I think that with *Hoax Canular*, we can understand how the "performativity of cinematic language" can include precisely the contingency of the real that renders physiognomy as a critical practice; the speaking subjects become "collaborators" in the practice of archiveology, and the potential of the form as I described it in 1999 is closer to being realized: "As a form of recovery, found footage does not render culture a lost property, but as an image-sphere in which the real is found in a new form. Once the salvage paradigm is allegorized and rendered uncanny, the Other is relocated in a history that is not vanishing, but exceeds and transcends representation, resisting its processes of reification."[77]

WORLD MIRROR CINEMA AND THE MUSEAL GAZE

> The whispering of gazes fills the arcades. There is no
> thing here that does not, where one least expects it, open
> a fugitive eye, blinking it shut again: but if you look more
> closely, it is gone. To the whispering of these gazes, the
> space lends its echo.
>
> Walter Benjamin, *The Arcades Project*

Gustav Deutsch emerged in the 2010s as one of the most prolific, respected, and established filmmakers working with archival and found footage. Since 1989 he has produced films "without a camera" — and many with a camera as well — and has become the subject of extensive critical attention. His epic compilation *Film Ist* began in 1998 and remains perpetually incomplete, although there have been no new installments since the thirteenth segment, *Film Ist: A Girl and a Gun* (2009). Deutsch's films are generated from pieces of film found in the garbage and other such casual, contingent, and accidental places; they are also frequently based on archival research. *World*

Mirror Cinema (2005) is one film that was developed entirely in collaboration with archives and archivists.

Deutsch says that he cannot rely on conventional search methods in the archive, looking for authors, dates, or titles. Instead, he looks for specific images that have specific movements or compositions: "What I'm looking for is special scenes and particular actions: somebody closing a door, somebody climbing a staircase, somebody reading a letter."[78] For this reason, archivists who are familiar with materials in their collection are more helpful than indices. Together with his research collaborator, Hanna Schimek, Deutsch watches hundreds of hours of footage, much of it "orphaned" without pedigree or provenance, to compile films that very literally "awaken" the archive and its hidden treasures. His editing in *World Mirror Cinema* is accompanied by original soundscapes, including samples of indigenous music and the work of four composers. Deutsch edits sound and music together, using a digital "library" of sounds compiled by his musical associates,[79] so his methodology is a combination of analog and digital techniques.

Tom Gunning uses the term *awakening* in his discussion of Deutsch's editing. For Gunning, the Austrian filmmaker "cares less about simply making new connections than about awakening energies slumbering in old material. This energy comes from a chain reaction."[80] Gunning compares Deutsch to Lev Kuleshov, whose montage experiments of actor's faces juxtaposed with affective images were among the first uses of found footage in film history. For Gunning, "Kuleshov vectorized editing, but Deutsch seems rather to make it twine and untwine in a helix pattern."[81] Discussing *Film Ist*, Gunning also says that Deutsch pushes the dual temporality of film in his montage; the films retain a sense of a historical past alongside "a strong present tense."[82] These themes of awakening, temporal duality, and editing according to an inner movement of the images are repeated by other critics. Nico de Klerk, one of the archivists with whom Deutsch has collaborated, describes his editing as "cognitive," insofar as it privileges neither continuity nor contrast but is "suggestive, tracing thought processes."[83]

World Mirror Cinema foregrounds Deutsch's idiosyncratic editing and enables a close analysis of his technique as approximate to Benjamin's notion of allegorical language and Aby Warburg's art-historical method of assemblage. This film is not only a great example of archiveology as a Benjaminian practice of collecting; it is also a great example of a city film. Deutsch's techniques of awakening are deeply embedded within a labyrinthine structure of passages into and out of urban space, the dynamics of the crowd, the layering of memory

World Mirror Cinema (Gustav Deutsch, 2005)

intrinsic to urban space, and, finally, the role of the cinema within the spectacle of the modern city. *World Mirror Cinema* consists of three episodes in three different cities at different points in time: Vienna in 1912; Surabaya, Indonesia, in 1929; and Porto, Portugal, in 1930. Each episode features a pan over a movie theater on a metropolitan street from a slightly elevated angle, but beyond that shared feature, the episodes represent three distinct chronotopes, compiled from archives in Austria, the Netherlands, Portugal, and Denmark.

Because of its specificity of places and times, *World Mirror Cinema* has a strong ethnographic feel to it. The "bits and pieces" of film clips provide a strong description for each chronotope, even if it is highly selective. The Austrian footage features families, children, and parks; the Indonesian footage features traditional "exotic" dances and performances as well as city traffic; the Portuguese footage features scenes of work in factories and fields. As historical knowledge, it is clearly sketchy and indeterminate (although Deutsch has filled in some detail in interviews),[84] and yet as archiveology, it is rich in detail and affect. Its mirroring conceit of the returned gaze, moreover, makes it exemplary of Benjamin's methodology, enabling a dialectical return to a

past that is not "prelapsarian" but nevertheless holds a lost promise of the future. For Deutsch, each of these moments marked a point of transition, and yet every moment in history is transitional. The conjunction of fantasy and historical reality embedded in the cinematic image is discovered in the first decades of the twentieth century at the very heart of the spectacle of modernity, in part because the spectacle of modernity is in turn depicted as an element of everyday life.

Deutsch, who began his career as an architect, describes the structure of *World Mirror Cinema* as being like a search engine: "Every person in an image can be linked to another image, and from there to an object and to another person and so on."[85] Many of these links are initiated by graphic matches: a zoom into one figure in the crowd dissolves into another image fragment that matches graphically and, occasionally, conceptually as well. A man on a street fades into a soldier; a little girl fades into another little girl in another film fragment, matching on the figures' posture and scale in the frame. These figures are usually described as "characters,"[86] although none are named and none of them speak, and the term can only be the projection of a viewer hungry for a narrative that is not there. In between the diversions to extraneous archival footage, Deutsch cuts back to the street outside the movie theater. The "passages" following individuated figures are imaginative suggestions of possible futures or possible flashbacks, but their connections are based entirely on details of appearance — clothing, gesture, gait, or posture — and not anything deeper than that.

Deutsch's montage aspires to a language of images; at the same time, the fact that his choice of chronotopes is governed by the presence of a movie theater suggests that this language is not simply imposed on the people in the film but might be theirs as well. In each case, he includes fragments from the films advertised on the walls of the theaters, taking us inside to see what the people on the street might have seen there themselves. In both Vienna and Portugal, moreover, the people in the crowds appeal to the camera's gaze, anxious to be included within the spectacle that has spilled out from the theater onto the street. Exhibitors of early cinema frequently staged such scenes to attract local audiences to see themselves on the big screen, alongside other crowd and street scenes from other countries. This is one of the ways in which cinema produced a global cosmopolitan modernity in its earliest incarnations, through the production and circulation of "actualité" footage across the globe.

In *World Mirror Cinema*, Deutsch has captured the network of gazes that characterized the first decades of cinema. Moreover, by compiling archival

World Mirror Cinema (Gustav Deutsch, 2005)

fragments of this process into a new film for new audiences, spectators in the present can project themselves into this network of gazes in which temporal and spatial distances are briefly crossed. Michael Loebenstein describes the Vienna Kino in the film as "the hub of the universe,"[87] and indeed the description applies equally to the theaters in Porto and Surabaya. As Benjamin notes in his section on mirrors in *The Arcades Project*, an abundance of mirrors makes orientation difficult and is deeply ambiguous and double-edged: "The space that transforms itself does so in the bosom of nothingness."[88] These are false mirrors, after all, and the impressions of connection, characterization, and identification are all constructed within the logic of the image itself. Any awakening that takes place in this film takes place precisely within the void of the mirrored space and is thus all the more surprising and sudden.

Paula Amad has noted the extensive use of the returned gaze in *World Mirror Cinema* and suggests that Deutsch has "invested" in the trope of visual reciprocity, as indicated in the title of the film itself. The mirroring effect, she argues, is finally questioned with the final shot of the film, in which a boy runs away from the camera into the depth of field of the image. She claims that the trope of "visual riposte" carries with it a reflexive critique of the colonial

World Mirror Cinema (Gustav Deutsch, 2005)

gaze, which may be true in many instances. In *World Mirror Cinema*, it is more complex than that, as the montage appears to actively respond to the returned gaze and to project onto the figures certain attributes that can, in some cases, be read as "characteristics." The crowds cheering at the camera are effectively rewarded for their desire for attention as they are able to be seen, still cheering, a hundred years later. It is true that Deutsch deploys techniques of magnification and slow motion to amplify his tactics of connection, but there is no pretense here of "resistance" instilled in the returned gaze. It does, as Amad argues, "hermeneutically imagine the challenge posed by looks at the camera as urgent and necessary fictions,"[89] but they are precisely that: performances for a camera that is itself a spectacle for those historical actors.

Amad also notes that Benjamin's concept of aura was defined as "the expectation of a returned gaze from a human or nonhuman, inanimate other."[90] In "On Some Motifs in Baudelaire," Benjamin suggests that photography is implicated in the decline of aura because it creates a unique distance within the structure of the gaze; but he also reserves the possibility of an "ability" corresponding to the mémoire involontaire: "To experience the aura of an object means to invest it with the ability to look back at us."[91] Of course, the people in old films are not

looking back at us; they are looking at a camera and a camera operator. They themselves are objects — strips of film that can be manipulated and frequently dissolve completely under magnification. In other words, insofar as the materiality of the celluloid and the historicity of the encounter with the camera are privileged, it is the film and not the person that might be said to return the gaze. Benjamin adds here that the "data" thus conceived are unique: "They are lost to the memory that seeks to retain them. Thus they lend support to a concept of the aura that involves the 'unique apparition of a distance.' This formulation has the advantage of clarifying the ritual character of the phenomenon."[92]

Benjamin cross-references this definition of aura with the third version of the artwork essay, even though the polarity of the concept seems to be inverted in that version. If the "ritual" element is perceived at a distance, we can begin to understand Deutsch's film practice as museological. His exhibition of ruins and relics of modernity is an exhibit that takes place in time; thus the various forms of visual riposte that we find in *World Mirror Cinema* are fleeting and momentary. They are always lost and found again, until the moment is caught by a frame capture and becomes a photograph. The "ritual element" of the film fragments collected from archives consists in their repetition. The people will perform those same gestures over and over again, every time someone screens the film.

In a quite different analysis of *World Mirror Cinema*, Michele Pierson describes Deutsch's technique as "re-enactment." She argues that the emphasis on facial close-ups as links or access to the past promotes forms of identification familiar from fiction film: "In *World Mirror Cinema* the past attains presence for the spectators through their own recognition of an identification with the agency of historical actors."[93] Pierson also notes that we have restricted ways of expressing the intersections between feeling and thinking that occur in experimental films, but that affective and emotional dimensions of film viewing are valuable to an understanding of history. While I would agree with the idea that *World Mirror Cinema* creates an affective relation to the historical past, I hesitate to describe it as reenactment. That term is best reserved, in my view, for live performances that simulate historical actions; applied to *World Mirror Cinema*, it disavows the documentary status of the materials mobilized by Deutsch. The figures in the films are often (but not always) performing for the camera; however, their performances have an originary chronotope that becomes linked to the present through repetition but is not therefore reenacted.

The role of faces may help to pull the spectator into the film fragments, but the relations between the images are actually quite variable and complex.

A shot through the front window of a moving car on a street in Surabaya zooms into a detail of a man walking in the background of the shot; this is dissolved into a shot of two men in turbans sitting at a low table who appear to be designing shadow puppets (one man clearly in charge of the other, who executes his orders); that shot dissolves into two similar ones, as if part of the work process had been skipped (in fact, Deutsch says he did edit some of the scenes collected for the film);[94] and finally a shot of the shadow puppets in action against a white background; and one more of the puppeteer in full light playing with a dragon puppet. This last shot dissolves back into the same street scene where it started, matching the puppet figure roughly with a pedestrian. Many of the transitions occur with "forced" graphic matches like this one and have little to do with character but manage smooth transitions between disparate subject matter.

The achievement of *World Mirror Cinema* in my view is Deutsch's use of the city street as the meeting place and intersection of gazes, figures, histories, and correspondences. His collection of film fragments coheres and coalesces outside of the three film theaters. Moreover, the three cities each feature a distinctive cultural chronotope that is developed in the vignettes and in the on-screen drama in the theater. In Vienna, the bourgeois crowd is associated with a detective film from Denmark (*The Black Cap*, Augustinus, 1911); in the Surabaya theater, Fritz Lang's *Siegfried* (1924) episode from *Die Nibelungen*; and in Porto, a film about a peasant revolt and a national hero called *Jose de Telhado* (Rino Lupo, 1929). Clips from these films are integrated without any identification beyond the "diegetic" posters on the walls of the theaters, and they help to fill in the cultural fabric of their respective cities, filling in the dream houses within the dream house that is *World Mirror Cinema*.

At the center of the film, in the middle of the second episode in Surabaya, is a slightly different kind of edit, as Deutsch cuts from the dragon scene in *Siegfried* to a scene of a local dragon ritual in the Indonesian footage. Deutsch says this scene initiated the whole project with the question "How was the myth of the dragon perceived by people engaged in an independence movement?"[95] But the film cannot answer that question, beyond pointing to the presence of dragons in both Germany and Indonesia. Rather than pursue deep explanations for the meaningfulness of the theatrical films, I would prefer to note the differences and similarities they strike with the actualité footage, with respect to the human figure. In the fiction films, the gaze is not returned, and the action is more stylized, rehearsed, and "dramatic." The images are thus differentiated, but at the same time, through their fragmenta-

World Mirror Cinema (Gustav Deutsch, 2005)

tion and the use of dissolves, the images are also continuous with the other pieces in the collection.

Tom Gunning has commented on the play of meaning in *World Mirror Cinema* and the viewer's desire for meaning to be made: "The film makes sense to us, but slowly this sense itself seems to dissolve into seemingly endless play of similarity and reflection, recognition and enigma. Walter Benjamin in a fascinating but obscure passage referred to the 'dream house of the collective,' the theaters and panoramas, as 'houses without windows.' Using this strange terminology he seems to reference Leibniz' description of the elements of reality, which he termed *monads*. The *monad*, Leibniz claimed, has 'no window through which anything could come in or go out.'"[96] The dream house for Benjamin was the phantasmagoria, and it is significant here that in the "colonial" section of *World Mirror Cinema*, the phantasmagoria is not only a Western preoccupation but has different histories, including the shadow plays of Southeast Asia. Other dream houses for Benjamin include "arcades, winter gardens, panoramas, factories, war museums, casinos, railroad stations."[97] His interest in the space of the dreaming collective was in the ability to awaken

from the dream, using the technologies that produce the dream itself: "The new, dialectical method of doing history presents itself as the art of experiencing the present as waking world, a world to which that dream we name the past refers in truth."[98] Deutsch may be said to have constructed a dream house of the twentieth century that looks inward toward its own histories to seek out the monodological cues to awakening.

Benjamin and Aby Warburg

> [Warburg] understood that symptoms are not "signs" . . .
> and that their temporalities, their clusters of instants and
> durations, their mysterious survivals, presuppose something
> like an *unconscious memory*.
>
> Georges Didi-Huberman, "Knowledge: Movement
> (The Man Who Spoke to Butterflies)"

Deutsch's montage is not only evocative of Benjamin's concept of the monad; it is grounded in a reading of the image as a form or shape. In this sense, his method of montage also veers toward that of Aby Warburg, who developed an innovative and influential system of "doing" art history in his *Mnemosyne-Atlas* project of 1929 by "showing" rather than "telling." Warburg is cited by Benjamin not in *The Arcades Project*, however, but in *The Origin of German Tragic Drama*, in conjunction with allegory and Baroque theater.

Allegory, for Benjamin, is not a fixed relation but a fluid relation between "the profane world" of things and the meanings that become attached to it. Thus, the image of Siegfried slaying the dragon in *Die Nibelungen* is not necessarily an image of David and Goliath, or a metaphor for an independence movement, or a Wagnerian image that appealed to Hitler, but simply an image of a man slaying a dragon: a piece of Weimar Expressionist cinema. For Benjamin, the image is allegorical when it is emptied of meaning, when it is rendered strictly figural, as in the relation of the corpse to the person. When Deutsch dissolves archival images into each other, reducing them to their most abstract shapes and compositions, including pixels and film grain, the image is emptied and effectively ruined. The transition to a subsequent "matching" image, of another dragon, in an Indonesian festival of some kind,[99] is created by dissolving the eye of one dragon into the eye of the other. Both cultures, German and Indonesian, feature fantastical, elaborately constructed dragons,

pointing to a mythological connection between two disparate global settings, made by and through the cinematic image.

Benjamin's later conception of allegory in modernity is less clear than his treatise on Baroque allegory, although the two are definitely linked. In "Central Park," a series of notes related to his Baudelaire project, he says explicitly, in several different formulations, that "allegorical emblems return as commodities."[100] Because the price of commodities is determined by the market and not by any intrinsic property within them, "the allegorist is in his element with commercial wares. . . . The modes of meaning fluctuate almost as rapidly as the price of commodities."[101] Furthermore, this allegorical perspective on modernity is fundamentally tied to the method of montage, which is an aesthetic practice specifically tied to a culture of melancholy: "The brooder's memory ranges over the indiscriminate mass of dead lore. Human knowledge, within this memory, is something piecemeal — in an especially pregnant sense: it is like the jumble of arbitrarily cut pieces from which a puzzle is assembled. An epoch fundamentally averse to brooding has nonetheless preserved its outward gesture in the puzzle. It is the gesture, in particular, of the allegorist."[102] In fact, Benjamin's conception of allegory waffled somewhat, as he conceived it to be a key technique of the avant-garde in its opposition to mythic, reified forms. In other words, his theory of allegory is grounded in premodern forms, but at the same time, it was instrumental in the contours of aesthetic modernity. As Rainer Rochlitz puts it, "This aesthetic modernity seeks precisely to conquer, in the medium of language, the empty abstraction that results from the historical process constitutive of social modernity, of desacralization and rationalization."[103]

Rochlitz also reminds us that, particularly with respect to allegory, "the lesson of Benjamin's writings is . . . that one must be wary of any general model and must adjust theory to phenomena."[104] In the context of archiveology, we are dealing with image objects that cannot always be identified as commodities. When they are "orphaned" fragments such as Deutsch is using, the images may be more closely related to the Baroque allegory of dead things. Their obsolescence consists in their lack of identity, and they have become more thinglike in the greater emphasis on gesture, composition, figure, and ground. This arguably aligns them more closely to the world of the Baroque, of which Benjamin has famously said, "Allegories are, in the realm of thoughts, what ruins are in the realm of things."[105] This is especially true when they are in the hands of a collector, "for whom the world is present, and indeed ordered, in each of his objects."[106]

Both Deutsch and Benjamin are familiar with the incomplete work of Aby Warburg, whose *Mnemosyne-Atlas* is constructed around similar patterns of graphic matching that bring together disparate cultural artifacts. Warburg's collection of images — photographs of artworks, sculptures, and architectural details — were mounted on panels with black backgrounds that he conceived in terms of intervals. He did not engage directly with moving images but was undoubtedly influenced by the contemporary avant-garde of the early twentieth century. For Philippe-Alain Michaud, the effect of Warburg's method of collecting and collage was to put images in motion by means of juxtaposition. Warburg collected images from diverse sources, making unprecedented connections between Renaissance paintings, Roman antiquities, and Hopi Indians from the American Southwest. Like Benjamin, he was also interested in tragic drama of the seventeenth century and its discourse of tableaux, gesture, and spectacle — and it is in that context that he is cited by Benjamin.[107]

Michaud notes that Warburg may have made few allusions to cinema, but his work is closely related to the experiments of Eadweard Muybridge and Étienne-Jules Marey and to the emergent cinema of attractions. He created panels of images of images, in order to *do* art history without a text. For Michaud, this mode of reproduction is "based on a cinematic mode of thought, one that, by using figures, aims not at articulating meanings but at producing effects."[108] Michaud ultimately compares Warburg's method to Godard's in *Histoire(s) du cinéma* insofar as both projects go "beyond the limits between the production and the interpretation of works, between language and metalanguage, drawing the meaning of an actualization of images from reciprocal relations possible only through montage."[109] Warburg's conception of *Pathosformel* refers to the analysis of expressive gestures that open up paths to figures of the past. This notion seems particularly applicable to Deutsch's technique in *World Mirror Cinema*, in which silent film fragments are made to speak for themselves and create fluid connections between discrete images drawn from the archive.

World Mirror Cinema can be seen as a museal gaze that awakens its materials from the slumbers of the past, precisely by motivating them from within. Like Warburg's panels, we are dealing here only with a photographed history, the ruins of what Benjamin might have described as the voluntary memory of modern technologies. And yet the practice of collection, display, and assemblage brings out those details that lurk in the background, or appear only to the perceptive viewer, the materialist historian, or the allegorist. Archival resurrection depends on the ability of the viewer, historian, and critic to recognize

the past in the present. If the pleasures of the Baroque lay in mourning and loss, Benjamin's conception of allegory aimed for an inversion of this structure, which at one point in the *Trauerspiel* he describes as melancholy immersion: "And this is the essence of melancholy immersion: that its ultimate objects, in which it believes it can most fully secure for itself that which is vile, turn into allegories, and that these allegories fill out and deny the void in which they are represented, just as, ultimately, the intention does not faithfully rest in the contemplation of bones, but faithlessly leaps forward to the idea of resurrection."[110]

The confluence of Warburg and Benjamin is multifaceted and deeply embedded in the negotiation of modernity. Warburg used photography as a mode of quotation, and both critics were avid collectors of images and objects. One century later, their understanding of visual montage as a mode of thought is made possible by works such as *World Mirror Cinema*. The conjunction of ethnographic detail, movement, and montage releases "secret psychic impulses" that are not necessarily magical or mythic but affective points of reference and empathy that function not as ideals but as passing moments that can be experienced in the present by the twenty-first-century spectator.

Warburg and Benjamin differed most crucially in their conception of the critical value of these "secret psychic impulses." Howard Caygill has pointed out that for Warburg, culture was a site of psychological and social healing, and art served to reconcile the "real and psychological tensions that attack the fabric of a given society."[111] For Benjamin, on the other hand, "the work of art presents the shattered emblems of allegory for contemplation, but not for healing or completion."[112] Benjamin and Warburg certainly developed concurrent theories of critical historiography that became manifest in the "interstitial" cinema of a project such as *Histoire(s) du Cinéma*, as Dimitrios Latsis has argued,[113] but Benjamin's insistence on dialectical historiography is significantly more critical. The "destructive element" of Benjamin's critical practice points to the incompleteness of the past, and it is that failure embedded in the fragment and the detail that produces the possibility of recognizing the fragmentation and incompleteness of the present.

Both Warburg and Benjamin were familiar with the psychoanalytic theory of their contemporary Carl Jung. Although Warburg never cited Jung directly, he shared some key ideas regarding the "collective unconscious" that is characterized by the reappearance of forms and figures over the course of history. And yet Warburg was interested not in archetypes as the substrata of the psyche but in the cultural artifacts that are loaded with an emotional

charge that repeated itself in a formal configuration over time.[114] For his part, Benjamin cites Jung several times in *The Arcades Project* as evidence of a collective unconscious, but at the same time, he was critical of the primitiveness or "archaic form of primal history" implied in the Jungian archetype.[115] The values of synchronicity, correspondences, and coincidence that underlie both Warburg's and Benjamin's projects speak to the traces of mystical thought that linger within the "fallen" world of industrial modernity. For Benjamin, it is the critic as allegorist who is best prepared to recognize these residues within the sphere of the image. Displaced into an assemblage, the figuration is detached from any "natural" home and from any psychic vision.

The awakening in *World Mirror Cinema* is tied not to ideology but to representation. Although the film includes numerous scenes of empire and colony, of political hierarchies and unrest, poverty, and heroism (Siegfried), its "revolutionary" character takes place on the level of the image, teasing it apart to release a new historical knowledge about the specific chronotopes of Vienna, Surabaya, and Porto, cities that were each the hub of the universe at the times they were filmed. In this sense, the film acts upon the twentieth century as Benjamin says his method does for the nineteenth: "The critique [is] not of its mechanism and cult of machinery but of its narcotic historicism, its passion for masks, in which nevertheless lurks a signal of true historical existence, one which the Surrealists were first to pick up."[116]

In archiveology we can finally move on from the surrealists, whose project for Benjamin also remained incomplete. The conceptual apparatus of the collective unconscious and the dream house may have lost some traction in the twenty-first century, and yet the archival method of collecting the "leavings" of visual culture promises new insights into the societies of spectacles past. As anthropology or archaeology, it should be considered a form of sensory anthropology, an experiential method of producing new knowledge about lived media cultures.

5

PHANTASMAGORIA AND CRITICAL CINEPHILIA

> At any given time, the living see themselves in the midday
> of history. They are obliged to prepare a banquet for the
> past. The historian is the herald who invites the dead to
> the table.
>
> Walter Benjamin, *The Arcades Project*

If Walter Benjamin taught us anything, it is that social relations
have not kept up with changes in technologies. The promise of the new brings
only repetition and melancholia. Seventy-five years after Benjamin's death,
this observation has been confirmed on multiple levels, and it is furthermore
evident that nature no longer exists as something before or outside technolo-
gies, or that technology can remain separate from nature. Maybe we remem-
ber when things were otherwise, but we only have other people's words for
this other time, if it ever existed. We may have an image of another way of
being, but it is constantly changing, twisting, and showing other faces.

In the digital era, the question arises of what kind of social relations can
follow from this latest technological revolution. Benjamin's answer might be,
implicitly, that new, improved social relations could be formed within the
practice of criticism. What is it that we do when we write about art? Benjamin
thought he could find the hidden dialectics of commodity capitalism revealed
in the poetry of Baudelaire. He did not write literary criticism to praise or to
condemn, although he could be harsh when he chose to be. The critic is yet
another avatar of the allegorist and the materialist historian. For Benjamin,
the experience of art is continuous with everyday life and not excluded from
it. Therefore, the critical experience is an ability to engage with the work sen-
sorily and intellectually in the context of the present, and in the heightened
knowledge and recognition of the present — especially when "the present" is
understood historically.

Within the scattered remarks that Benjamin made about criticism, he de-
scribes the critic as a "strategist," for whom the artwork is a "shining sword in the
battle of minds."[1] In other words, he advocated a form of critical activism that

was not afraid to destroy. In fact, the critic is not unrelated to the "destructive character," as Benjamin defined this figure in 1931: "The destructive character stands in the front line of traditionalists. Some people pass things down to posterity, by making them untouchable and thus conserving them; others pass on situations, by making them practicable and thus liquidating them. The latter are called the destructive. . . . What exists he [the destructive character] reduces to rubble—not for the sake of the rubble, but for that of the way leading through it."[2] And in yet another variation on the theme of critical practice, Benjamin aligns it with the dreamwork. The "aura" of a book can be sensed by forgetting it and having it return in a dream. The unconscious turns impressions into *extracts* that are recognizable in dreams.[3] I emphasize the word *extracts* to foreground the implicit link between quotation and destructive memory.

In light of Benjamin's understanding of criticism as at once activist, destructive, and dreamlike, I would like to develop the connections between the phantasmagoria and cinephilia as a critical practice. Benjamin did not specifically associate the illusionism of narrative cinema with the phantasmagoria, and yet film critics have long posited that the avant-garde countercinema associated with Brecht, the surrealists, and the Dadaists constitutes a dismantling of the phantasmagoria. Benjamin's name is frequently aligned with the avant-garde, but the concept of countercinema does not go far enough in postmodern digital culture. What happens when the avant-garde cozies up to mainstream cinema? What happens when the avant-garde appropriates its affective properties along with its images? Joseph Cornell did this as early as 1936 with *Rose Hobart*, and this chapter will explore that legacy and its resurgence in the digital era.

Works such as *The Clock* (Christian Marclay, 2010), *Kristall* (Christoph Girardet and Matthias Müller, 2006), and *Phoenix Tapes* (Christoph Girardet and Matthias Müller, 1999) are examples of a mode of archiveology that is dedicated to the lure of the film image and the desires embedded in mainstream narrative cinema. These are works that are born of a certain kind of cinephilia, or an affinity for cinema that involves not only "love" but a recognition of the social relations embedded in the cinema experience. By aligning that cinephilia with Benjamin's phantasmagoria, I hope to demonstrate how cinephilia can be considered a form of critical cultural anthropology. My argument hinges on a recognition of melodrama as the dominant genre of the classical era—a "genre machine," as Christine Gledhill puts it.[4] An investigation into the deep parallels between Benjamin's theorization of Baroque

theater, or German Tragic Drama, and melodrama will help to underscore the relations between phantasmagoria and cinephilia and will moreover link this relation in turn to critical practice, fragmentation, and collage.

As I argued in the previous chapter, archiveology involves the conception of images as things in the world. Torn out of their narrative homelands, they become cultural documents, allegories of their own production, and potentially "resurrected" to speak on their own terms. While these images retain an autonomy that leads out of the phantasmagoria, images of movie stars and scenes from familiar movies — the moments that attract the cinephile — lead back into the phantasmagoria and appropriate not only the image thing but its sensory memory.

Margaret Cohen has provided the most sustained discussion of Benjamin's theory of the phantasmagoria, based on the magic lantern shows of Étienne-Gaspard Robertson and developed as a conjunction of Marxist ideology and Freudian dreamscapes. The *phantasmagoria* became the general term for an array of visual devices, because it best describes the way that ideological experience is expressed.[5] It is not reflective but an expression that is "mediated through imaginative subjective processes." Cohen argues that Benjamin privileges the term in *The Arcades Project* because it is taken from the "time and place" of his study, nineteenth-century Paris. Ideological transposition, or the process by which the subject is caught up in ideology, is a demonic process, for which the iconography and procession of ghosts and the living dead is most appropriate. Cohen describes the phantasmagoria as the demonic doppelganger of allegory.[6] The concept is sufficiently polyvalent, she says, to designate "(1) the nineteenth-century Parisian cultural products working [creating] ideological transposition, (2) Benjamin's principle theoretical apparatus in analyzing this transposition, (3) the psychological content of the experience of ideological transposition, (4) the social causes of such transposition, and (5) the relation of Benjamin's Parisian production cycle to his work on the German baroque."[7]

Cohen is led to inquire, at this point, how allegory fits into this schema and concludes that because it describes the commodity form, "it cannot grasp the palpable way in which the commodity form *appears*."[8] The critical method that Benjamin assigns to profane illumination and the dialectical image could not yet be performed from within the phantasmagoria itself. However, he repeatedly points to the cinema as a technological figure for critical knowledge. For Cohen, "the last phantasmagoria turns the world as it exists outside the camera obscura to artificial show. Unable to seek access to the sun-filled

real, the critic remedies enclosure in the cave of ideology by producing technological spectacles herself."[9] If the nineteenth-century phantasmagoria is an important predecessor of narrative illusionism (and Jean Baudrillard's simulacra in turn), then critical cinephilia may be the archiveological method of demystification that neither Cohen nor Benjamin was able to recognize.

Paul Willemen noted in 1994 that cinephilia has never been a coherent discourse, and in my view, not much has changed since then.[10] For Willemen, cinephilia designates "something which resists, which escapes existing networks."[11] The conventional view of cinephilia points toward a love of cinema that is somehow beyond reason, somewhat involuntary, and deeply subjective. And yet, despite its affinities with the collector and the trivia hound, the fetishist and the helplessly addicted, I believe that it might provide the tools for the production of knowledge. Cinephilia need not be associated simply with the subjective state of the critic, his or her personal affinities with the text, the passion of writing about film, or the conversations between cinephiles.[12] It might also lead to a greater understanding of cultural history and the sensory, emotive, and affective worlds of the past.

In his essay on cinephilia, Thomas Elsaesser suggests that cinema might be thought of as "one of the great fairy-tale machines or 'mythologies' that the late 19th century bequeathed to the 20th, and that America, originally inheriting it from Europe, has in turn passed to the rest of the world."[13] The genre system of popular cinema, overlaid with the sensuality of modern experience, is arguably crystallized in cinephilia, which in turn becomes a kind of prism of the dream life of global modernity. Elsaesser may not be alluding directly to Benjamin in his use of the term *fairy tale*, but the term is often used by Benjamin to refer to the ur-form of popular narrative associated with Mickey Mouse. But as Miriam Hansen notes, the fairy tale can also be a dangerous ideological tool, which Benjamin recognized in the Disneyfictation of the kinetic cartoon character: "The fear that Mickey 'sets out to learn' in Benjamin's technological fairy tale is that of the reactions that it might catalyze in the mass audience, the 'inhuman laughter' that may be therapeutic discharge or prelude to a pogrom."[14]

The potential of cinephilia as a mode of cultural anthropology is implicit in the destructive practice of film criticism in which the cinematic phantasmagoria is dismantled into its documentary fragments. The *cinematic phantasmagoria* is a good term for the duality of the cinematic spectacle, as on the one hand a closed world of artifice and fantasy; and on the other, a document of social practices, rituals, and audiovisual culture. By examining more closely

the role of "things" in the films, and the role of the bodies of actors as people (rather than characters), "the cinematic" can also be thought of as a mode of cultural knowledge. Elsaesser points out that the wealth of the digital archive enables a "dialogical engagement with the object and its meaning," which might be simply a new way of thinking about a reading strategy that we once considered oppositional and resistant. Instead of resistance, cinephilia entails engagement.

Paul Willemen speculates that cinephilia concerns revelation and the production of insight that he cannot quite articulate in a long and provocative discussion of the topic. He comes close to defining the term when he identifies "films that 'inhabit' . . . their own cultural situation." He favors directors who "inhabit their cultures in very complex manners and that complexity is translated into a representational practice that goes beyond the narrative." Linking cinephilia to Third Cinema, Willemen suggests that "we are talking about the articulation between representation and history in cinema. The concrete, local, historical detail shines through."[15] Critical cinephilia, as practiced in writing, through the video essay, or in archiveology, would thus be able to reveal these details in such a way that cultural history is experienced rather than simply described.

Both Willemen and Elsaesser grapple with the ways that film theory in its psychoanalytic-semiotic phase of ideological critique felt obliged to deny the pleasures associated with film viewing. As Elsaesser puts it, "The love of cinema was now called by a different name: voyeurism, fetishism, and scopophilia."[16] However, we should recall that Christian Metz himself was fully aware of the deep ambivalence of his own critical method: "To be a theoretician of the cinema," he writes in *The Imaginary Signifier*, "one should ideally no longer love the cinema and yet still love it." The person who loves the cinema but also writes about it is like a child who breaks his toy.[17] He describes the acrobatic balancing act as a challenge to the "scientific" principle of any rational social theory, but he nevertheless points out parallels in other fields. Metz particularly aligns cinematic studies with the "subjective possibility of the ethnologist's work."[18] Cinephilia, in other words, should theoretically enable us to restore the dimensions of affect, enchantment, pleasure, and emotional investment to film studies, without abandoning the theoretical goals of cultural critique that informed the discourse of apparatus theory. Instead of a deterministic, mechanical model of pleasure, perhaps we can find a more selective and subjective means of connecting with narrative cinema.

The collector, as I have noted, collects images as things that have an autonomy, with the capacity to engage the spectator on an experiential level, outside narrative content or allegorical "meaningfulness." Leslie Stern introduces an essay on the notion of "the cinematic" with a question about the Maltese falcon: "Does the bird desire me?" Can a film desire its spectator? For Stern, this question hinges on the "mutability of things," or the capacity of cinema to combine the materialist dimensions of everyday life with the ephemerality of cinematic time.[19] Things in cinema are at once objects familiar from the real world and displaced from reality into the realm of thoughts and feelings. For example, the plethora of "things" that appear in Morgan Fisher's () may be divorced from narrative, but they are nevertheless cinematic by virtue of their lighting, framing, and connection to human gesture.

Leslie Stern's particular twist on the question of cinematic representation is to propose a taxonomy of "cinematic things" — objects that tend toward inflated, histrionic expression. The things she chooses to write about include raindrops and tears, foliage in the wind, kettles, and cigarettes. While these things tend toward ephemerality, her taxonomy is hardly exhaustive, as she also argues that gestures can "move" the quotidian to the histrionic. She cites examples of detailed mundane activities such as coffee-making scenes in *Umberto D* (Vittorio De Sica, 1952) and *Jeanne Dielman* (Chantal Akerman, 1975), and she also quotes Robert Bresson: "Cinematography, that new writing, becomes at the same time a method of discovery."[20] Things in cinema that evoke the senses of touch and sensuality achieve a level of affect that, in their excess, "elude the voracious grasp of the moment (and the narrative), to reverberate beyond the frame, to generate ideas within a cultural landscape not circumscribed by the diegesis."[21]

Lest we think of this as another version of Barthes's "third meaning," Stern's taxonomy of cinematic things insists on a materialism of "the cinematic." Smoking in cinema, for example, is not only visually sensuous; it is also linked to the quotidian in a circuit of gesturality: "Gestures migrate between everyday life and the movies, but where the gestural often goes unnoticed in the everyday, in the cinema . . . it moves into visibility."[22] Cinematic things do not transcend history or reality; they transform the everyday into a phantasmagoria, which may well create insights into the affective dimensions of history. It is precisely the idea of a cultural landscape to which Stern's notion of "the cinematic" leads — a landscape in which the everyday (the profane) is illuminated as being a crucial nexus of forces, flows, social interaction, and exchange.

Once we are engaged, or entranced, we are able to experience history as a cinematic text folding in on itself. The history of the twentieth century is in many respects also a history of the cinematic phantasmagoria that has effectively transformed things and places into images; "the cinematic" becomes a means of reclaiming the sensual, experiential world of audiovisual culture from within its commodification. Archiveology is a key method for making this happen, precisely because it entails the production of a new text for new spectators and, at the same time, transforms the phantasmagoria into an archive, one that is both accessible and transformative.

The "films" discussed in this chapter are video works that have been projected and displayed in galleries, although they each retain a "theatrical" sensibility insofar as their narrativity tends to hold a spectator in place. The practices of archiveology that I am interested in here are those concerned with celebrity culture, Hollywood cinema, and "mainstream cinema." In fact, *Los Angeles Plays Itself* is a good example of this type of archiveology, even if it had a good theatrical run and has had a DVD release. *The Clock, Kristall,* and *Phoenix Tapes,* however, are not available on DVD and exist only as gallery works with art-market price tags.[23] Their engagement with the "kitsch" of mainstream cinema is not only a matter of recycling and homage but involves a reconsideration of the archive of commercial cinema more broadly, and its appropriation as gallery art.

Erika Balsom has discussed the "ruins" of analog cinema that can now be found in museums and galleries in various forms. She argues that artists such as Tacita Dean, Stan Douglas, and Matthew Buckingham (to name only a few of the many artists she deals with) are interested in the "affective complex" of cinema's obsolescence — a complex that includes the materiality of celluloid and the *dispositif* of collective viewing. In their work, cinema assumes a new aura that points the way out of the phantasmagoria: "Recognizing the extent to which Hollywood functions as dream factory, as myth factory, as history factory, many of the artists producing derivative works turn to cinema as a site that crystallizes the pleasures and horrors of capitalist societies of control, finding in it a synecdoche for a spectacle that is inescapable."[24] For Balsom, the recycling of old films does not guarantee a critique or an inversion but might open up new pathways and avenues of investigation. It may even lay the groundwork for another kind of cinema.

Not surprisingly, Balsom cites Benjamin extensively in her account of what she calls the "remaking" of cinema in the gallery space. She notes that "if for Benjamin, the cinema could take what was second nature and deliver it over

to a space of eventfulness, unforseeability, and the generation of new atti-
tudes, the practice of remaking cinema shifts this activity into a second-order
system."[25] In other words, by rendering the cinema archival and recycling it in
fragmentary form, the alternative public sphere associated with the classical
mode is potentially resurrected in the postcinema era. Cinephilia in this sense
operates as a critical form of nostalgia (which is arguably "melancholy" in
Benjamin's lexicon) that lays the groundwork for a new cinema of the future
in which social relations can be transformed as radically as the technologies
of reproduction.

CINEMA AS TIMEPIECE: *THE CLOCK*

> In spleen, time is reified; the minutes cover a man
> like snowflakes.
>
> Walter Benjamin, "On Some Motifs in Baudelaire"

Since 2010, when it opened in London, *The Clock* has traveled
to dozens of different museums and galleries around the world. Christian
Marclay's work engages tropes of found-footage film and video in a gallery
installation to create a monumental form of digital cinema, challenging many
conventions of film practice and spectatorship. The work exists in the form of
a hard drive and a tandem computer program that synchronizes the projection
to the real time of the audience, such that the work itself literally "tells time"
over a twenty-four-hour period using close to a hundred thousand extracts
from feature films. The clocks and watches in the clips always correspond to
the clock time of the spectator. The installation also includes a specific seat-
ing arrangement of white sofas placed in a darkened room, evoking a home
theater in the public space of the gallery.

Although one critic has suggested that "this whole assembly could have been
made by a computer program,"[26] in fact it was a huge expenditure of manual
labor. Marclay's six assistants collected the material from thousands of films
over a course of three years, while Marclay edited the segments together. The
soundtrack, for which Marclay collaborated with Quentin Chiappetta, is a
tour de force of mixing, remastering, and counterpoint. Whatever one may
think of its blockbuster appeal, *The Clock* is a technically and formally accom-
plished work of picture and sound editing.[27] The montage is at many points

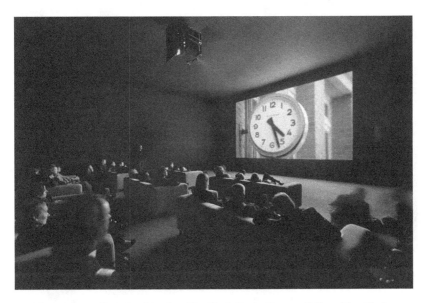

Installation view, Christian Marclay, *The Clock*, Paula Cooper Gallery, New York, 2011. © Christian Marclay. Courtesy Paula Cooper Gallery, New York.

highly expressive, while at others it is subtly invisible, and Marclay fully exploits devices of suspense, comedy, and contrast. On these levels, the piece sustains a rhythmic pace that varies, constantly, with irregular timings and shifts in mood and tempo. There is no question that it has a seductive appeal, due in part to the extensive use of suspense effects and the proliferation of movie stars.

People in *The Clock* are frequently seen waiting, sleeping, eating, smoking, or even watching a movie or a performance. By including this order of image, Marclay creates a rhythm of temporalities that implies that just about anything might have been included, but these are not "empty" scenes or random images, as they are always populated by people (actors) "spending" time. The inclusion of these shots contributes to the sense of duration that the piece invokes and aligns it with the realist aesthetics of Wim Wenders, Andrei Tarkovsky, Michelangelo Antonioni, Yasujirō Ozu, and Chantal Akerman. It should be stressed that there are no empty landscapes or cityscapes: almost every shot features either a clock face or a person's face, including a series of clips from Claude Chabrol's *This Man Must Die* (1969) featuring a smoldering cigarette in an ashtray perched before a table clock. In fact, the waiting and sleeping clips come from all manner of sources, but it is another way in which *The*

The Clock (Christian Marclay, 2010)

Clock incorporates a form of clock time that is as inactive as the time spent watching *The Clock*.

Any discussion of *The Clock* has to take into account its institutional context. As Erika Balsom argues, the work has been promoted in many cities as an event or a phenomenon, with a huge public profile. In this sense, it is consistent with the tendency toward accessibility and pleasure that museums around the world have embraced. Balsom suggests that the use of projected video since the late 1980s finally coincides, in Marclay's work, with the blockbuster museum shows that draw long lineups in major cities around the world.[28] Needless to say, the entertainment value of *The Clock* has made it a somewhat controversial piece for film and art critics. The rarified auspices of the art world have furthermore enabled Marclay to use the material under fair use guidelines, whereas most independent filmmakers are restricted in their use of borrowed copyrighted material. *The Clock* highlights a certain "mainstreaming" of experimental film, but by reaching a larger public than would typically experience archiveology, it raises some significant issues, particularly around the role of time in archiveology.

The synchronicity of *The Clock*, in which viewing time and screen time coincide, is in one sense an instrumentalization of time, situating the viewer within a repetitive, cyclical, regimented structure of clock time. There is no denying this. At the same time, though, the piece charges every second of clock time with sensory affect, arguably creating a "now time" of present-

tense experience. It is at once continuous in its twenty-four-hour cycle that flows without cease and discontinuous in its fragmentary status as found footage. The doubleness of this experience is allegorical and ironic, even comic at times, and yet as pastiche it is nevertheless thoughtful and provocative, and arguably recapitulates Benjamin's understanding of time in modernity within the sphere of digital image culture and archiveology.

For Benjamin, the now time (*Jetziet*) of the correspondence of past and present, potentially embedded in the dialectical image, has a utopian potential that he associated with both the Marxist revolution and Messianic revelation. The synchronicity of *The Clock* has been described by Rosalind Krauss as an instantiation of the "now effect" theorized by Edmund Husserl and critiqued by Jacques Derrida. At issue for these theorists is the "self-presence" or self-consciousness contained in the ability to conceive of the present as a once-only event. Marclay, according to Krauss, has discovered something new about medium specificity that counters Derrida's suspicions about the capacity of representation to realize the "now effect" of self-presence.[29] When Krauss writes that a "specific medium" is explored in *The Clock*, we need to pause and ask to which medium she is referring. Is this cinema? In fact, I would argue that it is not cinema but multimedia, combining installation art with digital cinema. What is at stake in *The Clock* is an experience, and it is one that produces a strong sense of "the moment" as an experience of being in the present. Whether it has revolutionary potential probably depends on the viewer and their level of engagement with the text as it unfolds.

The Clock is exemplary of Benjamin's notion of the "second technology" created in technological modernity by the image sphere in which we find ourselves immersed. The degree to which the work triggers memories will vary according to the viewer's cinephiliac inclinations, but for all spectators it creates a sense of correspondence between the fictions to which we have devoted so much of our time as spectators and the actual, real time of the present moment. In this sense, the piece evokes a third form of temporal experience, linked to memory, recollection, and obsolescence.

The inclusion of overlooked genre films and TV extracts is crucial, as they carry intimations of "wasted time," the durée of modernity. If we once watched movies to "escape time," *The Clock* rubs that escape in one's face. For Benjamin, the durée is an experience of time from which death has been excluded; it is repetitive without being ritualistic: "tradition is excluded from it." The durée, he says, "is the quintessence of an isolated experience [*erlebnis*] that struts about in the borrowed garb of long experience. Spleen, on the other

hand, exposes the isolated experience in all its nakedness."[30] (In Harry Zohn's original translation, he used the words *passing moment* instead of *isolated experience*, suggesting how close the sense of time is to Benjamin's theory of experience.)[31] We might say that *The Clock* puts on display precisely that "disintegration of aura" that Benjamin champions in Baudelaire. Moreover, it happens in *The Clock* on an experiential level, in which the "shocks" of mechanized time are felt and absorbed intensely: "In spleen the perception of time is supernaturally keen. Every second finds consciousness ready to intercept its shock."[32]

In spleen the subject tends to feel time in the body, as a ticking, mechanized system, but in *The Clock* this is in turn offset by the capacity for memory and recollection of previous viewing experiences that were less closely tied to the mechanical structure of *The Clock*. For Benjamin, kitsch was a key surrealist concept and figure of melancholy, especially when it takes the form of a souvenir, a fragment of memory that intensifies a moment otherwise lost to the past. *The Clock*, in this sense, constitutes a collection in which each piece of fiction is a document of another moment in time. The lack of hierarchies between art cinema and popular cinema renders each fragment a document of its own time, the time it was made, producing correspondences between the time of viewing and that other time when it was made or viewed in the past.

Celeste Olalquiaga has interpreted Benjamin's conception of kitsch most eloquently. She distinguishes between the fossilized time of nostalgic kitsch (linked to Benjamin's mémoire volontaire) and the souvenirs of unconscious remembrance and melancholy (linked to the mémoire involontaire). She says, "The yearning of reminiscence is nostalgic and never really leaves the past, while that of remembrance must be anchored in the present to experience the loss for which it melancholically languishes."[33] The thousands of film clips that are collected in *The Clock* are exemplary, in my view, of kitsch as unconscious remembrance, souvenirs of memories we did not know we had. Torn from genre films primarily (but not exclusively), the torrent of images reacquaint us with long-lost stars and movies that, like kitschy commodities, are products of industrial commerce and reproductive technologies. They are affective and sensual, and yet we still need to ask: Where is the détournement? How is this not another incarnation of the "society of the spectacle" that Guy Debord so critically dismantled in his own found-footage rage against the image machine of commodity capitalism? My own answer is simply the ability to leave at any time. *The Clock* addresses the viewer as the hypnotized, entranced spectator of narrative fiction but equally as the mobile spectator of installation gal-

lery art. We are free to go at any time, and people do come and go constantly from the theater space. This may not be a persuasive form of critique, but it aligns the work with the situationist *derive*, while stressing the experiential dimension of the piece that never lets us forget our own routine that is being interrupted as long as we remain seated in the darkened theater.

The cinephiliac trance created by *The Clock* — its lure — is offset by its discontinuous, heterogeneous style of collage, and in its predication on "now time" or continuous present tense. We cannot really lose ourselves if we always know what time it is in the real world. For Peter Osborne, the dialectics of duration and distraction are in fact characteristic of film and video in the gallery. The gallery, in his view, constitutes the new "training ground" of distracted reception, which Benjamin identified with film in the 1930s. Osborne points out that the philosophy of time has become a mine of conceptual resources for contemporary art, within which the notion of duration has been revised and rethought. The Bergsonian notion of temporal duration or durée, as a dynamic now time, implies an independence from spatial coordinates, and thus seems to apply especially well to the darkened theater of the cinema. As Osborne points out, the "marked spatiality" of the modes of display in museum spaces "undercuts the false absolutism of time to which cinema is prone. Furthermore, it highlights the constructed character of temporal continuity."[34] In *The Clock*, this physicality of sensory experience is further enhanced by the spleen-like experience of passing time.[35] In Baudelaire, it is opposed to an ideal, which in the early twenty-first century may be the "mass culture" or collectivity of classical cinema. In other words, the phantasmagoria may once have been dangerous and ideologically suspect, but its destruction potentially renders it a space in which to recognize difference.

The Clock is definitely not a "curated" work in the sense of a collection of key films that reference time, but it engages provocatively with a key tendency of art practices since the 1920s to recast the archive as a series or collection lacking a principle of provenance. Sven Spieker argues that after the surrealists, chance has invaded the archive, "where it now wreaks havoc with the archive's ambition to produce an ordered record of time."[36] The chaos and entropy of archival art practices, according to Spieker, come about as a challenge to the archival order of "the principle of provenance" that governed the nineteenth-century archive. In *The Clock* we quite remarkably have a reconstructed chronology from within the contingency of the archive, and it depends to some extent on our willingness not to identify the sources of the clips but to take them on their own terms. If "provenance" encompasses authorship

and authenticity, the clips in *The Clock* are only as authentic as their profilmic materials, the most obvious of which is the bodies of actors. Like the collage of fashion and architecture, the aging actors embody a multiplicity of histories, of which the film titles and directors are relegated to afterthoughts.

Spieker describes late twentieth-century art practices of artists such as Walid Raad and Gerhard Richter as follows: "Frequently resembling databases more than archives based in the principle of provenance, these archives focus on the signifier over its mythical or monumental signified, and they suggest that the relationship between signifiers in an archive is not determined by chronology alone. . . . It is not the linear sequence of moments . . . that takes center stage but the possibility of their combination and concatenation."[37] *The Clock* may be somewhat aligned with these projects, as it tends to transform the film archive into a database, even if it is one that requires manual searching; but it opens up a difficult return to chronology. Historical chronology remains fragmented and nonlinear, and yet a chronological principle has taken center stage, returning the work to the regimes of bureaucracy and administration that the avant-garde had otherwise jettisoned.[38] Marclay can be said to find order within contingency by bringing clock faces from the background into the foreground of the mise-en-scène, and there is a way in which the familiarity of his sources arguably returns us to archival principles of provenance. Why else would there be so much distaste and discomfort with his use of kitsch and genre films?[39]

In cinephiliac circles, *The Clock* was somewhat controversial. Whether one understands the piece as a good object or a bad object, it foregrounds a crucial tension in film aesthetics between "mainstream" genre cinema and the avant-garde and art cinemas. As a cult phenomenon, *The Clock* evokes the aura of the pre-cinematic artwork, and yet its strategies of sampling clearly embrace the reproducibility of the cinematic image that Benjamin endorsed for its potential engagement with progressive social politics. *The Clock* evokes the deeply ambivalent politics of representation that Benjamin ascribes to the phantasmagoria of the Paris arcades. It does so by effectively rendering film history into an archival language and then creating a discourse in that language that is at once entrancing and unsettling, and speaks back to the dispositif of classical cinema.

If we can analyze *The Clock* as a dispositif, which is to say, a cinema machine organized by its own internal set of rules that includes the social space of reception,[40] it is one based specifically on the expressive aesthetics of narrative cinema and the critical categories of mise-en-scène. *The Clock* invokes

the apparatus, including its theatrical seating arrangement, while also resisting it insofar as the viewer remains self-conscious about the time of day, and insofar as the diegetic narrative space is so heterogeneous and without any fixed subjectivity. Point-of-view editing and other principles of continuity are systematically used throughout the work to link shots from different movies. Sometimes the results are jarringly obvious, as when someone in a black-and-white film from the 1940s dials a phone and someone in a color film from the 1970s appears to answer it. Marclay exploits this principle with a great sense of humor, as when crashes or explosions appear to be caused or triggered by actions in different films. There is a beautiful moment when a black-and-white car crash is followed by a gently falling pink petal. Often, though, the discrepancies are not as evident, as when a glance is followed by a tight close-up of a watch or clock that loosely matches the style of the previous shot. Music, too, is often used to seamlessly blend together disparate material.

Music and sound effects are Marclay's original métier, and his montage practice is more or less based on music sampling. It is through the sound editing that *The Clock* achieves its trancelike effect, engaging and seducing the viewer into spending time, passing time, and losing track of time, even while always insisting on the precise time of day. We are entranced but also not entranced. Is there any room for revelation in this kind of cinephilia? Has Marclay beaten us to every punch with his jokes and his beautiful juxtapositions? In his collection of clips, he has included an ongoing commentary on cinematic time and even the practice of quotation, which tend to elicit knowing laughter from audiences sitting there watching time go by. Phrases such as "your obsession with time" or "you often pick words for their sound rather than their meaning" are reflexive gestures that are as funny as Peter Sellers trying to repeatedly synchronize his watch with Leonard Rossiter in *A Shot in the Dark* (Blake Edwards, 1964). Marclay's extensive use of comedy on both levels is responsible for the work's high entertainment value, which is in turn responsible for its successful museum run and perhaps what lies behind the casual scorn of some cinephiles. But the comedy is key to the work, which is devoted to genre cinema and not, in the end, to art cinema.

The piece has a grand narrative of rising, eating breakfast, working, eating again, being entertained in the evening, sleeping, and waking, forming a narrative that mimics the viewer's own routine. In this sense, *The Clock* invokes the rituals of everyday life that are familiar from the city film. And yet, while the viewer may share certain rituals of everyday life with the characters on-screen, we do not normally hold up banks, try to beat ticking time bombs,

The Clock (Christian Marclay, 2010)

rendezvous under station clocks, appear dramatically late for appointments, or hang on to the hands of huge tower clocks like Big Ben. These are things that people in movies do. We do not typically smash our clocks either, which happens a lot in *The Clock*.

The experiential dimension of *The Clock* is exemplary of what Walter Benjamin describes as innervation: that property of cinema that harnesses the body through the senses, bringing the mechanical and the human into a very close encounter. In addition to his reliance on continuity editing and sound dissolves, Marclay exploits techniques of suspense and comedy as tropes of genre cinema to create this effect. For Benjamin, innervation was both the danger and the potential of cinema, which is one of the reasons why I find *The Clock* to be so Benjaminian. It is exploitive in its unabashed appropriation of the entertainment value of commercial cinema, and at the same time, the work offers critical keys to the undoing of the phantasmagoric through techniques of quotation and montage.

The phantasmagoria on display in *The Clock* is a very specific one. It can almost be described as a documentary on London in the first decade of the twenty-first century, as the sources for the film clips came from the local video stores, and there is a surprisingly high quotient of British cinema. This is definitely not "the cinema" in any universal sense. The emphasis on American film, followed by British film, West European film, and a thin smattering of Asian cinema, is not only limited geographically and linguistically but is further weighted heavily toward postwar cinema and even post-1970s film after that. Although some art cinema is included, the emphasis on narrative feature

films puts the emphasis on "low-brow," genre cinema with a few U.S. tv shows such as *Mission Impossible* (1966–73), er (1994–2009), and *The X-Files* (1993–2002) thrown in, probably because that is what was found in the video store.

To criticize the work's lack of inclusivity is, however, to miss the point. As an essay on cinephilia, *The Clock* represents the phantasmagoria in ruins. The film archive, as produced by London video stores circa 2007 to 2010, is culled for content rather than its pedigree or representativeness. Visual style comes to stand in for historicity, ethnicity, and geography, with sound and montage functioning as the glue. In keeping with the mode of found-footage filmmaking, the images are wrested away from their narrative origins and stripped of aura, authorship, and narrative significance. On this level, the film opens itself up to the kind of mise-en-scène criticism that Adrian Martin claims returns with the form of the dispositif. He argues that a new mise-en-scène critical method is made possible in which "the integrated arrangement of form and content at all levels" is considered. For Martin, this is the failed promise of traditional mise-en-scène criticism.[41]

The Clock in many ways takes us back to the text of Hollywood, but it is a broken text, torn from its alibi as a story-telling medium. What this means for me is a reading of the work as a procession of movie stars subsisting within a world of things. We are returned to the profilmic documentary that lurks within every fiction film. Actors such as Nicolas Cage, John Malkovich, and Meryl Streep appear at various stages in their careers, producing a thematic thread of aging. The many names of clocks and watches — Bulova, Rolex, Casio, Gruen, Tisoo, and Caravelle automatic — are not merely product placements but underline the role of commodities in the phantasmagoria of Hollywood. When such details move into the foreground and out of the background of the image, they become the ruins of the original work, brought into legibility in a distant historical moment.

The stylistic variety of timepieces is in fact astonishing and is deeply integrated into the way that *The Clock* represents time. Within the strict chronology of the time of day lies a nonlinear, heterogeneous temporality of historically specific design, not only of commodities and material culture but of film style itself. The cuts from black and white to color are only the most obvious juxtaposition of styles of dress, architecture, set design, and behavior. The illusion of continuity is constantly, if subtly, undermined by shifts in stock, color palettes, and lighting design; the game for the cinephile is to identify not only film titles and actors but also time periods.

The recognition of such historical detail potentially renders the viewer of *The Clock* as a materialist historian, in Benjamin's sense of the term, which is close to what we might now call a cultural anthropologist. Marclay in this sense is a ragpicker rather than a curator, and the randomness that seems to inform the selection of source material makes what Benjamin describes as "science out of magic." In "One-Way Street," he describes the child looking for Easter eggs as an engineer disenchanting the gloomy parental apartment.[42] Fragments of narrative are stripped of their mystique in *The Clock* and rendered as cogs in a machine, which are in turn pieces of historical time. The energy and momentum of narrative cinema, along with its rhythms of emotional ups and downs, are laid bare as a succession of temporal increments. In "Dream Kitsch: Gloss on Surrealism," Benjamin argues that kitsch "catches hold of objects at their most threadbare and timeworn point."[43]

The Clock may evoke the sense of a phantasmagoria in decay, but Marclay has eliminated the look of decay by evening out and homogenizing the image quality and aspect ratios of his clips. Where Andersen in *Los Angeles Plays Itself* (2003) reproduced the grain of poor VHS copies when he first released the film, Marclay has almost completely erased such signs of image degradation (as has Andersen in his Blu-Ray DVD edition). There is very little "dust," in other words, on his collection of cinematic artifacts, which renders them even more kitsch-like, as souvenirs of the past. Even so, the images are nevertheless "threadbare" and "timeworn" in their revelation of stylistic time. Each clip marks a certain point in film history, which also turns out to be cultural history—insofar as fashion, hairstyles, and even modes of behavior and gesture signal a moment in time and are read as indexes and traces of the past. If, as Benjamin suggests, history decays into images, not stories,[44] *The Clock* helps us to better grasp the role of cinema in this process by immersing us in a nonlinear cycle of the accumulated debris of the film industry.

Benjamin had nothing to say about cinephilia, of course, given that he seems not to have seen many movies. And yet his concept of profane illumination is a useful means of grasping the critical potential of cinephilia as a category of cultural critique. I agree with Willemen that cinephilia must be "a question of something being revealed in a social relationship, because the cinema is a social relationship. Something is being activated and revealed in that relationship."[45] In *The Clock*, the "social" consists of the collective memory embedded in film history but also the intensified experience of the present. Thus, in the dispositif of *The Clock*, we need to note the omnipresence of the white Ikea sofas and the impossibility of transferring the work to a convenient

Christian Marclay, still from *The Clock*, 2010, single channel video with stereo sound, twenty-four hours, looped. © Christian Marclay. Courtesy Paula Cooper Gallery, New York.

format like the DVD that one could watch at home. The return to the theater, or its simulacrum in the gallery, is integral to the work. But as I have already noted, the viewing experience is nevertheless doubled and divided between one's own body, routine, and schedule, and the unrelenting momentum of the projection, a division that relates in turn to Benjamin's distinction between human experience and the more regulated experience of modernity.[46] Benjamin understood film as a privileged medium where these two forms of experience potentially collide; it could thereby function as a therapeutic tool for the poverty of experience endemic to industrial modernity.

As Miriam Hansen has noted, Benjamin's famous artwork essay underwent several revisions in which he finally ended up placing cinema on the side of "experiential poverty." And yet it is clear that in the second version of that essay, he held out some hope for film as a space for "room for play," "for trying out an alternative innervation of technology."[47] In conjunction with his conception of the archive, the collector, and the allegorist, it may be that such a space remains possible, especially in the dispositif of expanded cinema — such as an installation like *The Clock* — as a kind of game. Marclay's project displays an ambivalence regarding the medium that runs parallel to Benjamin's because it is a popular cinema and a mass aesthetic that is being both exploited and ruined.

Among the many remarkable features of *The Clock* is the way that it creates a trance-like sense of continuity, holding the viewer hostage in an unrelenting unfolding of time. Unless the gallery closes and you get kicked out by the guards, the only way to "end" *The Clock* is to get up and leave. We may recall that for Roland Barthes, leaving the movie theater was akin to awakening from a hypnosis, which provoked him to inquire how one could "pry oneself away from the mirror?" He advocates going to the cinema in a state of detachment, to be hypnotized by "a distance, and this distance is not an intellectual one. It is, so to speak, an amorous distance."[48] He wants to be "*twice* fascinated" by the image and by its surroundings, including the darkness and "the obscure mass of other bodies." Barthes's version of cinephilia embraces the hypnotic effect of the ideological veil, but he also sees the social, public space and the architecture of the theater. Watching *The Clock*, we are always leaving the movie theater, or not. People constantly coming and going creates an atmosphere of "mobile" viewing alongside the fixed gaze of cinematic spectatorship; both forms of viewing coexist.

CRYSTAL GAZING: *KRISTALL*

"To dwell" as a transitive verb — as in the notion of "indwelt spaces"; herewith an indication of the frenetic topicality concealed in habitual behavior. It has to do with fashioning a shell for ourselves.

Walter Benjamin, *The Arcades Project*

Christian Marclay was not the first filmmaker to make a film about clocks. Christophe Girardet's one-minute film *60 Seconds* (2003) predates it by seven years. According to Eli Horwatt, it "assembles shots of clocks in an attempt to represent every second of a minute from across sixty films."[49] For Horwatt, this constitutes an ironic statement on the superficiality of *The Clock*, which in his view embodies an instrumentalized mode of temporality, lacking inherent "content." An even more extreme minimalist version of a clock film is Morgan Fisher's *Phi Phenomenon* (1968), in which a single clock is shown for eleven minutes with no second hand, and all that happens is that the minute hand moves eleven minutes. Clearly, we have a spectrum of approaches in which the awareness of time is exaggerated at one extreme and minimized at the other. The ironic treatment displayed by Girardet, fall-

ing somewhere between Fisher's asceticism and Marclay's excess, is carried through all his work with found footage, particularly his collaborations with Matthias Müller.

In *Home Stories* (1990), Müller's groundbreaking collage of fragments from Hollywood women's films, the archive of narrative cinema began to yield unforeseen treasures. This film has been recognized as marking a real shift in found-footage filmmaking.[50] I believe that it is also one of the first video essays insofar as Müller used TV extracts from Hollywood melodramas to present a close analysis of the repetitions of gestures, facial expressions, and framings that repeatedly occur in 1950s American women's films and melodramas. The result is a collage that is both instructive and emotionally moving. In *Kristall* and *Phoenix Tapes*, Müller collaborated with Girardet to make a more "spectacular" digital collage along the same lines as *Home Stories*, and the two films enable us to pursue further the relation between archiveology and critical cinephilia.

In the contemporary media sphere, the mash-up and the scratch video have exploited the potential of the phantasmagoria in ruins for a variety of uses, including the VJ "wallpaper" appropriations and the more academic-inclined audiovisual essays that appear in online journals such as *[In]Transition*, NECSUS, and *Vectors*. Moreover, one finds dozens of homages to movies and stars made by fans and cinephiles that are routinely posted to YouTube and routinely removed for copyright violation. Audiovisual essays manage to avoid the need for permissions by publishing under fair use guidelines. Such essays are usually accompanied by written texts and/or explanations by curators for their merits and academic value. The form is so new that *[In]Transition* also publishes peer-reviewed commentaries in order to develop the discourse around the new forms of knowledge embedded in this work.

Walter Benjamin's name is frequently cited in the paratextual commentary surrounding video essays. To take just one example, in the introduction to a program of audiovisual essays at the Frankfurt Filmmuseum in 2013, Vinzenz Hediger described Benjamin's conception of criticism as "a kind of experiment performed on the work of art which awakens the art work's inherent potential for reflection, through which the work acquires a consciousness of itself."[51] It is important to contextualize this notion of criticism, which Benjamin did not simply "develop" from German Romanticism but theorized from a specifically post-Romanticist critical view. His own exemplary contribution to the critical project was his essay on Goethe's *Elective Affinities*.[52] His critical experiment consists in a kind of violence against the work in which he seeks

to escape the aestheticism of the Romantics. Rochlitz describes Benjamin's approach as follows: "Goethe's novel is interpreted both as the testimony of a culture that remained prey to the obscurity of pagan myths and as a sublime attempt to wrench free of it, and thus as a privileged moment in the break with 'destiny.' Before the messianic end of history, art alone is capable of making this break, and it is incumbent upon criticism to present the break in order to bring us closer to that end."[53]

In Benjamin's writings of this period (the early 1920s, around the same time he was writing about language and translation), he used the vocabulary of romantic aesthetics, including the concepts of truth and beauty. The latter he treats in terms of the concept of "semblance" and equates more or less with the fallen state of language; but he nevertheless pursues the notion of truth through the critical act, designed as an intervention aimed at recognizing a truth value that the artist may not him or herself be able to recognize. Historical distance certainly helps in this activity, and even here, Benjamin specifies that it is the "afterlife" of the artwork that he is most interested in. The question for contemporary modes of criticism, such as the audiovisual essay and archiveology more broadly, is how does this post-Romanticism manifest itself in contemporary media culture?

One way of answering this question is offered by the film *Kristall* (2006) by Girardet and Müller. This piece was included in the Frankfurt festival of audiovisual essays from which the Hediger essay comes.[54] It was included alongside such diverse works as *Rose Hobart* (Joseph Cornell, 1936), *Club Video* (Philip Brophy, 1985), *Alone, Life Wastes Andy Hardy* (Martin Arnold, 1998), and *Ozu//Passageways* (Kogonada, 2012). The programmers of this series, Adrian Martin and Christina Álverez López, mixed a range of experimental films and video essays, all of which are based in clips from narrative cinema, mainly "classical cinema" within a global perspective. In other words, they are films that are speaking back to the phantasmagoria.

Kristall is an especially interesting example of this practice, because it is working specifically with elements of melodrama, which might be considered a twentieth-century descendent of the romanticism that informed Benjamin's thinking. In one of the most influential theories of melodrama, Peter Brooks describes the mode as "an aesthetics of astonishment" and a "text of muteness," and identifies its "center of interest" in the " 'moral occult,' the domain of operative spiritual values." He compares this hidden domain to the Freudian unconscious and its processes of revelation and meaning-making to the domain of the signified, submerged or latent within the surface expressions of

signifiers that are terminally incomplete. Melodrama constitutes a form specific to the secular world of bourgeois values: a "repository of the fragmentary and desacralized remnants of sacred myth."[55]

As an expressionist form, melodrama serves a valuable role in media culture as a narrativization of conflicting values, victimization, power, gender, sexuality, and race — deeply rooted problems that are never neatly or finally resolved but continue to emerge in new forms at every historical juncture. As Linda Williams puts it, melodrama "has most powerfully articulated the moral structures of feeling that animates the goals of justice" in American democratic culture.[56] The modality of melodrama, in other words, is an excellent means of bringing together the themes of phantasmagoria, criticism, and allegorical ruins that inform archiveology. In Benjamin's writing, these ideas are intrinsically linked together, even if he did not specifically articulate their relationships. The fragmentation of melodrama renders it allegorical and conforms with Benjamin's advocacy of a critical practice that is at once destructive but also respectful of those deeply buried truths that may have been hidden from original authors and artists. As an audiovisual essay — and as an experimental film — *Kristall* performs a critical operation on classical forms of film melodrama. As archiveology, it performs a dialectical operation on the phantasmagoria of narrative cinema in its most sensual, affective, and emotional form.

Kristall is exemplary of how found-footage filmmaking constitutes in itself a form of research. Girardet and Müller have excelled (in this and many other works) in working through the Hollywood archive to collect and compile series of gestures, expressions, poses, compositions, and spaces that enable a return to the clichés of classical cinema with new eyes and ears. In *Kristall*, they have selected moments in mirrored bedrooms where men and women see themselves and see each other. These wordless encounters are loaded with anxieties and tensions, suspicion, fear, and vague forms of pensive apprehension. The pleasures of narcissism are infused with the paraphernalia of the bourgeois boudoir: jewels, makeup, luxurious hair, and Baroque furnishings. The filmmakers have pulled out the empty moments, times of waiting, expectation, solitude, and boredom, the moments just before and just after the "big moments," which are themselves limited to shots of mirrors being smashed.

The figures in *Kristall* are in some cases familiar friends, including both American and European stars, from Ingrid Bergman and Elizabeth Taylor to Jeanne Moreau, Sophia Loren, Kirk Douglas, Anthony Perkins, and many others whose names are elusive, triggering memories that are just out of reach

Joan Fontaine in *Kristall* (Christoph Girardet and Matthias Müller, 2006)

of films we may or may not have actually seen. These people live in the language of cinema, within the frames of reduplicated mirror images, within the spaces of windows and doors, the sounds of tinkling, crashing, and ominous soundtrack music. Girardet and Müller have not only compiled these fragments with virtuoso editing techniques; they have slightly distorted the rephotographed montage so that the images are slightly destabilized. Their small distortions accentuate the melancholic dreamy atmosphere in which these men and women subsist.

The short film climaxes with a series of forty-three quick shots of women turning away from their mirrors, turning with anticipation, as if something has caught their eye or their ear. These brief movements are followed by a series of shots of pensive men, and then the men start appearing behind the women, reflected in their mirrors as they enter the space of the bedroom. A final sequence of shattered mirrors, punched in anger by both men and women, further fragments the image into shards of violence. The film ends with a three-sided full-length mirror miraculously reconstructed in reverse motion from its shattered pieces, reflecting an empty, shadowed bedroom.

This remarkable film has the effect of abstracting a set of gestures from the image bank of "industrial cinema" and returning them to a collective subjectivity. It speaks to many conventions of gendered behavior, commodity capitalism, ideals of beauty, and literary tropes of loss and desire, not to mention the melodramatic dynamics of hysteria, repression, and home. The

Barbara Stanwyck in *Kristall* (Christoph Girardet and Matthias Müller, 2006)

filmmakers first saw Hollywood films on German television as kids, and Müller suggests that as a gay artist he was first drawn to this material because of its depiction of the American home as a claustrophobic "women's prison."[57] Regarding *Home Stories*, he says, "I also envy these female characters their privilege of being able to live out their emotions uninhibitedly on the domestic stage, through their large, expansive gestures."[58]

Indeed, Girardet and Müller's film practice is in keeping with a larger development in experimental and independent cinema that Roger Hallas describes as "gay cinephilia." He identifies a number of works that "approach the visual archive of popular culture as a rich source of affect, rather than merely as site for ideological analysis."[59] He claims that the AIDS crisis has provoked the tendency toward loss and melancholia alongside a tendency to "queer" the archive through creative misreadings. *Kristall* may have come out of this constellation of cultural politics and aesthetics, but I also think it points beyond identity politics to a broader conception of the "dreaming collective." The repetition of surprisingly similar gestures underlines the commodity character of genre cinema, and when they are reconfigured as ritual, they produce something close to that messianic, theological, or spiritual sense of recognition that Benjamin associates with revolutionary energies.

Giorgio Agamben has said that the human face is the sole location of truth because "what human beings truly are is nothing other than this dissimulation and this disquietude within the appearance." He claims that "the task of politics

165 *Phantasmagoria and Critical Cinephilia*

is to return appearance itself to appearance, to cause appearance itself to appear."[60] This, I would argue, is the achievement of *Kristall*. Benjamin's phantasmagoria is expertly reassembled as an invitation to the viewer to discover another form of experience within the public sphere of the "culture industry." We enter into a trance-like state, induced by the iconic aura of movie stars and the glitter of their decadent world, but we are invited to find something else there, in the interstices of hysteria and narcissism. Whether we name this something else as "affect," as gesture with neither means nor ends — pure mediality, in Agamben's words — or as *Erlebnis* (experience) in Benjamin's, the film has the effect of an awakening. Returning at the end to the empty, waiting, mirrored image, deeply shadowed and multiply fragmented, Girardet and Müller defer the revolutionary moment. And yet the strategies and aesthetics of this powerful film serve as a model for a film criticism that has likewise returned to the archive of film history in the spirit of critical reflection.

As a form of archiveology, *Kristall* may help to indicate how Benjamin's theory of the dialectical image can produce historical insight. Returning to the archive of the collective unconscious can be a critical means of historiographic activism, a means of excavating the dreamworld of commodity capitalism for a renewed humanism. The thoroughly mediated experiences that can be found there provide templates for the utopian promises of modernity that subsist within the catastrophe and perpetual emergency of the early twenty-first century.

The techniques that Benjamin proposes for an "awakening" from the dreamworlds of commodity culture are never far from reach. An awareness of the dialectical — the Copernican turn of remembrance — is embedded in the fundamentally collective nature of the phantasmagoria. "The dreaming collective," he argues, "communes with its own insides" through the arcades, as the sleeper communes with their inner organs. Further, "we must follow in its wake so as to expound the nineteenth century — in fashion and advertising, in buildings and politics — as the outcome of its dream vision."[61] As critical theory, Benjamin's program is predicated on the nightmare as well as the utopian dreamscape, finding them always firmly enmeshed and embedded within each other's imagery.

We know from the artwork essay how the fine line between the right and the left with respect to the modernity of the cinema is emblematically noted by Walter Benjamin: "The violation of the masses, whom fascism, with its *Fuhrer* cult, forces to their knees, has its counterpart in the violation of an

apparatus which is pressed into serving the production of ritual values."[62] If we are able to recognize American classical melodrama as a kind of kitsch, we may be better prepared to identify the utopian within the ideological. Benjamin describes kitsch as an "explosive" property of film. He explains, "For developing, living forms, what matters is that they have within them something stirring, useful, ultimately heartening — that they take 'kitsch' dialectically up into themselves, and hence bring themselves near to the masses while yet surmounting the kitsch."[63]

The phrase "brushing history against the grain" evokes the symptomatic reading of melodrama as a modernist form (Brooks, Geoffrey Nowell-Smith, Elsaesser, Mulvey), but it is also a phrase used by Walter Benjamin in his essay "On the Concept of History." In fact, it is fundamental to Benjamin's notion of cultural history, which he elaborates in more methodological detail in his 1937 essay on Eduard Fuchs. In Fuchs, Benjamin recognizes the appreciation of "anonymous artists" and the mass arts that refute the cult of the leader embodied in the fetish of "the master's name."[64] Writing in 1937, Benjamin imputed a certain urgency to a critical methodology that would "blast apart" the historicist's method of studying cultural history as an "inventory which humanity has preserved to the present day."[65]

MELODRAMA, ALLEGORY, AND THE FRAGMENT

> Just as tragedy marks the transition from historical
> to dramatic time, the mourning play represents the
> transition from dramatic time to musical time.
>
> Walter Benjamin, "*Trauerspiel* and Tragedy,"
> in *Selected Writings*, vol. 1

Both *Kristall* and *Home Stories* are inventories, on one level, of the gestures and behaviors typical of melodrama. As collections of scenes and shots, they underline the formulaic repetitions of genre cinema; at the same time, something of the affective register of these gestures is nevertheless preserved, precisely in the signs of mediation that interfere with the "directness" of conventional melodramatic language. In *Home Stories*, Müller has retained the video "noise" and pixilation of the material borrowed from broadcast TV. Despite his use of full-blown movie music enhancing the themes of suspense,

Lee Marvin and Angie Dickinson in *Kristall* (Christoph Girardet and Matthias Müller, 2006)

melancholy, and despair, we are still seeing through a veil of technological media. In *Kristall*, the mediations are created through the digital effects that enhance the fragility of the image as the soundtrack tinkles with delicate sounds of crystals and jewels that almost seem to be produced by the shiny surfaces of mirrors and women's jewelry. Both films are thus not only about the imagery of melodrama — women in their bedrooms, men and women expressing fear, desire, anxiety, and melancholy — they also play with the representational strategies of the genre, including reflections, music, and repetition.

In *Kristall*, the appropriated images are crystal clear in their reproductive glory, with high-contrast shadows, glowing colors, and deeply constructed spaces, but the digital effects make them appear tangible, fragile, and unstable — surfaces vulnerable to breakage and dissolution. These signs of mediation operate as an overlay, preserving the melodramatic language of gesture as being on the verge of disappearance; the images are ruins of their former selves, as if they were transient. Thus, even though this is not celluloid, Girardet and Müller endow the images with the sense that they are being rescued, and temporarily salvaged, from amnesia. Moreover, the film suggests strongly that this effect of loss, melancholia, and redemption is an effect of the melodramatic mode itself.

In Peter Brooks's influential account of the "classical melodrama" of the early nineteenth century, he describes it as a play of "pure, exteriorized

signs."[66] For him, melodrama "handles its feelings and ideas virtually as plastic entities, visual and tactile models held out for all to see and handle."[67] It partakes of a form of excess for the sake of a directness of expression that is not available by other means: "Desire cries aloud its language in identification with full states of being. . . . Desire triumphs over the world of substitute-formations and detours, it achieves plenitude of meaning."[68] He goes so far as to say that the language of gesture in melodrama cannot be accounted for by semiotics: the signifier and signified are overlayed. Melodrama is, finally, a language without a code, or at least for Brooks, it points to the possibility of such a "naturalized" mode of expression, even if there remains a gap, a break in meaningfulness that, as a modernist mode, remains incomplete: "In the gap of the language code, the grandiose, melodramatic gesture is a gesturing toward a tenor both grandiose and ineffable. Consequently, it is inaccurate to speak of *decoding* such a gesture; we must rather *decipher* it, follow its directions, rename its indications in our translation."[69]

The 1950s film melodramas sampled by Girardet and Müller are in many ways a different form than the theater productions discussed by Brooks, especially in their reconfiguration of Manichean polarities. Moral oppositions are far less clear-cut, and virtue is often recognized too late or not at all. Melodrama of the 1950s is more often about the failures of liberal idealism. As Thomas Elsaesser explains, "The best American melodramas of the fifties [are] not only critical social documents but genuine tragedies, despite, or rather because of, the 'happy ending': they record some of the agonies that have accompanied the demise of the 'affirmative culture.' "[70] By the time melodrama became recognized as an American art cinema, and directors such as Douglas Sirk and Vincente Minnelli were championed as auteurs, some decoding had clearly been going on. Melodrama was redeemed, in other words, when it was read "against the grain" and became ironic. As Linda Williams has noted, the capacity of melodrama to generate emotion in audiences was somewhat overlooked in favor of its formal tropes of excess and its critical ironies[71] — thus Elsaesser's use of the term *best* to distinguish good melodramas from bad. In fact, melodrama is a place where both pathos and critique can be located, and as a modality (rather than a genre), it has key effects of doubling and critical distance precisely because of its play with visual, nonlinguistic language that gives it an openness and directness drawing on the powers of desire and psychological expression.

By breaking melodrama down into its component parts of direct expression, amplified through ritualistic repetition, *Kristall* enables a recognition of

the struggle that lies at the heart of melodramatic language. It is a struggle for ethical and moral recognition that is almost by definition blocked by repressive forms of cultural institutions — and its critical potential lies precisely in the illumination of those forces of repression. In the fragmentation of melodrama, I would like to suggest, it becomes an allegorical modality that we can further link to strategies of pastiche, irony, and critique. At the same time, the experiential values of kitsch and innervation that Benjamin associates with film are still operative. In fact, as an allegorical form, the inherent parallels between Benjamin's theory of allegory, as he developed it in his book *The Origin of German Tragic Drama* (*Trauerspiel*), and film melodrama are arguably brought to light.

In the *Trauerspiel*, Benjamin was writing about German Baroque drama, produced in the seventeenth century, one hundred years before the French melodramas analyzed by Peter Brooks. However, both writers describe their respective theatrical styles as dissolving or evolving eventually into opera in the later part of the nineteenth century.[72] *Trauerspiel* and classical stage melodrama are perceived as fallen forms of mythic tragedy in which myth and heroism have given way to more secular forms grounded in history. Both are described as modes of writing that express truth and knowledge that are unavailable to spoken and written language. Benjamin and Brooks render their respective theatrical styles as already modern, or perhaps as having deep affinities with modern styles that are only perceptible in their afterlives, from the perspective of modernity.

Although both are dealing with modes of tragic drama in which heroism is displaced by secular issues of morality and ethics, a key difference is that Brooks's melodrama is considerably more sunny, with the triumph of virtue emerging from the machinations of evil and the resulting confirmation restoring the balance of civil society. Benjamin's version of tragic drama is more bleak, although he certainly recognized the key role of the "allegory of resurrection" by which Christianity appropriated the allegorical mode. He is interested in the underlying signification of death and damnation within the drama of salvation and redemption, which he argues is the privileged realm of allegory. In the "about turn" of the resurrection, allegory loses its melancholy immersion, its indulgence in the world of things, including the bones and ruins of bodies and buildings.[73] George Steiner points to the influence of the Warburg Institute on Benjamin's theorization of *Trauerspiel* as a fragmentary form.[74] Brooks's melodrama is not a fragmentary form but it is highly technological, exploiting all the latest dramaturgical effects of lighting and staging mecha-

Kirk Douglas in *Kristall* (Christoph Girardet and Matthias Müller, 2006)

nisms to produce sensational effects. The transition of melodrama from stage to screen in the silent era also took advantage of the full repertoire of film technologies, including montage (especially cross-cutting) and lighting for sensational dramatic effects, highlighting ethical conflicts and moral quandaries.[75] Postwar film melodrama in the hands of directors such as Sirk and Minnelli, however, begins to be less and less "resolved" and more and more "excessive," giving rise to a complex modality that critics have long judged to be "Brechtian," while the spectacular effects have kept the mode more or less mainstream.[76]

For Benjamin, the *Trauerspiel* becomes a form of writing for the allegorist; it lends itself to allegory, even while it can also lend itself to salvation and redemption, the happy ending of the resurrection. *Trauerspiel* is inherently double, and is thus the basis of Benjamin's theory of criticism as a mode of mortification: "Allegories become dated, because it is part of their nature to shock. If the object becomes allegorical under the gaze of melancholy, if melancholy causes life to flow out of it and it remains behind dead, but eternally secure, then it is exposed to the allegorist; it is unconditionally in his power. That is to say, it is now quite incapable of issuing any meaning or significance of its own; such significance it has, it acquires from the allegorist."[77] Benjamin's theory of allegory is subsequently developed into the concepts of shock and montage in his analysis of modernity, but in the seventeenth century, the discontinuities pertain to the production of meaning. Christine Buci-Glucksmann also describes

Benjamin's *Trauerspiel* as a metaphor of the world as theater, noting that in the "specific temporality of the baroque . . . the gulf between reality and illusion cannot be bridged: theatre now *knows* itself to be theatre."[78]

For Benjamin, the German mourning play shared something with the Jewish lamentation and offered a space where he could perform an analysis of the role of historical materialism in language. In an early essay, he says that the mourning play (the *Trauerspiel*) is "ennobled by the distance which everywhere separates image and mirror-image, the signifier and the signified."[79] The distance, or splitting, that he refers to is specifically temporal, historical, and mortal: "The mourning play is in every respect a hybrid form. The universality of its time is spectral, not mythic." But it is nevertheless a form based on feeling, sensation, and the immediacy of music: "The mourning play is built not on the foundation of actual language but on the consciousness of the unity that language achieves through feeling, a unity that unfolds in words."[80] *The Origin of German Tragic Drama* is not only a critique of Romanticism; it is a development of Benjamin's theory of language on the horizon of modernity. Thus, as Rochlitz puts it: "The allegorical turns out to be a poetic response to the degradation that language undergoes in the instrumental conception that modernity gives to it."[81] In other words, Benjamin sketches the contours of a language of sensory expression that is unfixed in codified language, a language that can articulate truths that are unavailable or inexpressible in spoken language. This language has more recently been taken up by various theorists as a language of gesture.

The parallels with Brooks's theory of nineteenth-century melodrama pertain to the ways in which the language of gesture evolved into late twentieth-century cinema. The tropes of the "text of muteness," "the aesthetics of astonishment," and "the melodramatic imagination" have clearly been translated into new technologies of representation, often through strategies of remaking, revisiting, and reworking melodramatic conventions: Luchino Visconti's appropriation of opera in *Senso* (1954), Derek Jarman's appropriation of Caravaggio in *Caravaggio* (1986), Martin Scorsese's appropriation of nineteenth-century painting in *The Age of Innocence* (1993), and Todd Haynes's appropriation of Sirk in *Far from Heaven* (2002), not to mention Rainer Werner Fassbinder's seminal appropriation of Sirk in *Ali: Fear Eats the Soul* (1974). These texts exemplify the mortifying effects of melodrama as a critical form of allegory — and many more examples could be offered as well.

Both Benjamin's allegory and postwar film melodrama are fallen forms, pointing to historical failures and disappointments within a language of

nonverbal signs, including gesture, music, and tableau. The unspoken "noumenal" realm of meaning that is Brooks's "moral occult" is in many ways a cipher for Benjamin's aura that is produced in the shocks of dialectical montage — which is to suggest, on the one hand, that Benjamin's theory is itself melodramatic; and, on the other, that Brooks's aesthetics may point to the linguistic character of archiveology. The return to the classical period on the part of so many filmmakers has effectively transformed the Hollywood archive into an inventory of fragments and ruins that can speak to the many failures and disappointments of the past. In keeping with Benjamin's historiography, these allegories of hell may enable us to conceive of a different kind of cinema of the future.

Christine Gledhill has suggested that melodrama is best conceived as an "umbrella genre" for the classical cinema that enables us to recognize its central role in negotiating social and cultural conflicts and differences, and is thus more of a mode than a genre: "The notion of modality, like register in socio-linguistics, defines a specific mode of aesthetic articulation adaptable across a range of genres, across decades, and across national cultures."[82] For her, "genre cinema personifies social forces as psychic energies," which give rise to a process by which melodrama, as a modality, is necessarily double. On one level, "ideologies provide material for symbolic actions" — which is to say that the films are ideologically constructed. On another level, though, "the aesthetic process hands back to the social affective experience and moral perceptions." In other words, melodrama lends itself to misreadings and it can be frequently remade, reconstructed, and reread differently by "audiences, scholars, students, and critics."[83]

To bring this discussion back to the video essay as archiveology, it should be evident that Benjamin's theory of allegory is not simply a concept of the fragment. It is about expressive fragments that may be assembled into a theatrical language that is detached and "fallen" but is nevertheless a language and a mode of writing. It is not "dramatic" as tragedy is but spectacular, with significantly different implications for spectatorship: "The spectator of tragedy is summoned, and is justified, by the tragedy itself; the *Trauerspiel*, in contrast, has to be understood from the point of view of the onlooker."[84] As a form of expression, it embodies a temporality of mortification in which the more dead it is, the more meaningful it becomes, and of course, vice versa. Gledhill's concept of double articulation is a means of perceiving the film fragment as belonging to another point in time, while gaining significance in its new contexts of production and reception.

PHOENIX TAPES: THE PHANTASMAGORIA IN RUINS

Cinema leads images back to the homeland of gesture.

Giorgio Agamben, *Means without End*

Benjamin's concept of destructive criticism is particularly relevant to Girardet and Müller's video essay *Phoenix Tapes* (1999), a six-part analysis of forty films of Alfred Hitchcock. While on one level the video is clearly about patterns and themes specific to Hitchcock, even the psychology of the auteur himself, it may also be read as an analysis of the cinematic phantasmagoria more generally. Hitchcock was the seminal figure in the elaboration of psycho-semiotic film theory for good reasons, and the "ruination" or dissection of his practice in *Phoenix Tapes* arguably has significant implications for the archiveology of the classical mode in general.

In the six different sections of *Phoenix Tapes*, the human body is caught up within the cinematic apparatus in contrasting ways. Each episode or "tape" of the work, which originated as a six-channel installation, features what Benjamin would describe as an interplay between technology and humanity. As Federico Windhausen has aptly put it, Girardet and Müller effectively reorder the jigsaw pieces of Hitchcock's extremely precise shooting style through a "formal intricacy" that is "indicative of an incisive understanding of the ways in which the viewer's attention can be guided." *Phoenix Tapes*, he argues, "builds up the connotational richness of Hitchcock's sounds and images in individual units."[85] The collection of puzzle pieces drawn from Hitchcock's oeuvre are fragments of film language that not only feature images and sounds but convey the experiences of anticipation, duration, and anxiety that are characteristic of the cinematic spectatorship constructed in the classical mode.

Phoenix Tapes is thus an example of critical cinephilia in the precision of its analysis and its destruction of the phantasmagoria. Moreover, insofar as the filmmakers have included some of the less well-known and less well-regarded of Hitchcock's films, including quite a number of titles from the 1930s and later films such as *Topaz* (1969) and *Torn Curtain* (1966), the video indulges in the kitschier end of the oeuvre. As a study of film language and as an exemplary video essay, *Phoenix Tapes* underscores the role of gesture in the human-apparatus interface of the phantasmagoria in ruins. For Benjamin, the actor serves as a kind of canary in the coalmine of technology, testing the limits of humanity within the apparatus, providing spectators with an opportunity to

confront their own self-alienation within technical modernity.[86] The audience may be able to control the body in the machine by reassembling the pieces of the performance, but the advantages of this control will only be apparent once film has "liberated itself from the fetters of capitalist exploitation."[87] Violation of copyright and the appropriation of industrial products by the avant-garde may be precisely the opening that is required. *Phoenix Tapes* was in fact commissioned by Modern Art Oxford as part of a Hitchcock exhibit (with credits for the film titles at the end), and, like Marclay, presumably bypassed the copyright issue by virtue of the gallery context.

The first episode of *Phoenix Tapes*, "Rutland," consists of long shots and establishing shots, figures in "grounds" such as Cary Grant in the cornfield and Paul Newman crossing the ornate floor of the Alte Nationalgalerie in Berlin in *Torn Curtain* (both of these shots are repeated several times). A sparse soundtrack and black-out inserts add an eerie atmosphere to this episode, with footsteps echoing in empty rooms accentuating the emptiness of the spaces. Shots of directional arrows only add to the disorientation of the viewer, who is not drawn into the spaces but offered a series of differentiated architectural, geographic, and urban spaces through which various characters (or actors) in various films move. The gesture performed in "Rutland" is the gesture of the body in space; the affinities between architecture and cinema are foregrounded in the ways that disparate shots repeatedly fail to draw the viewer into a diegetic space. We fail to follow the actors but they are nevertheless swallowed up into their respective spaces by virtue of camera movements and angles.

In "The Burden of Proof," Girardet and Müller use sound more functionally than in the first episode. Here we move into close-up as each shot features an object, a body part, or a thing. The repertoire of thinglike shots is similar to that of () a.k.a. *Parentheses* with the addition of sound — an addition that renders the shots more sensory and experiential so that they are not only a collection of objects but also a collection of effects. We hear fragments of voices and the sounds of texture and the weight of objects as well as bits of soundtrack music that are frequently familiar. Many shots include the hands of characters in action, packing suitcases, opening doors, writing notes, driving, or handling objects of various kinds. The inventory of things — including notes, cards, and lists — that circulate in Hitchcock's oeuvre is remarkably similar to Morgan Fisher's inventory in (). The sequence once again underlines the thinglike status of a shot in archive-based cinema. But it also takes the alignment further, to underscore the role of gesture.

Phoenix Tapes (Christoph Girardet and Matthias Müller, 1999)

Phoenix Tapes (Christoph Girardet and Matthias Müller, 1999)

When Agamben writes that "cinema leads images back to the homeland of gesture," he is inspired by Benjamin's notion of the dialectical image. Gesture is the means by which the image reaches beyond itself "to a whole of which it is a part" — but only in the form of an antinomy, the other half of which corresponds to the "recollection seized by voluntary memory."[88] The image as gesture is at once "isolated" or marked by its pastness and at the same time infused with the magic of a potential awakening to new meaning.[89] For Agamben, gesture not only intercedes between means and ends; it also constitutes a mode of communication: a "communication of a communicability." The gesture, he says, "has nothing to say because what it shows is the being-in-language of human beings as pure mediality."[90] The "pure mediality" of cinematic gesture is, moreover, derived by Agamben from Benjamin's theory of language that is not reducible to any particular grammar.[91]

Hitchcock's mobilization of the cinematic image for a mode of powerful seduction is deconstructed in part 3 of *Phoenix Tapes* — "Derailed." This section is entirely in black and white, including segments from films originally in color such as *Vertigo* and *Marnie*, and is accompanied by a continuous soundtrack of sampled sounds from the movies, with screeching train wheels featured prominently. Returning repeatedly to a looped segment from *Spellbound* in which Gregory Peck is sleeping, dreaming, and waking, the episode has a dreamlike, trance-like effect, despite the disparate images. The power of cinema is evoked by the speeding trains, the falling bodies, and the zombielike crowds staring back at the camera. The episode strongly evokes Benjamin's concept of "innervation" in its surreal conjunction of trance, suspense, fear, and thrills. At the same time, the mechanisms of such an appeal are laid bare and aligned with industrial modernity. The elimination of color tends to assign this sequence to prewar cinema (or pre-1950s cinema) and the interwar period in which Benjamin himself was immersed.

"Gesture" in this sequence corresponds not only to bodies interacting with the apparatus but spectators as well, drawn into and repelled by the river of images that includes men falling from trains (*The Lady Vanishes*), from high buildings (*Vertigo*), and into the bottomless abyss of the dreamwork (*Spellbound*). The episode also includes shots of anonymous expressionless faces and multiple close-ups of actors/characters. For Agamben, the face is a special kind of gesture, as the mask that strategically mediates between truth and simulation. It is a key mode of revelation of language itself and the means by which language appropriates nature.[92]

Phoenix Tapes (Christoph Girardet and Matthias Müller, 1999)

Agamben's theorization of gesture, in which he draws not only on Benjamin but also Debord and Warburg, two other proponents of the collage mode, is directed toward a utopian form of communication in which human experience would flourish without sovereignty or political straitjackets: "Politics is the sphere neither of an end in itself nor of means subordinated to an end; rather, it is the sphere of a pure mediality without end intended as the field of human action and of human thought."[93] An audiovisual work such as *Phoenix Tapes* is not going to single-handedly introduce the kind of language that Agamben imagines, but it might be a place where we can "encounter our own linguistic nature inverted."[94]

Thomas Elsaesser has described *Phoenix Tapes* as the "optical unconscious" of genre cinema. This dimension of the video emerges in episodes 4 and 5, "Why Don't You Love Me?" and "The Bedroom," where the gender dynamics of Hitchcock's cinema are brought to the fore. As Elsaesser notes, the "compulsive repetitions of identical gestures, identical turns of phrase and facial expressions," are not only common to the work of a single auteur but point to deeper anxieties and desires within the larger corpus of genre cinema. While the monstrous

mothers that appear in episode 4 are perhaps more symptomatic of Hitchcock than of any other director, the Oedipal drama is endemic to American cinema.

"Why Don't You Love Me?" features the repetitive "nursery rhyme" from the end of *Marnie*: "Mother, mother, I am ill" is played over the many Hitchcockian protagonists with domineering mothers. The misogyny with which this episode concludes underlines the intrinsic relations between violence and sexual anxiety that underscore Hitchcock's cinema and, arguably, the thriller genre more generally. Joseph Cotton in *Shadow of a Doubt* is juxtaposed with the skeletal mother from *Psycho*, after which hysterical laughter and circus music carry over a series of male protagonists, each of whom we may recall as being slightly psychotic, ending with a man in blackface, as if to underscore the perversity that underlies this form of entertainment. And yet the critical perspective that this video opens up can also lead to the showcasing and recognition of some of the outstanding character actors who played Hitchcock's monstrous mothers, including Jessie Royce Landis (*North by Northwest*), Leopoldine Konstantin (*Notorious*), Marion Lorne (*Strangers on a Train*), and Louise Latham (*Marnie*). These are women whose performances have been historically overlooked, and the video has created a critical cultural space whereby they can be named, recognized, and "revealed." In archival film practices, when we recognize faces they are more often of actors than characters — or we may be led to inquire who the actor is, rather than who the character is. Familiarity tends to trump fiction, supporting Agamben's observation that the face offers a kind of opening into communication.

In episode 5, "Bedroom," the women are more often recognizable stars (Tippi Hedren, Grace Kelly, et al.) and so are the men, although toward the end of the episode, bodies become more prominent than faces. This section of *Phoenix Tapes* is another variation on the theme of *Home Stories* and *Kristall* — women in the boudoir. This time, the series escalates slowly, as kissing scenes transition to women looking extremely concerned over the shoulders of the men they are embracing. The soundtrack begins with silence and gradually builds up a grinding, mechanical, threatening rhythm. (Dirk Schaefer, who scored *Kristall*, is credited for the soundtrack for this episode.) The anxiety culminates in a rapid finale of shots suggesting that women are being strangled, raped, and killed, ending with a bangle-adorned arm falling limp with a brief jangle.

Is this a critique of the systemic sexual violence of Hitchcock's cinema? Or is it an observation of it? Girardet and Müller are well versed in Hitchcock scholarship, including the psycho-semiotic critique that proliferated in the 1980s,[95] and so there is no reason not to read the sequence as a critique. Rather

Phoenix Tapes (Christoph Girardet and Matthias Müller, 1999)

than construct a logical argument, the video is persuasive in its mobilization of evidence that speaks "directly" to the viewer, rather than through the density of theoretical or critical jargon like this.

The final episode of *Phoenix Tapes*, "Necrologue," tends to confirm a feminist reading and takes us back to the critical ambiguity of the phantasmagoria. A single shot of Ingrid Bergman in *Under Capricorn*, lasting four minutes, is held in silence. She is lying down, shot in extreme close-up, with one eye in shadow and the other staring back at the camera, a tear slowly moving down her face. She blinks twice before her eye finally closes in a freeze-frame. The character Bergman plays in *Under Capricorn* is dosed with laudanum, and that drugged state is exaggerated by the manipulation of the image. At the same time, she stares back from her prison world of somnolent screen time in an accusatory fashion, implicating the viewer in her predicament. Following from the violence of the previous episode, it operates as both a desperate plea for redemption and a gesture of helplessness and resignation.

Anaesthetics were, for Benjamin, the obverse side of modernist aesthetics. In Susan Buck-Morss's cogent analysis of Benjamin's thought, including

Phoenix Tapes (Christoph Girardet and Matthias Müller, 1999)

his experiments with hashish, she points out that for Benjamin, both drugs and the phantasmagoria of modern display culture entail a mediation of the senses. They both create an illusory world without pain, and as the "intoxication of phantasmagoria" became the norm, "sensory addiction to a compensatory reality becomes a means of social control."[96] Art can combat this effect through techniques of destruction, fragmentation, and confrontation with pain. However, Buck-Morss further argues that modern techniques of fragmentation are easily and often reappropriated into the phantasmagoria of surface images (and the narrative cinema associated with Hitchcock is a perfect example of this). She offers an analysis of Nazi propaganda to support her analysis, underscoring Benjamin's own historical catastrophe and prescient critique. She concludes with the thought that fascism is the "afterimage" of a social apparatus of anaesthetics in which experience has been shut out.

In the case of Bergman's gentle yet disarming gaze from within the cinematic trance and dreamlike appropriation of Hitchcock's cinema, we are perhaps offered the opportunity to stare back and seize the connection to a history of cinema strewn with corpses and scenes of abuse. How the viewer

responds to this challenge depends entirely on their critical stance and their willingness to engage in the kind of destructive criticism that Girardet and Müller propose in *Phoenix Tapes*. The disorientation of the first two episodes is finally redressed as a challenge to the viewer to endure, to spend time, to be bored without any narrative bearings at all. The "playful innervation" that Benjamin recognized as the potential of a political cinema is furthermore laid out here precisely as a mode of allegory. Bergman's body, her eye, her dyed hair, and her dopey gaze are hers alone — and they are those of all the women violated in Hitchcock's world. Can we see ourselves in Bergman's passive gaze? As the paragon of the cinematic apparatus, Hitchcock's domineering and controlling gaze is overshadowed in this necrological epilogue by the gaze of one of his victims.

In her discussion of *The Clock*, Catherine Fowler describes Marclay's practice of "replaying" film images as being predicated on the mode of gesture, not only because of the imagery of hands and bodies in motion but also because of the craft of editing, which, like DJ-ing, is done with the hands. She draws on the work of Vilém Flusser, for whom gesture pertains not only to "making" but to a range of activities, including searching, filming, writing, loving, and so on. Fowler argues that Flusser's correlation between gesture and thought can help explain the relation to history that is produced in archive-based film practices such as those of Girardet and Müller, Marclay, and many others: "Taking other people's movies into their own hands, these artists grasp and seize gestures, observing how they mediate between the film's past and the viewer's present. Replaying these gestures, these artists attempt to comprehend and apprehend the impact of gesture at a given time and the impact it has had through time."[97]

Flusser's theory of gesture is remarkably in tune with those of Benjamin and Agamben, as a kind of interface of humanity and technology. Moreover, gesture for Flusser is a kind of "transport" that is intimately related to the critical act in an era in which "truth" is less valid, less useful, and less apparent than affect. Gesture is never empty, but like the production of meaning in melodrama, it is predicated on a broken language of symbolism, an ironic modality in which metalanguage is the only language. For Flusser, the "criticism of affect" "could become less subjective and one day — certainly with great effort — arrive at an interpretation not only of kitsch but also of those great moments in which humanity confers meaning in its actions and suffer-

ings."[98] The appropriation of classical Hollywood by the avant-garde might thus be a venue to this goal, or at least it represents a great effort that might be read as such. Like Benjamin, Flusser advocates a "second technology" insofar as "beyond the apparatus, there is nothing to do."[99] If gesture constitutes a mediation between present and past, in archiveology, the actor offers a "transport" that is deeply melodramatic, laden with the affect of a lost past. In archiveology, the romance of nostalgia can be replaced by a critical melancholia through the work of gesture: which is to say, an intervention designed to ruin the phantasmagoria and re-collect its failed aspirations, its sensory mode of experience, and its ethics of pain and suffering.

6

AWAKENING FROM THE GENDERED ARCHIVE

> For fashion was never anything other than the parody
> of the motley cadaver, provocation of death through the
> woman, and bitter colloquy with decay whispered between
> shrill bursts of mechanical laughter. That is fashion. . . .
> Now, finally, she is on the point of quitting the field. But he
> erects on the banks of a new Lethe, which rolls its asphalt
> stream through arcades, the armature of the whores as a
> battle memorial. □ Revolution □ Love □
>
> Walter Benjamin, *The Arcades Project*

Walter Benjamin's urgent call for an awakening from the dream of the phantasmagoria has implications for many humanist wrongs to be righted, and in his worldview, the most pressing was that of class. He seemed more or less oblivious to racial, ethnic, and gender inequities (with the important exception of Jewish identity), and yet he was perceptive to their presence within visual culture. From the perspective of the early twenty-first century, we can certainly add a long list of humanist inequities that desperately need to be redressed through techniques of awakening, détournement, and remediation. However, given the deep-seated gendering of twentieth-century image culture and the systematicity of misogyny within its archive, the most urgent and immediate mode of awakening pertains perhaps to the détournement of woman's image. Such an awakening would aim at a restoration of women's subjectivity, agency, and labor in the construction of the phantasmagoria. To think of awakening as a technique and not simply a theme or a metaphor, we need to perform a dialectical reading of the image through archiveology as a language of image history. In this chapter I explore the potential of such an awakening through the examples of *Rose Hobart* (Joseph Cornell, 1936) and *The Three Disappearances of Soad Hosni* (Rania Stephan, 2011), following a discussion of some key works by Chris Marker and Agnès Varda.

In a perceptive account of archival film practices by prominent artists such as Bill Morrison and Gustav Deutsch, Paul Flaig has pointed to the various

ways that media archaeology has a tendency to perpetuate the gendered structure of the media archive itself. The erotic dynamics of a "masculine archivist and the feminine body of the archive," he points out, are directly acknowledged in Derrida's term *patriarchive*, through which Derrida designates the Oedipal dynamics between loss and restoration that underscore archive fever. Flaig argues that "the medium of film has often been made to matter through patriarchal projection, an anxious yet utopian attachment to an antique cinema supposed as a lost feminine object."[1] Indeed, a woman's image is frequently found as a "support" for many filmmakers' investigations of found footage. In addition to the films that Flaig discusses, *The Film of Her* (Bill Morrison, 1997) and *Film Ist: A Girl and a Gun* (Gustav Deutsch, 2009), one could also point to *Marilyn Times Five* (Bruce Conner, 1973) and *Variations on a Cellophane Wrapper* (David Rimmer, 1970) as examples of woman standing in for "film." The recurring quotation of scenes from *Vertigo* in films by Godard and Chris Marker and the iconicity of Janet Leigh in the shower scene from *Psycho* underscore the gendered organization of the archaeological investigation of film history.

In the archive-based films of Jean-Luc Godard and Guy Debord, we find a conflicted recognition of the primordial role of the male gaze in mainstream cinema; both films launch a critique of its mechanism, and yet in both *Histoire(s) du cinéma* and *Society of the Spectacle*, the critique arguably fails to convince. Showing images of women is not in itself a strategy of critique, even when it is labeled "Fatal Beauty," as in section 4B of *Histoire(s)*. Kaja Silverman argues that Godard struggles in *Histoire(s)* to awaken from the dream of the nineteenth century, but if he does so, the awakening is oblique, as he repeatedly fails to "extrapolate a nondialectical sociality from a generalized femininity."[2] Despite his struggle to interrupt the dream factory in the many ways that Silverman itemizes, Godard's own subjectivity ultimately obscures any awakening from the dream sleep of the image factory. His recognition of Anne-Marie Miéville as his interlocutor may, as Silverman argues, constitute a recognition that his own subjectivity is subordinate to the "redemptive potential of the heterosexual couple," but it is hardly a rejoinder to the thorough demonstration throughout his epic archival work that 50 percent of the human race has been undone by cinema. Recognition of the fundamental I-you relation of sociality may indeed challenge the sovereignty of the auteur, but it remains a personalized intervention, as if Godard himself were limited by his own investment in cinema.

In Debord's case, over a montage of swimsuit models and other magazine images of women in *The Society of the Spectacle*, he says, "The fetishism of

the commodity — the domination of society by 'intangible as well as tangible things' — attains its ultimate fulfillment in the spectacle, where the real world is replaced by a selection of images which are projected above it, yet which at the same time succeed in making themselves regarded as the epitome of reality." Although he claims that he is engaging in a détournement of these images, in fact he seems almost to be blaming the women themselves for their role in the alienation of human relations. For more critical forms of détournement, we should turn to the important work of many women filmmakers working against this paradigm. In particular, Peggy Ahwesh's *The Color of Love* (1994) and Sue Friedrich's films *The Ties That Bind* (1985) and *Sink or Swim* (1990) are important examples of archival film practices that challenge and actually reconfigure the gender norms of historical film practices, including both pornography and home movies. These are works that extract feminine subjectivities and desires from the archive and work toward affective aesthetic relations between spectator and image — as opposed to Debord's technique that tends to exaggerate the alienation effects of the spectacle by transforming the archive into an aggressive assault on the spectator.

Chris Marker's *La Jetée* (1962) is neither a found-footage film nor drawn from an archive, and yet its collage structure and themes of memory, museums, time travel, and photography align it closely to archival film practices. Its discourse of gender may help us follow the trail of a feminist aesthetic that is produced within the interrupted, "heretical archive" described by Domietta Torlasco. For Torlasco, the heretical archive is one where chance and purpose meet; it is fluid, without inside or outside; it is a kind of unraveling of enunciation.[3] Marker's photomontage seems to be constructed from a collection of images, assembled into the story of a man lost in time, or lost to time. At the center of this film, a woman awakes, her opening eyes the single movement in a film made otherwise of still images. Victor Burgin has described this irruption in *La Jetée* as a screen memory. The woman in the image, the woman the man subsequently encounters, is indeed "woman as image."[4] In the twisted logic of the film's narrative, the woman is probably dreamt by the man, and in the labyrinthine layers of this dream, she is both lover and mother, witnessing the primal scene of the dreamer's death. The narrator says, before the sleeping, waking sequence: "He never knows if he directs himself towards her, if he is directed, if he invents her, or if he is dreaming."

The gender dynamics in this film of subjective dreamer and object of desire, woman-as-image, are explicitly based on Hitchcock's *Vertigo*, and Marker has done little to question or upset these dynamics, except for this fleeting gesture

La Jetée (Chris Marker, 1962)

of opening eyes. I would like to suggest that this interruption of the woman's presence in *La Jetée*, which is the only articulation of presence or present time in the film, points to the heretical archive that *La Jetée* radically represses. The awakening constitutes a violence against the "house arrest" of the archive, overdetermined in *La Jetée* by the immobilized dreamer whose memory has been appropriated by some kind of military-industrial prison camp. The waking woman is exemplary of what Torlasco describes as a subterranean or latent audiovisual modernity that is produced specifically within a "disorder of time" and a "disorder of media" — even if in this instance the media in question are film and photography.

Burgin notes that *La Jetée* has proved to be a compact and powerful generator of inexhaustible meanings; and he questions the film's own lesson: "There is no escaping time."[5] In fact, the waking woman does appear to be escaping time, especially when we cast a feminist gaze on this assemblage of all-too-familiar narrative conventions of gendered perception. If there is a zone between psychology and phenomenology, as Torlasco suggests, it may be glimpsed here in this fleeting moment in this canonical collage film when the woman takes her own time within a museum of memories. The actress Hélène Chatelain may have been forgotten, but her look remains intact.

Agnès Varda's films of the first decade of the twenty-first century provide one of the most sustained feminist interventions into archival film practices,

The Gleaners and I (Agnès Varda, 2000)

particularly *The Gleaners and I* (2000), *The Gleaners and I: Two Years Later* (2002), and *The Beaches of Agnès* (2008). These are far more personal than the collage films discussed in this book, and yet they are important works in the way that they point to the stakes of awakening from the gendered archive. In the first film, Varda explores the practice of "gleaning" (i.e., gathering or collecting) on many levels — through encounters with various collectors and gleaners in France, through her own collections of thoughts and memories — and links these practices to her own use of the digital camera as a tool for gleaning. Two years later, returning to many of her subjects in the first film, *The Gleaners and I* becomes remediated in an archival reflection on Varda's own work. This process of revisioning and recollection is continued in *The Beaches of Agnès*, in which Varda constructs a kind of autobiography through the recycling of clips of her films in a career that began in 1955, alongside various installations and performances produced specifically for the 2008 film.

Varda's archival film practice has been written about extensively and has been the subject of two especially perceptive commentaries by Domietta Torlasco and Homay King. For both critics, Varda's use of digital cinema points

to the potential of archival film practices to articulate a radically new cinema, which would invert the gendered conventions of the patriarchive. Because Varda places herself centrally in these films as a figure of mediation, whose memory is as ephemeral and contingent as her casual, aleatory approach to filming-as-gleaning, she tends to occupy the "border of time" that the archive itself conventionally delineates, thereby challenging its laws of inclusion and exclusion. Torlasco claims that Varda's filmmaking "articulates a heterodox image archive not only through choice of topic but also by virtue of compositional patterns and an editing style that unravel the distinction between subject and object — of recording, classification, and interpretation."[6]

Homay King's analysis of *The Gleaners and I* is focused more on the "materialism" of Varda's method, including the way her aging body is a topic to which she repeatedly draws the viewer's attention. Varda's hands frequently enter the frame as "an agent of linking, a connector to things of the earth."[7] For King, Varda's cinema challenges the ostensible immateriality of digital cinema, using it more as a tool of engagement with the world and with time: "Varda and her gleaners recover, save, and collect things not in order to embalm them but to use them, in the sense of putting them into practice and circulation — be they comestibles, tools, or pictures. Gleaning involves a recognition of transience, not a denial of it."[8]

Both Torlasco and King pause at Varda's invocation of psychoanalysis by way of an encounter with Jean Laplanche. She first visits him in *The Gleaners and I* as a gleaner of grapes; she revisits him in *Two Years Later* to talk about psychoanalysis, which Laplanche declares to be "a form of gleaning" as well. The psychoanalyst, like the gleaner, comes afterward, to pay attention to what could not be understood the first time around, "to what falls from discourse, what is dropped."[9] For Torlasco, this points to the way that Varda practices a "psychoanalysis of the outside, . . . an exhortation to refind our psychic history outside, on the side of things."[10] For King, it is related to Laplanche's theory of enigmatic signifiers that are like "psychical junk" or "base objects from which multiple versions of text may sprout," or "signs that may be recycled many times without ever being 'used up.'"[11] In other words, Varda's practice can be read as a template for the language of archiveology.

Torlasco's analysis of Varda's digital film practice is a key component of her larger argument about the digital archive as a potentially heretical space of inversion. She argues that if the archive of both cinema and psychoanalysis has been conventionally modeled on an Oedipal configuration in which Antigone and Anna Freud have been confined to the outside, the archives of the

digital age "can help us imagine a promiscuous, disorderly, polymorphous legacy, one in which the women of modernist cinema unravel the enunciation that had initially decided their destiny."[12] Her analysis, which also touches on Monica Bonvicini's installation *Destroy She Said!* (1998) and the work of Sophie Calle, is an inspiring critique of the patriarchive. She inquires into the Freudian legacy that informs Derrida's account of the archive in order to find the "Antigonnean" archive of the "future anterior" — a heretical counter-archive of possibility and resistance.

King's analysis is an equally adept review of digital cinema in which its capacity to be rooted and grounded in material culture is examined from a variety of perspectives. In her discussion of Varda, King analyzes Benjamin's critique of Henri Bergson, whose concept of durée eliminated the concept of death.[13] Following Benjamin and Varda, her project is to show how the apparent ephemerality of digital media is nevertheless a tool of memory, which in the process is transformed into something rather close to Benjamin's conception of "memory as medium" in his fragment on excavation.[14] She notes how Varda returns repeatedly to her own work, exploiting the variability and impermanence of digital media. Working counter to aesthetic principles of permanence and completion, Varda continues to make and remake her work in a generative structure that returns repeatedly to variations on previous encounters and recycled footage in a process of endless variability.[15]

We know that Benjamin's own archival method with *The Arcades Project* was terminally incomplete, and the notions of archaeology and collecting that are threaded through his work point repeatedly to the archive as a mode of transmission, an active site of critical recognition. And this is very much due to the harboring of death and loss, the spleen that inflects Baudelaire's melancholia. Shortly after the passage in which he points out the absence of death in Bergson's durée, Benjamin offers one of his many scattered definitions of aura: "If we think of the associations which, at home in the *mémoire involontaire*, seek to cluster around an object of perception, and if we call those associations the aura of that object, then the aura attaching to the object of a perception corresponds precisely to the experience [*Erfahrung*] which, in the case of an object of use, inscribes itself as long practice."[16]

Benjamin seems to anticipate Varda's crafty use of the digital camera as not only handheld but inclusive of her own gesturing hand. Her strategies of inversion and heresy point further to the convergence of mémoire volontaire and mémoire involuntaire. Her version of film language is a full mobilization of the archive as a means of knowing the world. Varda and the critical work

on her late films point to the way in which an archival language may coincide with a feminist critique and a feminist film language. For King, this extends to Varda's ability to relinquish total control and reveal her vulnerability to the contingencies of memory and practice.[17] Once filmmaking is conceived as a process of collecting, it may indeed become "vegetal" and organic, as Elsaesser has suggested — a process of extraction rather than "production."[18] Varda is a unique example of archiveology, and she works considerably more with her original footage than any of the other films and filmmakers discussed in this book. As an active, engaged, and embodied filmmaker, she is an exemplary essayist, whose subjectivity and authorship are foregrounded in a way that appropriation arts tend more often to obfuscate within recycled materials. Nevertheless, as a "heretical" archivist whose practice points to the affective forms of materialism within digital cinema, Varda's late films provide a valuable opening into questions of the gendered archive and its potential transformation through archiveology.

ANTHROPOLOGICAL MATERIALISM
AND FEMINIST UTOPIAS

Although Walter Benjamin's work has been of seminal importance to feminist film theory and underscores key works by Anne Friedberg, Patrice Petro, and Giuliana Bruno,[19] he himself was by no means an advocate for women's rights. As Susan Buck-Morss points out, "The image of the whore, the most significant female image in the *Passagen-Werk*, is the embodiment of objectivity, not subjectivity."[20] The prostitute is emblematic of the commodification of experience in modernity and the alienation of labor and erotic life in industrial capitalism. Benjamin does acknowledge that fashion, as the province principally of woman, holds certain "secret signals" of things to come, but at the same time, he notes that "the feminine collective" is an impenetrable source of knowledge, and he does not count himself among those who could possibly interpret those secret signals.[21]

The dialectical theater of fashion may lie at the heart of *The Arcades Project* as the surrealist gesture within nineteenth-century Paris, but it is a late twentieth-century feminist philosopher who has been able to perform the most convincing dream interpretation of Benjamin's account of the gendered terrain of the arcades. Christine Buci-Glucksmann argues that the "awakening" that Benjamin

repeatedly prophesizes is already inscribed in the feminist utopia that is acknowledged within the many convolutes of his labyrinthine work. She answers Benjamin's query about who can interpret those secret signals with the following list of themes that she has extracted from *The Arcades Project*:

> Women's power over images, the staging of female bodies in the imaginaries of allegory or the protest against modernity . . . all these new territories foreign to the "historicist" reason of progress, all these "primal historical forms" recaptured by "dialectical images" which bridge the past and the now-time. . . . The utopia of the feminine, in all its interpretive excess, might represent this intertwining of time, images and bodies in profane illumination. Benjamin "knew" this with an unconscious knowledge — the knowledge of the labyrinth which guides his archaeological reconstruction of certain imaginaries of the modern and its feminine allegories.[22]

Buci-Glucksmann reaches this conclusion by following several paths through Benjamin's work, one of which is "Convolute p" of *The Arcades Project*, titled "Anthropological Materialism: History of Sects." In this section he collects together a series of notes on nineteenth-century Christian cults and reproduces fragments of the writing of Claire Démar, a Saint-Simonian feminist, "rescuing them from oblivion," and, as Buck-Morss concurs, gives Démar's radical views regarding the termination of patriarchy "serious consideration."[23] Buci-Glucksmann poses the question of the connection between Benjamin's citations of feminist utopianism and the nominal framework of "anthropological materialism." The term refers to an intellectual tradition of the early nineteenth century that preceded Marxism, combining, "paradoxically, a romantic vision of human beings with a scientific vision of material energies" — a theory of modernity in which "physical forces of attraction and repulsion" apply to human society as a collective.[24] Benjamin's gesture toward this neglected discourse is made specifically from the surrealist perspective of interwar Europe. Within his network of "historical constellations," Buci-Glucksmann argues that he places the feminist critique of marriage and Démar's utopian vision centrally, and he brings the modern figure of the lesbian out of utopianism and feminism in order to advocate for a more "mysterious" relation between the sexes.

Miriam Hansen has linked Benjamin's notion of "anthropological materialism" to his theory of innervation. Both refer to "the fate of the human sensorium in an environment altered by technology and capitalist commodity

production."[25] The term actually originates with Adorno as a description of Benjamin's method, which he objected to: "It is as if for you the human body represents the measure of all concreteness."[26] Indeed, the alignment of anthropological materialism with the feminine in *The Arcades Project* has everything to do with the body, although for Hansen, the relevant body is not that of the woman but of the "collective body," which is potentially mobilized through technology, especially film and its mass audiences.

In the convolute on anthropological materialism, Benjamin returns briefly to Baudelaire's idealization of androgyny as the form of the heroic in modernity, but as Buci-Glucksmann notes, while Baudelaire "inscribes the *image* of the lesbian into modernity, Benjamin remains invested in 'anthropology' and therefore experience."[27] In her reading of the *Trauerspiel* (*The Origin of German Tragic Drama*), it is a dramatic anthropology that distinguishes the Baroque from the tragic, "a wager of passion on time, desire and death (sorrow and mourning); which are now liberated from Greek fate and represented in historical terms."[28] Buci-Glucksmann's reading of Benjamin is a process of excavation, a process of finding the "buried feminine [that] lies within experience. . . . It is as if the feminine, with its power of images and imagination, mainly affected the status of writing and experience — or even historical praxis — through its potential for otherness and transgression."[29]

Buci-Glucksmann may be preoccupied with the afterlife of Benjamin's texts, but given that he himself advocates such a method, it seems to me a fair game. One can find clues to the awakening potential of the feminine throughout *The Arcades Project*. In "Convolute O: Prostitution, Gambling," for example, Benjamin notes that "in Prostitution, one finds expressed the revolutionary side of technology." What he describes as "the sexual revolt against love" constitutes a demystification of the family system and its rites of passage.[30] He suggests that prostitutes love the thresholds of new forms of experience in modernity — "experience that surges over thresholds like the changing figures of the dream."[31] He brings together prostitution and gambling in Convolute O not only as preoccupations of the urban scene; they are also forms of play available to adults, in his view (which admittedly overlooks the social infrastructures of exploitation that subtend both prostitution and gambling). When he writes that "love for the prostitute is the apotheosis of empathy with the commodity,"[32] he also points to the obverse, allegorical, transactional relations between men and women implicit in prostitution. It "robs sexuality of its illusions" and transforms it into the energies required to realize the productive potential of technologies in modernity.

Despite the important critical tools that Benjamin has provided for an awakening of women from the archive, no one is claiming that he himself was particularly enlightened about women's emancipation from sexualized social roles. His one documented account with an actress, Anna May Wong, has been taken up in an installation piece by Patty Chang called *The Product Love* in which Benjamin's Orientalist paternalism toward the Chinese American actress is depicted in a complex assemblage of archival pieces, including a looped scene from a 1928 film called *Song* (a.k.a. *Show Life*, dir. Richard Eichberg). In Yiman Wang's view, the work "highlight[s] and problematize[s] the trans-cultural Orientalist erotic charge that underpins Benjamin's befuddled experience of encountering Wong. In this process, Wong's film is reworked not to figure out what or who the real Wong was under the guise of the image, but rather to enhance the image itself as an opaque, sometimes inert, construct."[33]

Chang's multichannel installation engages with Benjamin's curious text on Anna May Wong to challenge his preoccupation with the woman-as-image, and tries to pry apart the historical figure of the actress from the weave of dialogue that Benjamin conceives critically in terms of the image: "I know that I will see her again in a film that will be similar to the weave of our dialogue, of which I say, with the composer Yu-Kai-li: 'The fabric was donned divinely.' "[34] Despite Benjamin's awkward meeting with Wong, one of the few actors he actually discusses in his corpus, he does include an important commentary on film performance in the artwork essay, in which he argues that the actor "takes revenge" on behalf of the audience, against the apparatus with which she is tested. Film technology in this case is placed in the service of the actor's triumph. In other words, film acting is a key site in modernity in which the actor is tested, with the stakes of the challenge precisely the preservation of "one's humanity in the face of the apparatus."[35]

With these brief observations in mind, I want to pursue the question of "awakening" from the archive in the rather specific terms of actresses and performance in archival film practices. As I have already indicated, archiveology can and should be recognized as a language of the archive that can enable us to think through the history of the twentieth century differently. In keeping with Benjamin's concepts of historical dialectics and the afterlives of texts, archiveology provides an opening to redress the gendered operations that inform the media archive.

In *The Arcades Project*, Benjamin uses the term *awakening* in much the same way as he uses the term *refuse of history*, as a pendant or hyperlink following his epigrammatic collection of notes and quotes. For example, when

he counterpoises the mythic and the technological through memory, child-hood, and dream, he finishes the passage with the epigrammatic "awaken-ing"; he also uses it when he compares the "accelerated tempo of technology" with "the primal history of the present."[36] Awakening from the dream of the nineteenth century, Benjamin hoped that technological modernity might provide the dialectical tools to blast apart the phantasmagoria of commod-ity culture. By pitching outmoded dreams and desires against contemporary forms of commodity capitalism, Benjamin imagined a dialectical recognition of the failed promise and potential of technologies for social justice: "The mo-ment of awakening would be identical with the now of recognizability in which things put on their true — surrealist — face";[37] he goes on to quote Proust and Louis Aragon. I would like to suggest that such an awakening is produced in a feminist return to the archives of classical cinema, and that the confronta-tion with a past history of movies that were made under the sign and law of patriarchy can take the form of precisely such an awakening from the archive. Women's work and women's bodies may finally be released from their house arrest.

The motif of awakening in *The Arcades Project* is conceptually linked to auratic experience through the concept of shock. In Benjamin's large textual collage of nineteenth-century Paris, the shock of discontinuity is a kind of moment of recognition, of correspondence between present and past that disrupts the received historical narrative. Aura is likewise defined by disjunc-tive temporality that entails a "dislocation of the subject." Hansen argues that shock for Benjamin "relates to the idea of an involuntary confrontation of the subject with an external, alien image of the self," of which the actor's screen test serves as a key example.[38] Awakening and auratic experience are closely aligned, in other words, as forms of perception produced through techno-logical modernity and not opposed to it. They both have a utopian, messianic impulse behind them — a political urgency that is very specifically located in the realm of images.

ROSE HOBART AS STAR OF THE ARCHIVE

Domietta Torlasco proposes that a heretical archival practice is one that operates as an intervention into the Oedipal structures of institu-tional memory. Archiving as intervention functions as a "re-elaboration of

aesthetics and ideology."[39] Digital memory, she argues, can produce a memory of what did not happen, or the "future anterior" — a cinematic memory that is radically incomplete. Torlasco is interested in dismantling the Oedipal structure of Derrida's analysis of archival fever in order to recognize the unruly and heterodox archives of Antigone.[40] While digital media offers a range of new techniques and tools for this to happen, as we have already seen in the case of *The Gleaners and I*, in fact it is not simply a question of a new technology but a shift of perspective that can and has taken multiple forms.

Torlasco's radical methodology of reading against the grain of the archive might, for example, be retroactively applied to other archival film practices in which actresses challenge their narrative destinies, starting with Joseph Cornell's film *Rose Hobart* from 1936. Torlasco's approach is from the digital turn, but I would argue that its scope may be larger than that and encompasses older works made on film. When she points to a "disorder of media" that coincides with a "disorder of time" to outline a "subterranean or latent audiovisual modernity," I would argue that such a practice has been going on for decades. In the digital era, with its renewed access to canonical films and its tools for remixing, the archive has provoked an awakening that Walter Benjamin arguably foresaw around the same time as Cornell was making *Rose Hobart* in the mid-1930s. Torlasco's concept of possible futures produced through the dialectics of archival imagery is deeply evocative of Walter Benjamin's historiography, particularly in the way that she differentiates transformative repetition from endless cycles of repetition and return, thus pointing to the discontinuities made possible in nonlinear editing, shock effects, and awakening.

In *Death 24x a Second*, Laura Mulvey introduces the notion of the "possessive spectator," which offers another tool for "awakening" women from the archive. She suggests that digital, archival media might challenge the gendered structures of fetishization that she herself theorized in narrative film.[41] *Rose Hobart* is a good example of the sudden discovery of indexicality made possible by the delayed spectatorship of digital media, even if it originated on (celluloid) film. It also illustrates how the uncanniness of the fiction film archive can produce a fragmented "feminized" aesthetic of cinema when the actress is liberated from her narrative constraints. The possibility of "awakening from the archive" is also, on one level, an interpretive strategy, a question of rereading classical narrative cinema in ways that might redeem and rescue the women who subsist there. For example, in Maximilian Schell's experimental documentary *Marlene* on Marlene Dietrich, from 1984, the actress does not appear on camera, except in excerpts of her film performances. In interviews

played over the clips, she is critical and condescending toward many of the roles she played, dismissing them as "kitsch." Indeed, women such as Dietrich and Hobart were far more intelligent and worldly, free-thinking workers than most of their on-screen characters. In archiveology, the fragments and details of classical narrative films might constitute an awakening of women from the long sleep of mid-twentieth-century cinema.

Mulvey argues that the pensive spectator of "delayed cinema" constitutes a different kind of voyeurism in which "details suddenly lose their marginal status." As we have seen, this is an effect often produced in found-footage filmmaking, when people and things are ripped from their narrative contexts. Mulvey notes that stars are more often read as indexes of their own histories. She notes that an actor's extradiegetic presence can intrude, giving the star an "unexpected vulnerability," as if the character can suddenly be seen doubled with the actor playing her.[42] The actors in *The Clock*, for example, seen at various stages of their careers, illustrate this vulnerability exposed by the compilation method. Mulvey also discusses the "pensive spectator" as one produced by new technologies of viewing in which the "now time" of narrative fiction is always already a past time, producing "shifts of consciousness between temporalities."[43]

Both the pensive and the possessive spectator are invoked by archiveology as a mode that invites a viewing practice that is at once retrospective and imaginative. Filmmakers have done the initial work of delaying and possessing, but the spectator is key to the effects of punctured narratives, fragmented plots, and the surprising irruption of the indexical sign. The interactive spectator enabled by new technologies is furthermore motivated by the "automaton" of the woman caught in the narrative machine. She "returns in a double sense, first as the site of castration anxiety, this time threatening the 'body' of the film itself, and secondly as metaphor for a fragmented, even feminized aesthetic of cinema."[44] It is precisely this "possessive spectator" who may be able to recognize the "extradiegetic presence" of Hobart's performance and glimpse the woman before the camera, stripped of the accoutrements of character.

Joseph Cornell's *Rose Hobart* is an early and influential example of found-footage filmmaking, and although his intention may have originally aligned somewhat uncomfortably with those of a fetishist, I think the work is "open" enough to warrant alternative readings that can realign it with the "heretical archive" of archiveology. In his delayed, scrambled, discontinuous fragmentation of the original narrative of the 1935 Hollywood film *East of Borneo*,

Rose Hobart (Joseph Cornell, 1936)

Cornell renders Hobart as a ghost in the machine, isolating fragments of her performance within a tinted landscape of exotic decor. Instead of being an action heroine, rescuing her husband from the jungle and escaping the advances of a lecherous sultan, Hobart is reduced to a woman caught in the frame, silenced, and incapacitated. (In fact, even in the original female-centered action film, Hobart's character Linda Randolph ends up reconciled with her drunken philandering husband, who really did not deserve to be rescued from the many dangers of Borneo.) It is significant that Cornell's treatment of Hobart features few close-ups and favors medium and long shots in which her body is more or less intact and not broken down, as some of his surrealist contemporaries were wont to do. The film shares an oneiric quality of the dreamwork of other surrealist arts, as well as a play with found objects. The source text itself already included stock footage that Cornell recycles once again, because like most Hollywood jungle movies of the period, the actors never left the studio lot.

In 1936, when Hobart was a top star, *East of Borneo* was not a B movie at all. It was produced as a prestige picture by Universal Studios, one of the smaller Hollywood companies, and was billed on the top of a double bill, with F. W.

Rose Hobart (Joseph Cornell, 1936)

Murnau's *Tabu* running as the B picture. Guy Barefoot suggests that Cornell very likely purchased a print of *East of Borneo* as part of his sizable collection of 35mm prints that he collected and loaned out for screenings. It was not necessarily part of the remaindered footage that he bought from a New Jersey warehouse.[45] The distinction suggests that, after all these years of describing *Rose Hobart* as a found-footage film, it may be recognized as an example of archival film practice — a critical engagement with the films of the past. For Cornell, it was the recent past, but in its afterlife, it has become a remarkable interruption and détournement of the woman in the archive.

As a canonical example of experimental film, *Rose Hobart* has been analyzed by multiple commentators, many of whom attempt to interpret the significance of the shots that Cornell has added to the fragments of *East of Borneo*. These images include the opening shot of a crowd of people gazing skyward through viewing devices — probably watching an eclipse that is later inserted into the montage. The film also features a series of disconnected shots of various spheres falling into water and floating in a glass, shots of the moon, and low-angle shots of palms swaying against the sky. Many of these shots are

linked through editing to Hobart's gaze. Indeed, a great deal of the montage follows the direction of her look, implicitly invoking narrative structures of identification, even if the continuity is merely a formal device and the "structure" is radically discontinuous. Cornell also uses flash frames and irregular lengths of shots so that the film has an internal rhythm based in repetition, movement, and spectacle.

Adam Lowenstein has described *Rose Hobart* as an example of "collaborative spectatorship" that he recognizes as a progenitor of digital star tributes on YouTube. However, he describes that collaboration as being with the artist rather than the star, insofar as Cornell has "enlarged" the original text of *East of Borneo*. Lowenstein develops the concept of enlarged spectatorship from the surrealist discourse around film spectatorship in which a "collision between the film . . . and the fantasies of its viewers [produces] an enlarged text."[46] He furthermore associates this effect of enlargement with Roland Barthes's punctum and its relation to André Bazin's appreciation of surrealist cinema. We could also describe this process of enlargement as one more technique of appropriation arts and, at the same time, another incarnation of Benjamin's optical unconscious: "Clearly it is another nature which speaks to the camera as compared to the eye."[47] Cornell's work of cutting up the narrative arguably enables Hobart to emerge into the imagination of a feminist viewer as well as (or instead of) his own fantasies, whatever they may have been. The collaboration, in my view, is between spectator and actor, rather than spectator and auteur.

As a surrealist work, *Rose Hobart* is more "open" than many, and may not need to be decoded according to its symbols of "stars," stargazing, and "earthly objects" versus "heavenly objects," and the viewer may choose not to play that game but instead to play another. If we agree that the film constitutes an example of surrealist "enlargement" sparked by the details of the unexpected, unpredictable gaze of the viewer, then perhaps we can see how Rose Hobart herself, in the role of Linda Randolph, exemplifies the "self-alienation" of the actor in the machine that is narrative cinema. For Benjamin, when the actor "stands before the apparatus, he [*sic*] knows that in the end he is confronting the masses. It is they who will control him." For Benjamin, the cult of the movie star reinforces the "cult of the audience" that he saw being corrupted by fascism.[48] How to undo this process? Implicit in Benjamin's analysis is a critique of the actor's labor and his or her alienation from emotions, personality, and body. The human being forgoes his or her own aura when acting in a movie.[49]

Rose Hobart (Joseph Cornell, 1936)

Rose Hobart in the film named after her is no longer Linda Randolph but a woman who is caught in a variety of postures, often sharing the frame with others (men, woman, and animals). Her offscreen gaze, to the right, to the left, upward, and downward, helps to tie the discreet, spatially disconnected shots together, but the film also includes large action scenes involving many extras to which she seems tangential. The melodramatic elements of excess, romance, adventure, and exotic decor are all preserved, although they are slightly distanced by the mediation of a blue filter. Cornell's choice of Brazilian samba music that repeats relentlessly lends the film a campy light-hearted tone that conflicts with the earnestness of Hobart's performance, undermining the suspense that is implied in some of her looks, in her small handgun, the jealous gaze of the maid, and the crowds of brown bodies. In keeping with the genre of the Hollywood jungle movie, Hobart's whiteness is highlighted and of course that is what makes her shine through the "foliage" of the narrative setting. Indeed, her spectral glow within the Southeast Asian setting may be what attracted Cornell in the first place.

Rose Hobart (Joseph Cornell, 1936)

Catherine Fowler concurs that Hobart is "cut off from psychology and dramatic motivation" in Cornell's cut-up collage. And yet, even though her actions "have no apparent cause or effect," her gestures "seem more like life and less like art."[50] Fowler notes a particular tick of Hobart's performance in which she rubs the back of her neck, which may connote stress but nevertheless seems "overly intimate" given the lack of narrative explanation for that stress. She finds this foregrounding of gesture to be exemplary of Flusser's theory of gesture as "transport from one place to another that we see through."[51] A gesture "takes time" and therefore evokes a sense of presence, which in the case of *Rose Hobart* is experienced within the timelessness of the nonlinear collage of the film. It provides a point of access for a viewer who is radically distanced from the original narrative.

Benjamin's most succinct notes on gesture appear in his late commentary on Brecht in which he argues that a gesture in epic theater (i.e., Brechtian theater) must be quotable: "For the more frequently we interrupt someone engaged in acting, the more gestures result."[52] For Benjamin, gestures are "performative" insofar as they both produce action and represent it, and thus

they are potentially dialectical.[53] As discussed in the previous chapter, gesture is key to the fragmentation of the phantasmagoria in archiveology. In *Rose Hobart*, gesture furthermore leads to the awakening of the woman, Rose Hobart, from the narrative in which she was "domiciled." Her quotable gestures, particularly the repeated rubbing of her neck, become dialectical, revealing a woman working.

Fowler's remark that Hobart's gestures are incomplete overlooks the way that her glance and her eye movements are connected to other shots in the film — including Cornell's inserted "extradiegetic" material. Lowenstein argues that the frequent use of eyeline matches and reverse shots in *Rose Hobart* suggests a "perceptual doubling between the star and the filmmaker,"[54] and is thus a means by which Cornell is identifying with Hobart rather than simply desiring her. And yet the motivating use of the gaze also parallels that of the spectator and enables the viewer, too, to "identify" with Hobart's look. In this instance, the gesture of looking is an important means by which the viewer "collaborates" with the actor. Cornell, after all, is not the eye behind the camera but the hand behind the montage.

Cornell's fascination with Hobart, like his similar fetishization of Lauren Bacall in his collage assembly boxes, is admittedly suspicious from a feminist perspective. Jodi Hauptman describes the gender dynamics at work in Cornell's worshipful tribute to an actress he adored: "*Rose Hobart* . . . may be less about the actress (her pathologies or her role as a diva) and more about Cornell's (and all filmmakers') desire to capture, penetrate, and possess."[55] Lowenstein, on the other hand, argues that Cornell upsets the misogyny and homophobia of surrealist practices by covertly identifying with the actress. The film may even be a "valentine" to Marcel Duchamp and his alter ego Rrose Sélavy.[56] Hobart's many costumes in the film include a masculine safari suit, and some of her gestures and postures can arguably be read as androgynous.

The question that *Rose Hobart* the film poses to us in a digital age of archival film practice is whether Rose Hobart the actress can be awakened from her endless night. What would it mean to sidestep Cornell's auteurist desire and recognize the labor of the woman acting in *East of Borneo* in 1931? To some extent this may simply be a technique of interpretation or reading against the grain. Cornell's film is now available on a beautifully reproduced DVD released by the National Film Preservation Foundation in their series of restored Treasures from the American Film Archive. It is also available on YouTube. In digital form, *Rose Hobart* seems little changed from the original 16mm, except that now the viewer can stop and start the film and possess

Hobart's image in turn. In fact, still frames of her face adorn the marketing materials for the "Treasures" DVD series. Joseph Cornell's film arguably made Rose Hobart's name outlast her career by making her a star of the archive.

The contemporary viewer can now repossess Cornell's fetishistic portrait of the actress, delaying the film and interrupting it as what Mulvey has described as the "possessive spectator." She argues that because we are able to stop a film, slow it down, and even extract scenes and images, the dynamic structure of sexual desire that she herself famously analyzed in terms of scopophilia, fetishism, and voyeurism need no longer apply.[57] Cornell has, in a sense, already done this, foreshadowing the popular practice of YouTube homages to stars. The possessive spectator of *Rose Hobart*, armed with new technologies of "wounding" the film, may be able to unlock the mechanisms that Cornell has already unstuck, to recognize the interactive spectatorship of a feminized aesthetic of cinema.

Mulvey's theoretical move in *Death 24x a Second* is finally accomplished by turning to Benjamin's notion of "play," as Miriam Hansen has extracted this concept from Benjamin's diverse writings.[58] Benjamin's cultural aesthetics insist on a recognition of ambivalence in mainstream cultural production. The critical discourse of play becomes important when critics repeatedly turn to the notion of aura to describe the effect of archival film practices on the star image. William Wees, for example, in a key essay on stars in found-footage films, describes the effect of films such as *Rose Hobart* as having an ambiguous aura, noting how they seem to offer a counterdiscourse to Benjamin's theory. Wees argues that Hobart is rescued from the narrative clichés of *East of Borneo* and achieves an aura equivalent to that of a star such as Bette Davis, thanks to Cornell's "obsessive" re-editing.[59] I concur with Wees's reading, but it is important to understand that this remaking of aura on the other side of its demystification is in fact very much in keeping with Benjamin's theory, which is not just ambiguous but radically ambiguous. In fact, the aura of a star such as Rose Hobart, retrieved through the mechanics of archival film practices, comes very close to what Benjamin was getting at in his concept of aura, and it is quite distinct from the "cult" of the star.

By way of Cornell's film, Rose Hobart can be recognized as a human being—a woman who acted in Hollywood films. The comparison with Bette Davis is misleading given the comparable scales of the two women's careers. Hobart was a theater actress whose career lasted from 1930 to 1949, although she played the lead in only a handful of films from 1930 to 1932. She was blacklisted in 1948, mainly because of her membership in the Actors' Laboratory

Theatre, and she refused to cooperate with HUAC; thus her film career came to an abrupt end with the exception of a handful of TV roles in the late 1960s. In her 1994 memoir, *A Steady Digression to a Fixed Point*, she says that her name had not yet been cleared. In that book, the Cornell film is mentioned only by Anthony Slide, in the opening words of his introduction.[60] Hobart became a wife and mother, and trained as a psychologist, returning, in her own words, to anonymity. The rescue that takes place, therefore, in *Rose Hobart* is the awakening of the woman and an inscription of her everyday humanity into film history.

As I explained in chapter 2, Benjamin's concept of aura is not opposed to technology, or outside it, but key to the new form of perception available in modernity. Miriam Hansen describes aura as a *medium* that is linked to the epistemic structure of profane illumination and the optical unconscious in Benjamin's larger body of work.[61] In the final version of the artwork essay, he had to jettison the radical potential of aura because of the emergent threat of the fetishistic cult of aesthetics. Hansen argues that the artwork essay was a "desperate experiment" in which Benjamin had to mortify the term *aura* in order to make it useful.[62] In her account, the concept included the idea of the halo, which for Benjamin extended to the indexical trace of the photograph, and the romantic lyrical notion of unattainable beauty. The concept of aura also incorporated the Jewish mystical notion of collective forgetting and applied to the occult within the everyday.

Benjamin defined *aura* in the artwork essay as a strange conjunction of nearness and farness, which Hansen unpacks as a "theory of perception" in which "questions of the body, eroticism, and dream consciousness" are linked. If farness is aligned with images, and nearness with things and objects, the aura points to the materiality of images — their role in everyday life in modernity — and, at the same time, their immateriality as wish images. The aura of the actor in the archive is thus a critical point at which the "future anterior" might be glimpsed within the past: the actor's body, her labor, and her humanity survive beyond her characters and roles. The ironic status of Rose Hobart the actress as being "known for being forgotten," as Barefoot puts it, is symptomatic of what Derrida describes as archive fever. The archive destroys that which it preserves by putting it under "house arrest," but at the same time, quite clearly, Hobart is not forgotten at all, even if, as Cornell put it, she was "insufficiently famous."[63]

Significantly for our purposes, Hansen concludes her discussion of Benjamin's theory of aura with the claim that his "critical appropriation" of the

loaded term *aura* "could only be accomplished through a form of *apokatasta-sis*, a resurrection, as it were, through [mortification] and dismemberment."[64] The most basic form of dismemberment of a film is the stilling of movement, or the extraction of the film frame. Hansen uses a phrase similar to Tor-lasco's "future anterior" to explain the significance of this process within Benjamin's theory of technological modernity: the breakdown of film into still frames, revealing the photograph within the film, points to "film's forgotten future," that is, its ability to extract auratic experience from the technological everyday. The fragmentation of a film into film clips, or extracts, such as we find in archiveology, arguably conveys the experience of the actor more completely, in the capturing of a gesture or a glance, an action or an utterance that is indeed performative.

THE DISAPPEARING WOMAN

Soad Hosni (a.k.a. Soad Hosny or Suad Husni) was a great star of Egyptian cinema, which during her career was the backbone of Arab cinema more generally. Starring in eighty-two films from 1959 to 1991, her popularity extended far beyond Egypt, and her decline coincided with what some describe as the "collapse" of Egyptian cinema in the early 1990s. Declining production and a shift to TV produced in many parts of the Arab world contributed to the loss of Egyptian cinema's dominance in the region. At the height of her career, in the 1960s and early '70s, Hosni was arguably an icon of the utopian ideals of a pan-Arab modernism in which women's liberation was closely aligned with independence and postcolonial nationalism. In 2011 Lebanese filmmaker Rania Stephan made a collage-based video called *The Three Disappearances of Soad Hosni* consisting entirely of clips from Hosni's films. The opening titles remind us (or inform us, as the case may be) that Hosni died under mysterious circumstances in London in 2001.

Hosni was found dead on the street outside her apartment building, and although it has not been determined how or why she fell, it is well known that the last decade of her life had been very difficult. She had been largely forgotten and abandoned by her fans, and had both health and financial troubles. Hosni is sometimes referred to as the "Cinderella" of Arab cinema, in recognition of her having been overlooked for so many years.[65] Stephan made her film from VHS tapes, many of which she found in street stalls in Cairo.[66]

The Three Disappearances of Soad Hosni (Rania Stephan, 2011)

Although the Egyptian Film Center (the National Archive) is grossly under-
funded, and there is very little support for film preservation, a good portion
of Egyptian film history now belongs to TV stations in the Gulf region. Hosni's
films may be disappearing from official (national) film heritage, but they
nevertheless continue to circulate in the form of VCDs and on YouTube, in
addition to broadcast TV.[67] Stephan may have had trouble finding the films
on VHS when she began her research in 2000, but Hosni has definitely not
disappeared from Egyptian film culture.[68] In one of the clips in Stephan's film,
Hosni sings, "I'm going down to the square," which Stephan says became a
popular tag in the 2011 revolution.[69]

 Hosni played many different roles over the course of her long career, in-
cluding wives and mothers, working girls and housewives, prostitutes, mod-
els, and actresses. She worked with most of the major directors, in many
genres, although melodramas and musicals predominate, which is typical of
Egyptian cinema of this period. *Watch Out for ZouZou* (*Khali Balak Min Zou
Zou*, Hassan Al Imam, 1972), a touchstone of the early 1970s, was a film in
which Hosni's character ZouZou is at the center of the conflicting and con-
tradictory forces at work in a rapidly changing society. Her image was closely

The Three Disappearances of Soad Hosni (Rania Stephan, 2011)

tied to a "Westernized," secularized way of being, and yet she was nevertheless a central figure within the pan-Arab imaginary of the modern era. According to Joel Gordon, melodrama and movie stardom is a focal point for nostalgia in Egypt, "a black-and-white souvenir of public memory in a once optimistic, but ever after troubled post-revolutionary society."[70] Stephan's collection of Hosni films, acquired outside the scope of official archives, is remarkably complete, including the titles of all fifty-nine films in the credits. Her editing of sound and image is rhythmic, multilayered, and fast paced. Traces of vhs "noise" are retained, and an extraordinary range of color palettes and production styles are juxtaposed, so on a formal level alone, *The Three Disappearances* is an important example of archiveology, insofar as it translates the medium of celluloid cinema, with the intermediary language of vhs, into digital cinema and effectively transforms archival cinema into a mode of expression and transmission. In other words, the nostalgia and cultishness of Hosni's mystique are appropriated in the construction of a more radical form of critical memory.

To some extent, the compilation shares many formal techniques with *Home Stories, Kristall,* and *The Clock.* Stephan uses sound edits and continuity ef-

fects much like Christian Marclay does, to link disparate material into a "flow" of looks, movements, gestures, and sounds. Like *Kristall* and *Home Stories*, the affective realm of melodrama is privileged, with multiple shots of emotional close-ups of anxiety, fear, love, and desire. For some audiences, there is also a level of recognition, familiarity, and memory evoked by the return to long-forgotten movies. Stephan says that she re-edited many scenes, and yet people claim to remember them "wrongly." She describes her process as cutting the Hollywood-style Egyptian films in a "New Wave style," influenced by Godard. It is also important to note that the project actually started as a film studies dissertation at Paris XIII, and in many ways *Three Disappearances* is a great example of a video essay, based in extensive research.[71]

For global audiences who are not familiar with Hosni's career or Egyptian film history but who might find the film on YouTube or in an art gallery, *Three Disappearances* offers a unique insight into this important period of international film history. The detail of costumes, sets, and backgrounds, compiled into a heterogeneous journey through forty years of cinema, constitutes a remarkable phenomenology of the phantasmagoria of Arab modernity. If, for Gordon, Hosni's stardom is specifically tied to the black-and-white sixties, Stephan extends the Cinderella image into the later years of her career in order to complicate the mythic image. All the films are credited at the end with directors, dates, and other key credits. The titles themselves are revealing: *Girls and Summer* (1960), *Husband Comes Tomorrow* (1961), *Cairo Year 30* (1966), *Too Young for Love* (1966), *Beautiful and Naughty* (1968), *Love That Was* (1973), and *Love in a Prison Cell* (1983). In fact, the trajectory of the fifty-nine films follows a downward spiral on multiple levels, as Hosni plays older women who appear more and more troubled, and the selected scenes become more violent.

Three Disappearances is at once allegorical and indexical, psychological and phenomenological. The film is divided into three acts, with a prologue and an epilogue, but there are various ways of interpreting the three acts. As a narrative progression, they run from memory, to dream, to delirium;[72] and they roughly follow the chronology of Hosni's career as well, from the young fun-loving virgin, to independent woman, to delirious victim of domestic violence and psychological trauma. For Stephan, they also correspond to important dates in Egypt's political history. The first act, covering the years from 1959 to 1967, include the optimistic Nasser-era years, ending with the 1967 Six-Day War that significantly altered the geopolitics of the Arab world. The second act runs from 1967 to 1973, the year of the Arab-Israeli War (a.k.a. the Yom Kippur War); and the third act ends in 1991 amid the Gulf War.[73] These political events are not

The Three Disappearances of Soad Hosni (Rania Stephan, 2011)

referenced directly in the film, but for Stephan they are important markers of Egyptian cinema, and her emotionally charged choices of clips correspond to the political dramas of secular nationalism and the corresponding failures of women's rights over this period of time.

Historian Mériam Belli has written about postwar Egypt in a remarkable book called *An Incurable Past: Nasser's Egypt Then and Now*, in which she incorporates personal testimonies from people who lived through several decades of decolonization, pan-Arabism, and several phases of nationalism. This is a period in which, as she says, a "contradictory spectrum of experiences" needs to be accounted for.[74] *Three Disappearances* is a parallel version of this history, in which excerpts of Hosni's films serve as Bakhtinian "utterances" that point to a collective memory, particularly regarding the "sexual and sartorial mores" and how they changed over three decades of Egyptian modernism. Belli cites Pierre Nora, whose notion of *lieux de mémoire* is also an appropriate description of a film such as *Three Disappearances*. For Nora, memory and history have become deeply conjoined, not only in the mode of contested activities of official histories but also in terms of "psychologized histories."[75] Memory has become democratized, and yet history "besieges"

memory, as memory has been "contained" in the form of archives and other methods of inscription and commemoration.

Lieux de mémoires are produced through a certain tension between the "prosthetic memories" of culture and personal experiences. Nora describes them as "moments of history torn away from the movement of history, then returned; no longer quite life, not yet death, like shells on the shore when the sea of living memory has receded."[76] Like Benjamin, Nora's analysis is grounded in nineteenth-century France, where the "living heart of memory" can be perceived alongside the symbolic activities of official historicism. In keeping with Benjamin's imagistic historiography, Nora notes that "contrary to historical objects . . . lieux de mémoire have no referent in reality; or, rather, they are their own referent: pure, exclusively self-referential signs."[77] Like the recycled archival image, the lieux de mémoires are double: "A site of excess closed in on itself, concentrated in its own name, but also, forever open to the full range of its possible significations."[78]

Archiveology is consistent with Nora's conception of lieux de mémoire on a number of levels. The film excerpt is at once "immutable and mobile"; it is also both dead and living, reanimated by its new "place" in a new historical utterance. The coincidence of these two French theories of historical memory are especially relevant to the challenge of producing a woman's history from within Egyptian modernity. The melodramas and musicals in which Hosni starred are best described as vernacular versions of a melodramatic modality that draws from both global and Arab theatrical traditions, so while French critical theory may seem lightyears away from the cultural milieux of postwar Egypt, it is arguably harkened by the conventions of popular culture and "classical cinema."

For Benjamin, "the allegorization of the physis can only be carried through in all of its vigor in respect of the corpse,"[79] and here it is Hosni's death that enables the actress to figure on so many levels of disappearance, even while she visibly ages over the course of the film. The mystery surrounding her death is a red herring of sorts, because the structuring hermeneutic thread is not "how did she die?" but "how did she live?" Her mortification produces the language of allegory that Stephan has used to tell so many stories at the same time. Not only that, but Stephan has embraced Hosni's fall as the central allegory of failure. Hosni is at once the fallen woman, whose morals are questioned by a society that valued her only for her beauty; she is the failed woman in that the utopian ideals that she once represented have dissipated into geopolitical chaos, and she is a fading star in that she has not and will not actually go away in an era of digital media.

The Three Disappearances of Soad Hosni (Rania Stephan, 2011)

For Benjamin, allegory is about surface and image, not depth; it is about particularity in all its "vitality," "a form of expression" akin to speech and writing. In *Three Disappearances*, this form of expression is deeply embedded in the phantasmagoria, as Hosni's life is "staged" by the various characters that she played. The prologue is framed as a psychoanalytic session in which Hosni "tries to remember," coached by a male voice, most likely from the *Well of Deprivation* (1969).[80] On the couch, she shuts her eyes and the scene dissolves into a beautiful collage of her running across multiple landscapes in various styles of dress and film, cut on matching screen directions, with dissolves and hard cuts, while another male voice-over says, "Do you know that you dance like a goddess?" A collage of other voices shouts out a series of names — Salwa, Nabila, Fatma, Soad, and so on — to underline her multiple identities. Finally, back on the couch, she says, "I feel so very tired, as if I'd been on a long journey."

The prologue sets the tone for the film, at once tragic and slightly campy, partially because of the pacing that gives momentum to the tragic irony of Hosni's story. Male voices are frequently heard over the torrent of imagery, underlining the kind of patriarchal culture in which she was entrapped, and in which she held a certain sexual power. In act 1, after a series of images

The Three Disappearances of Soad Hosni (Rania Stephan, 2011)

from her early films, including musicals and teenage romances, she is back on the psychoanalytic couch. The doctor asks, "What was bothering you?" and she answers, "The image was bothering me." Cut to a café scene from another movie, in which she is looking at a newspaper (withheld from the viewer) with a man who says, "The image looks like you." This is followed by a series of clips from movies in which Hosni plays actresses and models. In these passages, her identification with the image is confirmed, suggesting that she is nothing but image, and yet even in that state she is nevertheless a subjective presence.

In several sections of the film, Stephan follows the pattern of so-called database films insofar as she has assembled "collections" of gestures and action (such as the running already mentioned) — including telephones, references to fathers, kissing scenes, and marriages. These tend to be enlightening in an ethnographic sense, but they are also frequently interrupted by more pensive and reflexive shots and scenes, such as the question about the image, which returns in the second act. The ongoing commentary on the image becomes embedded in the struggle to remember. If Hosni could only get past the image — her various images that are composed of her constantly changing makeup, hairdos, costumes, and postures — she may remember who she was.

The Three Disappearances of Soad Hosni (Rania Stephan, 2011)

The third act "flies away," in Stephan's description. All the violence is unloosed, not unlike the penultimate chapter of *Phoenix Tapes*. Hosni's dreams become nightmares of fires and screaming, slapping and fleeing. She is attacked and assaulted in multiple locations, but once again she becomes pensive and reflective, relaxing in an armchair. After a sound montage of alarms, chimes, and doorbells, a woman's body appears in silhouette on the sidewalk, as if having fallen. Soad Hosni enters a morgue to view a body. Through Stephan's deft editing, the body she see is hers (from another film). In a brief epilogue, a VHS cassette is inserted into a VCR, and a red-sequined shimmering Hosni appears on the screen. She has been effectively domesticated, trapped within the TV set in the home, which may well speak to the declining public presence of Arab women.[81] A male voice-over asks if we are "all children of Naima the dancer [Naima Akef]? Yes, children left behind by a world that's moving ahead. . . . Try not to look behind or sink into the present, but to always look ahead." Given the memory work of the preceding film, this might be a reference to the future anterior of archiveology, a "message" from a man who has learned, finally, from a woman who has fallen from the past into an allegory of awakening.

In *Three Disappearances*, the actress tries desperately to awaken from the dream state that has become the record — the document — of her life. At one point, she "awakens" after a scene on a rooftop and a view down through scaffolding to the street below, but she awakens dressed like a princess bedecked in jewels in some kind of period setting. The actress has truly disappeared into her roles, and yet Stephan's film has nevertheless opened up a critical space in which Soad Hosni can be recognized by new audiences in the Arab world and beyond. Her multiple disappearances serve as allegories for a cinephiliac historiography, not only for Arab cinema but for the role of the female image within that cinema.

Soad Hosni's disappearance is emblematic of the career trajectory of many women actors, whose image is only of value for a limited period of time. The fading actress, like the falling star, is exemplary of the obsolescence intrinsic to commodity capitalism. Reviewing and recycling images of women is not in itself a critique of that process of disposal, and yet once those images are endowed with allegorical powers of expression, as they are in this case, the "star" may be perceived as a "ruin" — revealing the critical edge of mortification. For Karen Beckman, the vanishing women of cinema constitute a valuable rupture of the parallel disavowal of actual violence against women. She enjoins the feminist critic to pay attention to the vanishing as a distraction and concealment of the gendered underpinnings of the phantasmagoria.

"The fading star bespeaks the space of vanishing at every utterance," says Beckman. And here she turns to Benjamin, for whom stars and their interpretation constitute the ur-model of language and criticism. As Eduardo Cadava paraphrases Benjamin: "[The] emergence of the past within the present, of what is most distant and closest at hand, suggests that, like the flash of similarity, starlight appears only in its withdrawal."[82] Beckman discusses Bette Davis as a star who "refused to fade," indulging in the "genre" of the fallen star over the course of her career. In her constant disappearing, Davis managed to appear and vanish in a constant oscillation in which presence is inseparable from absence and disappearance. As Beckman notes, if we "pay attention" to this refusal to vanish, it can produce a "critical viewing practice." Moreover, she underlines the prevalent use of film clips on TV in *Whatever Happened to Baby Jane* (Robert Aldrich, 1962) as a means by which this critical viewing practice is already incorporated into one of Davis's own "fading star" films. Beckman's theory of vanishing is "ambivalent" like Benjamin's theory of culture. She points out that "magic provokes critical spectatorship through its self-acknowledged performances of undisclosed activity," but this is precisely

the magic of technological modernity that Benjamin hoped could be transformed into a critical practice. The vanishing woman is "haunted by the specter of death," in Beckman's view, but, like Benjamin, she says, "this does not mean that we can do nothing with it."[83]

Eduardo Cadava points out that for Benjamin, criticism itself is modeled on the idea of the star as a vanishing light, insofar as interpretation is also always an act of mortification.[84] In the case of *Three Disappearances*, Hosni's death is the key to a dizzying series of deaths in which her image opens up into an awakening. The utopian spirit of Arab modernity and decolonization may have been mystified in any number of ways (and the embrace of feminism in Egyptian cinema was never more than a token gesture),[85] but its memory is arguably invaluable for the contemporary geopolitical imagination. Hosni herself may have appeared at the time to be on the periphery of social politics, but Stephan's film illuminates her expressive power within the cultural history of the Arab region. Her disappearance, along with the films that she and many others made during those critical years, is critically incomplete. Stephan's film underscores her refusal to actually disappear forever.

The interactive spectator of *Rose Hobart* and *Three Disappearances* finds herself divided triply, between the cinephiliac identification with and love of these actresses' performances, a recognition of their work in the industry, and a consequent repurposing of an archive of films largely made for and by men. The fragmented subject-effects of the possessive spectator are thus a provocative means of confronting oneself in technological modernity and, arguably, a means of awakening from the gendered archive. Laura Mulvey's "possessive spectator" of a delayed cinema is especially summoned by the star image because the star is always also an "indexical icon," shifting interminably between registers of semiotic meaning, from the historical, transient body — a ghostly trace of reality — and the fictions of performance and character. The double readings that enable us to see both the fiction and the working woman are modes of allegory and irony, produced through the metadiscursive language of archiveology.

Buci-Glucksmann's analysis of Benjamin is described by Bryan S. Turner as a "theology of modernity." In his introduction to Buci-Glucksmann's *Baroque Reason*, he argues that "the literary methods and devices of allegory, pastiche, parody, irony, and ambivalence" are derived "archaeologically from a Baroque period in which the library, the labyrinth and the ruin were cen-

tral themes."[86] According to Turner, Buci-Glucksmann situates these devices, which are fundamentally techniques of language, as an "alternative history of capitalism." The otherness of the feminine utopia is the key to the upsetting of "rational systems of bureaucracy and organization."[87] In archiveology, the techniques of allegory, pastiche, and irony are central to the critical détournement of "images of women" in classical cinema.

Another well-known archival film, *Meeting Two Queens* (1991) by Cecilia Barriga, is a great example of fan-based archiveology that extracts a kind of feminist utopia from classical cinema. Greta Garbo and Marlene Dietrich "meet" each other in a collage of scenes from their films, thematically linked by titles such as "Suitcase," "The Library," and "The Job." A fantasy of desire is constructed from the melodramatic cues of a classical modality from which all the men have been cut out. Barriga's treatment of the archive is once again deeply ironic, and her intervention and remixing produce a text that not only "queers" these actresses and their performances but "opens a feminist space for reading."[88]

Irony is a variation of allegory that Jaimie Baron argues "constitutes an ethics of the archive effect."[89] Camp is a mode of ironic playfulness in which gender performativity is exaggerated for stylistic effect, but it is also a social practice in which pastiche is at once affective and moving. Archiveology is arguably a technique through which kitsch, melodrama, the female body, and women's work can be revisited and reclaimed for an inversion of the gendered archive of film history.

The campiness of *Three Disappearances* is in keeping with the cinephilia of Girardet and Müller and is indicative of the critical role of pastiche in archiveology. Far from the emptiness of so-called postmodern pastiche, Richard Dyer has argued that precisely because pastiche brings us close to the appropriated film or image, it is a form that is affective in historical terms: "The most valuable point of pastiche resides in its ability to move us even while allowing us to be conscious of where the means of our being moved comes from."[90] In both *Rose Hobart* and *The Three Disappearances of Soad Hosni*, we are indeed brought close to the eponymous stars, and at the same time distanced. The fetishism endemic to their original texts, and even perhaps to Cornell's original appropriation, is laid bare, and yet the stars still shine in their vanishing.

EPILOGUE

> This is how the angel of history must look. His face
> is turned toward the past. Where a chain of events
> appears before *us*, *he* sees one single catastrophe, which
> keeps piling wreckage upon wreckage and hurls it at
> his feet. The angel would like to stay, awaken the dead,
> and make whole what has been smashed. But a storm is
> blowing from Paradise and has got caught in his wings; it
> is so strong that the angel can no longer close them.
>
> Walter Benjamin, "On the Concept of History,"
> in *Selected Writings*, vol. 4

If archiveology is a language of images, what kind of language is it? If this book can offer any way out of the reality-TV show that appears to have engulfed the political scene, it is by making this image language legible. Détournement is a more urgent critical practice than ever before, as the wreckage builds ever higher and "the media" has clearly become a conflict zone. The feminist gesture of awakening is itself more urgent than ever before in my lifetime, and the avant-garde is faced with a renewed challenge of breaking through the façade of commodity culture. The language of images that is archiveology may finally be illuminated through Benjamin's theory of translation. Appropriation is, in fact, a matter of translating from one medium to another, whether from film to video, analog to digital, narrative to nonnarrative, fiction to documentary, archival file to collage form, video to installation, and so on. In "The Task of the Translator," Benjamin writes, "A real translation is transparent; it does not cover the original, does not block its light, but allows the pure language, as though reinforced by its own medium, to shine upon the original all the more fully."[1] By "pure language," Benjamin may be evoking an idea of medium specificity, but I would prefer to think of it in terms of utterance, or speech act. Moving images are always shot by someone for some reason, and thus they set up a social relationship, a gesture of intersubjectivity.

When Benjamin describes translation as a means of recognizing the kinship of languages, he also claims that the "original" is itself a language. The concept of a "pure language" is produced through translation as a "release" or "liberation" of the language imprisoned in the work.[2] Nora Alter has pointed out the confluence between Benjamin's theory of translation and Hans Richter's early theory of the essay film. For Richter, the "essay film is an in-between genre that is not grounded in *reality*, but can be irrational, playful and fantastic."[3] The implication for Alter is that abstract concepts could be given abstract form, but I think it goes even further than that once we consider the role of archival images in this pure, liberated language, because they bare the traces of technologies of reproduction and the encounter of the body with the machine.

For Benjamin, certain works contain within themselves a "special significance" that is their "translatability," returning us to his idiosyncratic method of making words into active agents. Like "legibility," the idea of translatability pertains to the way a moving image may take on multiple meanings and accumulate them like a kind of palimpsest that one can recognize as a historical relationship. Of course, it takes talent, intuition, and research on the part of the filmmaker to bring about that flash of recognition, often through the combination and juxtaposition of multiple sources, not all of them archival and not all of them visible. And it takes a viewer to experience the images and recognize them as a historical dialectic. In fact, the essay film frequently operates as a pathway between the visible and the invisible.[4] Outside every frame of the archiveological fragment is a host of personnel, technologies, geographies, and histories.

The new works of appropriation as well as the old works that are revisited are essentially embryonic, fluid, social encounters in which both legibility and translatability are contingent on a viewer, an auditor, and a reader of the project of recycling. Benjamin's rhetoric of freedom and release echoes that of Morgan Fisher, who describes his film () as a liberation of insert shots from their narrative structures. But in the case of the awakened women in films such as *Rose Hobart* and the *Three Disappearances of Soad Hosni*, "freedom" is not the whole story, even if these women are arguably released from their narrative homes. In fact, the ethics of archiveology, which this book has hardly touched on, depend on a recognition of the social networks constituted in and by archiveology.

As Jaimie Baron has pointed out, all appropriation is on one level a "misuse" of filmed and recorded material as well as de facto "inappropriate."[5] A great

range of ethical effects can be created in archival film practices, from questions of copyright and ownership of images, to questions of credits and sources, to questions of representation. Of the latter, Baron describes a double-layered structure that creates the perceived ethical stance of a film: "the stance of the original filmmaker toward her material . . . and that of the filmmaker who has appropriated this material."[6] Baron agrees that it is ultimately the viewer who is the "judge," and for this reason, the ethics of archiveology are always going to be somewhat in flux and, in many ways, at the heart of the historical knowledge that is produced.

The question of copyright (or copyleft) are beyond the scope of this book. Issues of ownership pertain to the commodity status of audiovisual recordings, and in this sense, the allegorical potential of archiveology, its doublespeak or double articulation, constitutes a challenge to the commodity form of the images, stripping them of use value and exchange value in order to make them meaningful again. Benjamin certainly recognized how technologies of reproduction produced image commodities, but he also understood how these wish images contain the seeds of their own undoing, as ruins, fossils, and fetishes. Copyleft, or borrowing, is a more "appropriate" strategy of archiveology than the enforcement of copyright law. In fact, Benjamin says as much when he states that "no document is free of barbarism, so barbarism taints the manner in which it was transmitted from one hand to another. The historical materialist therefore dissociates himself from this process of transmission as far as possible. He regards it as his task to brush history against the grain."[7]

Archiveology, which renders the archive transmissible, its contents legible in the present, is above all a historical form, consistent, I have argued, with Benjamin's conception of historical materialism. The historical "object" — or fragment of film footage — is confronted as a monad. In Benjamin's rhetoric, this confrontation is depicted as a standing still, or an "arrest" of time in which tensions are crystallized in the now time of the present: "In this structure [the historical materialist] recognizes the sign of a messianic arrest of happening . . . a revolutionary chance in the fight for the oppressed past."[8] And yet, how does this "standing still" happen in the time-based medium of archival film practices?

The shock of montage is always a cutting up, cutting off, an extraction of some kind, even if that "blasting apart" is frequently softened in the films discussed here by the continuity effects of sound, including both musical effects and voice-over. In fact, from a formal perspective, the compilation mode of "collecting" images together appears to have prevailed over a more nonlinear

disjunctive mode of collage. Even the most discontinuous film, *Rose Hobart*, is accompanied by a musical score that creates an affective "flow" that cushions the shocks of Cornell's montage. In other words, there may not be any dynamic stasis in the examples of archiveology discussed in this book, but there is a dialectic of collecting and allegory going on in which the present moment is crystallized in the perception of the ruined image, or the image as ruin.

For Benjamin, translation is itself a "form."[9] Archival film practices "translate" between different media, and so as an act of appropriation, archiveology tends inevitably to invoke the obsolescence of technologies of reproduction. As "collectors," the filmmakers discussed here "struggle against dispersion" — and in this sense, the films tend toward a principle of classification that is borrowed from the systems of bureaucracy and discipline. Their "structures" are at times governed by architectures of files, tapes, convolutes, and other organizational rubrics (which tend to be displacing the older rubrics of structural film that pertained to medium specificity, such as fixed frame and duration — or sometimes coexisting with them in the case of *Toponimia* [Jonathan Perel, 2015]). Benjamin's collector, after all, is himself obsolescent in modernity: "Only in extinction is the collector comprehended."[10] The allegorist, on the other hand, is a reader of ruins. As Erika Balsom points out, with respect to Tacita Dean's work, "allegory allows for an understanding of the passage of objects through time, as well as historical and affective resonances that this entails."[11]

Archival film practices bring together the collector's urge to classify and organize, to search and save, with the allegorist's ability to break apart temporal continuity through mortification as an experience of time itself. The utopian urge for totality and systematicity is overshadowed by the recognition of failure and the dangers invested in such desires. Rosalind Krauss describes this convergence as "an object and its shadow, or a perception and its after-image. This is what links type to countertype, or, in the case of the commodity, produces what Benjamin called 'the ambivalence between its utopian and cynical elements.'"[12]

In Krauss's discussion of collecting and media obsolescence, she is concerned to reinvent medium specificity through the "recursive" structures of media — to push toward an autonomy of the artwork that might distinguish it from the commodity culture of kitsch. Balsom's rejoinder to this critique (that tends to indict the exploitation of classical cinema in appropriation arts) is to point out that cinema always functions as an archive and a social history, and thus tends to resist any claims of autonomy and medium specificity.[13]

Indeed, as we have seen in so many of the films discussed here, the archival ruins of "kitsch" are precisely the materials that enable the "tiger's leap into the past" that Benjamin ascribes to fashion as a technique of historical material-ism.[14] The kitschiness of melodrama is also that which warms and touches and evokes the collective experience.

The shocks of montage, the alarms of awakening, and the stilled time of "firing on clock faces"[15] are tropes of "filled time," as opposed to the homog-enous empty time of repetition. It would be a mistake to associate such a con-ception of historical time with a formal device, but the tension between the collector and the allegorist serves to underscore the potential of temporal dis-junction at work in archival film practices. Filmmakers and videomakers are not collecting objects but moving images, and this is ultimately what makes this practice distinctive among archival practices. Moving images take place in time and are responsible for complex forms of experience. The viewer is not simply a historian but a participant in historical construction.

Many of the films discussed in this book use gestures to link images, to mark movements, to "move" the spectator imperceptibly toward the next image, which is never the expected image but a gesture of disruption. Is this the in-nervation that Benjamin ascribed to film? For Giorgio Agamben, gesture is "the exhibition of mediality: it is the process of making a means visible," and "it opens the ethical dimension for human beings."[16] Drawing on Benjamin's dialectic of voluntary and involuntary memory, Agamben argues that cinema is best characterized as "gesture rather than image," and as such it "breaks with the false alternative between ends and means."[17] In another context, speaking of Auschwitz, Agamben argues that the term *testimony* is more appropriate than *archive*, because "we give the name *testimony* to the system of relations between the inside and the outside of *langue*, between the sayable and the unsayable in every language."[18] The remnant, or the archival fragment, as tes-timony is a process of subjectification and desubjectification: "What is truly historical is not what redeems time in the direction of future or past; it is, rather, what fulfills time in the excess of a medium."[19]

As a mode of artist's cinema, archival film practices extract fragments of historical memory from the recorded past, transforming those ruins and rem-nants into a medium. This new medium has the potential to assume the guise of the phantasmagoria, luring the viewer into a sensory embrace. The critical edge of archiveology is, however, destructive. As technologies of reproduction continue to supersede each other, only a language in which media archaeol-ogy is deeply embedded will be able to actually articulate the critical terms

of obsolescence. As archives are by definition interminable and incomplete, so also is the sociopolitical role of archiveology. As an architecture that is at once affective and historical, a passage into collective memories and networks of social relations, institutions, and visual cultures, archiveology enables archives to come alive. It provides passages into the imaginary phantasmagorias of generations and cultures past and unlocks their secret desires for the future. The aura of the future lies deeply embedded in past images that are always being remade and recycled in the practices of excavation, retrieval, and reuse.

NOTES

PROLOGUE

1. Benjamin, "The Author as Producer," in *Selected Writings*, vol. 2, 775.

2. Benjamin, "The Author as Producer," 780.

3. Weber, *Benjamin's -abilities*, 10.

4. Benjamin, *The Arcades Project*, 462.

5. Benjamin, "Program for Literary Criticism," in *Selected Writings*, vol. 2, 292.

6. Benjamin, "The First Form of Criticism That Refuses to Judge," in *Selected Writings*, vol. 2, 373.

7. Benjamin, "The First Form of Criticism That Refuses to Judge," 373.

8. Benjamin, "Program for Literary Criticism," 290.

9. Evidence of the flourishing of found-footage filmmaking can be found in a new journal devoted to found footage that has published three issues to date, *Found Footage Magazine*, in English and Spanish.

10. Balsom, *Exhibiting Cinema*, 107–48.

11. Shub is the director of *The Fall of the Romanov Dynasty* (1927). At least one more or less "invisible" woman is Gustav Deutsch's partner, or, as he puts it, "companion in life and in art," Hanna Schimek. For a good analysis of "Myriam" Borsoutsky, who worked extensively with many of the French directors of the 1940s through the 1960s, see Dall'Asta, "Looking for Myriam."

12. Russell, "Archiveology," 22.

13. Benjamin, "The Work of Art in the Age of Its Technological Reproducibility," second version, in *Selected Writings*, vol. 3, 108.

14. Benjamin, "Little History of Photography," in *Selected Writings*, vol. 2, 518–19.

1. INTRODUCTION TO ARCHIVEOLOGY

1. Katz, "From Archive to Archiveology."

2. Elsaesser, "The Ethics of Appropriation."

3. A German anthology was published in 2009 composed of articles by a range of theorists including Derrida and Foucault, plus numerous other literary and art theorists such as Boris Groys, Benjamin Buchloh, and Paul Ricoeur. See Ebeling and Günzel, *Archivologie*.

4. Huffer, *Mad for Foucault*, 177.

5. For some excellent discussions of the digital transformation of film preservation, see Prelinger, "Points of Origin"; Fossati, *From Grain to Pixel*; and the documentary *Cinema Futures* (Michael Palm, 2016).

6. Spieker, *The Big Archive*, xiii.

7. Amad, *Counter-Archive*.

8. Benjamin, "Excavation and Memory," in *Selected Writings*, vol. 2, 576.

9. See Nichols and Renov, *Cinema's Alchemist*.

10. Verwoert, "Apropos Appropriation."

11. Verwoert, "Appropos Appropriation," 9.

12. Cocker, "Ethical Possession," 93.

13. Cocker, "Ethical Possession," 92.

14. Foster, "The Archival Impulse," 22.

15. Benjamin, *The Arcades Project*, 61.

16. Enwezor, "Archive Fever," 11.

17. Glöde, "A Different Rediscovery of Something (Lost)," 106.

18. Fossati, "Found Footage."

19. Cocker, "Ethical Possession," 95.

20. See Leyda, *Films Beget Films*, for an excellent overview of the history of the compilation film.

21. See MacDonald, "Conversations on the Avant-Doc," for an overview of some of the key themes and characteristics of the films produced through the Sensory Ethnography Lab at Harvard University.

22. Baron, *The Archive Effect*, 9.

23. Wees, *Recycled Images*, 36.

24. Debord, *Society of the Spectacle*. Debord also made a film of the same name, which was released in 1974.

25. Sjöberg, *The World in Pieces*, 25.

26. HuffPost Entertainment, "I'm Too Old for This Shit," YouTube, March 13, 2014, accessed June 24, 2017, https://www.youtube.com/watch?v=MqBNSMbEzIo.

27. Manovich, "Database as Symbolic Form."

28. Benjamin, "The Storyteller: Observations on the Works of Nikolai Leskov," in *Selected Writings*, vol. 3, 154.

29. Benjamin, "The Storyteller," 162.

30. Corrigan, *The Essay Film*; Rascaroli, *The Personal Camera*.

31. Benjamin, "The Work of Art," second version, 114.

32. Corrigan, *The Essay Film*, 175.

33. Baron, *The Archive Effect*, 17.

34. Baron, *The Archive Effect*, 36.

35. Russell, *Experimental Ethnography*, 260–64; Zryd, "Found Footage Film as Discursive Metahistory," 46.

36. Baron, *The Archive Effect*, 37.

37. The concept of allegory is developed in Benjamin's book *The Origin of German Tragic Drama*, 159–235.

38. Benjamin, *The Origin of German Tragic Drama*, 182–83.

39. Hansen, *Cinema and Experience*, 183–204. The phrase "interplay between nature and humanity" is from Benjamin, "The Work of Art," second version, 107.

40. Alter, "The Political Im/Perceptible in the Essay Film," 167.

41. Alter, "The Political Im/Perceptible in the Essay Film," 171.

42. Cocker, "Ethical Possession," 92.

43. Shambu, *The New Cinephilia*.

44. Keathley, *Cinephilia and History, or The Wind in the Trees*.

45. Balsom, *Exhibiting Cinema in Contemporary Art*, 137.

46. Balsom, *Exhibiting Cinema in Contemporary Art*, 137.

47. Benjamin, "One-Way Street," in *Selected Writings*, vol. 1, 476.

48. Foster, "The Archival Impulse," 5.

49. Episodes 1–6 of *Film Ist* were released in 1998; Episodes 7–12 were released in 2002; *Film Ist: A Girl and a Gun* was released in 2009.

50. Benjamin, "One-Way Street," 459.

51. Benjamin, *The Arcades Project*, 396.

52. Benjamin, *The Arcades Project*, 476.

53. MacDonald, "A Conversation with Gustav Deutsch," 84.

54. Gunning, "From Fossils of Time to a Cinematic Genesis," 174.

55. Benjamin, *The Arcades Project*, xiv.

2. THE LANGUAGE OF THE MOVING IMAGE ARCHIVE

1. Mast and Cohen, *Film History and Criticism*, xxx. Benjamin's essay was titled "The Work of Art in the Age of Mechanical Reproduction" both here and in *Illuminations*.

2. Benjamin, *Charles Baudelaire*, 137.

3. The version of the artwork essay that appeared in *Illuminations* was in fact the third version, which had undergone substantial revision. It appeared in print in 1955, although Benjamin completed it in 1939. This version has also been reprinted in Benjamin, *Selected Writings*, vol. 4, 249–83.

4. See, in particular, Heath, *Questions of Cinema*, 10–11, 13.

5. Benjamin, "The Storyteller," 143–66.

6. Hansen's book, *Cinema and Experience*, synthesizes a series of essays she published on Benjamin, Adorno, and Kracauer over the previous two decades. The critical ones on Benjamin include "Benjamin and Cinema: Not a One-Way Street"; "Benjamin, Cinema and Experience: 'The Blue Flower in the Land of Technology' "; "Room-for-Play: Benjamin's Gamble with Cinema"; and "Benjamin's Aura."

7. Benjamin, "The Work of Art," second version, 101–33, 107.

8. Hansen, *Cinema and Experience*, 195.

9. Hansen, *Cinema and Experience*, 164–69.

10. Leslie, *Hollywood Flatlands*, 116.

11. For a full discussion of Benjamin's contradictory endorsement of Mickey Mouse, see Leslie, *Hollywood Flatlands*, 80–122.

12. Hansen, *Cinema and Experience*, 195.

13. Hansen, *Cinema and Experience*, 182.

14. Leslie, *Hollywood Flatlands*, 105.

15. Hansen, *Cinema and Experience*, 202.

16. Rochlitz, *Walter Benjamin and the Disenchantment of Art*, 9.

17. Benjamin, "On Language as Such, and on the Language of Man," in *Selected Writings*, vol. 1, 73.

18. Benjamin, "The Task of the Translator," in *Selected Writings*, vol. 1, 254.

19. Benjamin, *The Origin of German Tragic Drama*, 214.

20. Benjamin, *The Origin of German Tragic Drama*, 178.

21. Buci-Glucksmann, *Baroque Reason*, 71.

22. Rochlitz, *Walter Benjamin and the Disenchantment of Art*, 117.

23. Benjamin, "One-Way Street," 456. *One-Way Street* (*Einbahnstrasse*) was originally published as a stand-alone book in 1928. It has been translated and published in essay form in *Selected Writings*, vol. 1, 444–88, among other places.

24. Rochlitz, *Walter Benjamin and the Disenchantment of Art*, 127.

25. Rochlitz, *Walter Benjamin and the Disenchantment of Art*, 173.

26. Benjamin, *The Arcades Project*, 458.

27. Benjamin, *The Arcades Project*, 482.

28. Hansen, *Cinema and Experience*, 155.

29. Benjamin "On the Mimetic Faculty," in *Selected Writings*, vol. 2, 722.

30. Taussig, *Mimesis and Alterity*, 213.

31. Hansen, *Cinema and Experience*, 155.

32. Hansen, *Cinema and Experience*, 156.

33. Rochlitz, *Walter Benjamin and the Disenchantment of Art*, 240.

34. Benjamin, "On the Concept of History," in *Selected Writings*, vol. 4, 390; Benjamin, *The Arcades Project*, 476, 460.

35. Hansen, *Cinema and Experience*, 199.

36. Benjamin, *The Arcades Project*, 460–61.

37. Benjamin, *The Arcades Project*, 207.

38. Benjamin, *The Arcades Project*, 205.

39. Benjamin, *The Arcades Project*, 205–6.

40. Benjamin, *The Arcades Project*, 211.

41. Benjamin, "Eduard Fuchs, Collector and Historian," in *Selected Writings*, vol. 3, 269.

42. Benjamin, *The Arcades Project*, 460.

43. Benjamin, *The Arcades Project*, 461.

44. Benjamin, "Eduard Fuchs, Collector and Historian," 267.

45. Benjamin, "Eduard Fuchs, Collector and Historian," 267.

46. Benjamin, "Eduard Fuchs, Collector and Historian," 267.

47. Buck-Morss, *The Dialectics of Seeing*, 159.

48. Benjamin, *The Origin of German Tragic Drama*, 166.

49. Cocker, "Ethical Possession," 96. Cocker cites Dyer's work on pastiche as a mode of image appropriation that is not "empty" but conveys the effect of the original, added to an appreciation of its historicity. See Dyer, *Pastiche*.

50. Benjamin, *The Arcades Project*, 467.

51. The original 1906 film belonged to a cycle of early films dubbed "phantom ride films" by film historians because the camera was fixed to the front of a moving train or other vehicle.

52. Skoller, *Shadows, Specters, Shards*, 13–14, quoting Benjamin, "The Work of Art," second version, 117.

53. Benjamin, *The Arcades Project*, 462.

54. See Gunning, "What's the Point of an Index?"

55. Torlasco, *The Heretical Archive*, xviii.

56. See Fossati, *From Grain to Pixel*, for an extensive discussion of the transition from analog to digital restoration techniques and their theoretical and practical implications.

57. Benjamin, *Walter Benjamin's Archive*, 10.

58. Hansen, *Cinema and Experience*, 94.

59. Hansen, *Cinema and Experience*, 94.

60. Benjamin, *The Arcades Project*, 463.

61. Rochlitz, *Walter Benjamin and the Disenchantment of Art*, 170.

62. Benjamin, "The Work of Art," second version, 117.

63. Benjamin, *The Arcades Project*, 461.

64. Silverman, "The Dream of the Nineteenth Century," 3; Dall'Asta, "The (Im)possible History," 352; Benjamin, "On the Concept of History," 392.

65. Dall'Asta, "The (Im)possible History," 352.

66. Perhaps the most explicit homage to Benjamin in experimental film practice is Daniel Eisenberg, in particular his film *Persistence* (2007).

67. Dall'Asta, "The (Im)possible History," 354.

68. Benjamin, *The Arcades Project*, 26.

69. *Society of the Spectacle* was released in 1974, but Debord made several films between 1957 and 1994.

70. Benjamin, *The Arcades Project*, 462, quoted in Silverman, "The Dream of the Nineteenth Century," 5.

71. Benjamin, *The Arcades Project*, 463.

72. Benjamin, *The Arcades Project*, 463.

73. Benjamin, *The Arcades Project*, 462.

74. Silverman, "The Dream of the Nineteenth Century," 2.

75. Dall'Asta, "The (Im)possible History," 355.

76. Silverman, "The Dream of the Nineteenth Century," 18.

3. THE CITYSCAPE IN PIECES

1. Hansen, *Cinema and Experience*, 200.

2. Benjamin, *The Arcades Project*, 396.

3. Benjamin, *The Arcades Project*, 461.

4. Benjamin, *The Arcades Project*, 83.

5. Russell, "Parallax Historiography."

6. Gilloch, *Myth and Metropolis*, 5.

7. Gilloch, *Myth and Metropolis*, 12.

8. Gilloch, *Myth and Metropolis*, 19.

9. Benjamin, "One-Way Street," 455.

10. Osborne, *Walter Benjamin*, 359–60.

11. All three web documentaries are made or sponsored by the National Film Board of Canada. See http://highrise.nfb.ca/; http://pinepoint.nfb.ca/#/pinepoint; http://www.fortmcmoney.com/#/fortmcmoney.

12. Prelinger, "On the Virtues of Preexisting Material."

13. Kittler, "The City Is a Medium."

14. Straw, "Spectacles of Waste," 206.

15. Leyda, *Films Beget Films*, 79.

16. Nicole Védrès, quoted in the Toronto Film Society program notes for Monday, February 8, 1954, Film Reference Library, Toronto International Film Festival. The film was scheduled to play in Toronto on this date, but the print did not arrive. The screening was rescheduled in May 1987, more than thirty years later. Védrès provided notes for the film in English for the 1954 screening.

17. Crowther, "Snows of Yesteryear"; Anonymous, "*Paris 1900*, France, 1948."

18. Védrès, Toronto Film Society program notes.

19. Other information gleaned about Védrès includes the fact that she was a single mother, although not a feminist. She was modest and tall, and socialized with many of the intellectuals featured in her second film, *La vie commence demain*, another (less successful) compilation film about the future of science. See Knight, "Woman in a Masculine Movie World"; Tyler, "Four Million Dollars' Worth of Magic."

20. Védrès, Toronto Film Society program notes.

21. Many of these portraits are borrowed from Sacha Guitry's 1915 film *Ceux de chez nous* (*Those of Our Land*).

22. Bazin, "À la recherche du temps perdu," 41 (translation mine); Kracauer, *Theory of Film*, 57.

23. Bazin, "Death Every Afternoon," 30.

24. Dall'Asta concludes that while Bazin may or may not have been familiar with Benjamin's writing, there are several remarkable points of contact, including the concept of "dialectics at a standstill," which Bazin seems to "reenact" on a different level. Dall'Asta, "Beyond the Image in Benjamin and Bazin," 61.

25. Benjamin, "On Some Motifs in Baudelaire," in *Selected Writings*, vol. 4, 328.

26. Benjamin, "On Some Motifs in Baudelaire," 336.

27. Kracauer, *Theory of Film*, 57.

28. Benjamin, *The Arcades Project*, 207.

29. Amad argues that film and photography in the silent period contribute to the "historicist illusion of total recall," but at the same time, they offer a "counter-archival logic" in which they "appear to also reconfigure matters of memory according to rifts, voices, and disorder of a radically new type of history." Amad, *Counter-Archive*, 123.

30. Benjamin, "Karl Kraus," in *Selected Writings*, vol. 2, 453.

31. Benjamin, "Karl Kraus," 435.

32. Anonymous, "*Paris 1900*, France 1948." *Variety* also gave the film an enthusiastic review: Anonymous, "*Paris 1900*: French — Documentary."

33. Crowther, "Snows of Yesteryear."

34. *Paris 1900* was listed in 2007 among seventy-five important, neglected films. James, "75 Hidden Gems."

35. Benjamin, "On the Concept of History," 392.

36. Benjamin, "On the Concept of History," 391.

37. Benjamin, "On the Concept of History," 391.

38. Benjamin, "On the Concept of History," 395.

39. Amad has identified the source of this footage as *La bande de l'auto grise* and *Hors-la-loi*, two shorts from the series *Bandits en automobile* (1912), directed by Victorin-Hippolyte Jasset. Amad, "Film as the 'Skin of History,'" 98.

40. Amad, "Film as the 'Skin of History,'" 88.

41. Amad, "Film as the 'Skin of History,'" 94.

42. Corrigan, *The Essay Film*, 67.

43. Knight, "Paris 1900," 23–24.

44. Robert Griffith in the *Saturday Review*, quoted by Douglas S. Wilson in Toronto Film Society notes on the occasion of a screening of the film *Paris 1900* at the Royal Ontario Museum on May 28, 1987, p. 11, Film Reference Library, Toronto International Film Festival.

45. Amad, "Film as the 'Skin of History,'" 109. Amad also notes that the Pathé newsreel footage of Reichfelt's death was reproduced as a series of frame enlargements in an illustrated newspaper shortly afterward, emphasizing the way that cinema was producing new ways of knowing the world (106).

46. Wilson, Toronto Film Society notes, 11.

47. Bazin, "À la recherche du temps perdu," 41.

48. Kracauer, *Theory of Film*, 56–57.

49. Bazin, "À la recherche du temps perdu," 42.

50. Lehmann, *Tigersprung*, 278. For an analysis of cinematic fashion during the Belle Epoque from a Benjaminian perspective, see Russell and Pelletier, "'Ladies, Please Remove Your Hats.'"

51. Benjamin, *The Arcades Project*, 8.

52. Benjamin, *The Arcades Project*, 64; Benjamin, "On the Concept of History," 395.

53. Benjamin, *The Arcades Project*, 79.

54. Benjamin, *The Arcades Project*, 64. Adorno apparently wrote "counterrevolutions" in the margin of this particular fragment of Benjamin's project. See Benjamin, *The Arcades Project*, 959.

55. Wollen, "The Concept of Fashion in *The Arcades Project*," 142.

56. Evans, "The Walkies," 117.

57. Bruno, "Surface, Fabric, Weave," 94.

58. M. Cohen, *Profane Illumination*, 224.

59. Benjamin, "On Surrealism," in *Selected Writings*, vol. 2, 210.

60. Breton, "As in a Wood," 73.

61. Benjamin, "On Surrealism," 211.

62. M. Cohen, *Profane Illumination*, 225.

63. Benjamin, *The Arcades Project*, 474.

64. Gunning, "'Primitive' Cinema," 100.

65. Gunning, "The Long and the Short of It," 32.

66. M. Cohen, *Profane Illumination*, 219. As Cohen points out, the theory of the phantasmagoria further incorporates Benjamin's interest in the ways that Marx's own theoretical project engaged with Baudelaire and nineteenth-century Paris.

67. M. Cohen, *Profane Illumination*, 222.

68. Védrès, Toronto Film Society program notes, 2.

69. Benjamin, "Eduard Fuchs, Collector and Historian," 261.

70. Hansen, *Cinema and Experience*, 200.

71. Benjamin, *The Arcades Project*, 466.

72. Krugman, review of *Capital in the Twenty-First Century* by Thomas Piketty.

73. Benjamin, *The Arcades Project*, 464.

74. Benjamin, *The Arcades Project*, 460.

75. The text of Thom Andersen's narration (which is spoken in the film by Encke King) is transcribed at http://filmkritik.antville.org/stories/1071484/ (March 14, 2005; accessed June 12, 2016). Quotations from the narration are from this transcription.

76. Cocker, "Ethical Possession," 93.

77. Benjamin, *The Arcades Project*, 15.

78. Benjamin, *The Arcades Project*, 19.

79. Benjamin, "Central Park," in *Selected Writings*, vol. 4, 174.

80. Benjamin, "Left-Wing Melancholy," in *Selected Writings*, vol. 2, 425.

81. Benjamin, *The Origin of German Tragic Drama*, 162.

82. Benjamin, *The Origin of German Tragic Drama*, 185.

83. Benjamin, *The Origin of German Tragic Drama*, 177.

84. See Benjamin, Convolute I, "The Interior, the Trace," in *The Arcades Project*, 212–27, for the most sustained critique of interiority.

85. This description of the arcades as combining interiority and exteriority that blends critique with potential is articulated in various places, including the section of *The Arcades Project* on the flaneur (417–23).

86. Benjamin, *The Arcades Project*, 221.

87. Benjamin, *The Arcades Project*, 423.

88. Miller, "'Glass before Its Time, Premature Iron,'" 257.

89. Benjamin, "The Image of Proust," in *Illuminations*, 202.

90. Gilloch, *Myth and Metropolis*, 114, citing Benjamin, *Gesammelte Schriften*, vol. 1, 1233.

91. Olalquiaga, *The Artificial Kingdom*.

92. Benjamin, *The Arcades Project*, 460.

93. Benjamin, *The Arcades Project*, 460.

94. MacKenzie, "A Description and Examination of the Production of *The Exiles*," 156.

95. "Final Cut 2008"; Naremore, "Films of the Year, 2008"; "Staff Recommendations"; Charity, "The Exiles"; Garson, "*The Exiles*"; Antin, "The Exiles"; Brody, "The Exiles."

96. Foucault, "The Historical *a priori* and the Archive," 29.

97. Foucault, "The Historical *a priori* and the Archive," 30.

98. Benjamin, *The Arcades Project*, 462.

99. Burnett was not aware of MacKenzie's film until Thom Anderson brought it to his attention. In a radio interview, he says that after reading MacKenzie's notes, he realized that they were working toward the same ideas about filmmaking, although MacKenzie did so ten years earlier than he. WNYC Leonard Lopate Show with Sherman Alexie, Charles Burnett, and Denis Doros, audio bonus feature on Milestone Film and Video DVD release of *The Exiles*, 2008; also available on the WNYC website ("Young American Indians in 1961 Los Angeles").

100. Alexie, DVD commentary.

101. Greg Kimball in *Bunker Hill: A Tale of Urban Renewal* (2009).

102. Davis, *City of Quartz*, 72, 74.

103. Jameson, *Postmodernism*, 38.

104. Davis, "Urban Renaissance and the Spirit of Postmodernism," 86.

105. Davis, "Urban Renaissance and the Spirit of Postmodernism," 87. Davis's essay was originally published in 1985, responding to Fredric Jameson's 1984 essay "Postmodernism, or The Cultural Logic of Late Capitalism."

106. Benjamin, *The Arcades Project*, 473.

4. COLLECTING IMAGES

1. Benjamin, "Eduard Fuchs, Collector and Historian," 279.

2. Benjamin, *The Arcades Project*, 207.

3. Belting, *An Anthropology of Images*, 32.

4. Cavell, "The World as Things," 249.

5. Benjamin, *The Arcades Project*, 211.

6. Steinberg, "The Collector as Allegorist," 115.

7. Derrida, *Archive Fever*, 5.

8. Spieker, *The Big Archive*.

9. Spieker, *The Big Archive*, 173–74.

10. Spieker, *The Big Archive*, 114.

11. Spieker, *The Big Archive*, 56.

12. Rancière, "Godard, Hitchcock, and the Cinematographic Image," 231.

13. Rancière, "Godard, Hitchcock, and the Cinematographic Image," 225.

14. Rancière, "Godard, Hitchcock, and the Cinematographic Image," 226.

15. Rancière, "Godard, Hitchcock, and the Cinematographic Image," 225.

16. "Control of the Universe" is the title of Section 4a of *Histoire(s) du cinéma*, which includes a great deal of material about Hitchcock and his films.

17. Parikka, "Media Archaeology as a Trans-Atlantic Bridge," 29.

18. Parikka, "Media Archaeology as a Trans-Atlantic Bridge," 28.

19. For more on this, see Russell, "New Media and Film History."

20. See, for example, *Phi Phenomenon* (1968), *Production Stills* (1970), *Wilkinson Household Fire Alarm* (1973), *Picture and Sound Rushes* (1973), *Cue Rolls* (1974), *Projection Instructions* (1976).

21. Arthur, *A Line of Sight*, 68.

22. Camporesi and Censi, "Single Takes and Great Complexities," 91.

23. Fisher, "Writings," 71.

24. Fisher, "Writings," 72. The rule has something to do with how often a given film is cited, as in "no two shots from the same film appear consecutively," but there is also a pattern by which the films are woven together.

25. Andersen, "Pebbles Left on the Beach," 43.

26. Camporesi and Censi, "Single Takes and Great Complexities," 95.

27. Pimenta, "Serial Chance," 74.

28. Hansen, *Cinema and Experience*, 157.

29. Benjamin, "The Work of Art," second version, 117.

30. Hansen, *Cinema and Experience*, 157.

31. Benjamin, "Excavation and Memory," 576.

32. Andersen, "Pebbles Left on the Beach," 42.

33. Pensky, "*Geheimmittel*," 119.

34. Pensky, "*Geheimmittel*," 119.

35. Arthur, "()," 75.

36. Ernst, *Digital Memory and the Archive*, 52.

37. Ernst makes reference to Marshall McLuhan's famous slogan "The medium is the message" from *Understanding Media: The Extensions of Man* (London: Routledge, 1964) as an example of "an awareness of the medium at work with the message . . . the message being an emphatic notion of history." Ernst, *Digital Memory and the Archive*, 52.

38. Hansen, *Cinema and Experience*, 137.

39. Elsaesser, "Freud and the Technical Media," 108–9.

40. Huhtamo and Parikka, "Introduction," 6.

41. Ernst, *Digital Memory and the Archive*, 55, 218n1.

42. "Epic and rhapsodic, in the strictest sense, genuine memory must therefore yield an image of the person who remembers, in the same way a good archaeological report not only informs us about the strata from which the findings originate, but also gives an account of the strata which first had to be broken through." Benjamin, "Excavation and Memory," 576.

43. Ernst, *Digital Memory and the Archive*, 43.

44. Ernst, *Digital Memory and the Archive*, 45.

45. Ernst, *Digital Memory and the Archive*, 45.

46. Camporesi and Censi, "Single Takes and Great Complexities," 91.

47. Benjamin, *The Arcades Project*, 462.

48. Rancière, "Godard, Hitchcock, and the Cinematographic Image," 224.

49. Parikka, "Media Archaeology as a Trans-Atlantic Bridge," 29.

50. Parikka, "Media Archaeology as a Trans-Atlantic Bridge," 29.

51. Hansen, *Cinema and Experience*, 162.

52. Benjamin, *Charles Baudelaire*, 137.

53. Benjamin, *The Arcades Project*, 476.

54. Benjamin, "Excavation and Memory," 576.

55. Prelinger, "Points of Origin," 167.

56. Lundemo, "Archives and Technological Selection," 35.

57. Lundemo, "Archives and Technological Selection," 33.

58. Amad, *Counter-Archive*, 17.

59. Hans Belting makes this point in his discussion of digital imaging as not being the paradigm shift that theorists such as Lev Manovich have claimed. Belting, *An Anthropology of Images*, 26–27.

60. Janisse, "Apocalypse Now."

61. *Hoax Canular* is the third film in a trilogy that includes RIP *in Pieces America* (2009) and *Pieces and Love All to Hell* (2011).

62. Janisse, "Apocalypse Now."

63. *Hoax Canular* is available on YouTube, https://www.youtube.com/watch?v=ProeW9xWsiw (February 11, 2014; accessed July 1, 2015).

64. Clifford, *The Predicament of Culture*, 244.

65. Clifford, *The Predicament of Culture*, 244.

66. Clifford, *The Predicament of Culture*, 224.

67. Clifford, *The Predicament of Culture*, 226.

68. Gagnon's follow-up film *Of the North* (2015), made with Inuit-produced videos posted on YouTube, had a very controversial reception in Canada, where the Inuit community loudly protested the film to the extent that it was pulled from distribution. For a good account of the controversy, see Habib, "Positions."

69. Gagnon, master class at Concordia University, February 2014.

70. Benjamin, "Little History of Photography," in *Selected Writings*, vol. 2, 250.

71. Benjamin, "Reply to Oscar A. H. Schmitz," in *Selected Writings*, vol. 2, 18–19.

72. Sekula, "The Traffic in Photographs," 19.

73. Gilloch, *Myth and Metropolis*, 170.

74. Benjamin, *The Arcades Project*, 473.

75. Benjamin, *The Arcades Project*, 475.

76. Russell, *Experimental Ethnography*, 238–39.

77. Russell, *Experimental Ethnography*, 272.

78. MacDonald, "A Conversation with Gustav Deutsch (part 1)," 86.

79. MacDonald, "A Conversation with Gustav Deutsch (part 2)," 157.

80. Gunning, "From Fossils of Time to a Cinematic Genesis," 174–75.

81. Gunning, "From Fossils of Time to a Cinematic Genesis," 175.

82. Gunning, "From Fossils of Time to a Cinematic Genesis," 170.

83. De Klerk, "Designing a Home," 118.

84. The two conversations with Scott MacDonald in *Gustav Deutsch* could be considered to be paratexts to the work. In the context of an art-historical practice of the auteur interview, he actually provides the kind of information that might have gone into a voice-over narration.

85. MacDonald, "Conversation," part 2, 147–48.

86. The term *characters* is used in the video description online and the "liner notes" for the DVD. "World Mirror Cinema," accessed June 27, 2017, http://www.gustavdeutsch .net/index.php/en/films-a-videos/21-welt-spiegel-kino-episode-1-3.html.

87. Loebenstein, "The Hub of the Universe."

88. Benjamin, *The Arcades Project*, 542.

89. Amad, "Visual Riposte," 65.

90. Amad, "Visual Riposte," 60.

91. Benjamin, "On Some Motifs in Baudelaire," 338.

92. Benjamin, "On Some Motifs in Baudelaire," 338.

93. Pierson, "Avant-Garde Re-enactment," 14.

94. MacDonald, "Conversation," part 2, 154.

95. MacDonald, "Conversation," part 2, 150.

96. Gunning, "Living Mirrors."

97. Benjamin, *The Arcades Project*, 405.

98. Benjamin, *The Arcades Project*, 389.

99. Deutsch says that it is actually a Dutch wedding ceremony in which the colonists have appropriated elements of indigenous culture (MacDonald, "Conversation," part 2, 156); the interpretation of the scene as an allegory of colonial rebellion is offered by Nico de Klerk in "Enter the Dragon."

100. Benjamin, "Central Park," 183.

101. Benjamin, *The Arcades Project*, 369.

102. Benjamin, *The Arcades Project*, 368.

103. Rochlitz, *Walter Benjamin and the Disenchantment of Art*, 223.

104. Rochlitz, *Walter Benjamin and the Disenchantment of Art*, 221.

105. Benjamin, *The Origin of German Tragic Drama*, 178.

106. Benjamin, *The Arcades Project*, 207.

107. Benjamin cites Warburg's discussion of the various ways in which traces of Greek culture remained potent in the Renaissance, including the occult powers of gods, and were sensible within visual culture. Benjamin, *The Origin of German Tragic Drama*, 150, 225.

108. Michaud, *Aby Warburg and the Image in Motion*, 278.

109. Michaud, *Aby Warburg and the Image in Motion*, 262.

110. Benjamin, *The Origin of German Tragic Drama*, 232–33.

111. Caygill, "Walter Benjamin's Concept of Cultural History," 85.

112. Caygill, "Walter Benjamin's Concept of Cultural History," 88.

113. Latsis, "Geneologies of the Image in *Histoire(s) du cinéma*."

114. Sacco, "The Braided Weave of *Mnemosyne*."

115. Benjamin, *The Arcades Project*, 476.

116. Benjamin, *The Arcades Project*, 391.

5. PHANTASMAGORIA AND CRITICAL CINEPHILIA

1. Benjamin, "One-Way Street," 460.

2. Benjamin, "The Destructive Character," in *Selected Writings*, vol. 2, 542.

3. Benjamin, "The Task of the Critic," in *Selected Writings*, vol. 2, 548.

4. Gledhill, "Rethinking Genre," 229.

5. M. Cohen, *Profane Illumination*, 240.

6. M. Cohen, *Profane Illumination*, 236.

7. M. Cohen, *Profane Illumination*, 249.

8. M. Cohen, *Profane Illumination*, 250.

9. M. Cohen, *Profane Illumination*, 256.

10. I tend to agree with Thomas Elsaesser that with the digital turn, "cinephilia is not only an anxious love, but can always turn itself into a happy perversion"—which in my view is no more "useful" or historically reflexive. Elsaesser, "Cinephilia or the Uses of Disenchantment," 41.

11. Willemen, *Looks and Frictions*, 231.

12. See Shambu, *The New Cinephilia*, for a recent discussion of the practice of cinephilia as experiential and social but not necessarily critical, activist, or able to produce cultural knowledge.

13. Elsaesser, "Cinephilia or the Uses of Disenchantment," 32–33.

14. Hansen, *Cinema and Experience*, 181.

15. Willemen, *Looks and Frictions*, 254–55.

16. Elsaesser, "Cinephilia or the Uses of Disenchantment," 32.

17. Metz, *The Imaginary Signifier*, 15.

18. Metz, *The Imaginary Signifier*, 16.

19. Stern, "Paths That Wind through the Thicket of Things," 319.

20. Stern, "Paths That Wind through the Thicket of Things," 329, quoting from Robert Bresson, *Notes on the Cinematographer*, 59.

21. Stern, "Paths That Wind through the Thicket of Things," 354.

22. Stern, "Paths That Wind through the Thicket of Things," 352.

23. The physical size and amount of data of *The Clock* means that it may never be released in home video form; however, *Kristall* and *Phoenix Tapes* may be available one day. For a hopeful fan, see "Phoenix Tapes (Christoph Girardet and Matthias Muller, 1999)."

24. Balsom, *Exhibiting Cinema in Contemporary Art*, 146.

25. Balsom, *Exhibiting Cinema in Contemporary Art*, 135.

26. Sinclair, "Time Pieces."

27. *The Clock* won the Boston Society of Film Critics Award for editing in 2011.

28. Balsom, "Around *The Clock*," 177.

29. Krauss, "Clock Time," 216.

30. Benjamin, "On Some Motifs in Baudelaire," 336.

31. Benjamin, *Illuminations*, 185.

32. Benjamin, "On Some Motifs in Baudelaire," 335–36.

33. Olalquiaga, *The Artificial Kingdom*, 74.

34. Osborne, "Distracted Reception," 72.

35. The opening epigraph from this chapter makes this point. Benjamin, "On Some Motifs in Baudelaire," 335. Although the editors of Benjamin's *Selected Works* have supposedly preserved Harry Zohn's original translation, in the versions that appear in *Charles Baudelaire* and *Illuminations*, Zohn translated it as "time becomes palpable" rather than "time becomes reified" (*Illuminations*, 143).

36. Spieker, *The Big Archive*, 54.

37. Spieker, *The Big Archive*, 136.

38. See Horwatt, "On *The Clock* and Christian Marclay's Instrumental Logic of Appropriation."

39. Thom Andersen sums up the grumbling cynicism of cinephiles when he asks, "Is the clock dumb enough?" Andersen, "Random Notes on a Projection of *The Clock*

by Christian Marclay at the Los Angeles County Museum of Art," 11. See also Edelstein and Saltz, "Great or Gimmick?"

40. Martin, "Turn the Page," 223.

41. Martin, "Turn the Page," 231.

42. Benjamin, "One-Way Street," 466.

43. Benjamin, "Dream Kitsch: Gloss on Surrealism," in *Selected Writings*, vol. 2, 3.

44. Benjamin, "Dream Kitsch," 476.

45. Willemen, *Looks and Frictions*, 232.

46. The two forms of experience, *Erfahrung* and *Erlebnis*, are discussed most thoroughly in Benjamin, "On Some Motifs in Baudelaire," 313–55, although they recur throughout *The Arcades Project* as well.

47. Hansen, *Cinema and Experience*, 103.

48. Barthes, "Upon Leaving the Movie Theater," 3–4.

49. Horwatt, "On *The Clock* and Christian Marclay's Instrumental Logic of Appropriation," 217.

50. Glöde, "A Different Rediscovery of Something (Lost)," 106.

51. Hediger, "What Makes an Excerpt?" (published in German as "Der Kunster als Kritiker").

52. Benjamin, "Goethe's Elective Affinities," *Selected Writings*, vol. 1, 297–360.

53. Rochlitz, *Walter Benjamin and the Disenchantment of Art*, 70.

54. Audiovisual Essay: Practice and Theory International Workshop, presented by the Film, Media and Theatre Studies Department of Goethe University and the Deutsches Filmmuseum, Frankfurt, November 2013. The festival has been archived in the form of a website: "Frankfurt Papers," The Audiovisual Essay, accessed June 28, 2017, http://reframe.sussex.ac.uk/audiovisualessay/frankfurt-papers/.

55. Brooks, *The Melodramatic Imagination*, 5.

56. L. Williams, "Melodrama Revised," 49.

57. MacDonald, "Matthias Müller," 291.

58. MacDonald, "Matthias Müller," 292.

59. Hallas, "AIDS and Gay Cinephilia," 87.

60. Agamben, *Means without End*, 94–95.

61. Benjamin, *The Arcades Project*, 389.

62. Benjamin, "The Work of Art," third version, 269.

63. Benjamin, *The Arcades Project*, 395–96.

64. Benjamin, "Eduard Fuchs, Collector and Historian," 283.

65. Benjamin, "Eduard Fuchs, Collector and Historian," 267.

66. Brooks, *The Melodramatic Imagination*, 36.

67. Brooks, *The Melodramatic Imagination*, 41.

68. Brooks, *The Melodramatic Imagination*, 41.

69. Brooks, *The Melodramatic Imagination*, 72.

70. Elsaesser, "Tales of Sound and Fury," 89.

71. L. Williams, "Melodrama Revised," 44.

72. Benjamin, *The Origin of German Tragic Drama*, 212; Brooks, *The Melodramatic Imagination*, 49.

73. Benjamin, *The Origin of German Tragic Drama*, 232–33.

74. George Steiner, "Introduction," in Benjamin, *The Origin of German Tragic Drama*, 19. The lack of mutual recognition on the part of Erwin Panofsky and the Warburg Institute marks, for Steiner, "the most ominous moment" in Benjamin's career — preventing him from finding refuge in London — in a melodramatic turn of events.

75. For more on early screen melodrama, see Singer, *Melodrama and Modernity*.

76. For an excellent analysis of the history of melodrama criticism in relation to Sirk, see Klinger, *Melodrama and Meaning*.

77. Benjamin, *The Origin of German Tragic Drama*, 183–84.

78. Buci-Glucksmann, *Baroque Reason*, 71.

79. Benjamin, "*Trauerspiel* and Tragedy," in *Selected Writings*, vol. 1, 57.

80. Benjamin, "The Role of Language in *Trauerspiel* and Tragedy," in *Selected Writings*, vol. 1, 61.

81. Rochlitz, *Walter Benjamin and the Disenchantment of Art*, 99.

82. Gledhill, "Rethinking Genre," 229.

83. Gledhill, "Rethinking Genre," 241.

84. Benjamin, *The Origin of German Tragic Drama*, 119.

85. Windhausen, "Hitchcock and the Found Footage Installation," 120.

86. Benjamin "The Work of Art," second version, 108.

87. Benjamin "The Work of Art," second version, 113.

88. Agamben, *Means without End*, 55.

89. Agamben, *Means without End*, 56.

90. Agamben, *Means without End*, 59.

91. Agamben, *Means without End*, 70.

92. Agamben, *Means without End*, 90–91.

93. Agamben, *Means without End*, 117.

94. Agamben, *Means without End*, 115.

95. Windhausen, "Hitchcock and the Found Footage Installation," 107.

96. Buck-Morss, "Aesthetics and Anaesthetics," 23.

97. Fowler, "*The Clock*," 239.

98. Flusser, *Gestures*, 9.

99. Flusser, *Gestures*, 17.

6. AWAKENING FROM THE GENDERED ARCHIVE

Epigraph: The Lethe is a river in hell, in Greek mythology. The Greek term also means "forgetfulness."

1. Flaig, "Supposing That the Archive Is a Woman," 182.

2. Silverman, "The Dream of the Nineteenth Century," 21.

3. Torlasco, *The Heretical Archive*, 50.

4. Burgin, *The Remembered Film*, 99.

5. Burgin, *The Remembered Film*, 108.

6. Torlasco, *The Heretical Archive*, 29.

7. King, *Virtual Memory*, 75.

8. King, *Virtual Memory*, 83.

9. Torlasco, *The Heretical Archive*, 49; King, *Virtual Memory*, 87, both quoting from the film.

10. Torlasco, *The Heretical Archive*, 25.

11. King, *Virtual Memory*, 88.

12. Torlasco, *The Heretical Archive*, 50.

13. King, *Virtual Memory*, 71, citing Benjamin, "On Some Motifs in Baudelaire," in *Illuminations*, 185. The corresponding page in *Selected Writings*, vol. 4, is 336.

14. Benjamin, "Excavation and Memory," 576.

15. King, *Virtual Memory*, 86.

16. Benjamin, "On Some Motifs in Baudelaire," in *Selected Writings*, vol. 4, 337. The translation of this version of the essay in *Illuminations*, also credited to Harry Zohn, uses "long practice" instead of "the practiced hand" (186).

17. King, *Virtual Memory*, 99.

18. Elsaesser, "The Ethics of Appropriation," 37.

19. See, for example, Friedberg, *Window Shopping*; Petro, *Aftershocks of the New*; Bruno, *Atlas of Emotion*.

20. Buck-Morss, "The Flâneur, the Sandwichman and the Whore," 120.

21. Benjamin, *The Arcades Project*, 64.

22. Buci-Glucksmann, *Baroque Reason*, 113–14.

23. Buck-Morss, "The Flâneur, the Sandwichman and the Whore," 120.

24. Berdet, "What Is Anthropological Materialism?"

25. Hansen, *Cinema and Experience*, 133.

26. Adorno and Benjamin, *The Complete Correspondence*, 146.

27. Buci-Glucksmann, *Baroque Reason*, 108.

28. Buci-Glucksmann, *Baroque Reason*, 109.

29. Buci-Glucksmann, *Baroque Reason*, 109.

30. Benjamin, *The Arcades Project*, 494.

31. Benjamin, *The Arcades Project*, 494.

32. Benjamin, *The Arcades Project*, 511.

33. Wang, "Playback, Play-forward," 124. Benjamin's text on Wong is "Gesprächt mit Anna May Wong."

34. Benjamin, "Speaking with Anna May Wong," translation of "Gesprächt mit Anna May Wong" by Jeff Fort. Thanks to Shirley Jennifer Lim for the translation. See Lim, " 'Speaking German like Nobody's Business.' "

35. Benjamin, "Work of Art," second version, 111.

36. Benjamin, The *Arcades Project*, 461, 462.

37. Benjamin, The *Arcades Project*, 464.

38. Hansen, *Cinema and Experience*, 111.

39. Torlasco, *The Heretical Archive*, xiii.

40. Torlasco, *The Heretical Archive*, xix.

41. Mulvey, *Death 24x a Second*, 167–69.

42. Mulvey, *Death 24x a Second*, 173.

43. Mulvey, *Death 24x a Second*, 184.

44. Mulvey, *Death 24x a Second*, 180.

45. Barefoot, "Recycled Images," 156.

46. Lowenstein, *Dreaming of Cinema*, 21.

47. Benjamin, "The Work of Art," second version, 117.

48. Benjamin, "The Work of Art," second version, 113.

49. Benjamin, "The Work of Art," second version, 113.

50. Fowler, "*The Clock*," 232.

51. Fowler, "*The Clock*," 231, quoting Flusser, "The Gesture of Photographing."

52. Benjamin, "What Is the Epic Theater," in *Selected Writings*, vol. 4, 305.

53. Asman, "Return of the Sign to the Body," 49.

54. Lowenstein, *Dreaming of Cinema*, 154.

55. Hauptman, *Joseph Cornell*, 110.

56. Lowenstein, *Dreaming of Cinema*, 165.

57. Mulvey, *Death 24x a Second*, 167.

58. Mulvey, *Death 24x a Second*, 192.

59. Wees, "The Ambiguous Aura of Hollywood Stars in Avant-Garde Found-Footage Films," 8.

60. Anthony Slide, "Introduction," in Hobart, *A Steady Digression to a Fixed Point*, v.

61. Hansen, *Cinema and Experience*, 105.

62. Hansen, *Cinema and Experience*, 118.

63. Cornell, *Joseph Cornell's Theatre of the Mind*, 63, quoted in Barefoot, "Recycled Images," 153.

64. Hansen, *Cinema and Experience*, 130, quoting Wohlfarth, "Walter Benjamin and the Idea of a Technological Eros," 68.

65. Gordon, *Revolutionary Melodrama*, 271.

66. Khurana, "A Splice of Reel Life."

67. Badreya, "Saving Egyptian Film Classics."

68. In November 2016 Hosni's YouTube channel (https://www.youtube.com/user/SoadHosnyTV) boasted 48,000 subscribers and 21 million views, although in June 2017 it had been taken down. The films are nevertheless in circulation on other websites.

69. Stoney, "Life on Screen," 6.

70. Gordon, *Revolutionary Melodrama*, 277.

71. Stoney, "Life on Screen," 5.

72. This is how Stoney describes the three parts in her introduction to the interview with Stephan. Stoney, "Life on Screen," 2.

73. Stoney, "Life on Screen," 4.

74. Belli, *An Incurable Past*, 26.

75. Nora, "Between Memory and History," 14.

76. Nora, "Between Memory and History," 12.

77. Nora, "Between Memory and History," 23.

78. Nora, "Between Memory and History," 24.

79. Benjamin, *The Origin of German Tragic Drama*, 217.

80. Marks, *Hanan al-Cinema*, 186.

81. Thanks to Kay Dickinson for this particular point.

82. Cadava, *Words of Light*, 29–30, quoted in Beckman, *Vanishing Women*, 158.

83. Beckman, *Vanishing Women*, 190.

84. Cadava, *Words of Light*, 30.

85. Shafiq, "Women, National Liberation, and Melodrama in Arab Cinema," 18.

86. Bryan S. Turner, "Introduction," in Buci-Glucksmann, *Baroque Reason*, 34.

87. Turner, "Introduction," 34.

88. Desjardins, *"Meeting Two Queens,"* 33.

89. Baron, *The Archive Effect*, 38.

90. Dyer, *Pastiche*, 138.

EPILOGUE

1. Benjamin, "The Task of the Translator," 260.

2. Benjamin, "The Task of the Translator," 261.

3. Alter, "Translating the Essay into Film and Installation," 50. Alter is paraphrasing Richter's German essay from 1940, "Der Filmessay: Eine neue Form des Dokumentarfilms" (The Film Essay: A New Form of Documentary Film), in *Schreiben Bilder Sprechen: Texte zum essayistischen Film*, ed. Christa Blümlinger and Constantin Wulff (Vienna: Sonderzahl, [1940] 1992).

4. Alter makes this point as well, citing Richter's "Der Filmessay." Alter, "Translating the Essay into Film and Installation," 50.

5. Baron, "The Ethics of Appropriation," 156.

6. Baron, "The Ethics of Appropriation," 157.

7. Benjamin, "On the Concept of History," 392.

8. Benjamin, "On the Concept of History," 396.

9. Benjamin, "The Task of the Translator," 254. In the version published in *Illuminations, form* was used in place of *mode.*

10. Benjamin, "Unpacking My Library," in *Selected Writings*, vol. 2, 492.

11. Balsom, *Exhibiting Cinema in Contemporary Art*, 95. Tacita Dean is a British artist who works in many different media, including film. Balsom is referring here to several installation and book works that are based on collections.

12. Krauss, "A Voyage on the North Sea," 41. The quotation is from Benjamin, *The Arcades Project*, 7.

13. Balsom, *Exhibiting Cinema in Contemporary Art*, 93.

14. Benjamin, "On the Concept of History," 395.

15. Benjamin, "On the Concept of History," 395.

16. Agamben, *Means without End*, 58.

17. Agamben, *Means without End*, 56.

18. Agamben, *Remnants of Auschwitz*, 145.

19. Agamben, *Remnants of Auschwitz*, 159.

SELECTED FILMOGRAPHY

() a.k.a. *Parentheses* (Morgan Fisher, 2003)
Artist (Tracey Moffatt and Gary Hillberg, 2000)
Atomic Café (Jayne Loader, Kevin Rafferty, and Pierce Rafferty, 1982)
The Autobiography of Nicolae Ceauşescu (Andrei Ujica, 2010)
The Beaches of Agnès (Agnès Varda, 2008)
Century of the Self (Adam Curtis, 2002)
The Clock (Christian Marclay, 2010)
Decasia (Bill Morrison, 2002)
The Exiles (Kent MacKenzie, 1961)
Eureka (Ernie Gehr, 1974)
Film Ist (Gustav Deutsch, 2004–2009)
The Film of Her (Bill Morrison, 1997)
From the Pole to the Equator (Yervant Gianikian and Angela Ricci Lucchi, 1990)
The Gleaners and I (Agnès Varda, 2000)
The Gleaners and I: Two Years Later (Agnès Varda, 2002)
Le Grand Détournement: La Classe américaine (Michel Hazanavicius and Dominique
 Mézerette, 1993)
The Great Flood (Bill Morrison, 2012)
Handsworth Songs (John Akomfrah, 1986)
Histoire(s) du cinéma (Jean-Luc Godard, 1998)
Hoax Canular (Dominic Gagnon, 2013)
Home Stories (Matthias Müller, 1990)
Images of the World and the Inscription of War (Harun Farocki, 1988)
La Jetée (Chris Marker, 1962)
Kristall (Christoph Girardet and Matthias Müller, 2006)
Lip (Tracey Moffatt and Gary Hillberg, 1999)
Los Angeles Plays Itself (Thom Andersen, 2003)
Love (Tracey Moffatt and Gary Hillberg, 2003)
The Maelstrom: A Family Chronicle (Péter Forgács, 1997)
Marilyn Times Five (Bruce Conner, 1973)
Marlene (Maximilian Schell, 1984)
Meeting Two Queens (Cecilia Barriga, 1991)
A Movie (Bruce Conner, 1958)

My Winnipeg (Guy Maddin, 2007)

Paris 1900 (Nicole Védrès, 1947)

Persistence (Daniel Eisenberg, 2007)

Phi Phenomenon (Morgan Fisher, 1968)

Phoenix Tapes (Christoph Girardet and Matthias Müller, 1999)

Recollection (Kamal Aljafari, 2015)

Rose Hobart (Joseph Cornell, 1936)

Standard Gauge (Morgan Fisher, 1984)

The Three Disappearances of Soad Hosni (Rania Stephan, 2011)

Time and the City (Terrence Davies, 2008)

Toponimia (Jonathan Perel, 2015)

Tribulation 99 (Craig Baldwin, 1992)

Variations on a Cellophane Wrapper (David Rimmer, 1970)

Video Quartet (Christian Marclay, 2006)

World Mirror Cinema (Gustav Deutsch, 2005)

BIBLIOGRAPHY

Adorno, Theodor W., and Walter Benjamin. *The Complete Correspondence, 1928–1940.* Edited by Henri Lonitz. Cambridge, MA: Harvard University Press, 1999.

Agamben, Giorgio. *Means without End: Notes on Politics.* Minneapolis: University of Minnesota Press, 2000.

———. *Remnants of Auschwitz: The Witness and the Archive.* Translated by Daniel Heller-Roazen. New York: Zone Books, 2012.

Alexie, Sherman. DVD commentary. *The Exiles,* directed by Kent MacKenzie, 1961. DVD. Harrington Park, NJ: Milestone Film and Video, 2008.

Alter, Nora. "The Political Im/Perceptible in the Essay Film: Farocki's 'Images of the World and the Inscription of War.'" *New German Critique,* no. 68 (spring–summer 1996): 165–92.

———. "Translating the Essay into Film and Installation." *Journal of Visual Culture* 6, no. 1 (2007): 44–57.

Amad, Paula. *Counter-Archive: Film, the Everyday, and Albert Kahn's Archives de la Planète.* New York: Columbia University Press, 2010.

———. "Film as the 'Skin of History': André Bazin and the Specter of the Archive and Death in Nicole Védrès's *Paris 1900* (1947)." *Representations* 130, no. 1 (2015): 84–118.

———. "Visual Riposte: Looking Back at the Return of the Gaze as Postcolonial Theory's Gift to Film Studies." *Cinema Journal* 52, no. 3 (2013): 49–74.

Andersen, Thom. "Pebbles Left on the Beach: The Films of Morgan Fisher." *Cinema Scope,* no. 38 (spring 2009): 37–43.

———. "Random Notes on a Projection of *The Clock* by Christian Marclay at the Los Angeles County Museum of Art." *Cinema Scope,* no. 48 (2011): 11–13.

Anonymous. "*Paris 1900,* France, 1948." *Monthly Film Bulletin* 19, no. 216 (1952): 100.

———. "*Paris 1900:* French — Documentary." *Variety,* May 24, 1950, 20.

Antin, Eduardo. "The Exiles." *Cinema Scope,* no. 36 (2008): 72–73.

Arthur, Paul. *A Line of Sight: American Avant-Garde Film since 1965.* Minneapolis: University of Minnesota Press, 2005.

———. "()." *Film Comment* 40, no. 1 (2004): 75.

Asman, Carrie. "Return of the Sign to the Body: Benjamin and Gesture in the Age of Retheatricalization." *Discourse* 16, no. 3 (1994): 46–64.

Badreya, Sayed. "Saving Egyptian Film Classics." YouTube, September 3, 2008. Accessed June 30, 2017. https://www.youtube.com/watch?v=qWFEooTkCvE.

Balsom, Erika. "Around *The Clock*: Museum and Market." *Framework* 54, no. 2 (2013): 177–91.

———. *Exhibiting Cinema in Contemporary Art*. Amsterdam: Amsterdam University Press, 2013.

Barefoot, Guy. "Recycled Images: *Rose Hobart, East of Borneo,* and the *Perils of Pauline*." *Adaptation* 5, no. 2 (2012): 152–68.

Baron, Jaimie. *The Archive Effect: Found Footage and the Audiovisual Experience of History*. New York: Routledge, 2014.

———. "The Ethics of Appropriation in *Suitcase of Love and Shame* and *A Film Unfinished*." In *Contemporary Documentary*, edited by Selmin Kara and Daniel Marcus, 156–70. London: Routledge, 2015.

Barthes, Roland. "Upon Leaving the Movie Theater." Translated by Bertrand Augst and Susan White. In *Apparatus: Cinematographic Apparatus: Selected Writings*, edited by Theresa Hak Kyung Cha, 1–4. New York: Tanam Press, 1980.

Bazin, André. "À la recherche du temps perdu: *Paris 1900*." In *Le Cinéma française de la Libération à la Nouvelle vague (1945–1958)*, 41–43. Paris: Cahiers du Cinema, 1998.

———. "Death Every Afternoon." In *Rites of Realism: Essays on Corporeal Cinema*, edited by Ivone Margulies and translated by Mark A. Cohen, 27–31. Durham, NC: Duke University Press, 2003.

Beckman, Karen. *Vanishing Women: Magic, Film, and Feminism*. Durham, NC: Duke University Press, 2003.

Belli, Mériam N. *An Incurable Past: Nasser's Egypt Then and Now*. Gainesville: University Press of Florida, 2013.

Belting, Hans. *An Anthropology of Images: Picture, Medium, Body*. Translated by Thomas Dunlap. Princeton, NJ: Princeton University Press, 2011.

Benjamin, Walter. *The Arcades Project*. Translated by Howard Eiland and Kevin McLaughlin. Cambridge, MA: Harvard University Press, 1999.

———. *A Berlin Childhood*. Translated by Howard Eiland. Cambridge, MA: Harvard University Press, 2006.

———. *Charles Baudelaire. A Lyric Poet in the Era of High Capitalism*. Translated by Harry Zohn. London: Verso, 1983.

———. "Gesprächt mit Anna May Wong: Eine Chinoiserie aus dem alten Westen." *Die Literarische Welt*, July 6, 1928, 213.

———. *Illuminations*. Edited by Hannah Arendt. Translated by Harry Zohn. London: Verso, 1969.

———. *The Origin of German Tragic Drama*. Translated by John Osborne. London: NLB/Verso, 1977.

———. *Selected Writings*. Vol. 1, *1913–1926*. Edited by Marcus Bullock and Michael W. Jennings. Cambridge, MA: Harvard University Press, 1996.

———. *Selected Writings*. Vol. 2, *1927–1934*. Edited by Michael J. Jennings, Howard Eiland, and Gary Smith. Translated by Jonathan Livingstone et al. Cambridge, MA: Harvard University Press, 1999.

———. *Selected Writings*. Vol. 3, *1935–1938*. Edited by Howard Eiland and Michael W. Jennings. Translated by Edmund Jephcott et al. Cambridge, MA: Harvard University Press, 2002.

———. *Selected Writings*. Vol. 4, *1938–1940*. Edited by Howard Eiland and Michael W. Jennings. Translated by Edmund Jephcott et al. Cambridge, MA: Harvard University Press, 2003.

———. *Walter Benjamin's Archive: Images, Texts, Signs*. Edited by Ursula Marx, Gudrun Schwarz, Michael Schwarz, and Erdmut Wizisla. Translated by Esther Leslie. London: Verso, 2007.

Berdet, Marc. "What Is Anthropological Materialism?" *Anthropological Materialism* (blog), April 8, 2010. http://anthropologicalmaterialism.hypotheses.org/644.

Biemann, Ursula. *Stuff It: The Video Essay in the Digital Age*. Zurich: Edition Voldemeer, 2003.

Bloemheuvel, Marente, Giovanna Fossati, and Jaap Guldemond, eds. *Found Footage Cinema Exposed*. Amsterdam: Amsterdam University Press, 2012.

Bresson, Robert. *Notes on the Cinematographer*. Translated by John Griffin. London: Quartet, 1986.

Breton, André. "As in a Wood." In *The Shadow and Its Shadow*, translated and edited by Paul Hammond, 72–77. San Francisco, CA: City Lights Books, 2000.

Brody, Richard. "The Exiles." Movies. *New Yorker*, September 15, 2008, 22.

Brooks, Peter. *The Melodramatic Imagination: Balzac, Henry James, Melodrama, and the Mode of Excess*. New York: Columbia University Press, 1985.

Bruno, Giuliana. *Atlas of Emotion: Journeys in Art, Architecture, and Film*. New York: Verso, 2002.

———. "Surface, Fabric, Weave: The Fashioned World of Wong Kar-Wai." In *Fashion in Film*, edited by Adrienne Munich, 83–105. Bloomington: Indiana University Press, 2011.

Buchloh, Benjamin H. D. "Allegorical Procedures: Appropriation and Montage in Contemporary Art." *Artforum* 21, no. 1 (1982): 43–56.

Buci-Glucksmann, Christine. *Baroque Reason: The Aesthetics of Modernity*. London: Sage, 1994.

Buck-Morss, Susan. "Aesthetics and Anaesthetics: Walter Benjamin's Artwork Essay Reconsidered." *October*, no. 62 (autumn 1992): 3–41.

———. *The Dialectics of Seeing: Walter Benjamin and the Arcades Project*. Cambridge, MA: MIT Press, 1989.

———. "The Flâneur, the Sandwichman and the Whore: The Politics of Loitering." *New German Critique*, no. 39 (autumn 1986): 99–140.

Burgin, Victor. *The Remembered Film*. London: Reaktion Books, 2004.

Cadava, Eduardo. "Lapsus Imaginis: The Image in Ruins." *October*, no. 96 (spring 2001): 35–60.

———. *Words of Light: Theses on the Photography of History*. Princeton, NJ: Princeton University Press, 1997.

Camporesi, Enrico, and Rinaldo Censi. "Single Takes and Great Complexities: A Conversation with Morgan Fisher." *Millennium Film Journal*, no. 60 (fall 2014): 80–95.

Cavell, Stanley. "The World as Things: Collecting Thoughts on Collecting." In *Cavell on Film*, edited by William Rothman, 241–79. Albany: State University of New York Press, 2005.

Caygill, Howard. "Walter Benjamin's Concept of Cultural History." In *The Cambridge Companion to Walter Benjamin*, edited by David S. Ferris, 73–96. Cambridge: Cambridge University Press, 2004.

Charity, Tom. "The Exiles." Reviews. *Sight and Sound* 20, no. 2 (2010): 86.

Clifford, James. *The Predicament of Culture: Twentieth-Century Ethnography, Literature, and Art*. Cambridge, MA: Harvard University Press, 1988.

Cocker, Emma. "Ethical Possession: Borrowing from the Archives." In *Cultural Borrowings: Appropriation, Reworking, Transformation*, edited by Iain Robert Smith, 92–110. Nottingham: Scope, 2009.

Cohen, Margaret. *Profane Illumination: Walter Benjamin and the Paris of Surrealist Revolution*. Berkeley: University of California Press, 1993.

Cohen, Sol. "An Innocent Eye: The 'Pictorial Turn,' Film Studies, and History." *History of Education Quarterly* 43, no. 2 (2003): 250–61.

Comay, Rebecca, ed. *Lost in the Archives*. Alphabet City 8. Toronto: Alphabet City Media, 2002.

Cornell, Joseph. *Joseph Cornell's Theatre of the Mind: Selected Diaries, Letters and Files*. Edited by Mary Ann Caws. London: Thames and Hudson, 1993.

Corrigan, Timothy. *The Essay Film: From Montaigne, after Marker*. New York: Oxford University Press, 2011.

Crowther, Bosley. "Snows of Yesteryear: Paris 1900 Has Faults of Most Album Films." *New York Times*, October 29, 1950.

Cvetkovich, Ann. *An Archive of Feelings: Trauma, Sexuality, and Lesbian Public Cultures*. Durham, NC: Duke University Press, 2003.

Dall'Asta, Monica. "Beyond the Image in Benjamin and Bazin: The Aura of the Event." In *Opening Bazin: Postwar Film Theory and Its Afterlife*, edited by Dudley Andrew, 57–65. New York: Oxford University Press, 2011.

———. "The (Im)possible History." In *Forever Godard*, edited by Michael Temple, James S. Williams, and Michael Witt, 350–63. London: Black Dog, 2007.

———. "Looking for Myriam: A Secret Genealogy of French Compilation Film." *Feminist Media Histories* 2, no. 3 (2016): 29–53.

Davis, Mike. *City of Quartz: Excavating the Future in Los Angeles*. London: Pimlico, 1998.

————. "Urban Renaissance and the Spirit of Postmodernism." In *Postmodernism and Its Discontents: Theories, Practices*, edited by E. Ann Kaplan, 79–87. London: Verso, 1988.

Debord, Guy. *Society of the Spectacle*. Translated by Fredy Perlman and Jon Supak. Rev. ed. Detroit: Black & Red, 1977.

de Klerk, Nico. "Designing a Home: Orphan Films in the Work of Gustav Deutsch." In *Gustav Deutsch*, edited by Wilbirg Brainin-Donnenberg and Michael Loebenstein, 113–22. Vienna: SYNEMA — Gesellschaft für Film and Medien, 2009.

————. "Enter the Dragon: Gustav Deutsch's WELT SPIEGEL KINO #2." Accessed November 17, 2017. http://gustavdeutsch.net/en/films-videos/47-bibliography/bibliografie -thematical/76-enter-the-dragon.html.

Derrida, Jacques. *Archive Fever: A Freudian Impression*. Translated by Eric Prenowitz. Chicago: University of Chicago Press, 1996.

Desjardins, Mary. "*Meeting Two Queens*: Feminist Filmmaking, Identity Politics, and the Melodramatic Fantasy." *Film Quarterly* 48, no. 3 (1995): 26–33.

Didi-Huberman, Georges. "Knowledge: Movement (The Man Who Spoke to Butterflies)." Foreword to *Aby Warburg and the Image in Motion*, by Philippe-Alain Michaud, trans. Sophie Hawkes, 7–19. New York: Zone Books, 2004.

Dimitrakaki, Angela. "Materialist Feminism for the Twenty-First Century: The Video Essays of Ursula Biemann." *Oxford Art Journal* 30, no. 2 (2007): 205–32.

Doane, Mary Ann. *The Emergence of Cinematic Time: Modernity, Contingency, the Archive*. Cambridge, MA: Harvard University Press, 2002.

Dyer, Richard. *Pastiche*. New York: Routledge, 2007.

Ebeling, Knut, and Stephan Günzel. *Archivologie: Theorien des Archivs in Philosophie, Medien und Künsten*. Berlin: Kulturverlag Kadmos, 2009.

Edelstein, David, and Jerry Saltz. "Great or Gimmick? Edelstein and Saltz Spar over Christian Marclay's *The Clock*." *Vulture*, July 21, 2012.

Elsaesser, Thomas. "Cinephilia or the Uses of Disenchantment." In *Cinephilia: Movies, Love and Memory*, edited by Marijke De Valck and Malte Hagener, 27–43. Amsterdam: Amsterdam University Press, 2005.

————. "The Ethics of Appropriation: Found Footage between Archive and Internet." *Found Footage Magazine*, no. 1 (October 2015): 30–37.

————. "Freud and the Technical Media: The Enduring Magic of the Wunderblock." In *Media Archaeology: Approaches, Applications, Implications*, edited by Erkki Huhtamo and Jussi Parikka, 96–115. Berkeley: University of California Press, 2011.

————. "Tales of Sound and Fury." In *Imitations of Life: A Reader of Film and Television Melodrama*, edited by Marcia Landy, 68–92. Detroit, MI: Wayne State University Press, 1991.

Enwezor, Okwui. "Archive Fever: Photography between History and the Monument." In *Archive Fever: Uses of the Document in Contemporary Art*, 11–50. Gottingen: Steidl, 2009.

Ernst, Wolfgang. *Digital Memory and the Archive*. Edited by Jussi Parikka. Minnea-
polis: University of Minnesota Press, 2013.

Evans, Caroline. "The Walkies: Early French Fashion Shows as a Cinema of Attrac-
tions." In *Fashion in Film*, edited by Adrienne Munich, 110–34. Bloomington: Indi-
ana University Press, 2011.

Farocki, Harun, and Wolfgang Ernst. "Towards an Archive for Visual Concepts." In
Harun Farocki: Working on the Sightlines, edited by Thomas Elsaesser, 261–86. Am-
sterdam: Amsterdam University Press, 2004.

"Final Cut 2008: Terra Incognita; Unknown Pleasures from around the World." *Film
Comment* 45, no. 1 (2009): 41–45.

Fisher, Morgan. "Writings." In *Morgan Fisher: Two Exhibitions*, edited by Sabine Folie
and Susanne Titz, 71–75. Vienna: Generali Foundation, 2012.

Flaig, Paul. "Supposing That the Archive Is a Woman." In *New Silent Cinema*, edited by
Paul Flaig and Katherine Groo, 180–99. New York: Routledge, 2015.

Flusser, Vilém. "The Gesture of Photographing." *Journal of Visual Culture* 10, no. 3
(2011): 279–93.

———. *Gestures*. Translated by Nancy Ann Roth. Minneapolis: University of Minne-
apolis Press, 2014.

Fossati, Giovanna. "Found Footage: Filmmaking, Film Archiving and New Participa-
tory Platforms. In *Found Footage: Cinema Exposed*, 177–84. Amsterdam: Amster-
dam University Press, 2012.

———. *From Grain to Pixel: The Archival Life of Film*. Amsterdam: Amsterdam Uni-
versity Press, 2009.

Foster, Hal. "The Archival Impulse." *October*, no. 110 (autumn 2004): 3–22.

———. "Archives of Modern Art." *October*, no. 99 (winter 2002): 81–95.

———. "The Archive without Museums." *October*, no. 77 (summer 1996): 97–119.

Foucault, Michel. "The Historical *a priori* and the Archive." In *The Archive*, edited by
Charles Merewether, 26–30. Cambridge, MA: MIT Press, 2006.

Fowler, Catherine. "*The Clock*: Gesture and Cinematic Replaying." *Framework* 54, no. 2
(2013): 226–42.

Friedberg, Anne. *Window Shopping: Cinema and the Postmodern*. Berkeley: University
of California Press, 1993.

Garson, Charlotte. "*The Exiles*." *Cahiers du Cinéma*, no. 651 (December 2009): 75.

Gilloch, Graeme. *Myth and Metropolis: Walter Benjamin and the City*. Cambridge: Pol-
ity, 1996.

Gledhill, Christine. "Rethinking Genre." In *Re-inventing Film Studies*, edited by Chris-
tine Gledhill and Linda Williams, 221–43. London: Arnold, 2000.

Glöde, Marc. "A Different Rediscovery of Something (Lost): The Dynamics of Found
Footage Film after 1990." In *Found Footage Cinema Exposed*, edited by Marente
Bloemheuvel, Giovanna Fossati, and Jaap Guldemond, 105–11. Amsterdam: Am-
sterdam University Press, 2012.

Gordon, Joel. *Revolutionary Melodrama: Popular Film and Civic Identity in Nasser's Egypt*. Chicago: Middle East Documentation Center, 2002.

Gorfinkel, Elena. "Arousal in Ruins: *The Color of Love* and the Haptic Object of Film History." *World Picture*, no. 4 (spring 2010): 1–19.

Grant, Catherine. "On Cinematic Spontaneity." Online video essay. Vimeo. Accessed June 30, 2017. http://vimeo.com/46295112.

——. "Skipping Rope." Online video essay. Vimeo. Accessed June 30, 2017. http://vimeo.com/41195578.

Griffiths, Allison. "'Automatic Cinema' and Illustrated Radio: Multimedia in the Museum." In *Residual Media*, edited by Charles R. Acland, 69–96. Minneapolis: University of Minnesota Press, 2007.

Gunning, Tom. "From Fossils of Time to a Cinematic Genesis: Gustav Deutsch's *Film Ist*." In *Gustav Deutsch*, edited by Wilbirg Brainin-Donnenberg and Michael Loebenstein, 163–80. Vienna: Österreichisches Filmmuseum, 2009.

——. "Living Mirrors: Deutsch's Cinematic Monadology." May 7, 2017. https://www.gustavdeutsch.net/en/47-bibliography/bibliografie-thematical/74-living-mirrors-deutsch-s-cinematic-monadology.html.

——. "The Long and the Short of It: Centuries of Projecting Shadows, from Natural Magic to the Avant-Garde." In *Art of Projection*, edited by Stan Douglas and Christopher Eamon, 23–35. Ostfildern, GDR: Hatje Cantz, 2009.

——. "'Primitive' Cinema: A Frame-Up? Or, the Trick's on Us." In *Early Cinema: Space, Frame, Narrative*, edited by Thomas Elsaesser, 95–103. London: BFI, 1990.

——. "What's the Point of an Index? Or Faking Photographs." In *Still Moving: Between Cinema and Photography*, 23–40. Durham, NC: Duke University Press, 2008.

Habib, André. "Positions: Of the North." *Horchamp* (January/February 2016). http://www.horschamp.qc.ca/spip.php?article621.

Hallas, Roger. "AIDS and Gay Cinephilia." *Camera Obscura* 18, no. 1 (2003): 85–126.

Hansen, Miriam. "Benjamin and Cinema: Not a One-Way Street." "'Angelus Novus': Perspectives on Walter Benjamin," *Critical Inquiry* 25, no. 2 (1999): 306–43.

——. "Benjamin, Cinema and Experience: 'The Blue Flower in the Land of Technology.'" *New German Critique*, no. 40, special issue on Weimar film theory (winter 1987): 179–224.

——. "Benjamin's Aura." *Critical Inquiry* 24, no. 2 (2008): 336–75.

——. *Cinema and Experience: Siegfried Kracauer, Walter Benjamin, and Theodor Adorno*. Berkeley: University of California Press, 2012.

——. "Room-for-Play: Benjamin's Gamble with Cinema: The Martin Walsh Lecture 2003." *Canadian Journal of Film Studies* 13, no. 1 (spring 2004): 2–27.

Hauptman, Jodi. *Joseph Cornell: Stargazing in the Cinema*. New Haven, CT: Yale University Press, 1999.

Heath, Stephen. *Questions of Cinema*. Bloomington: Indiana University Press, 1981.

Hediger, Vinzenz. "Der Kunster als Kritiker." In *Laienherrschaft: 18 Exkurse zum Verhältnis von Künsten und Medien*, edited by Ruedi Widmer. Zurich: Diaphanes, 2014.

———. "What Makes an Excerpt? The Video Essay as an Experiment Performed on the Work of Art." "Frankfurt Papers," The Audiovisual Essay. Accessed July 1, 2017. http://reframe.sussex.ac.uk/audiovisualessay/frankfurt-papers/vinzenz-hediger/.

Hobart, Rose. *A Steady Digression to a Fixed Point: The Autobiography of Rose Hobart.* Metuchen, NJ: Scarecrow, 1994.

Horwatt, Eli. "On *The Clock* and Christian Marclay's Instrumental Logic of Appropriation." *Framework* 54, no. 2 (2013): 208–25.

Huffer, Lynne. *Mad for Foucault: Rethinking the Foundations of Queer Theory.* New York: Columbia University Press, 2009.

Huhtamo, Erkki, and Jussi Parikka. "Introduction: An Archaeology of Media Archaeology." In *Media Archaeology: Approaches, Applications, Implications*, edited by Erkki Huhtamo and Jussi Parikka, 1–22. Berkeley: University of California Press, 2011.

James, Nick. "75 Hidden Gems." *Sight and Sound* 17, no. 8 (2007): 18–32.

Jameson, Fredric. "Postmodernism, or The Cultural Logic of Late Capitalism." *New Left Review*, no. 146 (July–August 1984): 59–92.

———. *Postmodernism, or, The Cultural Logic of Late Capitalism.* Durham, NC: Duke University Press, 1991.

Janisse, Kier-La. "Apocalypse Now: An Interview with Video Artist Dominic Gagnon." *Spectacular Optical*, April 4, 2014. http://www.spectacularoptical.ca/2014/04/apocalypse-now-an-interview-with-video-artist-dominic-gagnon/.

Katz, Joel. "From Archive to Archiveology." *Cinematograph*, no. 4 (1991): 96–103.

Keathley, Christian. *Cinephilia and History, or The Wind in the Trees.* Bloomington: Indiana University Press, 2006.

Khurana, Chanpreet. "A Splice of Reel Life." *Live Mint*, August 2013.

Kimball, Greg, dir. *Bunker Hill: A Tale of Urban Renewal.* Special feature on *The Exiles*, directed by Kent MacKenzie, 1961. DVD. Harrington Park, NJ: Milestone Film and Video, 2008.

King, Homay. *Virtual Memory: Time-Based Art and the Dream of Digitality.* Durham, NC: Duke University Press, 2015.

Kittler, Friedrich. "The City Is a Medium." *New Literary History* 27, no. 4 (1996): 717–29.

———. "Memories Are Made of You." In *Lost in the Archives*, edited by Rebecca Comay, 405–16. Alphabet City 8. Toronto: Alphabet City Media, 2002.

Klinger, Barbara. *Melodrama and Meaning: History, Culture, and the Films of Douglas Sirk.* Bloomington: Indiana University Press, 1994.

Knight, Arthur. "Paris 1900." *Films in Review* 1, no. 7 (1950): 22–24.

———. "Woman in a Masculine Movie World." *New York Times*, November 23, 1952.

Kracauer, Siegfried. "Photography." 1927. Reprinted in *The Mass Ornament: Weimar Essays*, edited and translated by Thomas Y. Levin, 47–64. Cambridge, MA: Harvard University Press, 1995.

⸻. *Theory of Film: The Redemption of Physical Reality.* 1960. Reprint, Princeton, NJ: Princeton University Press, 1997.

Krauss, Rosalind. "Clock Time." *October* 136 (spring 2011): 213–17.

⸻. *"A Voyage on the North Sea": Art in the Age of the Post-medium Condition.* London: Thames and Hudson, 1999.

Krugman, Paul. Review of *Capital in the Twenty-First Century* by Thomas Piketty. *New York Review of Books*, May 8, 2014, 15–18.

Latsis, Dimitrios S. "Geneologies of the Image in *Histoire(s) du cinéma*: Godard, Warburg and the Iconology of the Interstice." *Third Text* 27, no. 6 (2013): 774–85.

Lehmann, Ulrich. *Tigersprung: Fashion in Modernity.* Cambridge, MA: MIT Press, 2000.

Leslie, Esther. *Hollywood Flatlands: Animation, Critical Theory, and the Avant-Garde.* New York: Verso, 2002.

Levin, Thomas Y. "Dismantling the Spectacle: The Cinema of Guy Debord." In *On the Passage of a Few People through a Rather Brief Moment in Time: The Situationist International 1957–1972*, edited by Elisabeth Sussman, 72–123. Cambridge, MA: MIT Press, 1991.

Leyda, Jay. *Films Beget Films.* New York: Hill and Wang, 1964.

Lim, Shirley Jennifer. "'Speaking German like Nobody's Business': Anna May Wong, Walter Benjamin, and the Possibilities of Asian American Cosmopolitanism." *Journal of Transnational American Studies* 4, no. 1 (2012): 1–17.

Loebenstein, Michael. "The Hub of the Universe: About the Viennese Episode of WELT SPIEGEL KINO." Accessed November 17, 2017. http://gustavdeutsch.net/en/films -videos/47-bibliography/bibliografie-thematical/75-the-hub-of-the-universe.html.

Lowenstein, Adam. *Dreaming of Cinema: Spectatorship, Surrealism, and the Age of Digital Media.* New York: Columbia University Press, 2015.

Lundemo, Trond. "Archives and Technological Selection." *Cinémas* 24, nos. 2–3 (2014): 17–40.

MacDonald, Scott. "Conversations on the Avant-Doc: Scott MacDonald Interviews." *Framework: The Journal of Cinema and Media* 54, no. 2 (2013): 259–330.

⸻. "A Conversation with Gustav Deutsch." Parts 1 and 2. In *Gustav Deutsch*, edited by Wilbirg Brainin-Donnenberg and Michael Loebenstein. Vienna: Österreichisches Filmmuseum, 2009.

⸻. "Matthias Müller." In *A Critical Cinema 5: Interviews with Independent Filmmakers*, 281–310. Berkeley: University of California Press, 2006.

MacKenzie, Kent Robert. "A Description and Examination of the Production of *The Exiles*: A Film of the Actual Lives of a Group of Young American Indians." Master's thesis, University of Southern California, 1964.

Manovich, Lev. "Database as Symbolic Form." *Millennium Film Journal*, no. 34 (fall 1999): 24–43.

Marks, Laura U. *Hanan al-Cinema: Affections for the Moving Image.* Cambridge, MA: MIT Press, 2015.

Martin, Adrian. "Turn the Page: From Mise-en-Scène to *Dispositif*." In *Cinephilia in the Age of Digital Reproduction: Film Pleasure and Digital Culture*, vol. 2, edited by Scott Balcerzak and Jason Sperb, 215–37. New York: Wallflower, 2012.

Mast, Gerald, and Marshall Cohen, eds. *Film History and Criticism: Introductory Readings*. Oxford: Oxford University Press, 1974.

Merewether, Charles, ed. *The Archive*. Cambridge, MA: MIT Press, 2006.

Metz, Christian. *The Imaginary Signifier: Psychoanalysis and the Cinema*. Translated by Celia Britton, Annwyl Williams, Ben Brewster, and Alfred Guzzetti. Bloomington: Indiana University Press, 1982.

Michaud, Philippe-Alain. *Aby Warburg and the Image in Motion*. Translated by Sophie Hawkes. New York: Zone Books, 2004.

Miller, Tyrus. "'Glass before Its Time, Premature Iron': Architecture, Temporality and Dream in Benjamin's *Arcades Project*." In *Walter Benjamin and "The Arcades Project*," edited by Beatrice Hanssen, 240–58. New York: Continuum, 2006.

Mulvey, Laura. *Death 24x a Second: Stillness and the Moving Image*. London: Reaktion Books, 2006.

———. "Notes on Sirk and Melodrama." *Movie*, no. 25 (winter 1977/78): 53–56.

Naremore, James. "Films of the Year, 2008." *Film Quarterly* 62, no. 4 (2009): 26–27.

Nichols, Bill, and Michael Renov, eds. *Cinema's Alchemist: The Films of Péter Forgács*. Minneapolis: University of Minnesota Press, 2011.

Nora, Pierre. "Between Memory and History: *Les Lieux de Mémoire*." *Representations* 26 (spring 1989): 7–24.

Nowell-Smith, Geoffrey. "Minnelli and Melodrama." *Screen* 18, no. 2 (1977): 113–18.

Olalquiaga, Celeste. *The Artificial Kingdom: On the Kitsch Experience*. Minneapolis: University of Minnesota Press, 1998.

Osborne, Peter. "Distracted Reception: Time, Art and Technology." In *Time Zones: Recent Film and Video*, edited by Jessica Morgan and Gregor Muir, 66–75. London: Tate, 2004.

———. *Walter Benjamin: Critical Evaluations in Cultural Theory*. Vol. 3, *Appropriations*. New York: Routledge, 2005.

Parikka, Jussi. "Media Archaeology as a Trans-Atlantic Bridge." In *Digital Memory and the Archive*, by Wolfgang Ernst, edited by Jussi Parikka, 23–31. Minneapolis: University of Minnesota Press, 2013.

Pensky, Max. "*Geheimmittel*: Advertising and Dialectical Images in Benjamin's *Arcades Project*." In *Walter Benjamin and "The Arcades Project*," edited by Beatrice Hanssen, 113–31. New York: Continuum, 2006.

Petro, Patrice. *Aftershocks of the New: Feminism and Film History*. New Brunswick, NJ: Rutgers University Press, 2002.

"Phoenix Tapes (Christoph Girardet and Matthias Muller, 1999)." *Make Mine Criterion!*, August 9, 2014. Accessed June 29, 2017. https://makeminecriterion.wordpress.com/2014/08/09/phoenix-tapes-christoph-girardet-and-matthias-muller-1999/.

Pierson, Michele. "Avant-Garde Re-enactment: *World Mirror Cinema, Decasia,* and *The Heart of the World*." *Cinema Journal* 49, no. 1 (2009): 1–19.

Pimenta, Joana. "Serial Chance: Inserts and Intruders." *Millennium Film Journal,* no. 60 (fall 2014): 72–79.

Prelinger, Rick. "On the Virtues of Preexisting Material." 2007. Reprinted in *Contents,* no. 5 (January 31, 2013). http://contentsmagazine.com/articles/on-the-virtues-of -preexisting-material/.

———. "Points of Origin: Discovering Ourselves through Access." *Moving Image* 9, no. 2 (2009): 164–75.

Rancière, Jacques. "Godard, Hitchcock, and the Cinematographic Image." In *Forever Godard,* edited by Michael Temple, James S. Williams, and Michael Witt, 214–31. London: Black Dog, 2007.

Rascaroli, Laura. *The Personal Camera: Subjective Cinema and the Essay Film.* London: Wallflower, 2009.

Rochlitz, Rainer. *Walter Benjamin and the Disenchantment of Art: The Philosophy of Walter Benjamin.* Translated by Jane Marie Todd. New York: Guilford, 1996.

Russell, Catherine. "Archiveology." "Lexicon 20th Century A.D. Vol. 1 of 2," edited by Christine Davis, Ken Allan and Lang Baker, *Public* 19 (spring 2000): 22.

———. *Experimental Ethnography: The Work of Film in the Age of Video.* Durham, NC: Duke University Press, 1999.

———. "New Media and Film History: Walter Benjamin and the Awakening of Cinema." *Cinema Journal* 43, no. 2 (2004): 81–85.

———. "Parallax Historiography: The Flâneuse as Cyberfeminist." In *A Feminist Reader in Early Cinema,* edited by Jennifer Bean and Diane Negra, 552–70. Durham, NC: Duke University Press, 2002.

Russell, Catherine, and Louis Pelletier. "'Ladies, Please Remove Your Hats': Fashion, Moving Pictures and Gender Politics of the Public Sphere 1907–11." *Living Pictures* 2, no. 1 (2003): 61–84.

Sacco, Daniela. "The Braided Weave of *Mnemosyne*: Aby Warburg, Carl Gustav Jung, James Hillman." Translated by Emily V. Bovino. *Engramma,* no. 114 (March 2014). http://www.engramma.it/eOS2/index.php?id_articolo=1521.

Sekula, Allan. "The Body and the Archive." *October,* no. 39 (winter 1986): 3–64.

———. "The Traffic in Photographs." *Art Journal* 41, no. 1 (1981): 15–25.

Shafiq, Viola. "Women, National Liberation, and Melodrama in Arab Cinema: Some Considerations." *Al-Raida: Arab Women and Cinema* 16, nos. 86–87 (1999): 12–18.

Shambu, Girish. *The New Cinephilia.* Montreal: Caboose, 2014.

Silverman, Kaja. "The Dream of the Nineteenth Century." *Camera Obscura* 17, no. 3 (2002): 1–29.

Sinclair, Iain. "Time Pieces." E-mail exchange between Chris Petit and Iain Sinclair. *Film Comment* 47, no. 3 (2011): 50.

Singer, Ben. *Melodrama and Modernity: Early Sensational Cinema and Its Contexts.* New York: Columbia University Press, 2001.

Sjöberg, Patrik. *The World in Pieces: A Study of Compilation Film.* Stockholm: Aura Florlag, 2001.

Skoller, Jeffrey. *Shadows, Specters, Shards: Making History in Avant-Garde Film.* Minneapolis: University of Minnesota Press, 2005.

Spieker, Sven. *The Big Archive: Art from Bureaucracy.* Cambridge, MA: MIT Press, 2008.

Springgay, Stephanie. "Corporeal Pedagogy and Contemporary Visual Art." *Art Education* 61, no. 2 (2008): 18–24.

"Staff Recommendations: Cineaste Editors Tout Their Favorite DVD Releases." *Cineaste* 35, no. 2 (2010): 75.

Steedman, Carolyn. "Something She Called a Fever: Michelet, Derrida, and Dust." *American Historical Review* 106, no. 4 (2001): 1159–80.

Steinberg, Michael P. "The Collector as Allegorist." In *Walter Benjamin and the Demands of History*, edited by Michael P. Steinberg, 88–118. Ithaca, NY: Cornell University Press, 1996.

Stern, Leslie. "Paths That Wind through the Thicket of Things." *Critical Inquiry* 28, no. 1 (2001): 317–54.

Stoney, Elisabeth. "Life on Screen: Rania Stephan." *Art Asia Pacific* 79 (July/August 2012). http://artasiapacific.com/Magazine/79/LifeOnScreenRaniaStephan.

Stork, Matthias. "Chaos Cinema Part 1." Online video essay. Vimeo. Accessed July 1, 2017. http://vimeo.com/28016047.

———. "Chaos Cinema Part 2." Online video essay. Vimeo. Accessed July 1, 2017. https://vimeo.com/28016704.

Straw, Will. "Spectacles of Waste." In *Circulation and the City: Essays on Urban Culture*, edited by Alexandra Boutros and Will Straw, 184–213. Montreal: McGill Queens University Press, 2010.

Taussig, Michael. *Mimesis and Alterity: A Particular History of the Senses.* New York: Routledge, 1993.

Torlasco, Domietta. *The Heretical Archive: Digital Memory at the End of Film.* Minneapolis: University of Minnesota Press, 2013.

Tyler, Parker. "Four Million Dollars' Worth of Magic." *Theatre Arts*, January 1953.

Verwoert, Jan. "Apropos Appropriation: Why Stealing Images Today Feels Different." *Art and Research* 1, no. 2 (2007). http://www.artandresearch.org.uk/v1n2/verwoert.html.

Wang, Yiman. "Playback, Play-Forward: Anna May Wong in Double Exposure." In *New Silent Cinema*, edited by Katherine Groo and Paul Flaig, 106–25. New York: Routledge, 2016.

Weber, Samuel. *Benjamin's -abilities.* Cambridge, MA: Harvard University Press, 2008.

Wees, William C. "The Ambiguous Aura of Hollywood Stars in Avant-Garde Found-Footage Films." *Cinema Journal* 41, no. 2 (2002): 3–18.

———. *Recycled Images: The Art and Politics of Found Footage Films*. New York: Anthology Film Archives, 1993.

Willemen, Paul. *Looks and Frictions: Essays in Cultural Studies and Film Theory*. London: British Film Institute, 1994.

Williams, James S. "Histoire(s) du cinéma." *Film Quarterly* 61, no. 3 (2008): 10–16.

Williams, Linda. "Melodrama Revised." In *Refiguring American Film Genres: History and Theory*, edited by Nick Browne, 42–88. Berkeley: University of California Press, 1998.

Windhausen, Federico. "Hitchcock and the Found Footage Installation: Müller and Girardet's *The Phoenix Tapes*." *Hitchcock Annual*, no. 12 (2003–4): 100–125.

Wohlfarth, Irving. "The Measure of the Possible, the Weight of the Real and the Heat of the Moment: Benjamin's Actuality Today." In *The Actuality of Walter Benjamin*, edited by Laura Marcus and Lynda Nead, 13–39. London: Lawrence Wishart, 1998.

———. "Walter Benjamin and the Idea of a Technological Eros: A Tentative Reading of *Zum Planetariium*." In *Benjamin Studies/Studien 1: Perception and Experience in Modernity*, edited by Helga Geyer-Ryan, Paul Koopman, and Klaas Yntema, 65–109. Amsterdam: Rodolpi, 2002.

Wollen, Peter. "The Concept of Fashion in *The Arcades Project*." "Benjamin Now," special issue, *Boundary 2* 30, no. 1 (2003): 131–42.

"Young American Indians in 1961 Los Angeles." *The Leonard Lopate Show*, WNYC, July 9, 2008. http://www.wnyc.org/story/56435-young-american-indians-in-1961-los-angeles/.

Zryd, Michael. "Found Footage Film as Discursive Metahistory: Craig Baldwin's *Tribulation 99*." *Moving Image* 3, no. 2 (2003): 40–61.

INDEX

archiveology (*continued*)
melodrama, 163; mortification, 46–47;
narrative, 22; and nonsensuous
correspondence, 43–44; overview
and definitions, 1, 4–7, 9, 11–12, 22, 27,
143, 221; signification in, 47; socio-
political role, 224; term history, 11–12;
as uncanny discourse, 63; ungrasped
potential of, 16–17; and women's work,
6, 217
archives: Benjamin on, 112–13; and
chance, 153; cities as, 59; and
collections, 27, 118; as construction
sites, 13; democratization of,
118; digital, 103, 118, 189–90; and
dreamworlds, 49; and historiography,
13; and legibility, 101; post-Freud, 100;
predicates, 96; and revelation, 101;
as social practice, 12–13; twentieth-
century reinvention, 100; twenty-
first-century changes, 12–13, 95; as
transformational, 13; types of, 5, 11
art, 3–4, 38, 40–41
art-culture system, 122
artwork essay, 37–39, 133, 159, 205, 227n3
Atget, Eugène, 9
audiovisual essays, 161–63, 173, 209
aura: and acting, 200, 204; as complex,
37–38; decaying, 41; definition, 205;
and dreamwork, 142; experiences of,
42, 190; Hansen's interpretation, 205–6;
and language, 39; as melodramatic,
173; and the returned gaze, 132; and
shock, 195
auratic experience, 38, 42–44, 195, 206
authenticity, 122
awakening: actress of the, 194; in *The
Arcades Project*, 47, 75, 194–95;
definition, 28; dialectical images, 52;
and feminism, 34, 188, 191–96, 216,

218; Godard's failed attempt, 185;
Gunning's theory, 128; from image
culture, 71–72; and inequity, 184; and
Kristall, 165–66; phantasmagoria,
from the, 68, 184; in *Rose Hobart*, 202,
205; use of the term, 194–95; in *World
Mirror Cinema*, 131, 136, 140

Baron, Jaimie, 20, 23, 217, 220, 221
Baroque allegory, 41–42, 46, 137
Baroque art, 40–41
Baudelaire, Benjamin on, 41, 81–82, 115,
137, 141
Beaches of Agnès, The (Varda), 188–89
Benjamin, Walter: Andersen,
similarities to, 81, 83–84, 90; cultural
theory, 1, 4; and feminism, 191–94;
influences on, 36–37; interpretations
of, 36–37; language, theory of, 41;
language, use of, 2; legacy, 3–4, 35–36,
38, 43; as modernist, 57; personal
archive, 48; picture writing, 41; and
Warburg, 136–40, 237n107; works in
English, 2–3; on writers, 1–2; writing
style, 55–56
Berlin Childhood, A, 55–56
Bonaventure Hotel, 94
Bradbury Building, 89
Buci-Glucksmann, 40, 171, 191–93,
216–17
Buck-Morss, Susan, 46, 180–81, 191–92
Bunker Hill, 93–95

camp, 217
catastrophe, 3, 38, 95–96, 116, 125, 166, 181
cinema: ambiguity of, 76; analog, 147; as
archival language, 12; in the artwork
essay, 159; Bazin on, 62–63; classical
(*see* classical cinema); as cultural
knowledge, 145; and fashion, 72;

genre, 173; as gesture, 223; as healing, 38; as history, 28; as old media, 26; things in, 146; and time, 63

Cinémathèque Française, 66

cinematic things, 146

cinephilia: and archiveology, 25; Barthes's, 160; critical, 144–46, 174; as critical nostalgia, 147–48; as cultural anthropology, 142, 144; definition, 144–45, 158; and film studies, 145; gay, 165; justification for, 237n10; *Los Angeles Plays Itself* as, 80–81

city: Anderson's view of, 90; as archive, 59; in Atget's photography, 9; Benjamin on, 55, 57, 87, 90; and catastrophe, 96; the flaneur, 56; as model for the Internet, 59; *My Winnipeg*, 58; *Time and the City*, 58; women in, 71. *See also* urban life

city films, 55–56, 58, 77–78, 128–29, 134, 155. See also *Los Angeles Plays Itself* (Andersen); *Paris 1900* (Védrès)

city writing, Benjamin's, 55–57

classical cinema: as archival cinema, 25–26, 105, 222; and Benjaminian allegory, 26; and melodrama, 142–43, 173; and phantasmagoria, 33, 51, 162; power of, 5; women awakening from, 196–97

Clock, The (Marclay): as archival, 154; as Benjaminian, 156, 158; comedy, 155–56; controversy, 154, 238n39; as *derive*, 152–53; as dispositif, 154–55; as documentary, 152, 157–58; and innervation, 156; institutional context, 150, 160, 238n23; and kitsch, 152, 154, 158; as multimedia, 151; narrativity, 142, 147, 155–56; as not curated, 153–54; overview, 148–50; phantasmagoria, 49–50, 153, 156–57; as social, 158–59;

sound, 155; time, use and representation, 150–53, 157, 160

clock films, 160–61

Cohen, Margaret, 73, 75, 143–44

collage: Deutsch's techniques in *Film Ist*, 29; in essay films, 24, 28; Godard's, 51–52; Rancière on, 102; in trick films, 74; Wees on, 19; writing style, 55–56

collecting: and allegory, 100; and archival film practices, 99; Benjamin on, 45, 63, 97; challenging cultural history, 97–98; creating new functions, 98; as historical materialism, 97; prominence of, 221–22; as redemptive, 99; as thinking, 99

collections: anthropological perspective, 99; *The Arcades Project* as, 102; as archives, 13, 27, 118; *The Clock* as, 152–53; cultural value, creating, 97–98; images in, 100, 106; as incomplete, 45

collective memory, 5, 22, 158, 210

collective unconscious, 49, 107, 139–40, 166

collector: and the allegorist, 99–100, 222–23; Andersen as, 80; definition, 44–45, 80, 146; filmmaker as, 98; and montage, 97; as obsolete, 222; physiognomist as, 123; and surrealism, 97

commodities: and allegory, 137, 143; as allegory, 41; fetishism, 50, 69, 75 (*see also* collector); and image objects, 137; images as, 103, 110, 111, 221; and nostalgia, 91

commodity culture, 46, 71, 83, 110, 166, 218, 222

compilation films: as archiveology, 21, 103; in digital culture, 103; origins of, 18, 21, 60; as remix, 21; vulnerability created by, 197; Wees's critique, 19–20.

compilation films (*continued*)

 See also *Film Ist* (Deutsch); *Los Angeles Plays Itself* (Andersen); *Paris 1900* (Védrès); *Three Disappearances of Soad Hosni, The* (Stephan)

construction sites, 13, 16

copyright and copyleft, 221

counterarchive, 13, 118

countercinema, 142

critic, 38, 42, 124, 140–42, 144

criticism, Benjamin on, 3–4, 141–42, 161–63, 171, 216

cultural history: and appropriation filmmaking, 17–18; archiveology and, 25; Benjamin on, 46, 167; collecting, as challenge to, 97–98; as constructed, 113–14; and critical cinephilia, 144–45; Ernst on, 113–14; found-footage filmmaking as, 113–14; and materiality, 12; and media archaeology, 113; modes of presenting, 98. See also *Hoax Canular* (Gagnon); *Parentheses* (Fisher); *World Mirror Cinema* (Deutsch)

database films, 21–22

databases, 103, 154

Davis, Bette, 204, 215

death, filming of, 62

Derrida, Jacques, 12, 100, 151, 185, 190, 196

destructive character, 142

détournement, 26, 152, 184, 186, 199, 218

Deutsch, Gustav, 127–28, 130

dialectical image: in *The Arcades Project*, 52; and archiveology, 53–54; documentary-fiction interpenetration, 53; fashion as, 69; film examples, 49–50; in Godard, 52; and involuntary memory, 87; theory of, 23, 52, 64, 103, 110, 111, 166

digital cinema, 148, 188–90

digital culture, 7, 28, 47, 103, 118

digital media: and archives, conceptions of, 118; as democratizing, 13, 28–29, 43, 47–48; and images, 9, 103; and memory, 32, 190, 196; new language of, 28

digitization, 48

dispositif, 147, 154, 157–59

documentary-fiction dialectic: definition, 53; and *Los Angeles Plays Itself*, 79; and *Paris 1900*, 76–77

documents: archival footage as, 23; Benjamin on, 28–29, 46, 221; cinematic spectacle as, 144; *The Clock* as, 152; *The Exiles* as, 91; *Paris 1900* as, 76; as untrustworthy, 48

double articulation, 34, 173, 221

dream house, 134–36, 140

dreamworlds, 33, 44, 47, 49–50, 67, 71, 75, 166

durée, 126, 151, 153, 190

East of Borneo, 197–99

enlarged spectatorship, 200

essay films: archiveology and, 22–25; *Home Stories*, 161; origins of, 65–66; *Parentheses*, 106; Richter's theory, 220; *Standard Gauge*, 106

essayistic agency, 22–23

ethical possession, 15–16

ethnography, 119, 122–23, 129

Eureka (Gehr), 47

excavation, 16, 59, 107–8, 193

Exiles, The, 79, 90–95

fairy tales, 144

Falls, The (Greenaway), 126

fashion, 69–73

feminism: and archival film practices, 185, 187–89; and Benjamin, 191–94;

testimony, 223

Three Disappearances of Soad Hosni, The
(Stephan): allegory, central, 211–13;
awakening in, 215–16; as critical
memory, 208; editing techniques,
208–9; and Egyptian history, 209–10;
as film history, 209; identity, Hosni's,
211–13; as *lieux de mémoire,* 210–11;
overview, 206–8; as pastiche, 217; vio-
lence in, 214

time, 150–53

Time and the City (Davies), 58

tragic drama. See *Origin of German
Tragic Drama, The*; *Trauerspiel*

translation, 40, 218–19, 222

Trauerspiel, 40–41, 139, 170–72, 193

trick films, 74–75

urban life, 55–56, 59; as thick, 59

utopianism, feminist, 191–92, 216–17

vanishing women, 215–16

Varda, Agnès, 187–91

Védrès, Nicole, 60–61, 230n19

video essays, 4, 21, 25, 145, 173–74, 209

violence, sexual, 178–80

Warburg, Aby, 136–40

women: challenging gender norms,
185; in the city, 71; fashion of,
69–73; in *Histoire(s) du cinéma*, 185;
in Hitchcock, 178–80, 182; *Home
Stories*, 16, 161; as image, 185, 194; in
Kristall, 164–65; in *La Jetée*, 186–87;
the lesbian, 192–93; in *Parentheses*,
108–10; in *Paris 1900*, 61, 64; in *Society
of the Spectacle*, 185–86; suffrage
movement, 70; in twentieth-century
image culture, 184; vanishing, 215–16.
See also feminism; gender; Hobart,
Rose; Hosni, Soad

Wong, Anna May, 194

"Work of Art in the Age of Mechanical
Reproduction, The." *See* artwork
essay

World Mirror Cinema (Deutsch):
awakening in, 135–36, 140; as city film,
128–29, 134; dragon scenes, 134–36;
editing, 128, 133–34; as ethnography,
129–30; as museological, 133, 138–39;
Pathosformel, 138; phantasmagoria,
135–36; as re-enactment, 133; returned
gaze, use of, 131–32; source material,
98, 127–28; structure, 130; theaters,
use of, 130–31, 134

writers, Benjamin on, 1–2